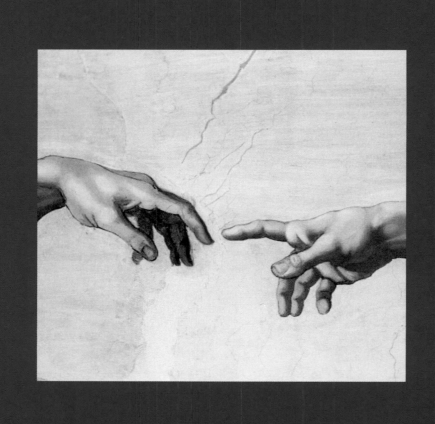

DISCOVERING
MICHELANGELO

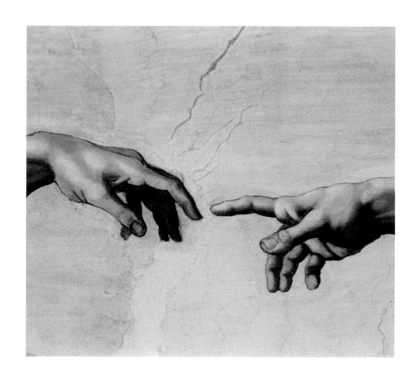

*The Art Lover's Guide
to Understanding
Michelangelo's
Masterpieces*

WILLIAM E. WALLACE

UNIVERSE

(PAGES 1, 3 AND 5)
Ceiling of the Sistine Chapel (DETAIL)
1508–12

DISCOVERING MICHELANGELO

The Art Lover's Guide to Michelangelo's Masterpieces

Published by Universe Publishing
A Division of Rizzoli International Publications, Inc.
300 Park Avenue South
New York, NY 10010
www.rizzoliusa.com

© 2012 Universe Publishing

BOOK DESIGNER: Kevin Osborn, Research & Design, Ltd.,
 Arlington, Virginia

PROJECT DIRECTOR: James Muschett

EDITOR: Mary Ellen Wilson

PHOTOGRAPHY CREDITS

Albertina Museum, Vienna: pp. 30, 31

Alinari / Art Resource, NY: pp. 44–45

The Art Archive / Ashmolean Museum: pp. 92, 95

Isabella Stewart Gardner Museum, Boston / The Bridgeman Art Library: pp. 198–199

Collection of the Earl of Leicester, UK / The Bridgeman Art Library: pp 68, 71, 72–73

Erich Lessing / Art Resource, NY: front cover, pp. 1, 3, 5, 16, 17, 18, 19, 78, 81, 96, 99,
 100–101, 102, 105, 106, 109, 110, 113, 114–115, 116, 119, 120, 123, 130, 133,
 134, 137, 152, 153, 180, 183, 204, 207

Réunion des Musées Nationaux / Art Resource, NY: pp. 26, 29, 130, 133

National Gallery, London / Art Resource, NY: pp. 184–185

Pierpont Morgan Library / Art Resource, NY: pp. 246, 249

Royal Academy of Arts, London: pp. 74, 77

Scala Art Resource, NY: pp. 8, 12, 13, 14, 18, 20, 21, 22, 23, 32, 33, 36, 39, 40, 43, 46, 49, 50,
 53, 54, 57, 58, 59, 82, 85, 88, 91, 138, 141, 144, 147, 156–157, 158, 161, 162, 165, 166,
 169, 170–171, 172, 175, 176, 179, 186, 189, 200, 203, 208, 211, 226, 227, 228, 231,
 232, 235, 236, 239, 240–241, 242, 245, 256, 259

Scala / Ministero per i Beni e le Attivitá culturali / Art Resource, NY: pp. 9, 15, 60, 63, 64,
 67, 124, 127, 128–129, 142–143, 212–213

Trustees of The British Museum / Art Resource, NY: pp. 19, 190, 193, 194, 197, 250,
 253, 254, 255

ISBN-13: 978-0-7893-2268-5

Library of Congress Catalog Control Number: 2012932097
2012 2013 2014 2015 / 10 9 8 7 6 5 4 3 2 1

PRINTED IN CHINA

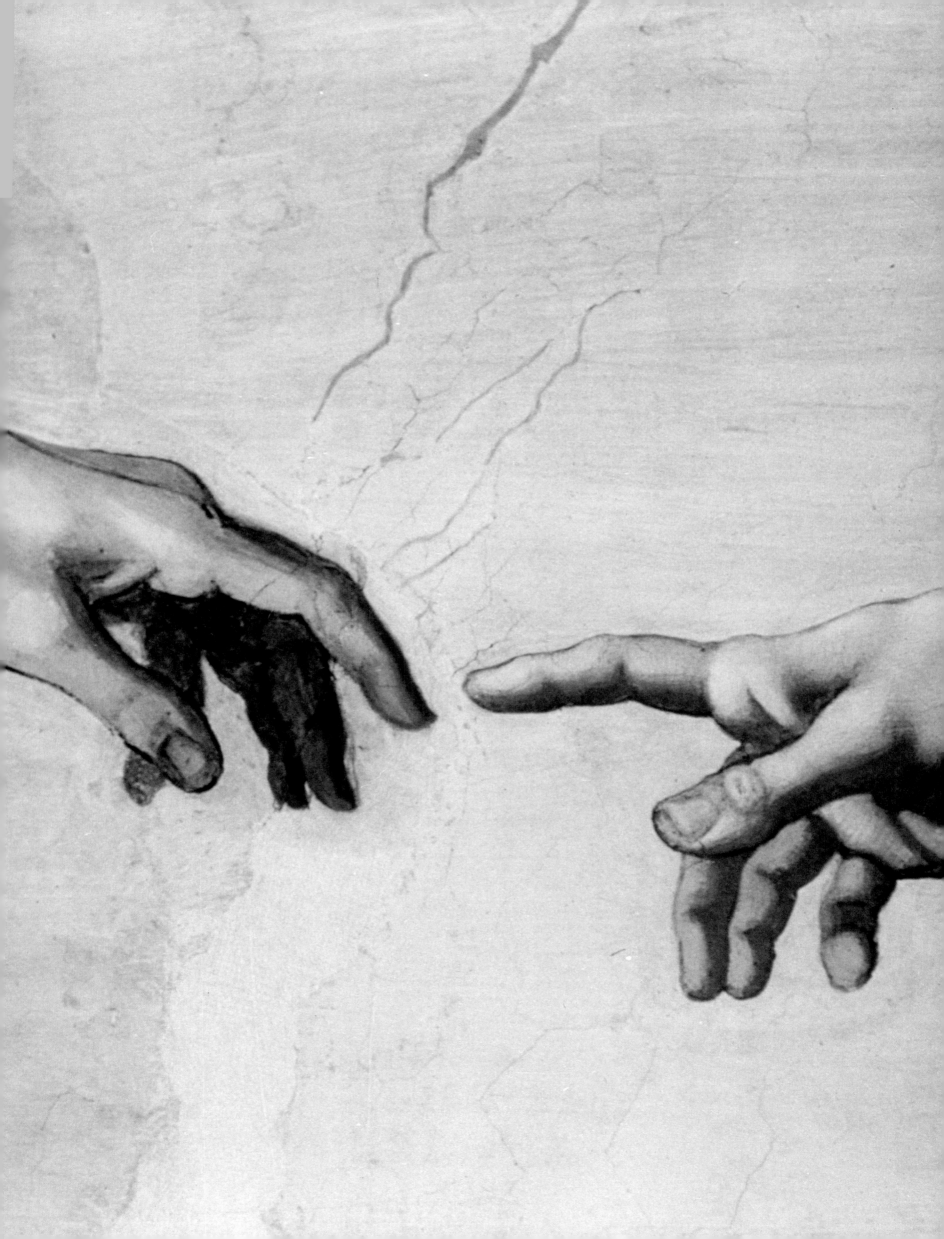

Contents

Introduction . 8

Group of Two Figures, after Giotto . 26

Madonna of the Stairs . 32

Battle of the Centaurs . 36

St. Petronius . 40

Bacchus . 46

Pietà (Rome) . 50

St. Paul and *St. Peter* . 54

David . 60

St. Matthew . 64

Aristotile da Sangallo, copy after Michelangelo, *Battle of Cascina* . 68

The Virgin and Child with the Infant St. John (Taddei Tondo) . 74

Madonna and Child and the Child St. John (Pitti Tondo) . 78

Holy Family with the Infant and St. John the Baptist (Doni Tondo) . 82

Madonna and Child . 88

Preparatory Drawing for the Ceiling of the Sistine Chapel . 92

Ceiling of the Sistine Chapel . 96

Flood . 102

Temptation and Expulsion . 106

Creation of Adam . 110

Cumaean Sibyl . 116

Libyan Sibyl . 120

Moses .. 124

Rebellious Slave ... 130

Dying Slave .. 134

"Atlas" or *"Blockhead" Slave* ... 138

Risen Christ .. 144

Drawing of Quarried Blocks ... 148

Tomb of Giuliano ... 152

Night ... 158

Medici Madonna ... 162

Laurentian Library ... 166

Laurentian Library Reading Room ... 172

Fortification drawing ... 176

Apollo/David .. 180

Victory .. 186

Fall of Phaeton ... 190

Crucifixion ... 194

Last Judgment .. 200

Brutus ... 204

The Capitoline Hill ... 208

Rachel and *Leah* .. 214

Conversion of Saul ... 218

Crucifixion of Peter .. 222

New St. Peter's ... 228

Pietà (Florence) .. 232

Porta Pia .. 236

Plan of San Giovanni dei Fiorentini .. 242

Cartonetto of the Annunciation ... 246

Crucifixion ... 250

Rondanini Pietà .. 256

INDEX OF WORKS .. 260

ARTIST AND ARISTOCRAT

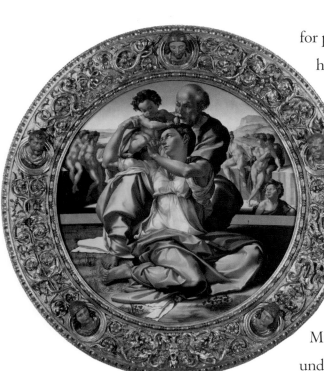

Holy Family with the Infant and St. John the Baptist (Doni Tondo)
CA. 1504

WHEN Michelangelo finished the large tondo of the Holy Family that hangs today in the Uffizi Gallery, he sent the round painting to its patron, Agnolo Doni, along with a note asking for payment of seventy ducats. Doni, a wealthy merchant who was cautious with his money, was disconcerted about the high price, "even though he knew that, in fact, it was worth even more." He gave the messenger forty ducats and told him that was enough. Michelangelo was incensed. He returned the money and demanded that Doni either pay him one hundred ducats or return the picture. But Doni liked the painting and so agreed to pay the original price of seventy ducats. Michelangelo was far from satisfied. Because of this breach of faith, he purportedly then demanded 140 ducats, double the original fee.

This story, related with evident relish by Giorgio Vasari, Michelangelo's contemporary and biographer, marks an important early moment not only in Michelangelo's career but also in the larger history of patronage in the arts. Vasari undoubtedly embellished the tale, but its narrative served to contrast an artist's demand for preferred treatment with a patron who was slow to recognize that negotiation was no longer acceptable. It is an opening salvo in a long battle for artistic recognition and independence that is still being waged: Do we pay artists for their time and materials or for their genius?

Another favorite story concerns the *David*, carved at the behest of Piero Soderini, head of the Florentine government. When Soderini saw the figure nearly completed, he was duly impressed but also a little critical—to him, the nose appeared too thick. To satisfy his patron, Michelangelo climbed the scaffold and grabbed his hammer while discreetly snatching a handful of marble dust. He tapped lightly on his chisel, altering nothing but permitting dust in his hand to fall little by little. "Ah, that's much better," exclaimed the duped observer. Michelangelo climbed down, "feeling sorry for those critics who talk nonsense in the hope of appearing well informed." In addition to allowing us a glimpse into

Michelangelo's cleverness, the story serves to emphasize that artists, rather than patrons or the public, are the final arbiters of aesthetic judgment. Different from the sometimes irrational and headstrong behavior of, say, Caravaggio or Rembrandt, Michelangelo's actions were a demand for respect born of lifelong privilege. They highlight his sustained effort to redefine the relations between artist and patron, and to reshape the artistic profession as a whole.

Such anecdotes have become an indelible part of Michelangelo's life and legend. Indeed, many people's image of the artist is largely indebted to Irving Stone's hugely popular novel, *The Agony and the Ecstasy*, and the equally successful movie. Stone offers the classic portrait of an irascible and misunderstood genius, isolated from all things mundane, including the routine world of family, friends, and most normal human emotions. One often hears, for example, that Michelangelo accomplished everything alone, which is certainly not the case, or that he was a homosexual, which is probably true but does little to elucidate his complex and largely repressed passions. The women in his artworks are frequently criticized for looking like men. Yet, assuming Michelangelo's lack of sympathy for female beauty can blind us to the many tender representations of women he painted on the Sistine Chapel ceiling and the surpassingly beautiful figure of Leah he carved on the tomb of Pope Julius II. In fact, Michelangelo took far greater liberties with the male nude. One need only examine the exaggerated musculature of *Day* in the Medici Chapel, or the impossible elongation and bizarre contortions of *Victory*, to realize that the human body, whether male or female, was his principal arena of artistic expression.

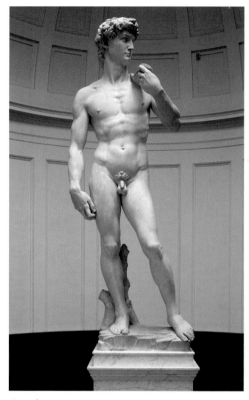

David
1501–4

With remarkable frequency I find people confusing Michelangelo and Leonardo da Vinci—their works, life stories, even their personal characteristics. Which artist had a broken nose and which wrote in mirror script? At some point the stature of these titans is such that we blur their lives and individualities and unwittingly attach messy accretions to their legends. Advertising only compounds the confusion by indiscriminately exploiting the artists' works to sell wine, pasta, T-shirts, toothpaste, toilet paper, and Tuscan holidays. Thanks to this pervasive imagery, many of the works in this volume will be familiar. But no matter how well we think we know them, Michelangelo's creations still fascinate, astonish, and humble us. This book offers a vivid portrait of an exceptional yet deeply human individual and the many remarkable works of art he made.

Renaissance Italy

In the film *The Third Man*, the character of Harry Lime (played by Orson Welles) declares: "In Italy, for thirty years under the Borgias, they had warfare, terror, murder, bloodshed, but they produced Michelangelo, Leonardo da Vinci,

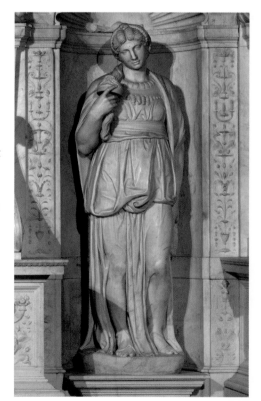

Leah from the Tomb of Julius II
1505–45

and the Renaissance. In Switzerland, they had brotherly love; they had five hundred years of democracy and peace. And what did that produce? The cuckoo clock." The Renaissance, from a French term meaning "rebirth," was a time of tremendous political and social change. As Lime recognized, it was a period of upheaval, but it is also regarded as the beginning of the modern world.

Modernity finds many of its roots in the profound changes that took place in Renaissance Italy between approximately 1300 and 1700: the growth of populous cities built and governed by its citizens; regulated manufacture and trade, resulting in unprecedented prosperity; banking and financial practices, which included the widespread use of credit and capital, double-entry bookkeeping, and a pan-European monetary standard (the Florentine gold florin); the invention of the printing press and the rapid spread of literacy; the rise of vernacular languages and literature; the institutionalization of manners and decorous behavior; inquiry based on scientific principles and objectively gathered evidence; the exploration of new worlds and technologies; a new focus by religion on the here and now; and, perhaps most important of all, the revival of interest in the cultures and accomplishments of ancient Greece and Rome, which spawned a philosophy called Neoplatonism and an outlook on life called humanism. Michelangelo was born into this early modern world.

Having achieved renown during his lifetime, Michelangelo was celebrated as "Il Divino," or the Divine One. In five hundred years his fame has scarcely diminished. He is universally recognized as among the greatest artists of all time. He set new and still unsurpassed standards of excellence in all fields of visual creativity—sculpture, painting, architecture—and was an accomplished poet and engineer. Along with Dante and Shakespeare, Mozart and Beethoven, he stands as one of the giants of western civilization. His career spanned from the glories of Renaissance Florence and the discovery of a new world to the first stirrings of the Catholic Counter-Reformation. Living nearly eighty-nine years, twice as long as most contemporaries, he witnessed the pontificates of thirteen popes and worked for nine of these powerful men. Although his art was occasionally criticized (he was accused, for example, of impropriety in the *Last Judgment*), his stature and influence have rarely been questioned. During a long and productive career, he fashioned some of the key images of western Christianity. Many of his works—including the *Pietà*, *David*, *Moses*, and Sistine Chapel ceiling—have become ubiquitous cultural icons.

We know more about Michelangelo than any other Renaissance artist; indeed, he is one of the best-documented artists of all time. Nearly fourteen hundred letters written by and to him survive, along with more than three hundred pages of his personal and professional records *(ricordi)* and an extensive

correspondence among members of his immediate family (440 published letters). By his hand are some three hundred poems, many fragments, approximately six hundred drawings, and of course the finished and unfinished works of sculpture, painting, and architecture. Then there are the many related documents: contracts, business and bank records, a nearly complete picture of the artist's finances and property holdings, and innumerable notices by his contemporaries. The wealth of information offers a fresh perspective on his life and relations with family, friends, patrons, and professional associates. In contrast to the romantic conception of the artist as a lone genius, contemporary scholars tend to view Michelangelo's life and work within a broad historical and social context.

Although Michelangelo is the best-documented artist of the Renaissance, we know little about the beginning of his career. His first extant letter was written from Rome in 1496, when he was already twenty-one years old. Altogether, only six letters to and from the artist date from the first thirty years of his life. Moreover, the information we do have has been subject to a continuous process of distortion and creative embellishment by Michelangelo as well as by his contemporaries.

The biographies written by the artist and writer Giorgio Vasari (first published in 1550) and his pupil/assistant Ascanio Condivi (first published in 1553) are generally considered important primary resources. Yet, these are fictionalized accounts tinged by the self-fashioning recollection of an artist more than seventy years old and at the height of his international fame. Employing literary description and anecdote, the biographies were primarily intended to praise Michelangelo's genius and unprecedented achievements (Vasari) and to tell the artist's own story (Condivi). Therefore, their value should be qualified by our recognition of their status as works of imaginative literature.

An Unconventional Beginning

Michelangelo was born on March 6, 1475, in the small town of Caprese, overlooking the lush Casentino valley, some ninety kilometers east of Florence. His father, Ludovico Buonarroti, was a minor Florentine official and the local governor (*podestà*) of the small town. After his six-month term of office, Ludovico moved his family back to Florence, where they owned a good-size farm in the village of Settignano. Perched in the hills overlooking the city, Settignano was home to many fine craftsmen and sculptors who found work in the nearby booming metropolis. Dante described them as men who "still smack of the mountains," and locally they are known as persons "that smell of stone" ("*che sente del macigno*"). Michelangelo once joked that he learned to carve

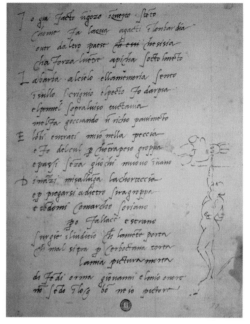

MICHELANGELO'S SONNET ABOUT PAINTING THE SISTINE CHAPEL CEILING CA. 1511-12

Having endured "stupendous labours" and "a thousand anxieties," Michelangelo wrote of his experience painting the Sistine ceiling in this humorous yet acerbic sonnet. At the bottom of the sheet, Michelangelo complained, "I'm not in a good place, and I am no painter."

marble from having been suckled by the daughter of a stonemason who was also the wife of a stonemason. Here and in the surrounding hills pock-marked with quarries, Michelangelo grew up and was exposed to the art of carving stone.

Despite petty concerns and frequent bickering, Michelangelo was attached to his father and three younger brothers. (His mother had died when he was just six years old, and his older brother became a Dominican monk.) In Italy and throughout European civilization, the family was fundamental to self-definition:

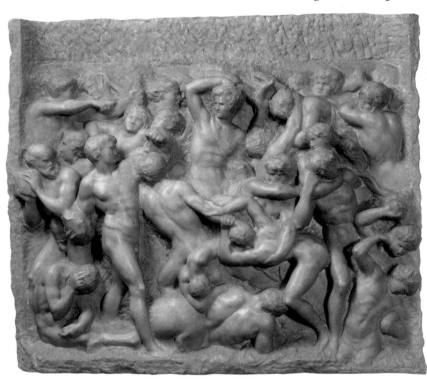

Battle of the Centaurs
CA. 1491–92

its status established an individual's status. Michelangelo was one of just a handful of Renaissance artists, including Brunelleschi, Donatello, and Leon Battisti Alberti, who were born into patrician families. He ardently believed that his family was descended from the medieval counts of Canossa, as is emphatically stated in the opening lines of Condivi's life of the artist: "Michelangelo Buonarroti, that outstanding sculptor and painter, traced his origin from the counts of Canossa, noble and illustrious family of the territory of Reggio through their own quality and antiquity as well as their relationship with the imperial blood." This belief in the antiquity and nobility of his origins fueled Michelangelo's lifelong ambition to improve his social and financial situation. His pride of ancestry is evident in his dress and comportment as well as in his frequent admonitions to his brothers and nephew to behave in a manner befitting their elevated social station.

Appropriately for a son whose family had noble pretensions, Michelangelo attended grammar school until the age of thirteen. It is uncertain when he first became an artist, but understandably his father opposed such a predilection. The manual crafts of painting and sculpture were considered lowly occupations; as the breadwinner of the family, Michelangelo was expected to enter a more lucrative profession. When the boy showed greater aptitude for carving stone than declining the Latin subjunctive, Ludovico sent him into the city, hoping that the cosmopolitan atmosphere would provide his son with the education and polish appropriate to his class. Thanks largely to his father's exertions and family connections, Michelangelo enjoyed a brief and undemanding apprenticeship with Domenico Ghirlandaio (ca. 1449–94), then the most fashionable painter in Florence.

Although he later denied learning much from Ghirlandaio, Michelangelo's early drawings and first efforts in painting (the *Doni Tondo* and Sistine ceiling) offer abundant evidence that the young man imbibed the rudiments of his craft. Under the master, he learned the complicated mechanics of fresco painting and,

perhaps more important, practiced the arts of drawing and design *(disegno)*, which became foundational principles of his art. Long before completing a traditional apprenticeship, however, Michelangelo secured a place in the large entourage of the era's greatest patron, Lorenzo de' Medici, again thanks to the intervention of his father, who could claim a distant relationship to the illustrious family.

The fifteen-year-old youth spent two of the happiest years of his life in the Medici palace (ca. 1490–92). There he was able to study some of the finest works of ancient and modern art and was introduced to the most important literary and intellectual figures of the day, including Marsilio Ficino, Angelo Poliziano, Cristoforo Landino, and Giovanni Pico della Mirandola. He received the beginnings of a humanist education, a unique opportunity for an artist. Although he never mastered Latin, the lingua franca of educated individuals, he gained much from the bright minds and scintillating conversation encountered within Lorenzo's household. In our modern culture saturated with printed words and images, we sometimes forget the importance of conversation and oral tradition: books were read aloud, poetry was memorized and recited at length, sermons were explained and elaborated, street and court performances made works of literature accessible. In addition, Michelangelo was learning alongside two future patrons, Giovanni and Giulio de' Medici (who would later become Pope Leo X and Pope Clement VII, respectively). Leo later spoke of Michelangelo familiarly and with love, referring to him as "his brother," because the two had been nurtured together ("*nutriti insieme*"). Similarly, a reference to Michelangelo as Clement's "brother" was not the idle chatter of a courtier but tacit acknowledgment of his special connection to the Medici. From early in life, he forged strong bonds with persons of wealth and prestige.

Among Michelangelo's surviving early works are exercises in low relief *(Madonna of the Stairs)* and higher relief *(Battle of the Centaurs)*, revealing the artist's emulation of Donatello and classical antiquity, respectively. After the death of Lorenzo de' Medici, in 1492, Michelangelo actively sought patronage among the Strozzi family, probably carving for them a life-size marble *Hercules* (now lost). Without a regular artistic practice or steady patronage, his future and economic security remained tenuous. When the Medici were expelled from Florence in 1494, he elected to follow the family to Bologna, where he lived for nearly a year, from 1494 to 1495, in the house of Giovanni Francesco Aldovrandi, a local patrician. Aldovrandi encouraged Michelangelo's interest in vernacular literature, especially Dante and Petrarch, and arranged for the twenty-year-old artist to carve small statuettes representing St. Petronius and St. Proclus, as well as an angel candelabrum, for the still-incomplete tomb of St. Dominic, in the basilica of San Domenico. Later in life, Michelangelo complained about the envious Bolognese artists, but of course they had to

Madonna of the Stairs
CA. 1491–92

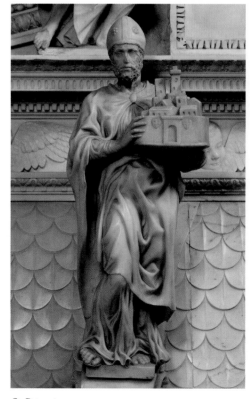

St. Petronius
1494–95

run workshops, pay rent, purchase materials, and compete for commissions. Michelangelo, unwilling to practice his profession in traditional fashion, was awarded a commission, supplied with marble, and given a place to work while living in the house of one of the town's leading citizens. Despite these comfortable conditions, opportunities were limited, and in late 1495 Michelangelo returned to Florence.

The city was then under the sway of a fiery Dominican preacher, Girolamo Savonarola, who managed to turn Florence into a virtual theocracy. Preaching to overflowing crowds, Savonarola condemned the profligacy of the Florentines. In a frenzy of reform, citizens gave up their luxurious living, even consigning books and works of art to a bonfire of the vanities. In need of a patron, Michelangelo curried favor with Lorenzo di Pierfrancesco de' Medici, a member of the family's cadet branch. For him, Michelangelo carved two marble statues: *St. John the Baptist* and *Sleeping Cupid* (both now lost). Lorenzo recommended Michelangelo to Cardinal Raffaele Riario, nephew of Pope Sixtus IV and one of the richest and most powerful men in the Roman curia. Armed thus with letters of introduction, the twenty-one-year-old arrived in Rome for the first time in the summer of 1496.

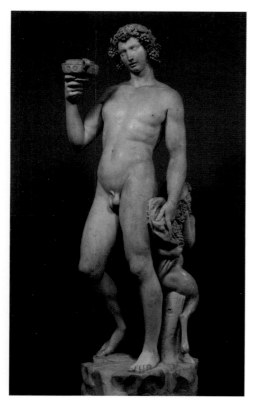

Bacchus
CA. 1496–97

The ancient monuments of Rome must have been a revelation, inspiration, and challenge to Michelangelo, for he immediately attempted some extremely audacious works, beginning with the *Bacchus*. He carved this *all'antica* figure at the behest of Cardinal Riario, who then inexplicably rejected it. The sculpture ended up in the collection of the Roman banker Jacopo Galli, who encouraged and supported Michelangelo, even guaranteeing the agreement calling for him to create a Pietà for the French cardinal Jean de Bilhères de Lagraulas, which he worked on from 1497 to 1499. A tour-de-force of aesthetic design and technical realization, the two-figure composition was carved from a single, large block of Carrara marble. It is the only work Michelangelo ever signed and remains one of the best-loved and most beautiful religious images of all time.

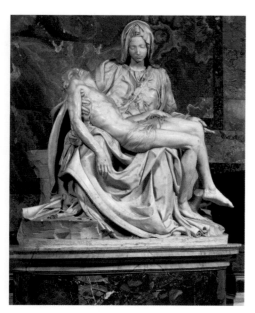

Pietà
1497–99

During this same period, Michelangelo purportedly carved marble statues of Cupid and St. John, both variously (but dubiously) identified with surviving sculptures. In 1501, again through the agency of Jacopo Galli, he was commissioned by Cardinal Francesco Piccolomini to carve fifteen statuettes for the Piccolomini altar in Siena, which had been left incomplete by the sculptor Andrea Bregno. Despite his extremely important patron (Piccolomini would become Pope Pius III in 1503, reigning only twenty-six days), the commission proved singularly unsuited to Michelangelo's temperament. Reluctant to work like some journeyman completing another artist's unfinished work, he carved just four of the statuettes and avoided fulfilling

the remainder of his obligation, even to the point of legal difficulties. Michelangelo readily set the project aside upon receiving the unusual opportunity to carve what may be his most famous work.

Florence and Bologna, 1501–1508

Quarried and worked some forty years earlier by the Renaissance sculptor Agostino di Duccio, a huge marble block, commonly referred to as "the giant," stood abandoned in the workshop of Florence Cathedral. Thanks to the intervention of Piero Soderini, the local head of government, Michelangelo was entrusted with the old and partially sculpted stone. After five years in Rome, the artist was anxious to produce a spectacular work in his native city. The resulting sculpture, *David*, is testimony not only of his overweening ambition but also of his recent experience and successes in Rome. It is an awe-inspiring symbol of Florence, the Renaissance, and human potential.

With the twin achievements of the *Pietà* in Rome and *David* in Florence, Michelangelo's reputation was firmly established, and he would never again lack for commissions. He was now the greatest living sculptor, a creator of marvels—everyone wished to employ him. Patrons and opportunities proliferated. Between 1501 and 1508, he sustained an astonishing level of productivity, which included not only *David* but also the *Bruges Madonna*, *St. Matthew*, marble tondi for the Taddei and Pitti families, the painted tondo for Agnolo Doni, a bronze *David* sent to France (now lost), a monumental bronze statue of Pope Julius II for Bologna (destroyed), and a commission for *The Battle of Cascina*, a grand fresco that was never completed. The number and stature of Michelangelo's international patrons during these years are equally impressive. They include a pope and a cardinal; the head of the Florentine government; four prominent Florentine families; the Florentine Cathedral Board of Works (*Opera del Duomo*), a company of rich Flemish merchants, and the French minister of finance. Condivi asserts that Michelangelo even considered accepting an invitation from the sultan of Turkey to construct a bridge across the Bosporus at Constantinople. In a bid for artistic preeminence, and contrary to his later practice, he appears to have refused no one. In hindsight, it seems irresponsible for Michelangelo to have accepted so many concurrent obligations, but there was little room for refusal and every commission offered a new challenge. Besides, nothing could have seemed impossible for the sculptor of the *Pietà* and *David*.

Amid this busy period, Michelangelo was commissioned to paint a fresco depicting the Battle of Cascina. It would be opposite one to be created by his rival Leonardo da Vinci in the Sala dei Cinquecento, the Florentine hall of state, in the Palazzo della Signoria. There, the two greatest artists of the Renaissance

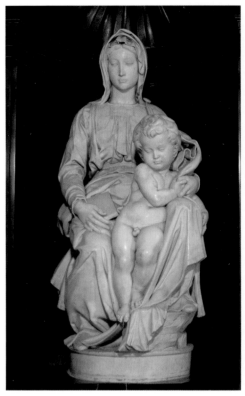

Madonna and Child
1503–5

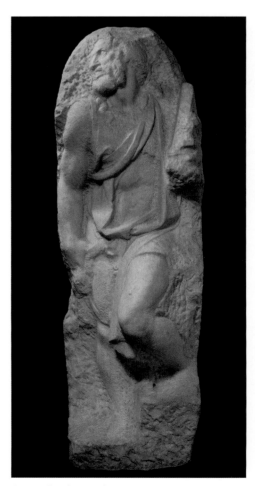

St. Matthew (DETAIL)
1505–8

were pitted against each other—a confrontation intended to elicit both artists' supreme effort. For differing reasons, neither completed his painting: Leonardo because of technical frustrations and Michelangelo because, in 1505, he was summoned to Rome by Pope Julius II. The unrealized frescos remain one the greatest "what if?" episodes in the history of art.

Rome and the Pope, 1505–1516

In Rome, the recently elected pontiff, Julius II (Giuliano della Rovere; reigned 1503–13), was in the midst of a complete overhaul of both the city and the papacy. With unparalleled energy and ambition, Julius reinvigorated papal authority through bold military action and a sweeping program of artistic patronage. He employed Giuliano da Sangallo and Donato Bramante to rebuild the venerated basilica of St. Peter's, Raphael to decorate the Vatican apartments, and Michelangelo to carve his tomb. Together, the ambitious pope and the equally ambitious artist conceived a giant monument that would rival those of the emperors of ancient Rome. And so began the long, convoluted history of a project that Condivi aptly called "the tragedy of the tomb." At least six designs, four contracts, and some forty years later, a much-reduced but still grand monument was installed in San Pietro in Vincoli, Julius's titular church.

In characteristic fashion, Michelangelo began the project in the marble quarries, supervising the selection and extraction of the large quantity of material needed to construct the giant mausoleum. Returning to Rome eight months later, he discovered that the pope's attention had turned elsewhere, mainly to war and the rebuilding of the venerated basilica of St. Peter's, then more than a thousand years old. Offended that attention and resources had been deflected from his project, Michelangelo returned to Florence despite the pope's intense displeasure and repeated efforts to lure him back. Not until Julius was on campaign in nearby Bologna was Michelangelo persuaded to appear before the pope and ask for forgiveness. Julius assigned him the unwelcome task of casting a monumental papal portrait in bronze for the main piazza of Bologna, the second-most important city of the Papal States. Though it must have seemed like penance, such a statue was a vigorous assertion of the pope's authority in a subject city. Michelangelo spent more than a year in Bologna wrestling with the problems of bronze casting, recalcitrant assistants, and poor local wine. Just three years later, in an attack on papal authority, a mob destroyed the statue, thus erasing a chapter in Michelangelo's career and his greatest achievement in the demanding medium of bronze.

Almost immediately after completing the statue, Michelangelo returned

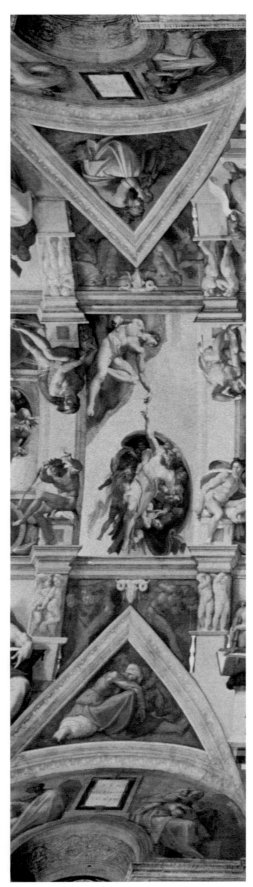

Ceiling of the Sistine Chapel (DETAIL)
1508–12

to Rome and was once again assigned a task ill-suited to a marble sculptor: a fresco for the ceiling of the Sistine Chapel. His lament that "painting is not my art" proved a hollow objection, for the pope's authority and stubbornness were greater than the artist's. Yet, like all commissions Michelangelo initially resisted, once reconciled to the task, he devoted immense energy and creativity to carrying it out in spectacular fashion. For four years, from 1508 to 1512, Michelangelo struggled with the manifold difficulties of painting nearly ten thousand square feet of a highly irregular, leaky vault. He spoke of his tribulations in an acerbic sonnet and appended note: "I'm in no good place, nor am I a painter." The ceiling tells a different story, one of magnificent accomplishment and sublime beauty.

The Sistine ceiling is a transcendent work that never fails to inspire wonder. It is replete with narrative scenes from the book of Genesis, alternating male prophets of the Bible and female sibyls of classical antiquity, a series of nude youths *(ignudi)*, lunettes with representations of the ancestors of Christ, and a host of secondary figures and decoration. In the words of the great German author Johann Goethe: "Until you have seen the Sistine Chapel, you can have no adequate conception of what man is capable of accomplishing." The ceiling was officially unveiled on October 31, 1512, shortly before the death of Julius, in February 1513. Michelangelo signed a new contract with Julius's heirs and turned once again to the pope's tomb, which he worked on from 1513 to 1516. During these years he carved a statue of Moses as well as the so-called Rebellious and Dying Slaves.

Florence, 1516–1534

The newly elected pontiff, Leo X (Giovanni de' Medici; reigned 1513–21), was Michelangelo's boyhood acquaintance and the first Florentine pope. Although Leo's tastes favored painting and precious objects, he commissioned Michelangelo to design a facade for the family church of San Lorenzo. Inspired by Roman antiquity, Michelangelo imagined a marble facade adorned with a dozen monolithic columns. Despite having little training in architecture, he promised to create "the mirror of architecture and sculpture of all Italy."

Once again, Michelangelo began in the quarries. He selected blocks of a size and quantity unequalled in more than a thousand years, extracted from Alpine quarries that even today are virtually inaccessible. He worked with a transport system of sleds, carts, boats, and oxen that had to be organized and staffed, equipment that was made and borrowed and sometimes defective, and a group of handpicked men who required constant supervision. The weather was often uncooperative and roundly cursed. He chose and inspected all his materials;

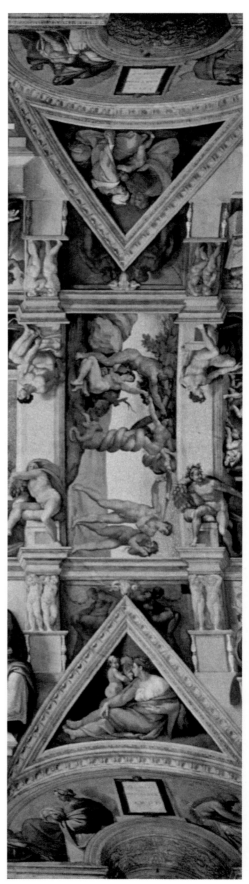

Ceiling of the Sistine Chapel (DETAIL)
1508–12

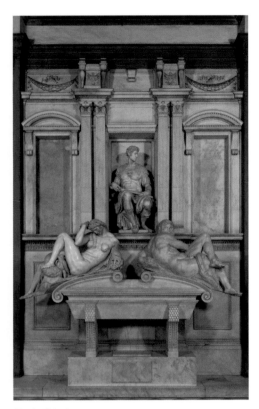

Tomb of Giuliano
1519–34

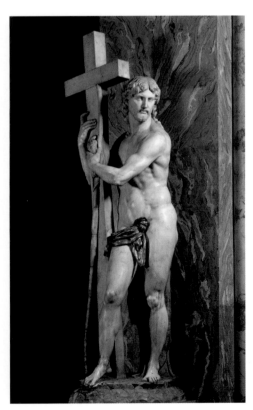

Risen Christ
CA. 1519–20

arranged for rope, tackle, and boats; haggled with carters about fees; and made drawings for even the tiniest, seemingly insignificant details before turning over the paper to make calculations, count bushels of grain, draft a letter, or compose poetry. Not only was Michelangelo a creative genius, he was a savvy businessman—a person who shuttled between the mundane and the sublime.

A large wooden model was constructed, and tons of marble were shipped to Florence. In the narrow streets of dark brown stone, the marble facade would have provided a spectacular contrast in the medieval city. Michelangelo assured his patron, "With God's help, I will create the finest work in all Italy." Sadly, not a single piece of marble was set in place, and today the raw facade of irregular masonry courses serves as a convenient roost for pigeons. (Florentines have recently considered completing the facade according to the artist's original design.) Although never realized, this ambitious undertaking prepared the way for Michelangelo's subsequent architectural projects.

The exceptional cost of the facade may have contributed to its suspension in March 1520, but equally important was the pope's urgent desire to turn Michelangelo's attention to the construction and adornment of a Medici mausoleum at San Lorenzo. The untimely deaths of the family's two young scions, Giuliano (d. 1516) and Lorenzo (d. 1519), served as the immediate impetus to build the Medici Chapel (1519–34). Statues of the men now grace its interior, along with the unfinished *Medici Madonna* and the allegories *Night, Day, Dawn,* and *Dusk.* In the midst of this project, Giulio de' Medici, another boyhood acquaintance and a highly astute patron of Michelangelo, was elected pope, assuming the name Clement VII (reigned 1523–34). Together—artist and patron, ideator and financier—they collaborated to realize some of the artist's most acclaimed works, including the chapel ensemble and the Laurentian Library, as well as several less-grand projects.

For sixteen years, Michelangelo devoted himself to the commissions at San Lorenzo while taking on other ambitious projects: the life-size *Risen Christ* (ca. 1519–20), the unfinished *Apollo/David* (ca. 1530), and the enigmatic *Victory* (ca. 1532–33). In hiring and supervising more than three hundred workers for the Medici Chapel, the artist demonstrated his effectiveness as a business manager as well as his versatility and inventiveness. He paid his workers well, provided housing for them, and was genuinely fond of many of them, employing some for ten years or more, a remarkable display of loyalty, given the unreliable nature of labor. Sometimes his workers disappointed him: "One must have patience," he mused. In short, Michelangelo micromanaged, keeping tabs on all facets of his multiple operations. So many obligations, he wrote, "require a hundred eyes." Like many entrepreneurs, there were flaws in

his managerial style and personal relations, but he was enormously successful in eliciting the best from himself and his many assistants.

* * *

On May 6, 1527, the disgruntled troops of the Holy Roman Emperor, Charles V, sacked Rome. With the city in turmoil, the pope and his immediate entourage barely escaped to the comparative safety of nearby Orvieto. Florence threw off the shackles of Medici rule and declared an independent republic. To reinstate his family became Pope Clement's overriding objective during the next three years. Michelangelo, a lifelong republican but also a Medici client, found himself in an extremely awkward situation. Despite Clement's efforts to dissuade him, the artist elected to side with his native city, devoting himself to the heroic but ultimately doomed republican cause.

In the fall of 1528, Michelangelo offered his services to Florence, and in April of the following year he was appointed governor and procurator-general of Florentine fortifications. As military engineer, he designed, coordinated, and directed the enormous defense effort. Florence was invested in October 1529 and withstood a grueling ten-month siege. The city finally capitulated on August 12, 1530, and then sustained a protracted witch-hunt of retribution. It is something of a miracle that Michelangelo survived these chaotic times. Fortunately, he had friends in high places and a pope who greatly admired him. Clement magnanimously forgave his defection and set him to work once again on the commissions at San Lorenzo.

Michelangelo turned to these previous obligations somewhat less enthusiastically. After the extended interlude of the Republic and the dangerous period after its collapse, he clearly no longer felt the same commitment to the Medici projects. Increasingly disaffected with Florence, where the last vestige of republican liberty was erased when the tyrant Alessandro de' Medici was declared duke in 1532, he spent increasing amounts of time in Rome. There, he found a large community of Florentine expatriates and a new friend, Tommaso de' Cavalieri, who renewed his artistic and poetic inspiration. In 1534, Michelangelo departed Florence and never returned, spending the remaining thirty years of his life in Rome.

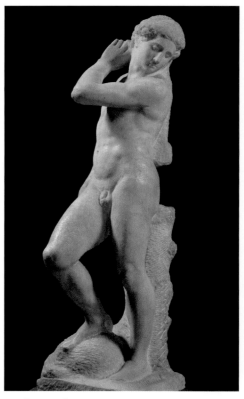

Apollo/David
CA. 1530

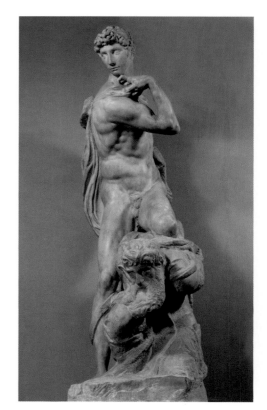

Victory
CA. 1532–33

Rome, 1534–64

In 1534 the energetic and reform-minded Alessandro Farnese was elected Pope Paul III (reigned 1534–49). A trust and mutual respect grew between Michelangelo and the new pontiff, based largely on their both being devoutly Christian and of a venerable age. Paul lost no time in employing Michelangelo's talents, first commissioning the *Last Judgment* fresco for the altar wall of the Sistine Chapel, a project that required nearly six years (1536–41) to complete.

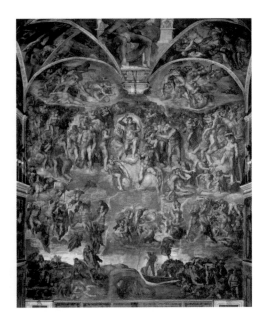

Last Judgment
1534–41

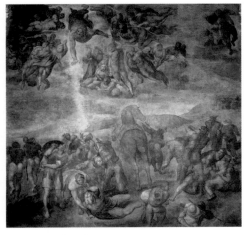

Conversion of Saul
COMPLETED 1549

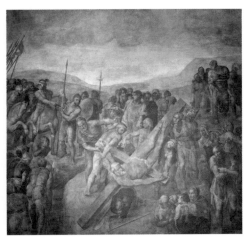

Crucifixion of Peter
COMPLETED 1549

When Michelangelo protested that he was still under obligation to complete the tomb of Pope Julius II, Paul is said to have burst out: "I have nursed this ambition for thirty years, and now that I'm pope am I not to have it satisfied? I shall tear the contract up. I'm determined to have you in my service, no matter what." And he succeeded, keeping the artist busy throughout much of his fifteen-year pontificate. Despite these added pressures, Michelangelo was still able to finish and install Julius's monumental tomb.

Shortly after completing the *Last Judgment*, Michelangelo painted two large frescos for the nearby Pauline Chapel, the *Conversion of Saul* and the *Crucifixion of Peter* (1542–50). Far less accessible and familiar than the frescos of the Sistine Chapel, these two late works are sometimes considered exemplars of the artist's old age or "mannerist" style. On the contrary, they are profound meditations on matters of faith, painted by the elderly and deeply religious artist for an equally sensitive patron.

The pope also patronized Michelangelo as an architect, appointing him in 1546 to direct the construction of St. Peter's and the Farnese Palace. St. Peter's was Michelangelo's torment and his final triumph: it is the largest church in Christendom, an imposing manifestation of papal authority, and a crowning achievement of Renaissance architecture. Despite myriad changes inflicted on the building during its approximately 150-year construction history, we properly think of it as Michelangelo's creation. In less than twenty years he corrected the missteps that had gone before and shaped what came afterward. He devoted his final years to the project, despite intrigue, construction debacles, and the repeated efforts of Duke Cosimo de' Medici to persuade him to return to his native Florence.

Also during the pontificate of Paul III, Michelangelo undertook the redesign and refurbishment of the Capitoline Hill (begun 1538), the geographical and ceremonial center of ancient Rome. As with many of Michelangelo's architectural commissions, most of the Campidoglio project was realized after the artist's death, but the force and clarity of his design ensured that, for the most part, the result reflects his intentions.

In Rome, Michelangelo had a large circle of friends and acquaintances. Acutely conscious of his claim to nobility, he was particularly attracted to those of high social station, as they were to him. His friendship with the young Roman nobleman Tommaso de' Cavalieri continued until the artist's death, even if somewhat diminished from its initial passionate intensity. Another close friend, Luigi del Riccio, encouraged Michelangelo to publish his poetry. Despite a remarkable burst of creative and literary activity, the project was suspended upon the sad and untimely death of Del Riccio in 1546. Michelangelo also found sustained nourishment from a friendship

with Vittoria Colonna, the scion of a noble Roman family and an accomplished poetess whom he met while working on the *Last Judgment* fresco. Stimulated by the passions aroused by Cavalieri and Colonna especially, Michelangelo succeeded in writing some of the most intensely emotional poetry of the Renaissance.

Thanks in part to Colonna, Michelangelo was introduced to such contemporary religious thinkers as Juan de Valdés, Bernardino Ochino, and Cardinal Reginald Pole, all associated with the *spirituali,* a group committed to church reform and individual salvation. As his drawings and letters testify, Michelangelo was sympathetic to the reformers' belief in justification by faith, a position that ran afoul of Catholic orthodoxy. Given the charged and increasingly conservative atmosphere of the Council of Trent (1545–63), the climate turned decidedly chilly, and then downright dangerous, for many reformers. By nature a cautious individual, Michelangelo mostly succeeded in avoiding political and religious controversy. With each successive pontificate, he was confirmed in his position as architect of St. Peter's, all the while taking on additional responsibilities from popes or select patrons. During the reign of Pius IV (1559–65), for example, he designed the Porta Pia, transformed the Baths of Diocletian into the Christian church of Santa Maria degli Angeli, and designed the Sforza Chapel in Santa Maria Maggiore.

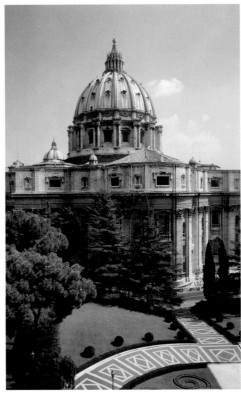

New St. Peter's
DIRECTED BY MICHELANGELO, 1546–64

While working as an architect in the public sphere, Michelangelo continued to plumb the depths of his personal faith in the more private world of poetry, drawings, and sculpture. Quite remarkably for an artist who earlier had proudly signed himself "Michelangelo *scultore,*" in the last thirty years of his life he completed just three sculptures: *Rachel* and *Leah* for the tomb of Julius II and *Bust of Brutus.* The Florentine *Pietà* was destined for his own grave but was left unfinished and then given away, and the *Rondanini Pietà* was begun for no ostensible reason, except perhaps to keep himself alive and spiritually nourished. Architecture was his final and most influential legacy.

We are left with a remarkable contemporary description of the speed and energy of Michelangelo's carving, even in old age:

> I have seen Michelangelo, although more than sixty years old and
> no longer among the most robust, knock off more chips of a very
> hard marble in a quarter of an hour than three young stone carvers
> could have done in three or four, an almost incredible thing to one
> who has not seen it; and I thought the whole work would fall to
> pieces because he moved with such impetuosity and fury,
> knocking to the floor large chunks three and four fingers thick
> with a single blow so precisely aimed that if he had gone even
> minimally further than necessary, he risked losing it all . . .

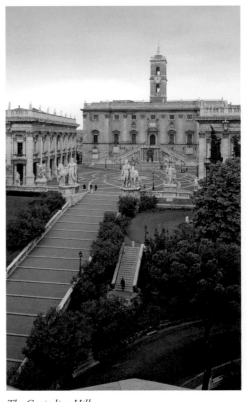

The Capitoline Hill
BEGUN CA. 1538

And the words of the artist himself, reflected in a sonnet:

> If my crude hammer shapes the hard stones
>
> into one human appearance or another,
>
> deriving its motion from the master who guides it. . . .

In 1555 the artist became an octogenarian, almost unheard of in the Renaissance, when life-expectancy was approximately half that age. Yet, his creative powers scarcely flagged. Despite worsening pain caused by kidney stones, he continued in his multifarious duties as architect and urban planner. He took great interest in the business affairs and marital plans of his nephew, and he kept up an impressive correspondence with family, friends, admirers, and hopeful patrons. Just a few days before his death, Michelangelo was still carving the *Rondanini Pietà*. In a poetic fragment, he mused, "No one has full mastery before reaching the end of his art and his life." At the same time, he lamented, "Art and death do not go well together."

Sadly, Michelangelo outlived most of his friends and every member of his immediate family. He faced the death of his brother in 1555 with stoic composure: "I had the news of the death of Gismondo, my brother, but without great sorrow. We must be resigned; and since he died fully conscious and with all the sacraments ordained by the Church, we must thank God for it." He was completely devastated, however, by the death in 1556 of Urbino, his faithful servant and companion of twenty-five years. Revealing the depth of his emotions, Michelangelo wrote to his nephew of "his intense grief, leaving me so stricken and troubled that it would have been easier to have died with him." Instead, he lived for another eight years, more alone but never neglected or forgotten. The world watched as the master approached death. Fully conscious of his hero's place in history, Giorgio Vasari wrote to Duke Cosimo de' Medici in 1560:

> He now goes about very little, and has become so old that he
>
> gets little rest, and has declined so much that I believe he will
>
> only be with us for a short while, if he is not kept alive by
>
> God's goodness for the sake of the works at St. Peter's, which
>
> certainly need him. He made me astonished that the ancients
>
> are surpassed by the beauty and grace of what his divine
>
> genius has been able to achieve.

In the Renaissance there could be no higher praise than to compare an artist to the ancients.

At Michelangelo's side during his final illness were his friend Tommaso de' Cavalieri and his pupil Daniele da Volterra. The great artist died on

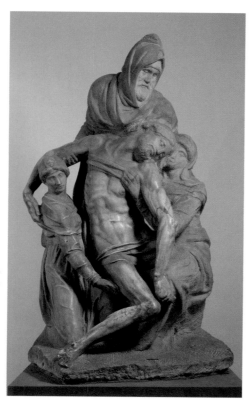

Pietà
CA. 1547–55

February 18, 1564, just two weeks shy of his eighty-ninth birthday. That same year, Galileo Galilei and William Shakespeare were born.

<p style="text-align:center">* * *</p>

Michelangelo's early career followed a desultory course largely independent of the fiercely competitive art world. He never maintained a conventional workshop, and he avoided the type of professional cooperation that was a fact of life for most Renaissance artists. He never matriculated into a professional guild, not because the medieval system was moribund, but because he never established a typical business practice in a fixed location. Rather, he lived on the basis of comparatively few commissions, obtained by skillfully navigating a dense web of personal and professional relations. The tension between his patrician birth and his fundamentally manual profession occasionally caused Michelangelo to experience doubt about his art (best expressed in his poetry) and to encounter conflict with his patrons.

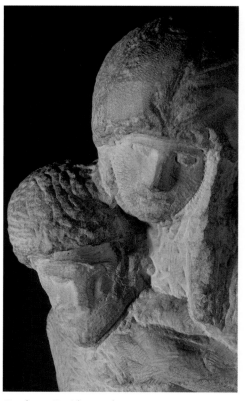

Rondanini Pietà (DETAIL)
1555–64

From early in his career, Michelangelo made art as a privileged commodity for a select few. His oeuvre is marked by a series of unique objects that are never repeated and not easily imitated: *Bacchus*, *Pietà*, *David*, the Sistine Chapel ceiling, *Last Judgment*, the tomb of Julius II, new St. Peter's. His biographer Ascanio Condivi noted that "when he was asked by growing numbers of lords and rich people for something from his own hand, and they gave lavish promises, he rarely did it, and when he did it was rather from friendship and benevolence than from hope for reward." Condivi may have been exaggerating, but not by much. Michelangelo's relations with his patrons were extensions of social bonds founded on favor, friendship, and family ties. Like Leonardo da Vinci before him, he attempted to live as a sort of artist/courtier, blurring the distinctions between artist and patron, between professional duties and personal obligations. He was an artist but also a patrician, and he demanded to be treated as such.

Although it is a cherished myth, Michelangelo hardly ever lived or worked alone. For most of his long life, he resided with one or more male assistants, at least one male servant, and one or more female housekeepers. He never married, but that was not uncommon among Renaissance artists. Instead, he formed lasting attachments with a few friends and was loyally committed to his immediate and extended family. He was pleased when his favorite brother, Buonarroto, married into the noble Della Casa family. His nephew and niece also wedded Florentine aristocracy by marrying into the Ridolfi and Guicciardini families, respectively. Thus was fulfilled his ardent wish to perpetuate the Buonarroti line, which survived to the mid-nineteenth century.

Acutely conscious of his family's social station, he was ashamed that he had a brother "who trudges after oxen." He was particularly sensitive about being

treated like an artisan, insisting, "I was never a painter or sculptor like those who run workshops." Having formerly signed his letters "Michelagniolo schultore," in his later years he began insisting on using his surname. In his old age, he considered it unseemly to be paid a daily wage for his work at St. Peter's. Instead, he accepted remuneration as a favor from the pope, mostly in the form of lucrative benefices.

As an elderly man, Michelangelo suffered from excruciatingly painful kidney stones, and he worried incessantly about his nephew's marriage, property investments, and general comportment. He was irascible and suspicious, kept his money hidden in socks, and died a millionaire, though he scarcely lived like one. At the same time he was eminently human, capable of extreme grief at his servant's death and generous in providing financial security for the widow and her children. He took pleasure in the company and conversation of friends, had a quick acerbic wit, and enjoyed joking and "roaring with laughter."

Renaissance humanists were fond of writing treatises on nobility. A central concern of these writings was the question of whether nobility was a matter of birth or personal virtue and attainments, a continuation of a debate that dated from classical antiquity. On both counts, Michelangelo had a rightful and substantial claim to nobility. His concerns with family and lineage coincided with a pan-European preoccupation with the true nature of nobility. His desire for wealth, landed security, and social status place Michelangelo squarely in a contemporary milieu, sharing the most cherished values of his fellow citizens. At the same time, these concerns distinguish him from most of his fellow artists, few of whom could claim a noble birth or were so preoccupied with family honor and social appearances.

Michelangelo was an aristocrat who made art. It is little wonder that he styled himself a patrician whose humble origins in Settignano and slow beginnings as a sculptor are obscured by popular myth and his greatest accomplishments. His contribution, in part, lay in the scale and audacity of his imagination and in his many masterpieces in painting, sculpture, and architecture. He fashioned artworks of universal significance that still astonish and inspire us more than five hundred years later. No artist has achieved as much and in such diverse fields of endeavor. Few so completely embody the notion of artistic genius. But his legacy is greater than the sum of his works. More than anyone who came before him, Michelangelo found success in forging a life as both artist and aristocrat, a feat that proved instrumental in advancing the status of his profession. In the words of his admiring contemporary Pietro Aretino: "The world has many kings and only one Michelangelo."

DISCOVERING MICHELANGELO

*The Art Lover's Guide
to Understanding
Michelangelo's
Masterpieces*

MICHELANGELO
(1475–1564)

Group of Two Figures, after Giotto
CA. 1488–90

PEN AND BROWN INK ON PAPER
12 ½ X 8 IN. (315 X 206 MM)
THE LOUVRE, PARIS

WE FIRST LEARN of Michelangelo not for his role in the stone trade, but as a member of the prestigious city-based workshop of the painter Domenico Ghirlandaio. Apprenticeships were legally binding and generally lasted six or more years: boys were expected to live with and obey their masters, and masters were required to provide lodging and sometimes clothes, as well as instruction, for the stipulated period. Michelangelo left his apprenticeship after fewer than two years, however, without incurring legal difficulties.

Everything about Michelangelo's abbreviated time with Ghirlandaio suggests that the association was not a traditional apprenticeship but rather a special arrangement extended to a youth with comparatively elevated family connections. If we entertain this possibility, then it becomes less difficult to explain why, for example, Michelangelo was given access to Ghirlandaio's most precious assets: the master's own drawings and a fifteenth-century engraving by Martin Schongauer, *The Temptation of St. Anthony.* Moreover, no evidence exists that Michelangelo was involved in the usual laborious day-to-day tasks of grinding and mixing pigments, slaking plaster, pricking and transferring cartoons, fetching water and supplies, and cleaning up at the end of the ten-hour workday. Rather, he was granted time to learn from the old masters, Giotto and Masaccio, and to copy drawings made by Ghirlandaio.

With time and freedom to study the art of Florence, the young Michelangelo—he was perhaps fifteen years old or younger at the time—made this drawing, the earliest known by his hand. Using a quill pen and brown ink, he copied two figures from the far left of Giotto's fresco *The Ascension of St. John,* in the Peruzzi Chapel of Santa Croce. This church, close to where Michelangelo's family lived in Florence, signals the beginning and the end of his career, for he would one day be buried there.

Michelangelo was attracted to several aspects of Giotto's narrative art, especially the weight and gravity of the figures and their surprised reactions as witnesses to John's ascension. As would be characteristic throughout his career, Michelangelo was drawn to the figures' unconscious gestures: the surprise expressed by hands raised to beard and face, and the right hand of the more fully drawn figure at left that clutches at his drapery, thereby unwittingly revealing astonishment and consternation at witnessing a resurrection.

Giotto created volume and substance through modeling, using light and shadow to suggest three-dimensionality on a flat surface. Without resorting to shading with colors, Michelangelo endowed his figures with substance by using a dense yet precise pen and ink cross-hatching technique that effectively describes the highlights and deep shadows of drapery folds. Although some awkwardness remains in the hand gestures, Michelangelo's superb manual dexterity is fully evident. Despite the close-knit weave of cross-hatching, the nearly perfect parallel strokes never become messy or muddled. Ultimately, Michelangelo would prefer to draw in red and black chalk, a media that offered more suggestive and pictorial qualities than the linear precision of pen and ink.

MICHELANGELO, THE TEENAGE DRAFTSMAN, IS A BIT CLUMSY WHEN COPYING THE HAND RAISED IMPETUOUSLY TO THE YOUNG MAN'S FACE. NONETHELESS, THE INVOLUNTARY GESTURE EFFECTIVELY EXPRESSES ASTONISHMENT AND WONDER AS THE FIGURE WITNESSES THE MIRACLE OF ST. JOHN'S RESURRECTION.

AN EXTERNAL SIGN OF AN INTERNAL AGITATION, THE HAND CLUTCHES AT THE DRAPERY, BUNCHING THE HEAVY CLOTH INTO DEEPLY CREASED FOLDS. SUCH UNCONSCIOUS MOVEMENTS LEND AN ADDITIONAL AND DYNAMIC ASPECT TO MICHELANGELO'S FIGURES' EMOTIONAL AND PSYCHOLOGICAL STATES.

MICHELANGELO'S DENSE BUT HIGHLY CONTROLLED PEN AND INK CROSS-HATCHING DESCRIBES POOLS OF DARK SHADOWS IN THE COMPLEX SERIES OF BULBOUS FOLDS. TO CREATE THE PROJECTING RIDGES OF CLOTH, HE DREW MORE LIGHTLY OR LEFT THE PAPER UNMARKED, CREATING A SINGULAR SENSE OF THREE-DIMENSIONALITY.

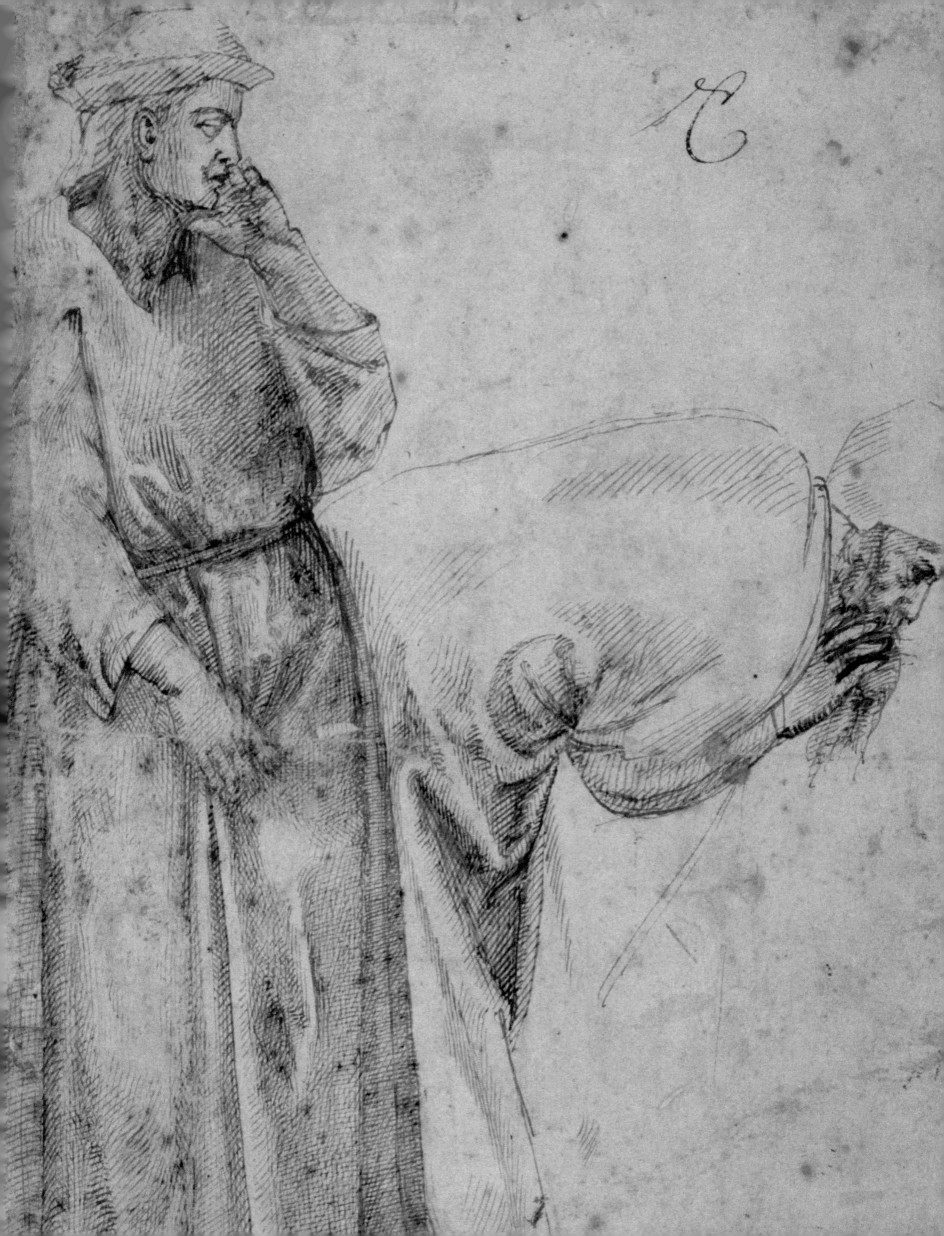

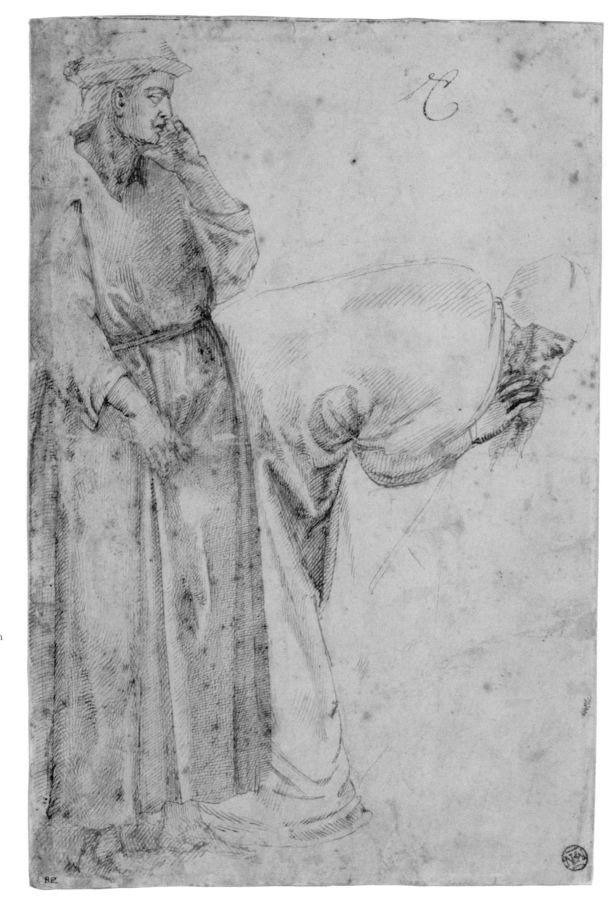

(LEFT)

MICHELANGELO
Group of Two Figures,
after Giotto
CA. 1488–90
PEN AND BROWN INK ON PAPER
12 ½ X 8 IN. (315 X 206 MM)
THE LOUVRE, PARIS

(RIGHT)

MICHELANGELO
Group of Figures,
after Masaccio
PEN AND BROWN INK ON PAPER
CA. 1490–92
11 ½ X 7 ⅞ IN. (290 X 200 MM)
ALBERTINA MUSEUM, VIENNA

Michelangelo was between 13 and
15 years old when he drew these
copies from frescoes by past
Florentine masters—Giotto *(left)*
and Masaccio *(right).* No wonder we
perceive him as a prodigy, given the
hand–eye control and sophistication
of pen work evident in these two
minor masterpieces.

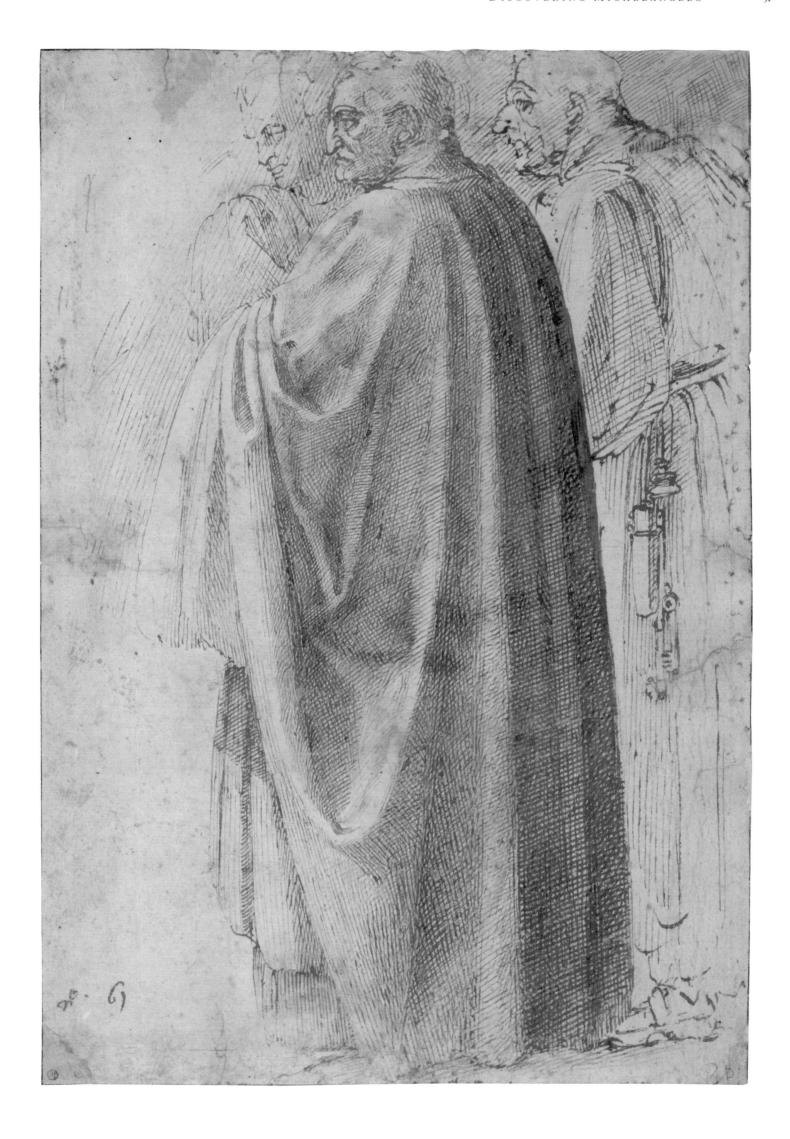

MICHELANGELO
(1475–1564)

Madonna of the Stairs

CA. 1491–92

MARBLE
22 ½ X 16 IN. (57.1 X 40.5 CM)
CASA BUONARROTI, FLORENCE

THE *Madonna of the Stairs* relief is a curious combination of sophistication and technical awkwardness. The sculpture has a grandeur well beyond its modest dimensions; it measures only about two feet tall. The Madonna fills the field, extending from the top to the bottom edges of the marble. This maximum extension of figures within the confining boundaries of their blocks is a hallmark of Michelangelo's sculpture.

Mary is seated on a square plinth, less a throne than a beautifully dressed hunk of quarried stone. Her idealized, classic profile is framed by the circle of her halo and accentuated by the fold in the fabric that extends the line of her aquiline nose. The drapery cascades in soft abundant waves over the shoulder, around the arms and legs, and over the raised lip of the carved frame.

Despite her proximity to the other figures in the relief, the Virgin is immensely remote, far removed from us as well as from her child. The physical and psychological distance from her offspring is remarkable, especially for a nursing mother. But, in fact, the child is no longer nursing: though still at his mother's breast, he slumps in sleep. His head falls to his chest, his muscular pronated arm (a pose associated since antiquity with sleep or death) caught in a large crease in his mother's robe.

And what a child! It is a body of some years, not an infant recently issued from the womb. A little Hercules. His compact, muscular form remains enclosed within heavy folds of drapery that delineate a protective womblike space. As is often the case in Renaissance art, the sleeping Christ child is a foreshadowing of his fate. The drapery that protects the infant also suggests the linen tomb shroud: the peacefully resting child soon will pass into the oblivion of death. Perhaps this omen helps explain the mother's distracted look. She alone foresees her son's destiny, from swaddling cloth to winding sheet.

The child's head is discernible even from underneath the raised portion of his mother's robe. Similarly, we perceive the pristine geometry of the Madonna's seat despite the fabric obscuring its top edge. These passages are a tour de force of illusionistic carving. So, too, are the Virgin's foreshortened right foot, which crosses underneath the left, and the disporting cherubs on the staircase. Here, the artist reveals not only great skill but also occasional awkwardness in working in a difficult medium.

The *Madonna of the Steps* is a demonstration of low-relief carving in the tradition of Michelangelo's great predecessor Donatello. But was the sculpture made for anyone but himself? What possible purpose could it serve? It is too small to function as a devotional object and too large to be a plaquette-like, collectable art object. It cannot be handled or easily moved despite its modest size. Therefore, we must be suspicious of the supposition that it was made in the Medici household, or at least wonder if it was later reworked by an artist conscious of fashioning his biography and precocious origins.

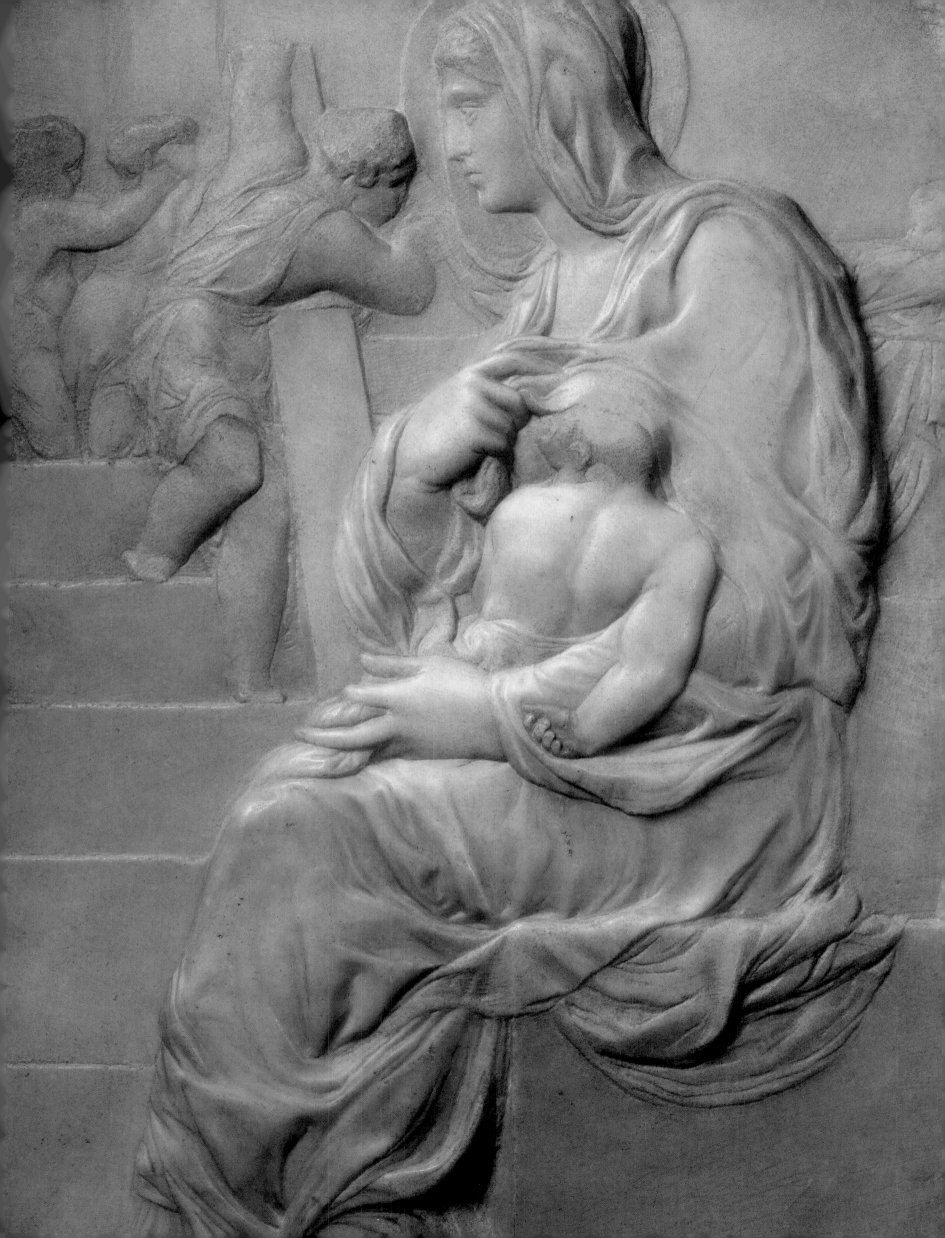

MICHELANGELO

(1475–1564)

Battle of the Centaurs

CA. 1491–92

MARBLE
33 ¼ X 35 ½ IN. (84.5 X 90.5)
CASA BUONARROTI, FLORENCE

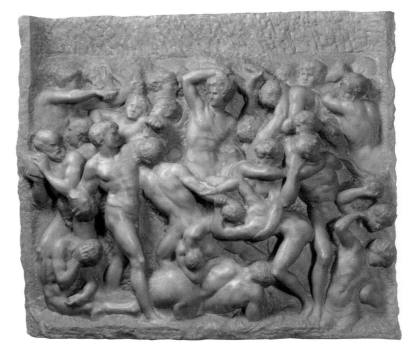

IT IS OFTEN said that this relief anticipates ideas that Michelangelo subsequently explored in painting and sculpture, notably in the Sistine and Medici chapels. It certainly reveals one of the dominant themes of his art: the male nude in action.

The jumble of writhing, struggling figures tumbles from the block and into our space. Because of its roughly sketched, unfinished, and unevenly polished surfaces, we are never far from the raw stone from which these figures were carved. But what is the subject? Michelangelo's own biographers were uncertain. Ascanio Condivi confusingly reported that this work represented the rape of Deianira (it does not). Most follow Vasari in calling it the *Battle of the Centaurs*, although few such creatures are identifiable. Rather, it is a swirl of struggling, entwined humanity in which bodies emerge and disappear in a flotsam of petrified flesh. The complicated interlocking of entwined forms and the contrapuntal echoing of limbs create some semblance of order amid chaos. The artist masterfully suggests that these are complete figures even though we discern only partial bodies.

Michelangelo has exploited the full thickness of the block, layering the human forms in different spatial planes. Although almost no free space emerges from this compact mass, depth is created by overlapping. Michelangelo has worked to the extreme edges of the block except at the top, where he has left a wide band of rough-chiseled stone. There is no logical reason for this undifferentiated slab. It is conceivable that Michelangelo thought of removing it (note how he scored the stone horizontally just above the heads of the background figures), in which case the relief would more closely resemble ancient sarcophagi, which he undoubtedly knew and studied, especially in nearby Pisa. On the other hand, the roughened band suggests an architectonic element, albeit an unfinished one, such as those that frame the pulpit reliefs carved by his famous Trecento predecessors, Nicola and Giovanni Pisano. Whatever the explanation for this anomaly, it certainly insists on the unfinished nature of the work and forcefully reminds us that there is no obvious destination for such an object. It cannot stand by itself, and the extremely heavy slab is difficult to affix to a wall. Most likely, this sculpture was a practice and demonstration piece, one that Michelangelo in his old age considered among his finest.

On the left side, two figures are about to toss stones into the melee; the one projectile is faceted, the other is crude and appears little different from several of the roughly shaped heads. Perhaps Michelangelo is playing on the nature of artifice, reminding us that an artist fashions new realities from raw materials. We are witness to the artistic process, the sculptor creating a miracle of living flesh from inert rock yet simultaneously reminding us of the miracle's humble, lapidary origins.

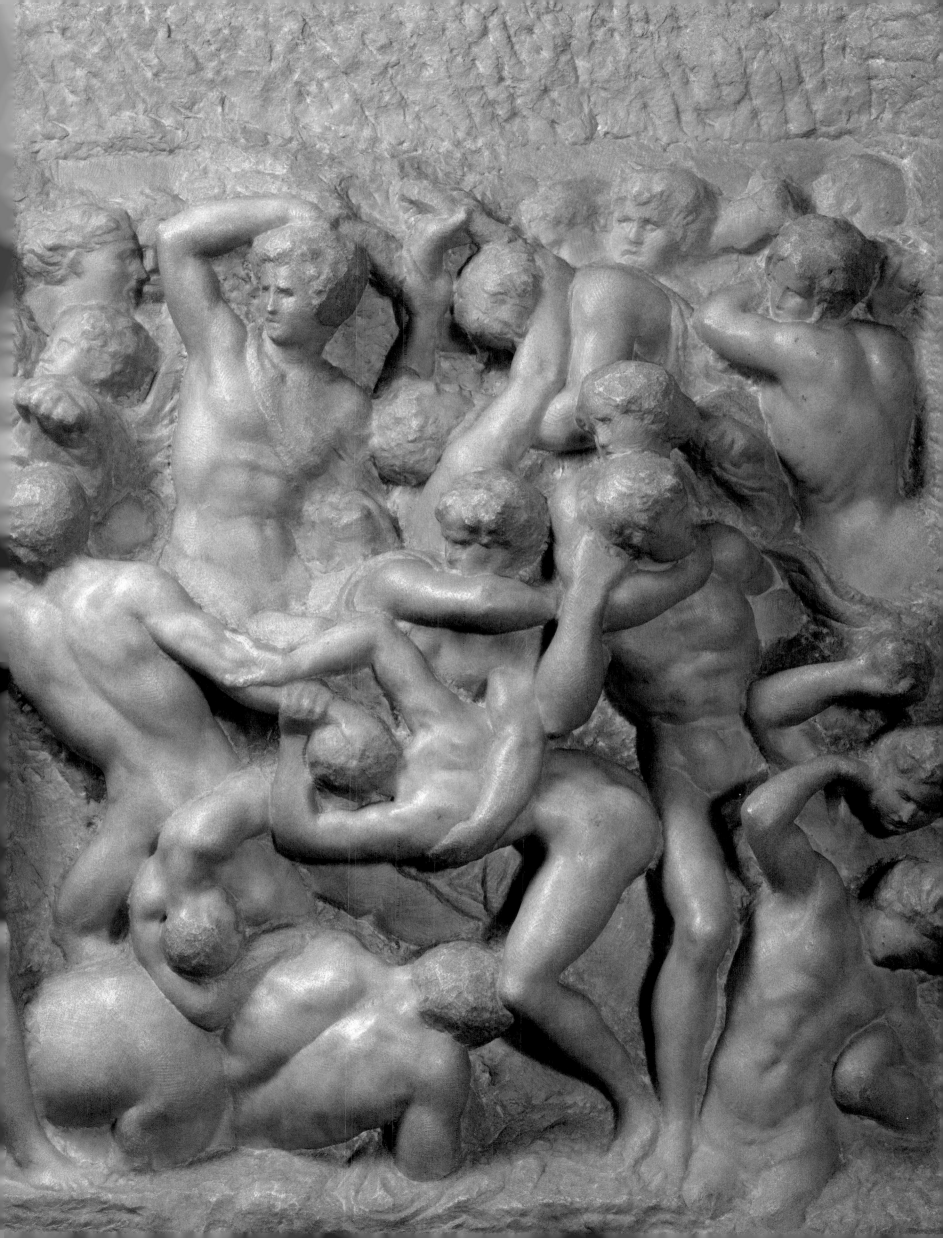

MICHELANGELO
(1475–1564)

St. Petronius

1494–95

MARBLE
HEIGHT: 25 ¼ IN. (64 CM)
TOMB OF ST. DOMINIC, BOLOGNA

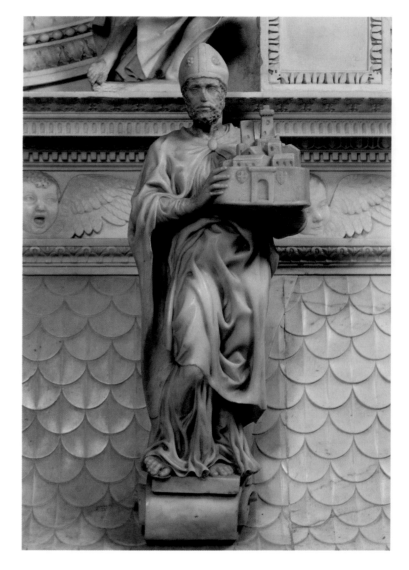

WHEN THE Medici fled Florence in 1494, Michelangelo followed his patron and protectors northward. It would have been more logical for an aspiring sculptor to visit Rome, as did his great predecessor Donatello. Yet Michelangelo chose to maintain the ties of patronage he had developed, no matter how threatened he was by current circumstances.

Probably thanks to his famous connections, Michelangelo was received in Bologna and taken into the household of Gianfrancesco Aldrovandi, one of the most prominent local citizens. In addition, Aldrovandi secured some work for the nineteen-year-old sculptor. The tomb of St. Dominic was, and still is, one of the city's most important pilgrimage sites and artistic monuments. Begun by Nicola Pisano in the fourteenth century and left incomplete upon the death of Niccolò dell'Arca in 1494, the giant tomb ensemble was still missing some of its statuettes and one of the altar candelabra when Michelangelo set to work.

With the model of Niccolò dell'Arca directly before him, Michelangelo carved a kneeling angel candelabrum, one of the sweetest of all his sculptures. Indeed, he may even have purposely imitated the gracile style of his predecessor. Unlike Niccolò's more androgynous figure, Michelangelo's angel is clearly male and robust, despite its diminutive size. His nascent skills as a marble carver are displayed in the lively expression of the open mouth, the thick head of hair, the layered feathers of the stout wings, and the pliant folds of drapery.

The two other statuettes are standing figures and represent patron saints of Bologna: Petronius (Petronio) and Proculus (Procolo). Just as Michelangelo looked to Niccolò dell'Arca for the model for his candelabrum, so, too, did he refer to the prominent Sienese sculptor Jacopo della Quercia for inspiration for his figure of St. Petronius (and, later, some of the figures in the Sistine Chapel).

As bishop of Bologna in the fifth century, Petronius repaired many of the city's churches that had been damaged during the Goth invasion. Given his status as patron saint and noted builder, it is appropriate that Petronius holds a model of his city, carved from the same small marble block as the figure itself. It is a marvelous, cubistic composition but also a recognizable miniature of Bologna and its most notable landmarks, including the city walls with prominent gate, the flanking coats of arms, and the famous leaning towers noted in Dante's *Inferno* (*Inf.* XXXI:136–38). The rugged face of the saint is framed by his bishop's mitre, his body animated by the abundant folds of the mantle that cascades to feet barely visible under the active hem of his garment. The drapery enlivens the figure while revealing a body standing in *contrapposto*, with a bent and projecting right knee and weight firmly planted on a straight left leg. As in the *Madonna of the Stairs*, the forcefulness of the figure and the density of carving belie the sculpture's diminutive size.

Learning to employ drapery as an expressive device would serve Michelangelo well. It became especially important when, just two years later, he carved the Rome *Pietà*, one of his most accomplished essays in artistic drapery.

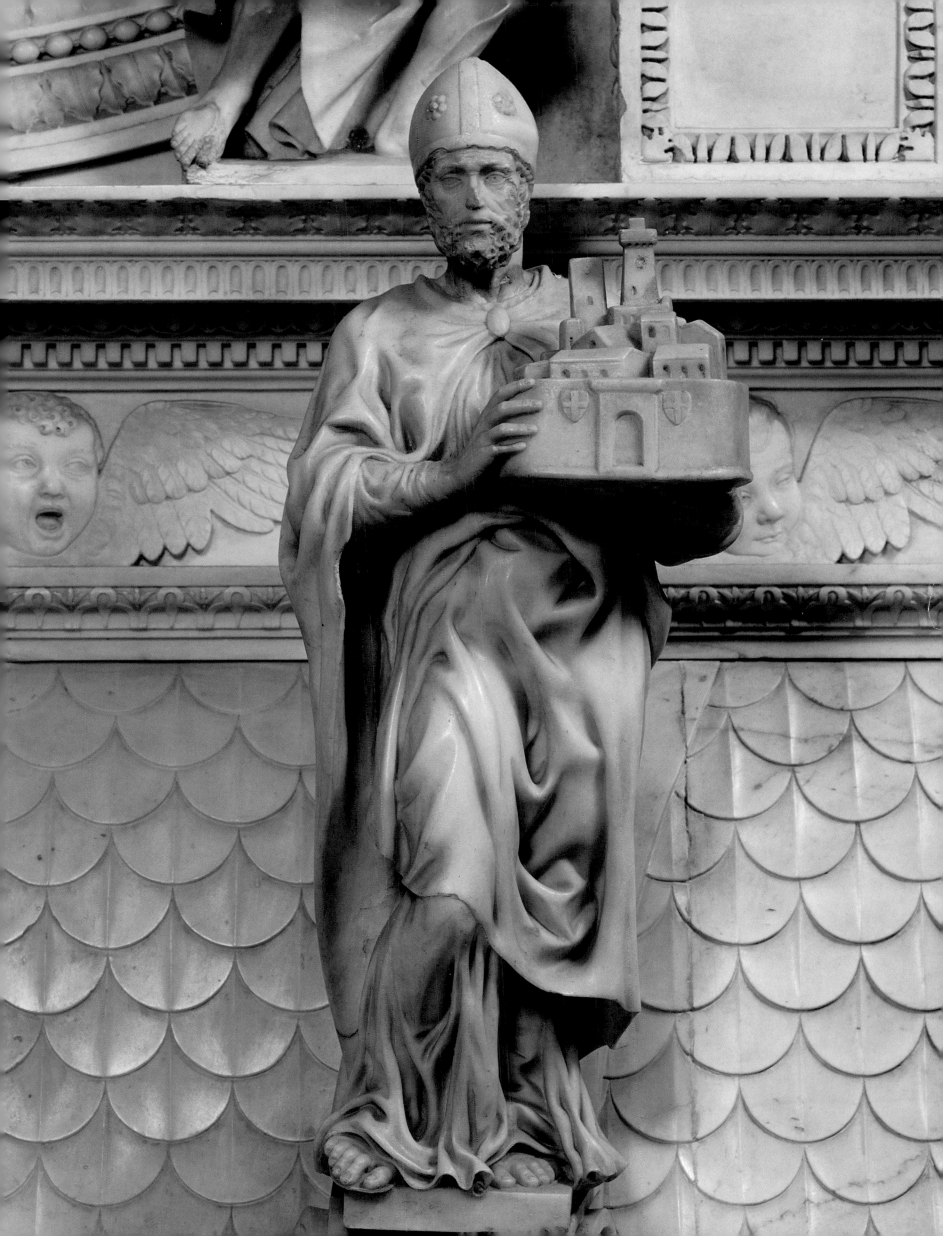

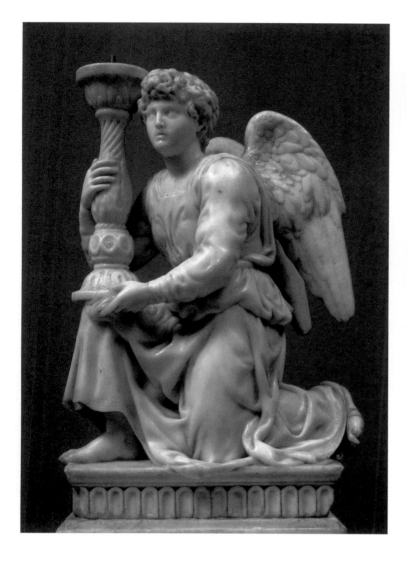

(ABOVE)

MICHELANGELO
Angel Candelabrum
1494–95
MARBLE
HEIGHT: 20 ¼ IN. (51.5 CM)
TOMB OF ST. DOMINIC, BOLOGNA

(RIGHT)

MICHELANGELO
St. Petronius (DETAIL)
1494–95
MARBLE
HEIGHT: 25 ¼ IN. (64 CM)
TOMB OF ST. DOMINIC, BOLOGNA

Although only secondary figures
in a gigantic marble ensemble
largely carved by earlier artists,
Michelangelo's contributions to the
tomb of St. Dominic are nonetheless
impressive. Here are St. Petronius,
Bologna's patron saint, holding a
miniature of the city, and a kneeling
angel, one of two candelabra
adorning the altar table.

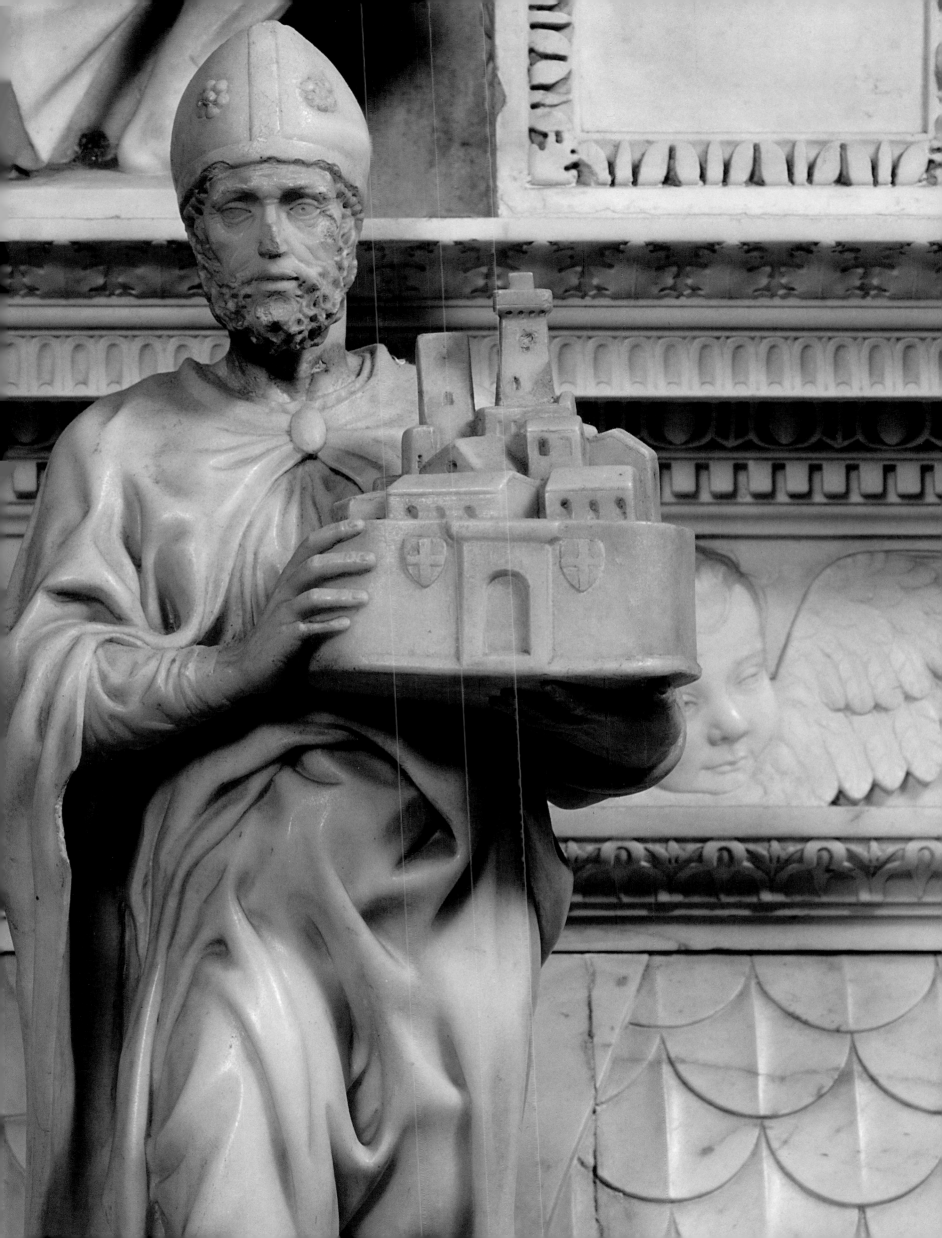

MICHELANGELO

(1475–1564)

Bacchus

CA. 1496–97

MARBLE
82 ¼ IN. (209 CM), INCLUDING BASE
BARGELLO MUSEUM, FLORENCE

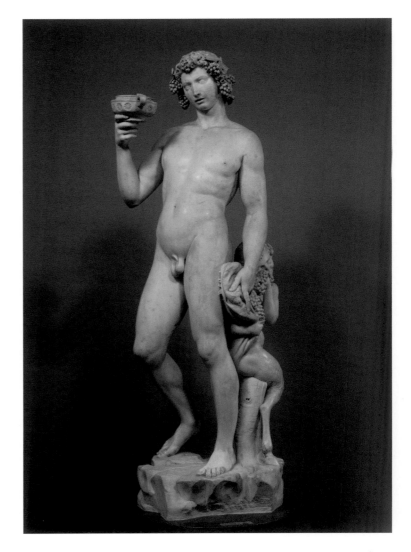

IN 1496, the twenty-one-year-old artist arrived in Rome. Given a block of marble by his new patron, Cardinal Raffaele Riario, Michelangelo was invited to "show what he could do." The youthful sculptor rose to the occasion by carving the *Bacchus*.

Our admiration for Michelangelo's early work little prepares us for the stunning accomplishment of the *Bacchus*. Whether or not the sculpture appeals to us—and it embodies qualities that simultaneously attract and repel—we must acknowledge it as a virtuoso accomplishment. With this work, the artist made a spectacular bid for public recognition as a talented carver of marble.

To many viewers, the *Bacchus* is a disquieting, if not disturbing, figure. It has few of the heroic and idealizing qualities normally associated with Michelangelo or with classical antiquity. He was certainly inspired by ancient art, but just as surely he was no mere copyist. In the contemporary sense of artistic imitation (*imitatio*), Michelangelo re-created the antique, almost more successfully than any known work of the classical past. His *Bacchus* could well be a Hellenistic sculpture, standing comfortably alongside the most famous surviving work of antiquity, the *Apollo Belvedere*, with which it shares technical and stylistic features even while diverging in spirit.

The ancient god of wine appears far too enamored of the elixir that was his gift to humankind. His soft, pliant body moves unevenly, even awkwardly—a serious undermining of the classical conventions of balanced movement (*contrapposto*). His teetering stance, lolling head, and sloshing cup underscore the figure's disconcerting imbalance. To avoid its unsteady movement, we move to the side, and then around it, noticing that the sculpture works well from multiple views. Each angle offers new surprises, such as the impish satyr, in mirror image of Bacchus's pose, who mischievously smiles at us while stealing his companion's fruit. As we continue circling, we become increasingly dizzy until eventually our state begins to approximate inebriation. Through the antics of moving and looking, life unwittingly imitates art as we act and perhaps feel every bit as tipsy as the drunken deity. By means of a smile and a slightly swirling head, we are afforded a glimpse of the divine.

For the first time, Michelangelo has made extensive use of the running drill, a tool especially favored by ancient Roman sculptors. Evidence of it is found in the carving of the grapes, the lion pelt, and along the edges of limbs, such as the satyr's left leg. Like the Romans before him and Bernini after him, Michelangelo employed the drill to create illusionistic effects that were impossible with his favored implements: the claw, toothed, and flat chisels.

The *Bacchus* is simultaneously human and divine, poised between ordinary sobriety and beneficent inebriation. To us, it is a brilliant essay by a budding genius. But it is easy to imagine why Raffaele Riario, the high-ranking ecclesiastic who commissioned the work, found it distasteful and, perhaps, inappropriate.

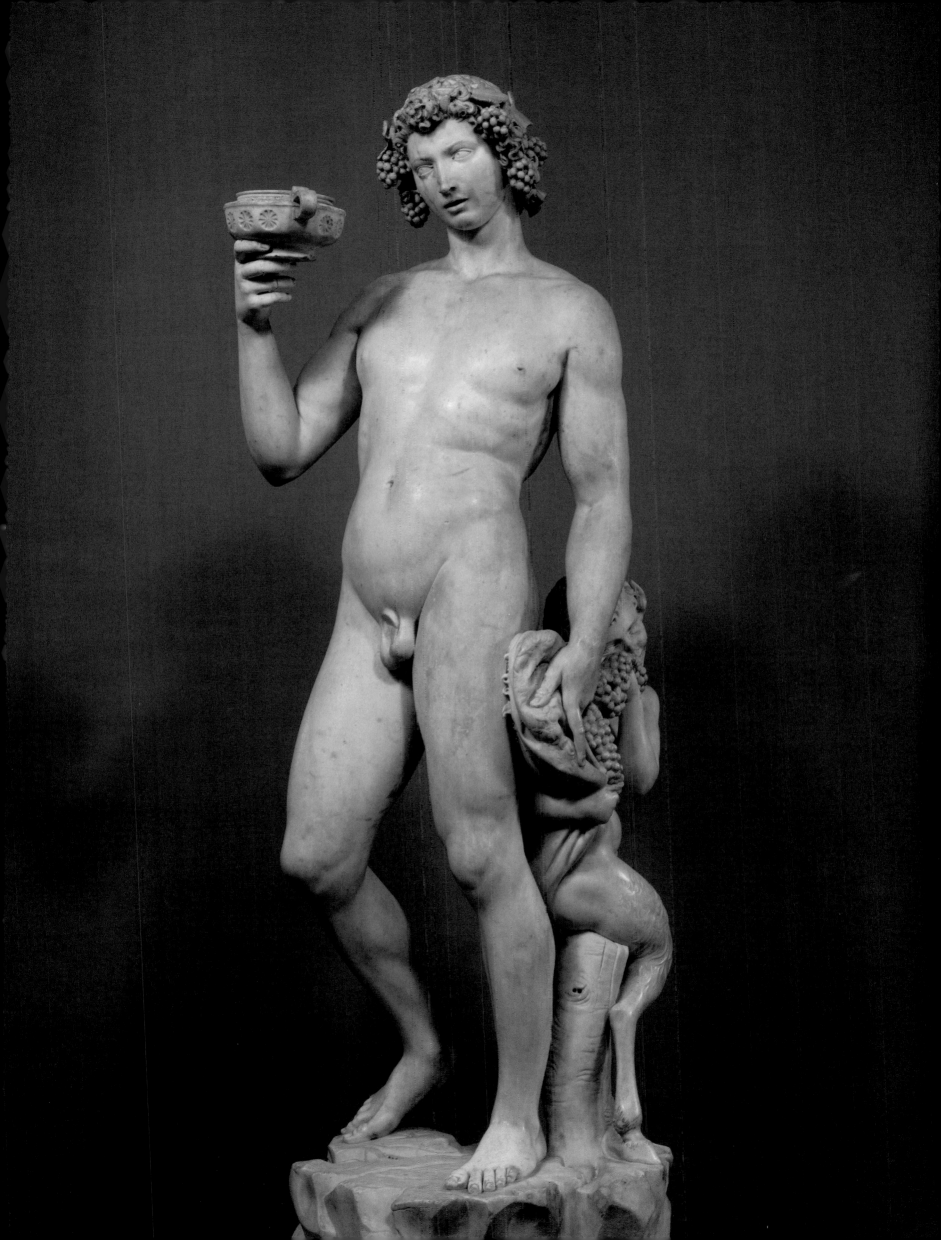

MICHELANGELO

(1475–1564)

Pietà

1497–99

MARBLE
HEIGHT: 68 ½ IN. (174 CM)
ST. PETER'S BASILICA, ROME

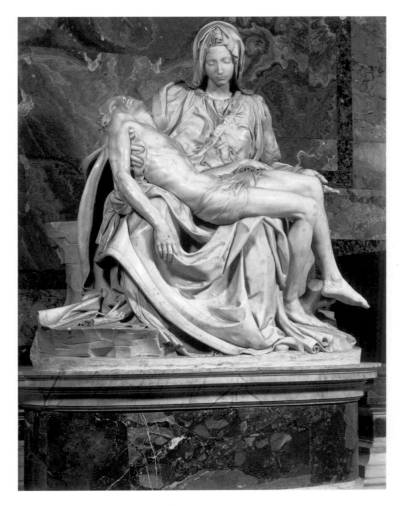

IN 1498, Michelangelo received the commission for the *Pietà* from a powerful French cardinal, Jean de Bilhères de Lagraulas. Suddenly, he had the opportunity to create a monumental religious work for an important foreign patron, destined for a conspicuous public location: the ancient basilica of St. Peter's.

The *Pietà* is a moving and deeply affecting portrayal of the Virgin and Christ, of a mother mourning the loss of her son. The sculpture is currently exhibited in St. Peter's on a high pedestal behind bulletproof glass. Originally, the large sculpture, commissioned to mark the cardinal's grave, most likely sat on a low plinth, with a tomb slab in the floor directly in front of it. Having been moved several times within the basilica, the *Pietà* has evolved from being an eloquent meditation on death into a tourist icon, yet it continues to instill wonder and retains its power to move us.

Most viewers tend to focus on the Virgin, whose lovely visage is alternately sad and serene. Her expression of outward calm suggests her inward peacefulness, for she knows, perhaps better than we, that this is the son of God. Moreover, her tranquility offers some assurance of Christ's eventual triumph over death. But is it proper to intrude upon the sorrow of a grieving mother, to be curious about the emotions of the mother of God? In fact, Mary's head is tilted noticeably downward; she avoids our stare and internalizes her sorrow. Her quiet dignity and resignation are beautifully conveyed through her averted gaze and the gesture of her left hand, which indicates that her son is the proper object of our contemplation.

Michelangelo's biographers tell the delightful (though likely apocryphal) tale of how the artist overheard two people incorrectly attributing the sculpture to a certain "Gobbo" (hunchback) of Milan. Incensed, Michelangelo returned that night and prominently carved his name onto his work, an inscription that translates as: "Michelangelo Buonarroti Florentine made this." A close examination of the diagonal sash, however, reveals that it was conceived as an integral part of the sculpture; therefore, it is likely that Michelangelo always intended to sign or decorate that area in some manner. Although the story may be fictional, it nevertheless captures an important

truth: this unique work was a bold quest for fame and remains the only one the artist ever signed.

In its original installation in Old St. Peter's, the *Pietà* was lit by soft, natural light falling from windows high above. The Virgin's face was cast in shadow, while the body of Christ was fully illuminated, the radiance suggesting the only remaining warmth in the dying flesh. Mary presents her dead son—our hope for salvation and our guarantee of eternal life. Her gaze and open hand direct our attention first to Christ and then to the mortal remains of the cardinal originally buried in the floor before her. It is an eloquent yet decorous funerary monument and an effective devotional image, a private memorial that prompts us to reflect on our own mortality. Despite changes in its location and harsh modern lighting, the *Pietà* remains one of the best-loved sculptures of all time.

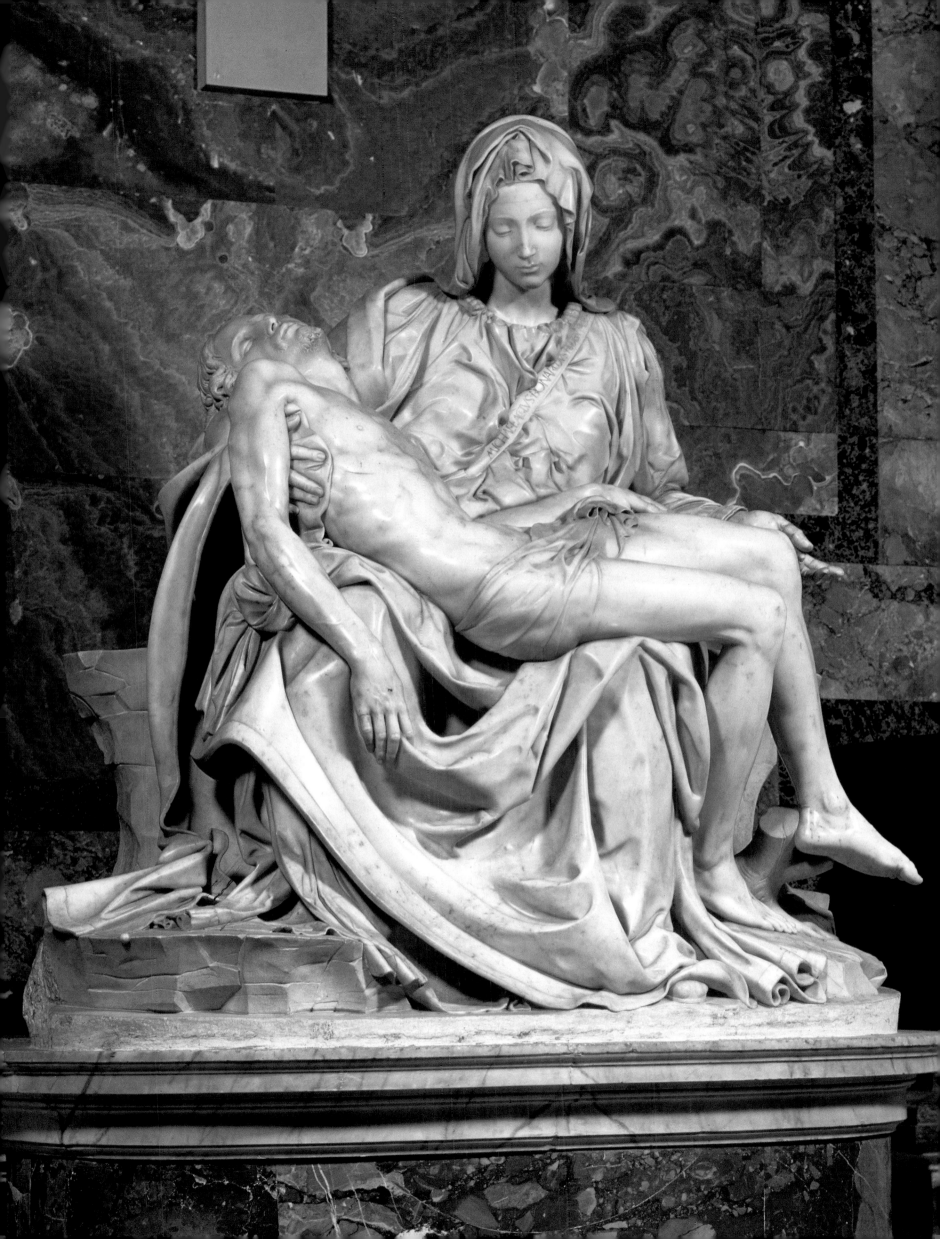

MICHELANGELO
(1475–1564)

St. Paul and St. Peter

1501–4

MARBLE
HEIGHT: APPROX. 50 IN. (127 CM)
PICCOLOMINI ALTAR, SIENA

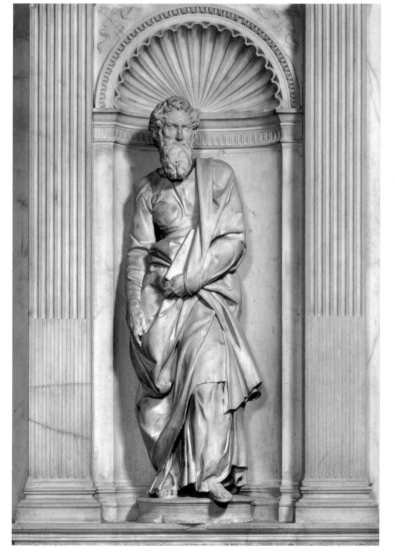

MICHELANGELO claimed to be living in near destitution following the completion of the *Pietà*, and therefore he must have welcomed a commission from Cardinal Francesco Piccolomini in 1501. The artist was charged with carving fifteen statues to complete the Piccolomini altar in Siena Cathedral that had been begun, but left incomplete, by the fifteenth-century sculptor Andrea Bregno. Even though the commission guaranteed employment, Michelangelo could not have been wildly enthusiastic about the task. It was not unlike the work he had done in Bologna for the tomb of St. Dominic, that is, completing a large decorative ensemble envisioned and largely carried out by others. In the end, he fulfilled barely a quarter of his contract, the first of many such projects the artist left incomplete.

Peter and Paul are the most interesting figures carved by Michelangelo for the altar. As the most important early Christian saints, both martyred in Rome, the two apostles are often represented as a pair, and it seems likely that Michelangelo conceived them as such. They are nearly mirror images: Paul animated and extroverted, Peter more introverted; the former standing with locked right leg looking right, the other composed in just the opposite manner. Both men are bearded, their bodies heavily draped. The thick swirls of locks are Michelangelo's signature hairstyle, seen again later in the similarly expressive sculptures *David* and *Moses*.

Both figures hold books in their left hands while their right arms hang at their sides, active rather than limp. The animation of limbs—even if unconscious and unspecific—is another hallmark of Michelangelo's style; we see it especially in the bunching of drapery in the right hands of both saints. Voluminous folds envelop Paul, yet one can still discern the position of the body underneath. The distinct tilt of the shoulders, the left hip and leg thrust forward, the exposed feet, all suggest the figure's imminent movement. It is not always possible to make sense of the convoluted drapery; one might see it, however, as an analogue of Paul's character and teaching: assertive and emphatic.

Michelangelo repeatedly experimented with traditional iconography in his exploration of sacred meaning. He was no iconoclast; rather, in pondering faith deeply, he inevitably invented unconventional means to express meaning. The large volumes are presumably the saints' sacred writings, but Peter was an illiterate fisherman and Paul usually wields a sword. For Michelangelo, significance is not conveyed primarily by attributes or symbols but through eloquent expressions and gestures. In this, the artist shares the ideas of his great rival Leonardo da Vinci, who stated that "the soul is revealed through gesture." Michelangelo brilliantly employed artistic devices, whether vivid features, unconscious gestures, or animated drapery, to endow his figures with vitality and significance.

In carving these sculptures, Michelangelo was largely fulfilling an obligation. Thus, he did not hesitate to abandon the commission when presented with a better opportunity: the *David*.

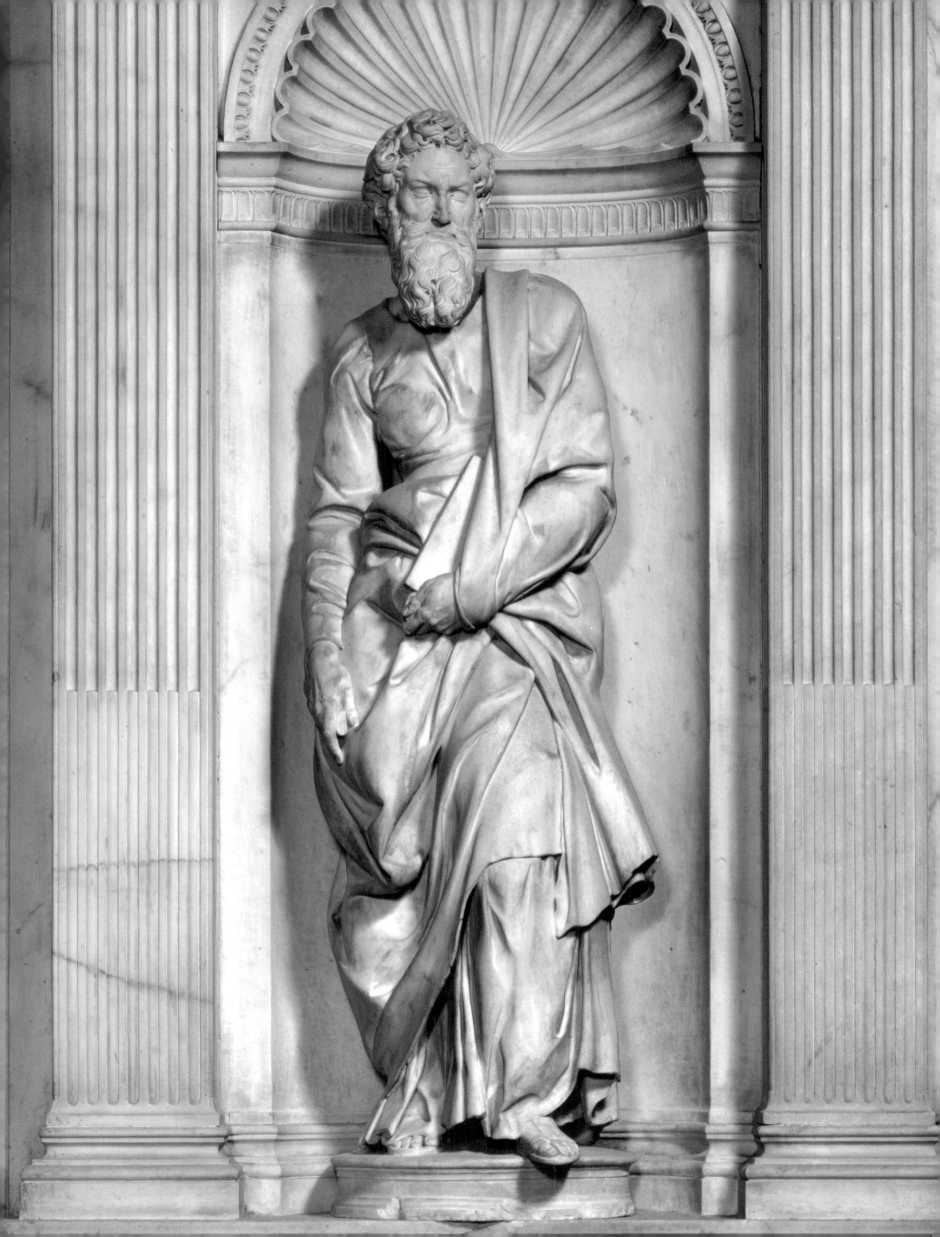

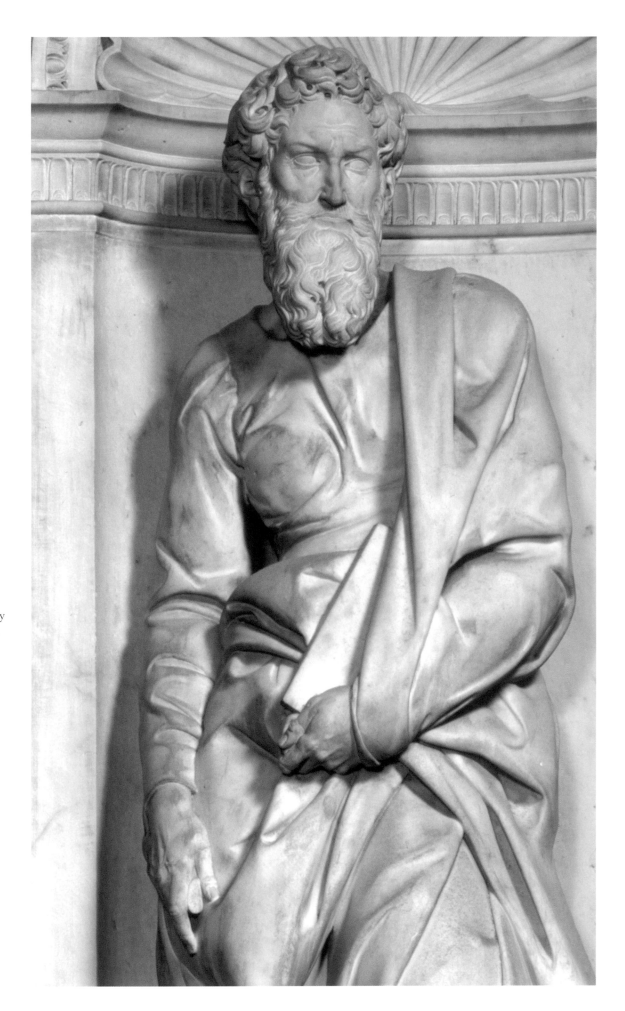

(LEFT)
MICHELANGELO
St. Paul (DETAIL)
1501–4
MARBLE
HEIGHT: APPROX. 50 IN. (127 CM)
PICCOLOMINI ALTAR, SIENA

(RIGHT)
MICHELANGELO
St. Peter (DETAIL)
1501–4
MARBLE
HEIGHT: APPROX. 50 IN. (127 CM)
PICCOLOMINI ALTAR, SIENA

Both saints hold books (although Peter was an illiterate fisherman!), but otherwise lack identifying attributes. For Michelangelo, identity and meaning were largely conveyed by artistic rather than symbolic means: glance, gesture, drapery, and the movement of the body, naked or clothed.

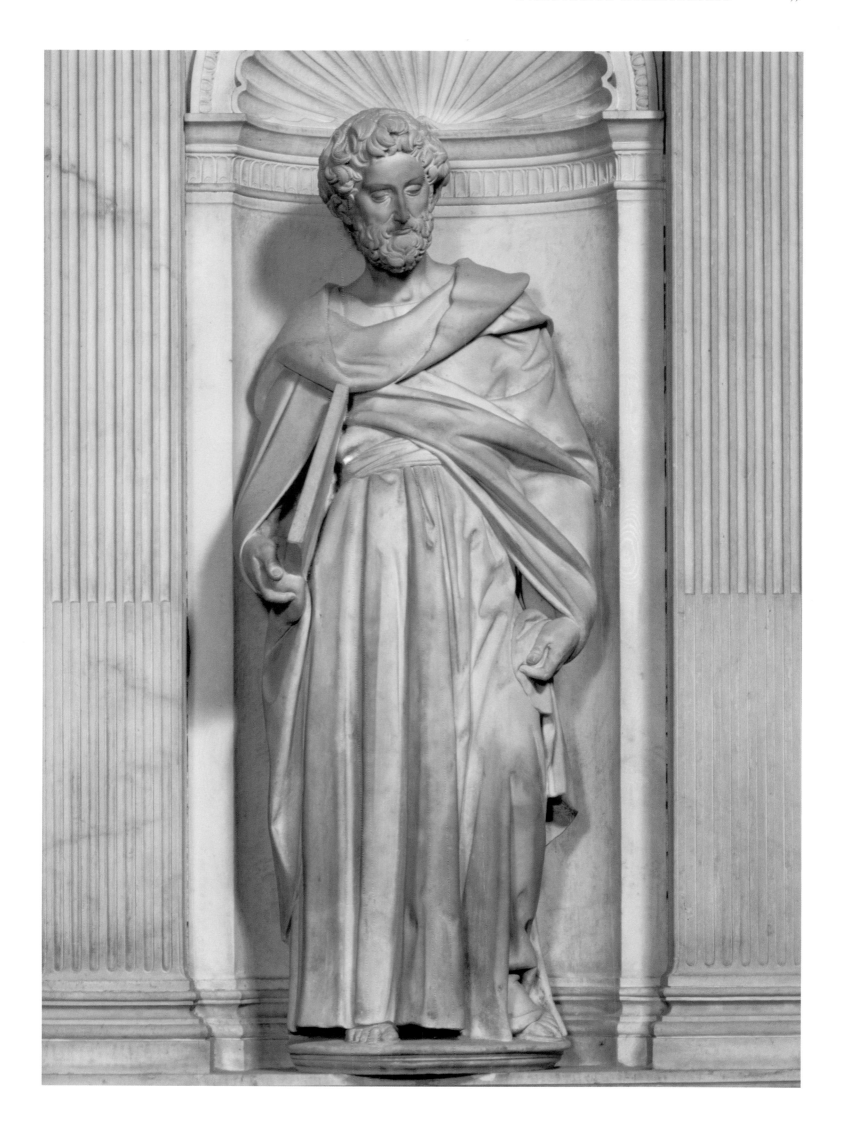

MICHELANGELO

(1475–1564)

David

1501–4

MARBLE
HEIGHT: 17 FEET (517 CM)
ACCADEMIA GALLERY, FLORENCE

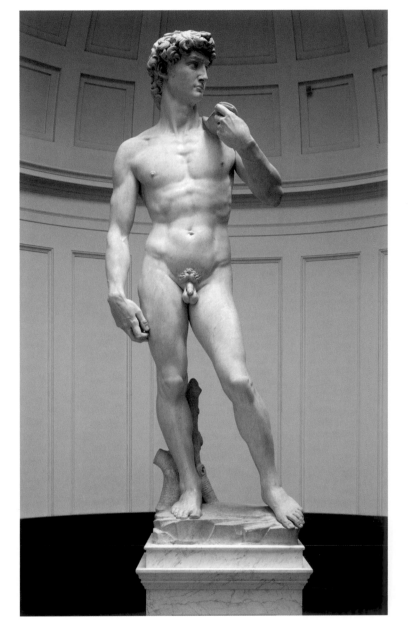

THE SCULPTURE we call *David* began life in a compromised state. The block of marble, referred to by contemporaries as "the Giant," had been quarried more than forty years earlier and partly carved by a succession of sculptors. Already narrow to start, the stone grew thinner, more weathered, more intractable.

After spending five years in Rome, Michelangelo was inspired to create a spectacular work in his native Florence. Yet nothing in ancient or contemporary art fully prepared him for the task he was about to undertake. No matter how many sources we cite— from the giant horse tamers, known as the *Dioscuri*, on Monte Cavallo (Rome) to works by Nicola Pisano, Jacopo della Quercia, or Donatello—the *David* surpasses all precedents. Like *Bacchus* and the *Pietà*, it is unique. When we speak of the Renaissance as the rebirth of classical antiquity, no work demonstrates this idea better than Michelangelo's *David*.

Different books report widely divergent measurements for the *David*, reminding us not only of the difficulty of measuring a colossal statue but also that, at some point, size fails to express its grandeur. The sculpture describes less the biblical narrative than the spirit of David, who was a giant slayer, a future king, and whose faith and courage were of such gigantic proportions. Equally illogical, the young shepherd boy is shown completely nude, although this aspect serves to establish the figure's ancestry in ancient art, his rejection of Saul's armor, and his naked courage.

David stands with his weight shifted to his right leg, suggesting the imminence of movement. The massive torso bends in the opposite direction from his piercing glance. The head is disproportionally large, both for expressive effect and to correct the natural diminution created when viewing the sculpture from a distance. The thick neck and prominent bulging muscles increase the sense of taut preparedness—it is a figure ready to unleash coiled energy. The achievement is similar to Myron's famous discus thrower (*Discobolus*) of the fifth century BCE; the suggestion of movement belies the fact that these sculptures are made of marble and forever frozen in time.

For Florentines, David was a hero with whom they identified closely—an exemplar of strength and courage in the face of adversity. So, too, did Michelangelo identify with his sculpture:

like David slaying Goliath, the young artist had conquered the huge block of marble. Immediately upon completion, Michelangelo's colossus became a focus of civic pride and was given a place of honor on the main piazza, where it symbolically guarded the city. The *David* had guaranteed Michelangelo's eternal fame.

Today, the sculpture remains a symbol of Florence and of the Renaissance; it stands paradoxically for the achievements of an entire era even as we recognize that it is the creation of one remarkable individual. Giorgio Vasari, attempting to capture in words its monumental grandeur wrote: "Without any doubt this figure has put in the shade every other statue, ancient or modern, Greek or Roman. . . . To be sure, anyone who has seen Michelangelo's *David* has no need to see anything else by any other sculptor, living or dead."

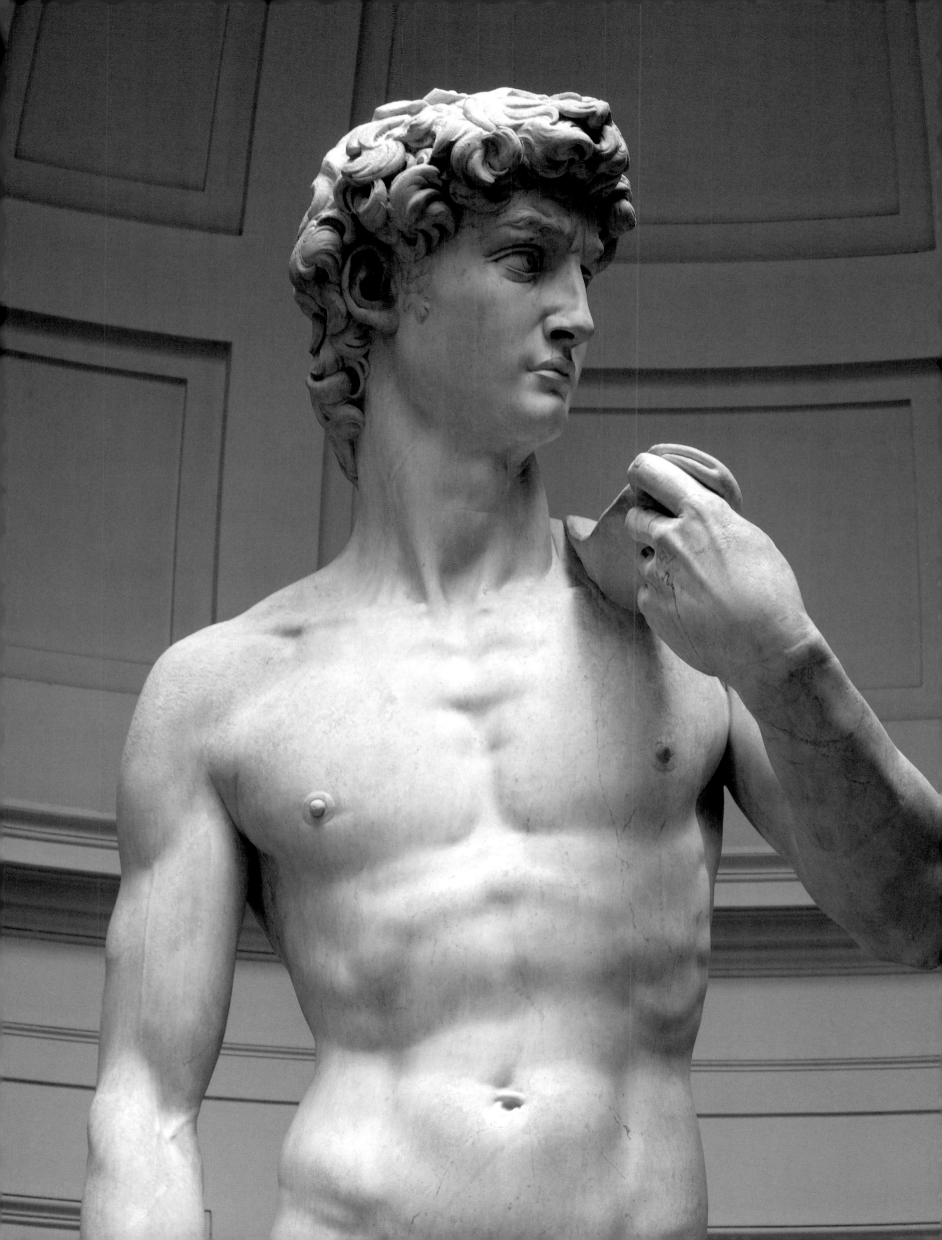

MICHELANGELO
(1475–1564)

St. Matthew

1505–8

MARBLE
HEIGHT: 85 IN. (216 CM)
ACCADEMIA GALLERY, FLORENCE

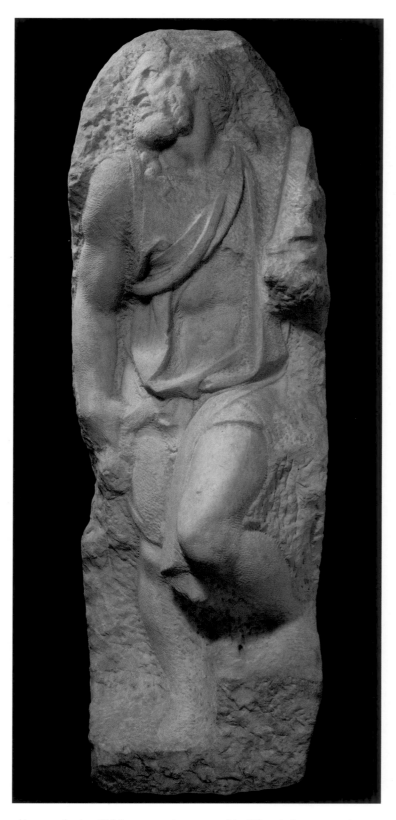

WITH THE TWIN achievements of the *Pietà* in Rome and the *David* in Florence, Michelangelo's reputation was firmly established, and he would never again lack for commissions. He was a creator of marvels and by far the greatest living sculptor—everyone wished to employ him.

Even before he had completed the *David*, the consuls of the Florentine wool guild (*Arte della Lana*) contracted with him to carve twelve larger-than-life apostles destined for the city's cathedral, a lucrative appointment that was projected to keep the sculptor occupied for a dozen years. It was also an opportunity to entirely transform the course of modern sculpture, to single-handedly create a sculptural Renaissance. The commission tested the artist's powers of invention to the extreme. How to express through gesture, body language, and a minimum of attributes the spiritual strength and individual characters of Christ's twelve disciples? Michelangelo traveled to the marble quarries of Carrara, selected his blocks, and ordered at least five shipped to Florence. Only the *St. Matthew* was ever begun.

Although the figure is roughly carved, the upper torso clearly faces forward while the head and left leg are turned sharply to the right. This pose reveals Michelangelo experimenting with a gesture seen later in some of the prophets and sibyls he painted on the ceiling of the Sistine Chapel. The turned face and over-the-shoulder glance suggest the saint's communication with the divine. Since Carolingian times, St. Matthew had been described as unlettered, aided in writing his gospel by an angel who was often shown whispering in his ear and guiding his hand.

Michelangelo has not carved an angel. Rather, in the unusual turn and torsion of the figure, he has discovered a bodily language that eloquently describes a state of divine inspiration, as though Matthew were receiving God's word directly. The saint is not represented writing his gospel, as was usual, but rather holding a book (or tablet) high in his left hand. Located along the same diagonal as the saint's glance, the volume is a tabula rasa raised to receive the word of God. By contrast, his right hand hangs limply at his side. One can imagine it holding a quill, the useless instrument emphasizing that the gospel of the illiterate Matthew was inscribed not by human agency but through divine intervention.

Even in its unfinished state, this inspired saint permits us to glimpse the ineffable, to see the unseeable. That is how, even in inert stone, Michelangelo describes matters of faith. Despite being left incomplete, the *St. Matthew* exerted a lasting influence on the artist's contemporaries. One sees immediate reflections in Raphael's painting of *St. Catherine* and in the work of Jacopo Sansovino, one of the sculptors hired to complete the commission after Michelangelo abandoned it. Michelangelo himself further explored an exaggerated but highly artistic form of *contrapposto* in his sculpture *Victory*, in the 1530s.

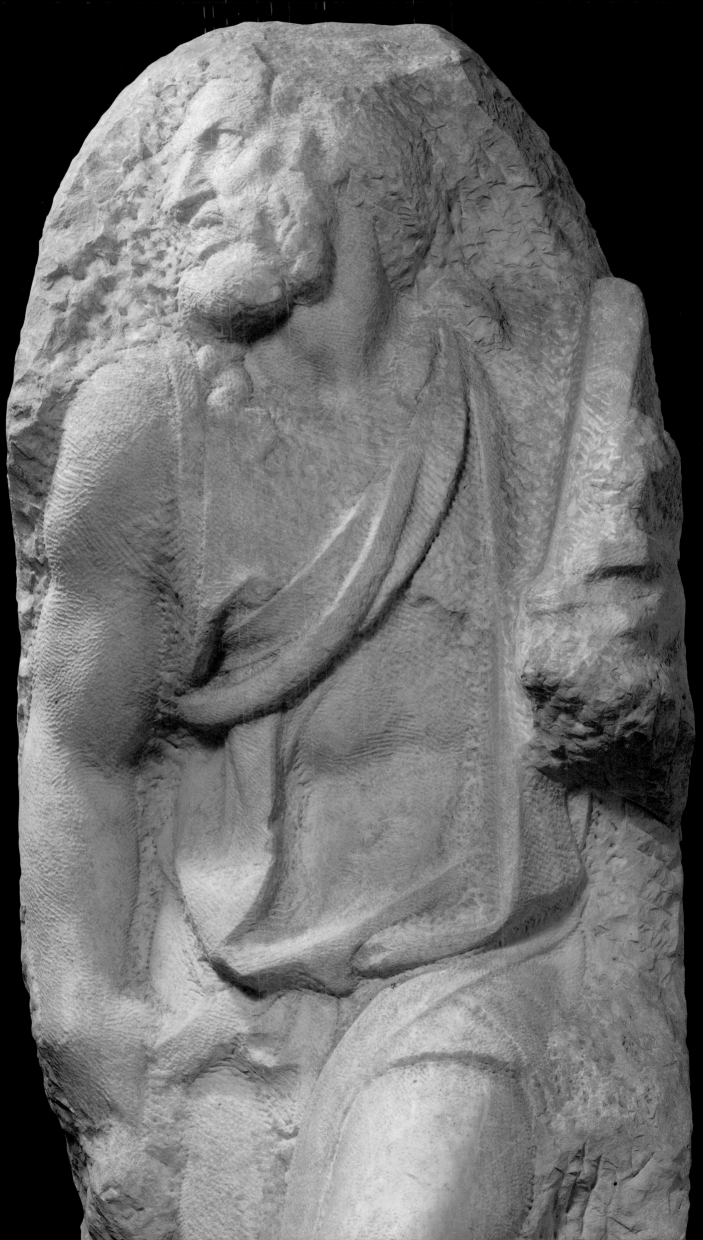

ARISTOTILE DA SANGALLO, COPY AFTER MICHELANGELO
(1481–1551) (1475–1564)

Battle of Cascina

CA. 1542

OIL ON PANEL
50 ¼ X 30 IN. (129 X 76 CM)
COLLECTION OF THE EARL OF LEICESTER, HOLKHAM HALL, NORFOLK, ENGLAND

IN 1504, shortly after completing the *David* and amid one of the busiest periods of his life, Michelangelo received an additional commission to paint a battle fresco, which would be located opposite one to be created by his rival Leonardo da Vinci in the Florentine Hall of State (the Sala dei Cinquecento, or Hall of the Five Hundred), in Palazzo Vecchio. With this project, Michelangelo was given the opportunity to prove himself in painting, just as he had in sculpture. He prepared a cartoon (from the Italian *cartone*) of more than 116 square meters (about 1,200 square feet) by gluing together multiple sheets of paper. For differing reasons, both artists failed to complete their frescoes: Leonardo because of technical frustrations and Michelangelo because he was summoned to Rome by Pope Julius II in 1505. Although the *Battle of Cascina* never proceeded beyond this preliminary stage, Michelangelo's monumental drawing exercised a profound influence on subsequent generations who made copies from it.

The never-completed composition of bathers is preserved in a handful of extant drawings as well as this grisaille panel painted by Michelangelo's assistant, Aristotile da Sangallo. These later copies show that Michelangelo chose to represent a peculiar and utterly minor episode in Florence's protracted struggle against its archrival Pisa. Contemporary accounts record that the extreme summer heat drove the Florentine soldiers to find relief in the Arno River; as they were bathing, their captain raised a false alarm. Here, we witness the chaotic scene of soldiers scrambling to dress and arm themselves. It is a curiously unheroic battle picture, especially given its intended public location. Rather than celebrating a victory, a hero, or some divine intervention—as state commissions tended to do—Michelangelo's fresco was meant to serve as a clarion call for civic and military preparedness. This peculiar emphasis gave the artist unprecedented scope to exercise his specialty: the male nude in action. Such a display was of

particular importance, given that Leonardo's *Battle of Anghiari* would similarly highlight his talent for depicting equestrian battle scenes.

As has often been noted, Michelangelo's crowded friezelike arrangement is not wholly successful. Indeed, later copyists and engravers selectively focused on individual figures and small groups rather than the composition as a whole. The original cartoon was soon cut up, probably not maliciously but to preserve the very thing most admired about the work: its repertoire of figural inventions. Benvenuto Cellini declared the *Battle of Cascina* to be the "school of the world," because every young Florentine artist mined it for ideas.

The *Battle of Cascina* fresco was Michelangelo's most important commission to date, and it promised to be one of the greatest paintings of the Renaissance. Like so much else in the artist's career, the project languished and was ultimately abandoned. But its scale and ambition, as well as specific figural poses, had a decided impact on the history of art. We cannot say the same about the unfulfilled dreams of many other artists. Rarely has so much attention been given to a work of art that never existed.

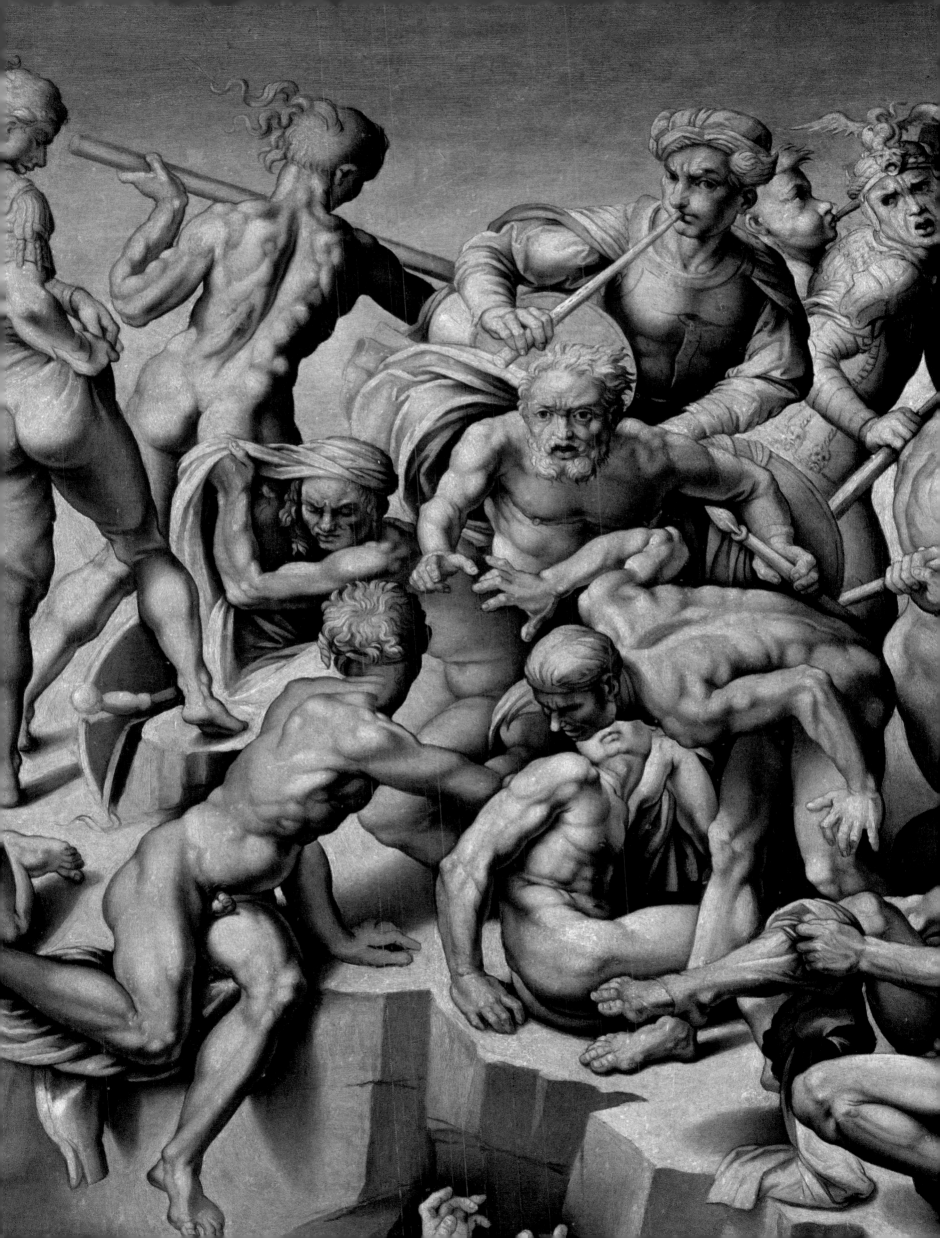

ARISTOTILE DA SANGALLO
Copy after Michelangelo,
Battle of Cascina
CA. 1542
OIL ON PANEL
50 ¾ X 30 IN. (129 X 76 CM)
COLLECTION OF THE EARL OF
LEICESTER, HOLKHAM HALL,
ENGLAND

Surely the strangest "battle" picture
ever imagined! Although designed
for a prominent location (the
Florentine Hall of State) and an
important purpose (nationalistic
propaganda), this work highlights
Michelangelo's great specialty:
the male nude in action. But
what exactly is the action?

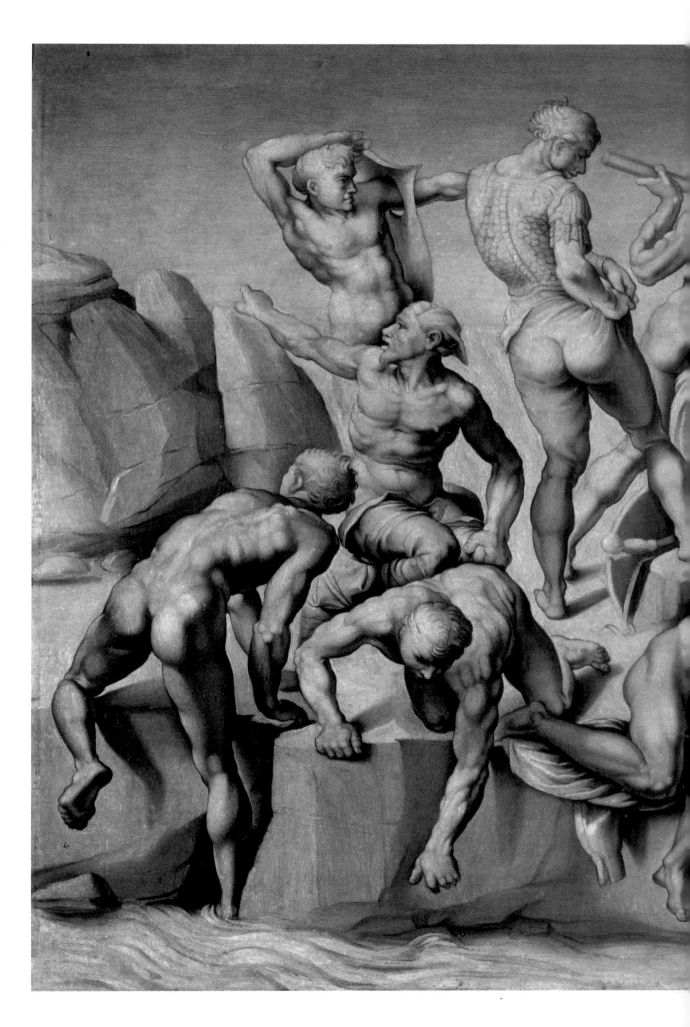

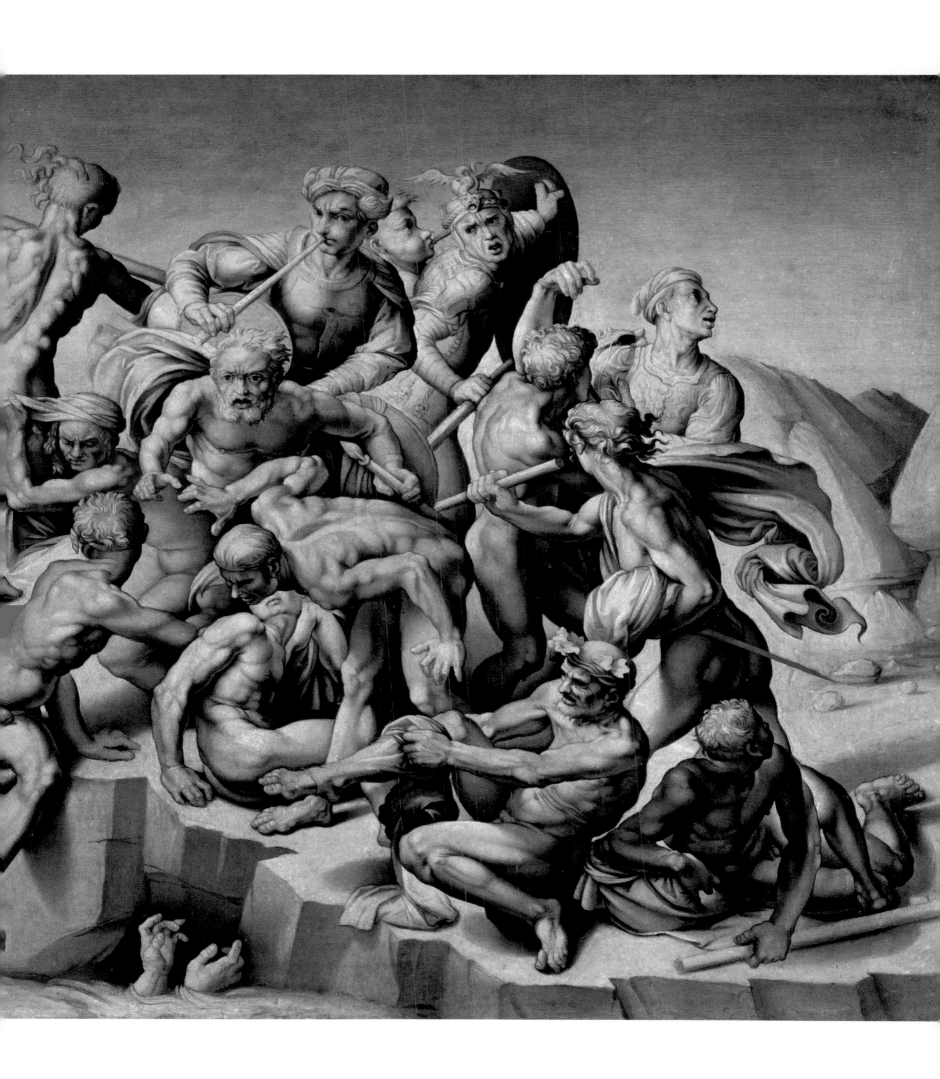

MICHELANGELO
(1475–1564)

The Virgin and Child with the Infant St. John (Taddei Tondo)

CA. 1504

MARBLE
DIAMETER: 42 IN. (106.8 CM)
ROYAL ACADEMY OF ARTS, LONDON

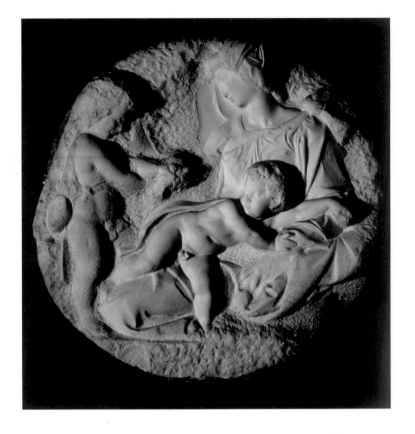

THE COMMISSIONS for the *David* and the *Battle of Cascina* placed Michelangelo firmly in the public eye, but creating marvels hardly guaranteed steady employment. Most Renaissance patrons desired familiar, affordable objects, a situation made clear in contracts of the time, which often cited existing artworks as models to be imitated. Successful artists such as Fra Angelico, Fra Filippo Lippi, and Sandro Botticelli satisfied market demand by churning out paintings with similar subjects and compositions, possible only because of the considerable assistance their workshops provided.

Michelangelo never replicated his works, once remarking that it was "better to make a mistake than to repeat oneself." At the same time, the ambitious artist accepted nearly every opportunity to prove his superiority in not just one but all media. In the space of a few years, between 1501 and 1506, he produced three distinct examples of a familiar genre, the tondo (or round composition), created at the request of a trio of prominent Florentine families: the Taddei, Pitti, and Doni. In these works, Michelangelo came closest to providing the luxury products desired by bourgeois Florentine patrons.

For the so-called *Taddei Tondo*, Michelangelo returned to the medium with which he had begun his career: relief carving. Most tondi were painted or made of lightweight stucco. How does one display a round piece of marble or fasten such a heavy object to a wall? As with many of Michelangelo's experimental works, such banal but fundamental questions remain unanswered and, frequently, unasked.

To carve a circular composition from a block of stone is itself a challenge: note the ragged edge, the flattening of the Virgin's turban, and the incision in the lower right, perhaps where a flaw in the marble was removed. Within this irregular space, Michelangelo created a complex three-figure design. The long sinuous form of the baby Jesus is accentuated and extended by a flutter of the Virgin's robe, creating a lyrical line that flows across the composition. The active pose of the child reveals the influence of contemporary compositions by Leonardo da Vinci. It was just like Michelangelo to take an idea the older master applied in

his paintings and translate it into the three-dimensional medium of sculpture.

Also similar to Leonardo is Michelangelo's willingness to explore the boundary between suggestion and definition, finished and unfinished *(non-finito)*. Many passages reveal the marks of the sculptor's chisel, as though he were proud of his handiwork and unwilling to polish it away. The infant John is still part of the roughly hewn stone, and the Virgin emerges incompletely from a hazy background.

But is the work finished? Would Taddeo Taddei, the Florentine businessman who commissioned not only this work but also an exquisitely wrought painting by Raphael, be satisfied with it? Evidently so. To the best of our knowledge, the relief was delivered and admired by its owner and by Raphael, who made a spirited drawing from it. The relief is testament to Michelangelo's rapidly growing stature and perhaps provides evidence of an increasing taste for the *non-finito*. In this and other works, Michelangelo has begun the process of molding contemporary taste and expectations.

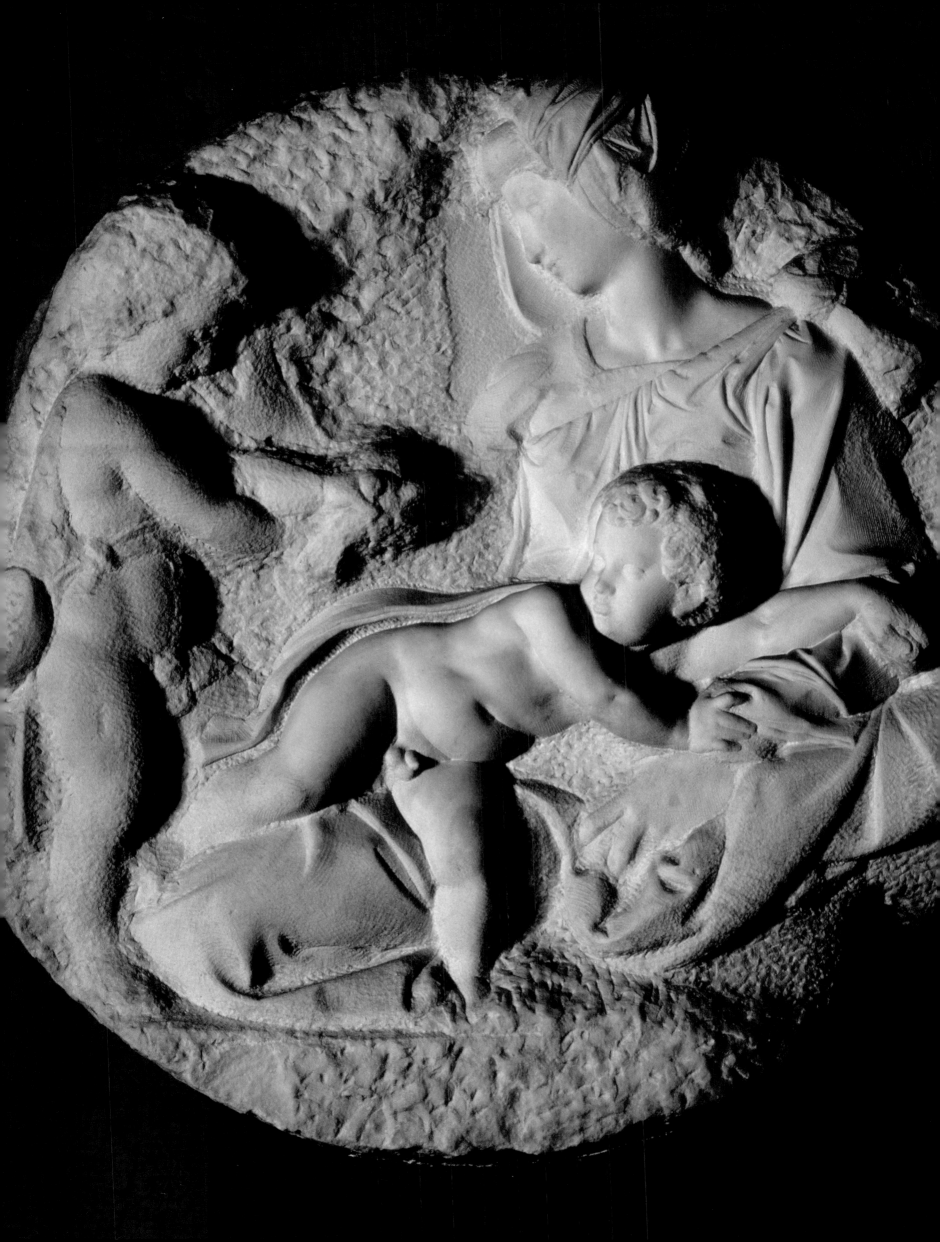

MICHELANGELO
(1475–1564)

Madonna and Child and the Child St. John (Pitti Tondo)

CA. 1504

MARBLE
DIAMETER: APPROX. 32 ¼ IN. (82 CM)
BARGELLO MUSEUM, FLORENCE

THE EXPLORATION of the aesthetic effects of the unfinished is carried to an even more sophisticated level in the so-called *Pitti Tondo*, in which the *non-finito* is clearly used as an expressive device. Michelangelo offers a catalogue of sculptor's marks, from the lightly polished face of the Virgin to the rough grooves at the left, created with a pointed chisel to suggest an atmospheric background. Even the obviously unfinished passages—such as the rough-cut parallel channels or the various textures of the block on which the Madonna is seated—appear self-conscious. Seeking a means to create three-dimensionality in a low-relief sculpture, Michelangelo used a variety of marks and surfaces to suggest a spatial depth far greater than the physical limits of the marble tondo. At the same time, he made little effort to disguise the medium or his working methods.

When asked by the humanist scholar Benedetto Varchi about the relative merits of painting versus sculpture, Michelangelo responded: "In my opinion, painting should be considered excellent in proportion as it approaches the effect of relief, while relief should be considered bad in proportion as it approaches the effect of painting." Michelangelo's *non-finito* ensures that we will never mistake this tondo for the slick surface and illusionistic tricks of painting.

The same compositional elements are present here as in the *Taddei Tondo*: the seated Virgin and Christ child, accompanied by the infant St. John. The Madonna more substantially dominates the space, so much so that John, glimpsed just over her right shoulder, is left little room at the margins. Mary is the intermediary between the two infants. She embraces her own child while her over-the-shoulder glance suggests cognizance of John's presence.

The classical features seen in the Pitti Madonna are similar to those of the Rome *Pietà* and the nearly contemporary *Bruges Madonna*: refined and aristocratic. The Virgin's body exhibits curiously squat proportions, however. Taking a lesson from Donatello, Michelangelo recognized that the tondo would be placed high on a wall or as the crowning ornament for a

Florentine tomb, and he adjusted his forms for these circumstances. Seen *di sotto in su*—that is, foreshortened from below—the Madonna's proportions do not seem at all strange, but rather quite natural; she is the queen of heaven ensconced on a simple throne, itself a perfect cube. From this vantage, the holy mother is inscribed within the circular field of the tondo, which stands in for her absent halo.

Christ looks down meditatively toward us. His fleeting smile and casual, unthinking pose—elbow resting on an open book—beguile us into accepting this domesticized version of a religious subject. Temporarily, we are relieved of the obligation to meditate on his unhappy future, but that delay makes a return to contemplation all the more poignant. This is not just a mother whose reading has been interrupted by her impetuous child; these are sacred figures with a destiny, and that anachronistic book is Holy Scripture.

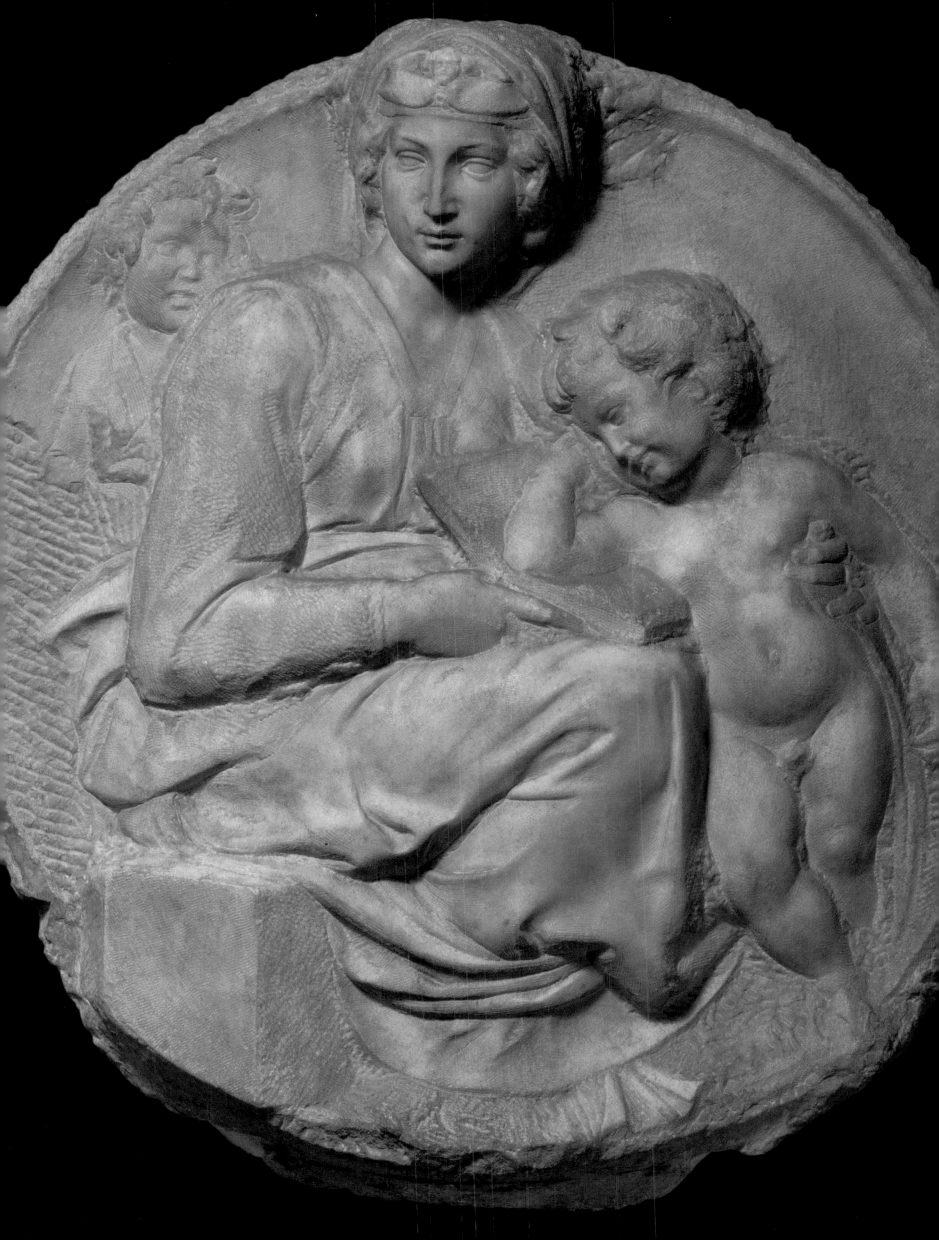

MICHELANGELO
(1475–1564)

Holy Family with the Infant and St. John the Baptist (Doni Tondo)

CA. 1504

OIL AND TEMPERA ON PANEL
DIAMETER: 47 ½ IN. (120 CM)
UFFIZI GALLERY, FLORENCE

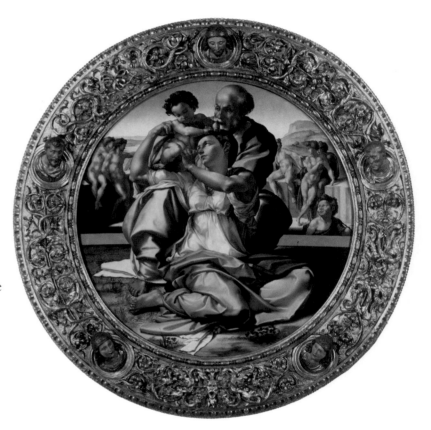

THERE is little in Michelangelo's oeuvre to prepare us for the innovative features of the *Doni Tondo*. As for his sculptures, all the sources and influences cited by scholars inadequately explain the beauty, invention, and subtle intelligence of this painting. Among the many unanswered questions are why a Florentine businessman, Agnolo Doni, commissioned a renowned sculptor to paint a picture, and why Michelangelo agreed to do so. Despite only limited experience using tempera, the artist succeeded in creating a masterpiece.

The Madonna is seated on the ground with a closed book on her lap. She turns toward her athletic child while her husband, Joseph, kneels behind her. It is uncertain whether he is taking the child or passing him to Mary. The purposeful ambiguity of the action permits us to read it either way, investing the composition with continuous movement. The heads, arms, and hands of the Holy Family form a tightly knit composition, enriched by the intensity and intimacy of their gazes. The rapt adoration and glowing face of Mary are an especially eloquent expression of profound love and prescient knowledge.

The gesture of the Christ child recalls that of a priest or healer laying hands on a person in need. The mother's left hand both conceals and calls attention to the boy's genitals, an assertion of Jesus's humanity and a reminder of his dual nature as man and God, flesh and spirit. The fullness of emotions finds its counterpart in the bright, metallic colors of the tempera paint. The Madonna's traditional red dress and blue mantle are framed by a strip of deep green and the glowing, iridescent orange of Joseph's cloak. The radiant blue folds that fill the foreground are echoed in the deeper tones of Joseph's tunic and in the lighter hues of the sky and distant landscape.

Just beyond a low, smoothly cut ledge of stone is the young St. John the Baptist. As the link between the Old Testament and the New, he appropriately occupies the picture's middle ground. His ecstatic gaze reflects that of the Madonna, and with similar purpose, for John and Mary are blessed with prophetic insight and were the first to recognize Christ's divinity. Beyond John is a group of nude youths who lounge in various attitudes of repose and more intimate erotic embrace. Theirs is a carnal love that serves as a foil to the spiritual love of the Holy Family, a recollection of the pagan past before the advent of the Christian era.

The nude youths occupy a semicircular cavity reminiscent of the excavated face of a quarry. The faceted stone wall may also evoke the partly constructed apse of a Christian church, as though we are witnesses to both the new dispensation and its architectural expression. It is fitting, then, that the Holy Family occupies the place of the altar. In this stunningly beautiful and highly crafted artwork Michelangelo presents an image of the Christian church as history, physical space, and visible doctrine.

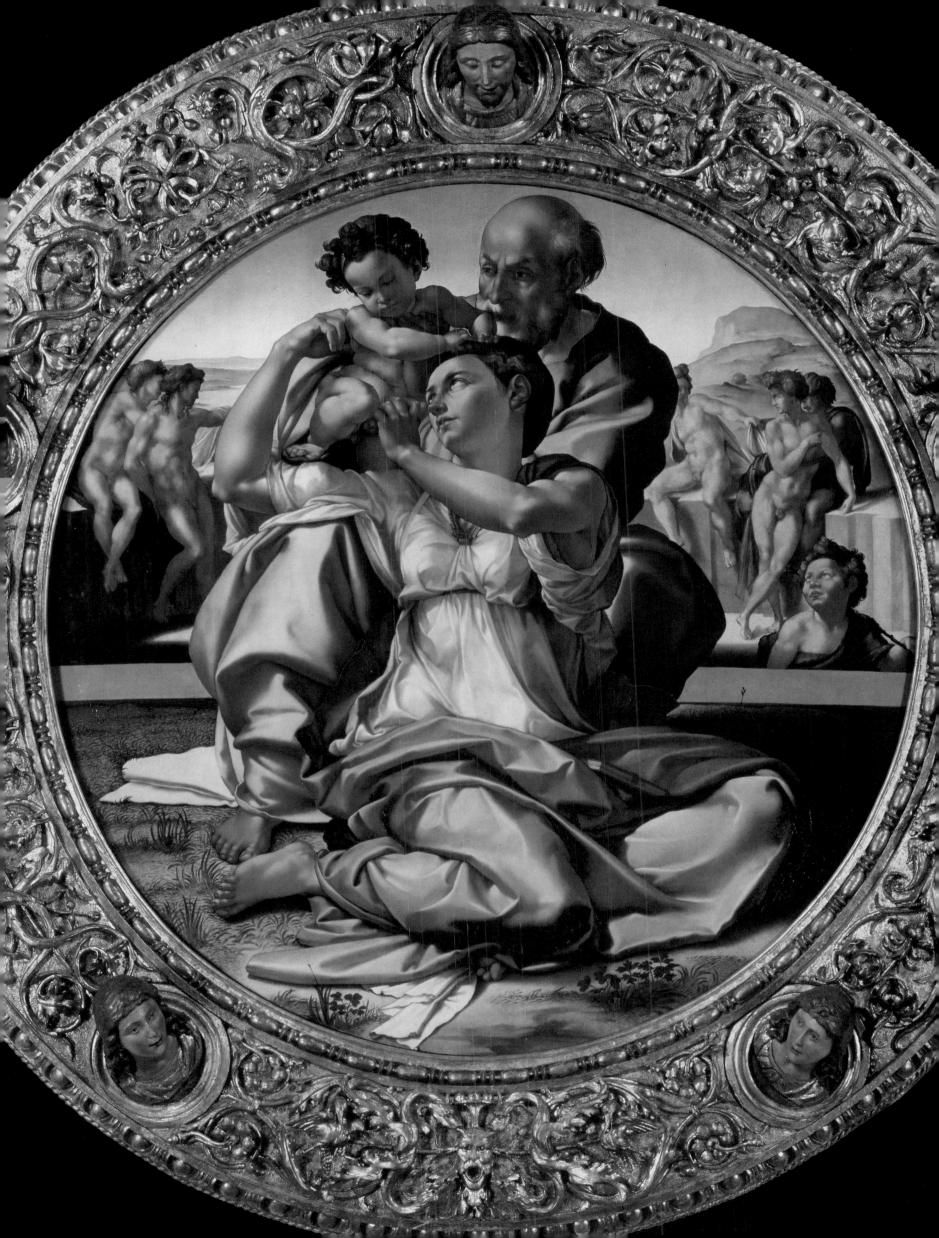

MICHELANGELO
*Holy Family with the Infant
and St. John the Baptist
(Doni Tondo)* (DETAIL)
CA. 1504
OIL AND TEMPERA ON PANEL
DIAMETER: 47 ½ IN. (120 CM)
UFFIZI GALLERY, FLORENCE

How could Michelangelo,
with so little training in
painting and no previous
experience using tempera,
have painted such a breath-
taking masterpiece?
At some level, the artist's
biography fails to explain
the genius that is so
evident here.

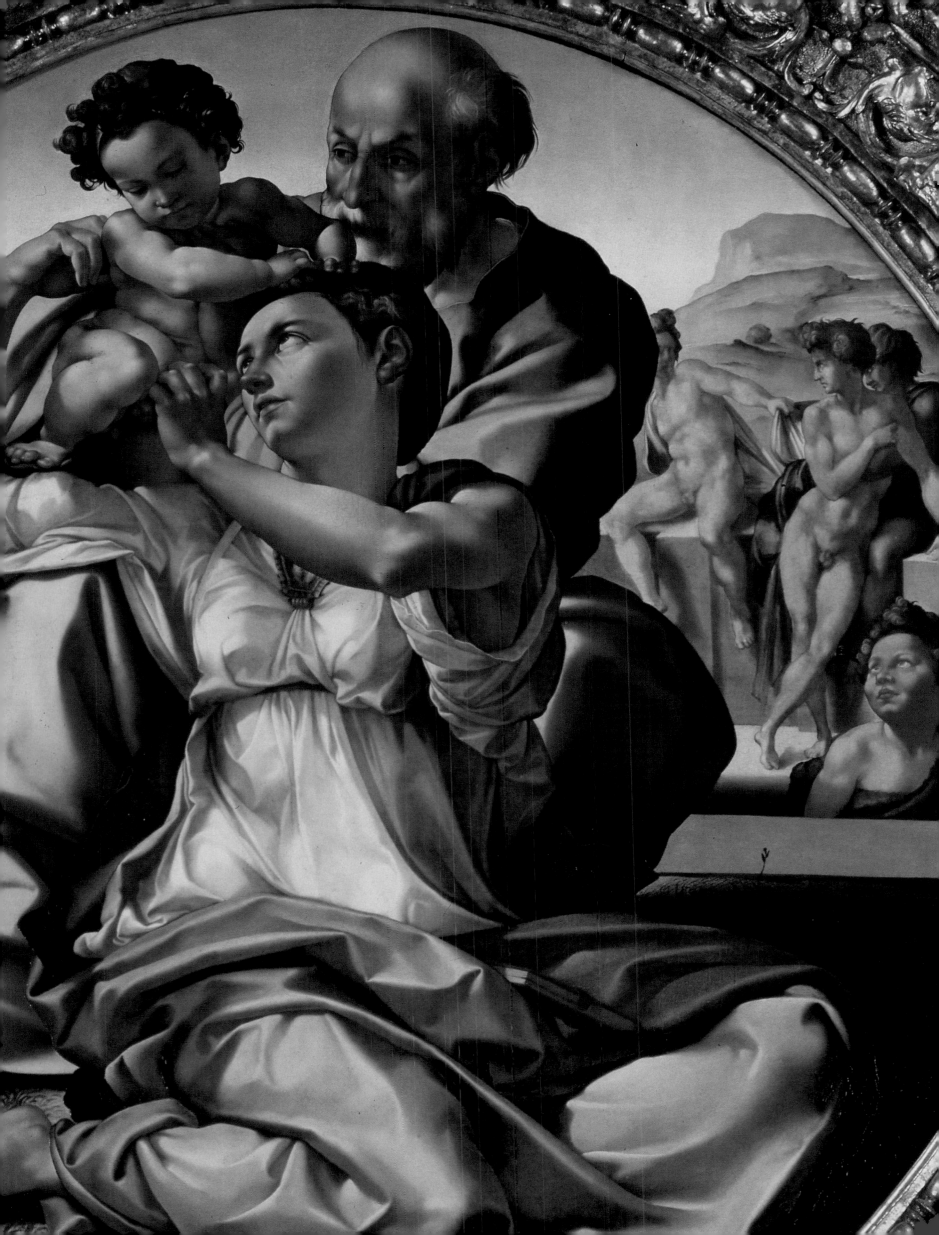

MICHELANGELO
(1475–1564)

Madonna and Child

1503–5

MARBLE
HEIGHT: 50 ¼ IN. (128 CM)
CHURCH OF NOTRE DAME, BRUGES, BELGIUM

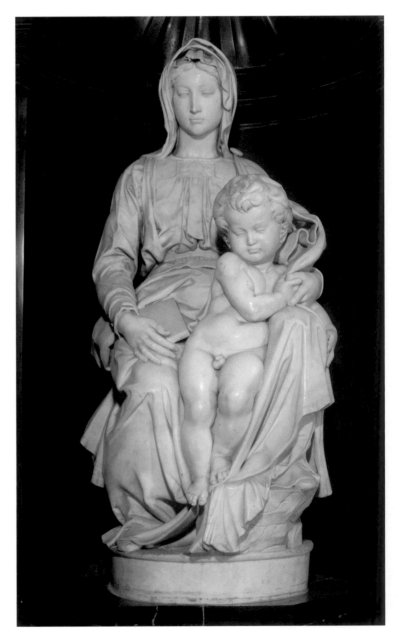

ONE OF THE many would-be patrons who successfully hired Michelangelo during the busy first decade of the sixteenth century was a company of rich Flemish merchants who wished for a statue to decorate the church of Notre Dame in their hometown of Bruges. Responding to the prestige of the commission, Michelangelo created one of his most beautiful, although less familiar, works of art, the so-called *Bruges Madonna*. Part of the sculpture's allure derives from the beauty of the flawless, translucent marble. The artist miraculously transformed the resistant material into malleable flesh and large, supple folds of drapery. But brilliant carving is placed in the service of Michelangelo's imaginative approach to his subject: the poignant interaction between a reluctant mother and her only son.

The naked Christ child, prescient beyond his indeterminate age, stands between the protective legs of his mother. He is enfolded within her statuesque form, as though still one with her flesh. She is as stable as the rock on which she sits, offering an immobile counterpart to his tentative movements. The child's left arm is draped across her raised left leg, and his right hand is entwined with hers. This example of an invented, unconscious gesture often characterizes Michelangelo's figures and helps to illuminate an inner state. In the slippage of those tiny fingers we sense the reluctance, yet also the obligation, to relinquish the maternal embrace. The activity contrasts with the Madonna's right hand, which inattentively secures a falling book. The volume suggests that her reading has been interrupted while also evoking the Holy Scripture, in which is foreshadowed the painful history unfolding before us.

The child has already begun his first step. His weight, barely supported by his left leg, pulls at the folds of his mother's robes, creating a long sweeping arc of drapery that rises from the lower left and extends all the way to the bunched folds by the child's head. This inexplicable flourish, with its contrasting shadows and highlights, solids and voids, punctuates the tremulous emotions expressed in faces and gestures. Christ's right leg is suspended in space—his next step is the passage from childhood to manhood, from human to God, from gift to sacrifice. With lidded eyes, he looks toward the altar, and we realize his destiny.

The broad, chubby features of the child contrast with the thin, drawn countenance of his mother, whose eyes, nostrils, and lips are described by sinuous calligraphic lines. The cloth draped over her head accentuates the attenuated proportions of her face, and the bunched folds atop her head form a sort of diadem. Michelangelo has incised a fine line across her forehead that catches the light and produces a slight shadow, suggesting a transparent veil.

As he did in the Rome *Pietà*, Michelangelo seduces us with the sheer beauty of his creation. And yet, our immersion in aesthetic pleasure makes all the more moving the gradual realization of the work's profound implications.

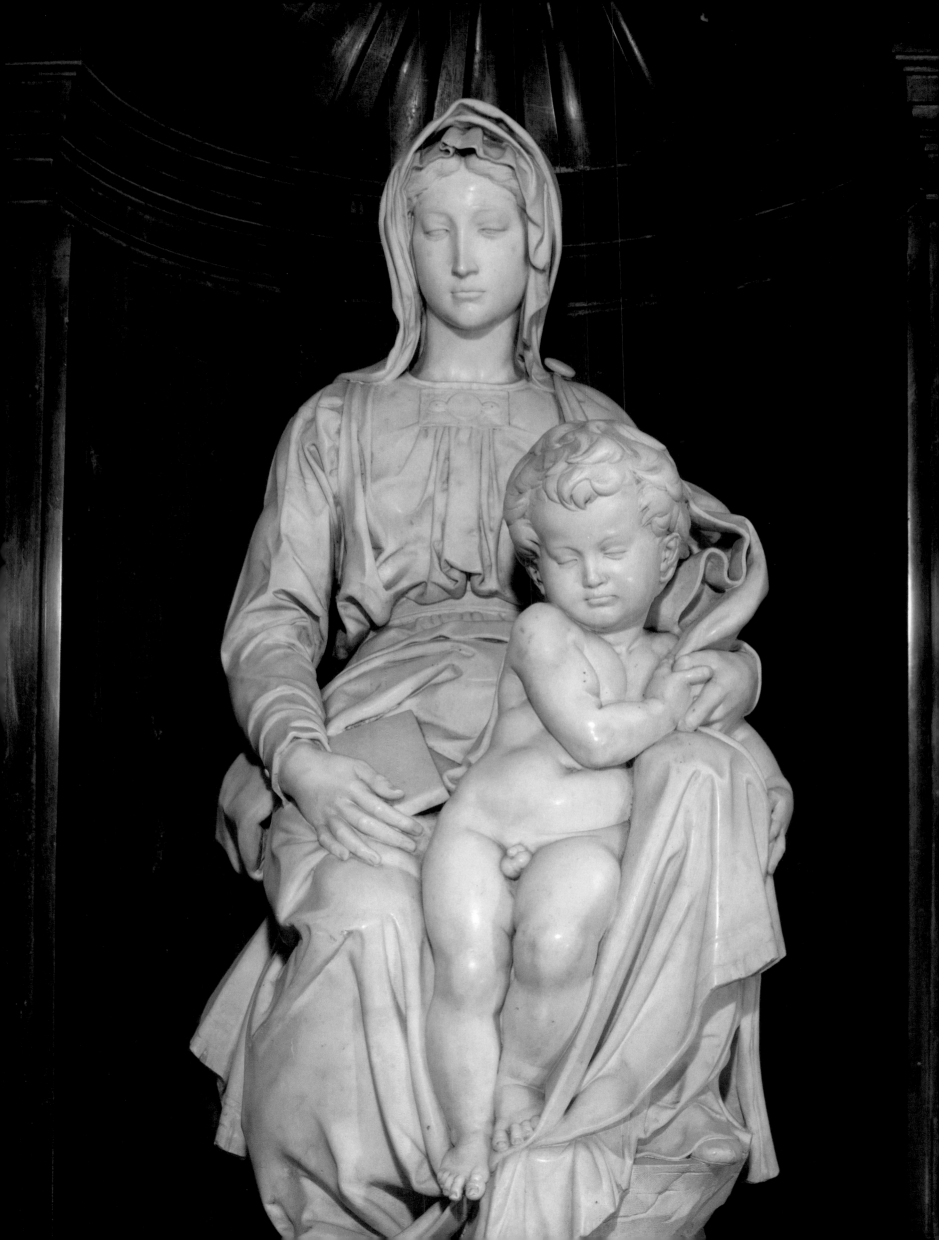

MICHELANGELO

(1475–1564)

Preparatory Drawing for the Ceiling of the Sistine Chapel

CA. 1508–9

RED CHALK AND PEN AND BROWN INK ON PAPER
11 ¼ X 7 ¾ IN. (285 X 195 MM)
ASHMOLEAN MUSEUM, OXFORD

WHEN THINKING about the daunting task of painting the ceiling of the Sistine Chapel, we might wonder, *How did Michelangelo begin?* The answer: reluctantly. The evidence of his hesitation is found in this drawing.

For such a large and complex undertaking—populated with more than 250 figures—Michelangelo must have made hundreds, if not thousands, of preparatory drawings. Yet, less than fifty can be connected to the monumental endeavor. We know that he destroyed many of his working drawings: he wished us to see the final product, not his exorbitant efforts. Thanks to the survival of a few sheets, including this one, we are afforded a precious glimpse into the creative processes of the artist, both at work and while distracted from his Sisyphean task.

The first and largest depiction in this sketch is a red chalk study for the young ephebe, or "genie," that accompanies the Libyan sibyl. The half-length figure corresponds directly to the one that was eventually painted on the ceiling, including the head turned in *profil perdu* (lost profile), the left arm that clutches a scroll, and the gesturing right arm. Also in red chalk, he drew the straining right hand of the sibyl as it grasps the weighty tome that contains her prophecies. After completing these two studies, Michelangelo clearly became distracted. It is uncertain whether minutes or hours passed, but sometime later and on the same paper, he made several additional sketches in pen and ink. Filling the space at the bottom of the sheet are six different ideas for bound figures. These are surely designs for marble sculptures that were intended to adorn the tomb of Pope Julius II. Then, turning the sheet ninety degrees, he drew a section of entablature that likely is also related to the architecture of the same tomb. We see Michelangelo's thoughts taking a tangent, moving from the immediate task at hand—making studies for the giant vault—to the project to which he most wished to devote his time and energy: the giant tomb. Thus, in one modest drawing, we are witness to the artist's schizophrenic attention and his difficulty reconciling conflicting imperatives.

Fresco work can be undertaken only during the dry months of late spring, summer, and autumn. During the winter months, the dampness makes it difficult to mix the correct proportion of plaster and water needed to carry out the *buon fresco* technique. One imagines that, with a large supply of marble on hand, Michelangelo continued carving sculptures for Julius's mausoleum in winter and even as he drew hundreds of studies for the Sistine Chapel fresco. This drawing attests to the dual obligations of tomb and ceiling, sculpture and painting. Indeed, attending simultaneously to a variety of initiatives was Michelangelo's usual working manner. It is rare, however, that we are given such an eloquent glimpse of the master's day-to-day activity.

MICHELANGELO

(1475–1564)

Ceiling of the Sistine Chapel

1508–12

FRESCO
APPROX. 134 X 44 FT. (40.9 X 13.4 M)
SISTINE CHAPEL, VATICAN CITY, ROME

MICHELANGELO was called to Rome in the spring of 1508, not to renew work on the tomb of Pope Julius II, as he had hoped, but to undertake a task ill-suited to a marble sculptor: painting the ceiling of the Sistine Chapel. His objection that "painting is not my art" proved ineffectual against the will of an imperious Julius II. As with other commissions that the artist initially resisted, once reconciled to the task, he devoted unrestrained energy to creating a masterpiece.

For the next four years, between 1508 and 1512, Michelangelo struggled with the manifold difficulties of painting the chapel's irregular, leaky vault. The commission presented formidable obstacles, but, more important, it unleashed the artist's imagination. He began with his usual concentrated fury, neglectful of health and sociability. In a letter to his son, Ludovico Buonarroti expressed his worry: "It seems to me you are doing too much, and it upsets me that you are not well, and are discontent. You will not do well if you are sick or unhappy." Michelangelo compounded his father's concerns when he confessed to having no money but being "still obliged to live and pay rent."

Despite his time spent as a youth in the workshop of the painter Domenico Ghirlandaio, Michelangelo was largely inexperienced in carrying out a large-scale fresco. To help with such an ambitious undertaking, he hired about a dozen of his Florentine compatriots, including longtime friends Francesco Granacci and Giuliano Bugiardini as well as the talented young painter Bastiano ("Aristotile") da Sangallo. Others assisted with the technical problems of building the scaffolding and preparing the vault's uneven surface. They hauled water, slaked lime for plaster, ground and mixed pigments, prepared brushes, and pricked, cut, and transferred cartoons. Several worked alongside Michelangelo, painting minor figures and ornament as well as miles of architectural decoration. Michelangelo reserved for himself most of the central narratives and all the important figures. When his biographer Ascanio Condivi wrote that the artist finished the job in twenty months "without any help whatever, not even someone to grind his colors for him," he was grossly exaggerating the truth in an effort to praise a superhuman achievement.

"In the beginning God created the heavens and the earth. . . ." These words from *Genesis*, the first book of the Christian Bible,

march with stately dignity through our minds as we look upon one of the greatest works of art ever created. Like a handful of extant monuments of the ancient and modern worlds—the pyramids in Egypt, India's Taj Mahal, and the Great Wall of China among them—the Sistine Chapel never fails to astonish. Even in a fast-paced world of rapid change and technological marvels, the ceiling causes us to pause, awestruck at the creative imagination and stupendous accomplishment of one human being. No one forgets the experience of stepping through the small doorway into the vast expanse of the chapel and having eyes drawn inexorably to the heavens.

Michelangelo proceeded backward in painting the huge, uneven barrel vault. He began with what he knew best, the sinful state of humanity, and proceeded to the scenes of the Creation, for which he would be forced to imagine and portray the face and figure of God. This is also the manner in which visitors were originally meant to experience the frescos, entering the chapel under the scene of the *Drunkenness of Noah* and proceeding, in reverse chronological order, toward the Creation. The experience mimics, by analogy, the path of humanity's present sinful state to a renewal of faith at the altar. (Today, tourists enter the chapel at the opposite end, under the *Last Judgment*.) This was not the first time the subject of the Creation had been depicted; Lorenzo Ghiberti, Paolo Uccello, and Jacopo della Quercia all provided well-known models for Michelangelo to follow. Yet, like Leonardo's *Last Supper*, the Sistine representation has become canonical. We visualize the first scenes of the Bible according to Michelangelo's vision.

In a total of nine narrative scenes—four large and five smaller rectangular fields—Michelangelo imagined the beginning of time. Yet, many people find it difficult to focus on a linear story. This is partly because the scenes from Genesis form only the central spine of the densely populated vault, and many other parts compete for our

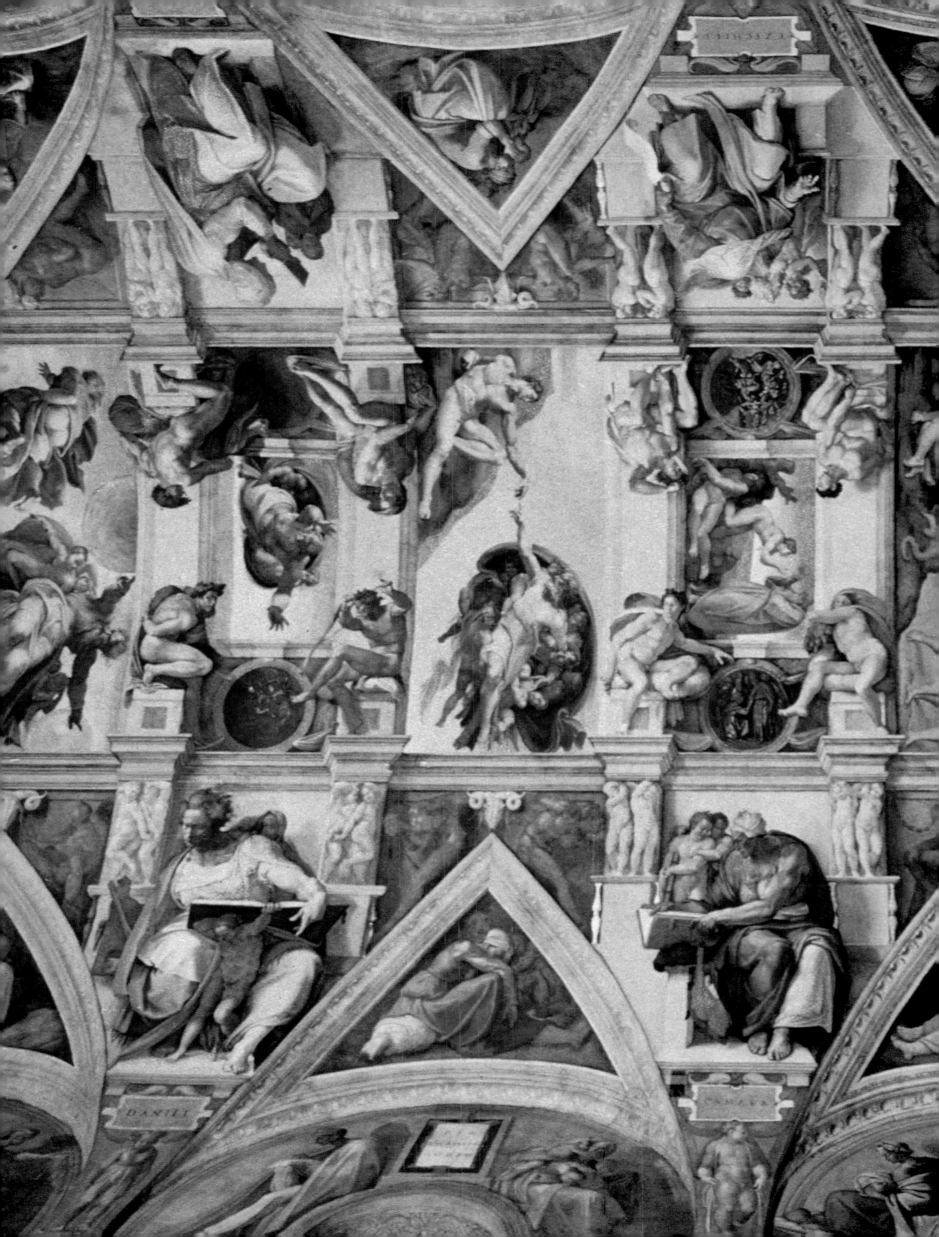

attention. Rather than looking at the ceiling in some sort of logical order, most visitors find themselves turning in various directions, each presenting a new and valid experience of the vibrant ensemble.

Michelangelo endured "the utmost discomfort and weariness" and "a thousand anxieties" over the course of the four years he worked on the chapel's decoration. The ceiling was unveiled on All Saints Day, November 1, 1512. To his father, he was notably laconic: "I have finished the chapel I have been painting: the Pope is very well satisfied." He spoke more eloquently, and humorously, of his tribulations in an acerbic sonnet:

> I've already grown a goiter from this toil
> as water swells the cats in Lombardy
> or any other country they might be,
> forcing my belly to hang under my chin.
> My beard to heaven, and my memory
> I feel above its coffer. My chest a harp.
> And ever above my face, the brush dripping,
> making a rich pavement out of me.
> My loins have been shoved into my guts,
> my arse serves to counterweigh my rump,
> Eyelessly I walk in the void.
> Ahead of me my skin lies outstretched,
> and to bend, I must knot my shoulders taut,
> holding myself like a Syrian bow.

At the bottom of the sheet, Michelangelo mused, "I'm not in a good place, and I'm no painter." The frescoed ceiling, however, tells a different story, one of magnificent accomplishment and sublime beauty.

Until modern times, the Sistine ceiling was celebrated mostly for the density and diversity of its figural repertoire; Michelangelo had always been hailed as a draftsman, not a colorist. That assessment has since changed. Between 1980 and 1990, the Vatican undertook a campaign to conserve the chapel's colossal decorative scheme, in the process removing more than five hundred years of dust, varnish, and greasy candle soot. To most, the colors revealed by the cleaning were a delightful surprise; to others, they were an unwelcome shock. The bright, *cangiante* (changing), and unexpectedly juxtaposed hues help create the visual equivalent to stereophonic sound and assist in reading the narrative scenes from a distance in natural light, an issue more obvious in situ than in reproduction.

In many ways the ceiling is a compendium—of Michelangelo's art, of the Renaissance, of Christian theology. Like Verdi's *Requiem* or Milton's *Paradise Lost*, it is a transcendent work of genius that will never be exhausted through looking or describing. Michelangelo was just thirty-seven years old when he completed the Sistine Chapel ceiling. Had he died in 1512, he would have been considered a great artist, but he still had another fifty-two years left to live.

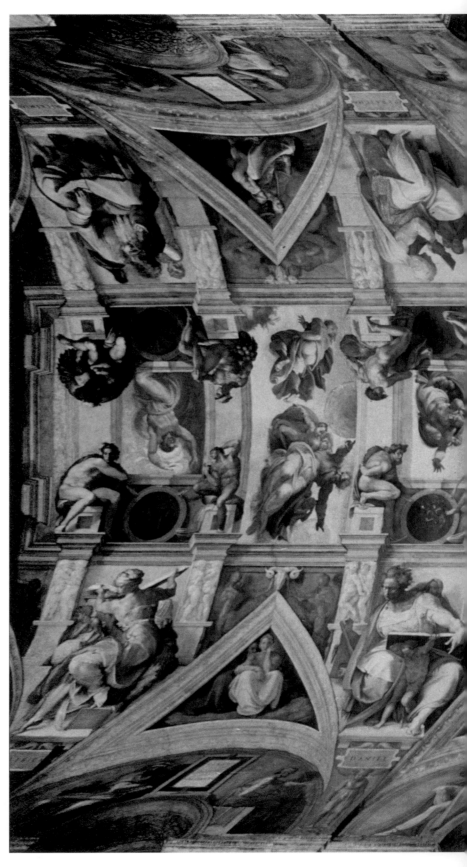

MICHELANGELO
Ceiling of the Sistine Chapel
1508–12
FRESCO
APPROX. 134 X 44 FT. (40.9 X 13.4 M)
SISTINE CHAPEL, VATICAN CITY,
ROME

The world will never tire of nor cease admiring this ceiling. No wonder that Sir Joshua Reynolds, the great 18th-century English artist and writer, advised: "The first exercise that I should recommend to the young artist when he first attempts invention, is to select every figure, if possible, from the inventions of Michael Angelo."

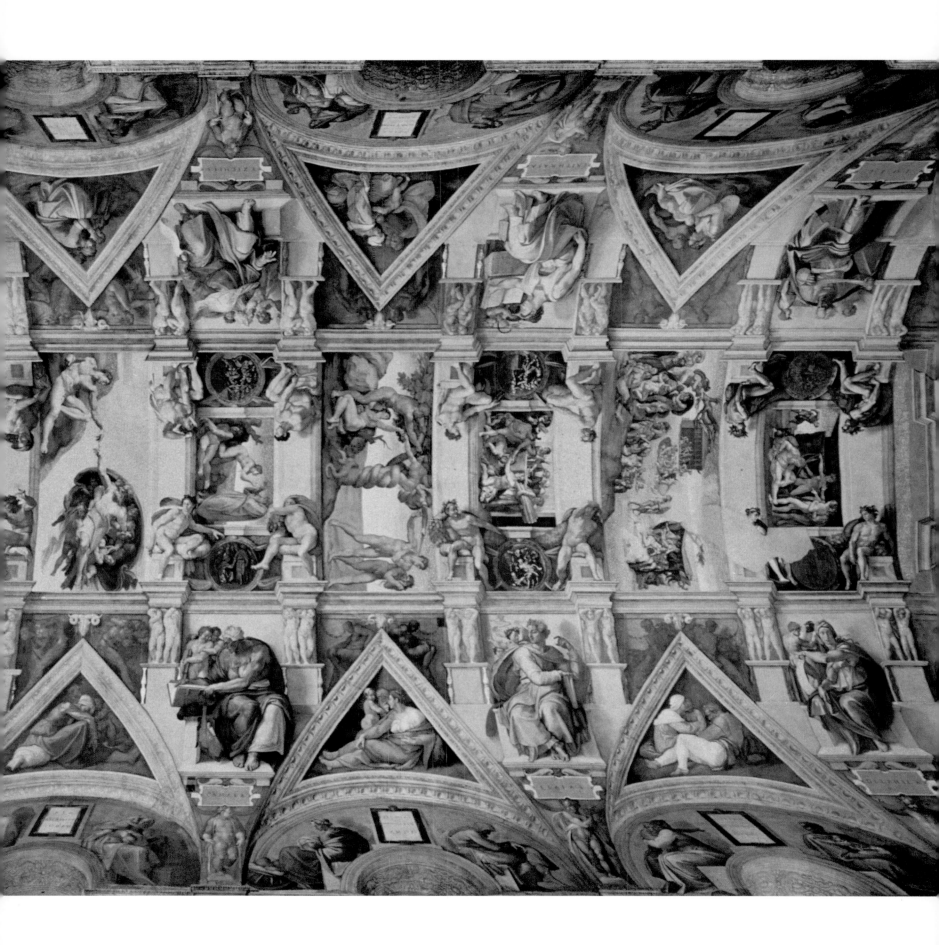

MICHELANGELO

(1475–1564)

Flood

1508–12

FRESCO
SISTINE CHAPEL, VATICAN CITY, ROME

IN A MEMORANDUM dated April 1508, Michelangelo noted expenses for a new pair of stockings, a lining for a leather doublet, and the transport of a bundle of his drawings from Florence to Rome. Always insisting on the best-quality materials, the artist obtained azurite from Florence, which he would use to make the deepest blue paint. On May 10, he received 500 ducats "on account of the painting of the vault of the chapel of Pope Sixtus, which work I began today."

Because he had never before carried out a large-scale fresco, Michelangelo hired several Florentine compatriots to assist him with painting. They were a conservative lot whose contributions are most in evidence in the *Flood*, one of the ceiling's earliest painted sections. The result is an overly crowded composition, albeit one that suitably suggests the whole of humankind. The helpers painted small figures slowly and laboriously, adding too much detail and giving too little consideration to the eventual audience, who would be viewing the work from a significant distance below. As he worked, Michelangelo's own confidence grew, as did his impatience with the old-fashioned manner of his assistants. After a few short months, Michelangelo sent some of them back to Florence and thereafter reserved all the most important painting for himself.

More than sixty figures populate the flood scene, ranging from the heroic effort of a naked father to rescue his drowned son to the ignoble fighting for a place aboard the boat precariously listing in the middle ground. The square ark floats in the far distance, where it, too, serves as temporary refuge for a group of struggling, murderous people desperate to save themselves. Because we are aware that salvation is reserved for a select few aboard the vessel, the viewer is left in a hopeless situation, stranded on a small patch of dry earth in the immediate foreground. But even this green haven is threatened by the rapidly rising waters and the press of dismal humanity.

Unaware of their inevitable fate, many victims burden themselves with worldly possessions. Amid the destruction are a few moments of tenderness. A mother lovingly cradles her baby while her older child clings fearfully to her leg. A husband labors up a steep slope, carrying his incapacitated wife, who, glancing back in terror, confirms that the disaster will soon engulf them all. Others, refusing to accept the situation, seek refuge in desperate measures, as in the young man attempting to escape the inundation by climbing a tree. Though its stunted growth and naked limbs signal both the futility of his effort and the eventual total destruction, they also direct us to the background. Finger-like, those same straggly branches point to the ark and a sign of hope: a white dove framed in its darkened window. That tiny spot of brightness is visible even from the floor of the chapel and prompts us—with a glimmer of hope—to recognize Noah leaning forth and gesturing to a brightening sky and a new world.

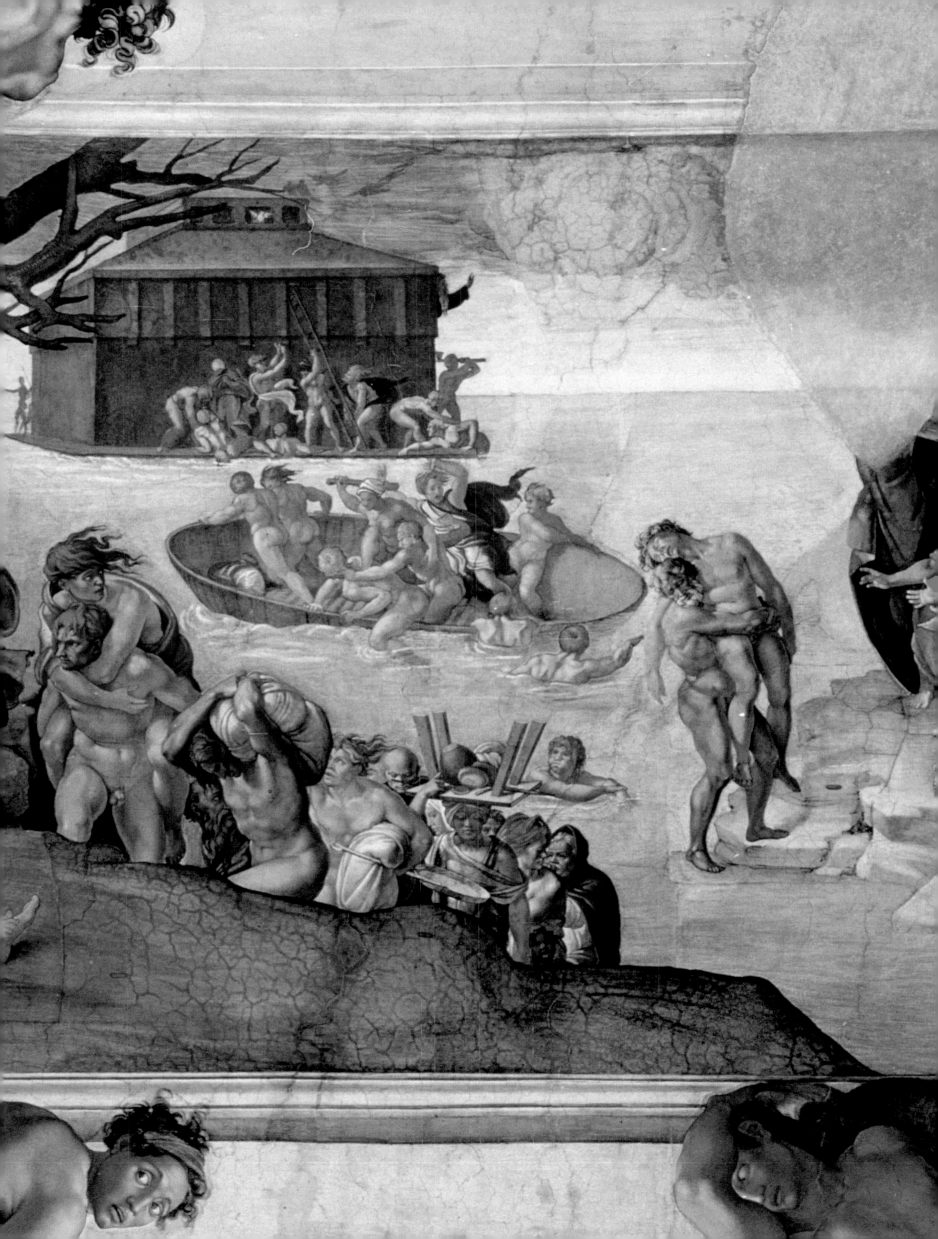

MICHELANGELO

(1475–1564)

Temptation and Expulsion

1508–12

FRESCO
SISTINE CHAPEL, VATICAN CITY, ROME

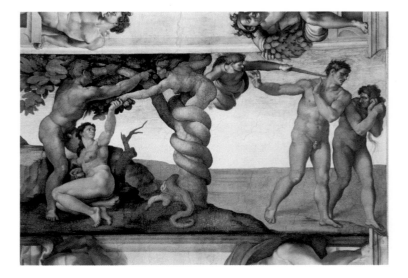

IN CONTRAST to the first three crowded scenes of the Sistine ceiling that relate the history of Noah and the flood, the next episode, the *Temptation and Expulsion*, is a large field with few figures. In a somewhat old-fashioned manner of presentation, Adam and Eve are shown twice, before and after the fall. The two sides of the painting form an obvious visual contrast that also helps relate its narrative; we move left to right, from the comparative verdancy and intimacy of the Edenic garden to the barren, endlessly expansive plain of the couple's exile. Life in innocence is to the left, life with sin and death to the right.

At the center of the garden, and appropriately central to Michelangelo's composition, is the Tree of Knowledge. Winding around the thick trunk are the iridescent coils of the serpent, seeming to strangle the remaining life from its already lopsided green growth. Is that a single or a double coil? In attempting to understand the serpent's entwined body, we are tricked into relying upon knowledge and intellect, the very things forbidden by God and responsible for tempting the first humans to sin.

The snake (traditionally represented as female) seduces Eve while, at the same moment, Adam reaches toward the tree and, of his own accord, plucks the forbidden fruit. Rather than woman being responsible for tempting the man, Adam is thus the agent of his own fall from grace. Michelangelo, a profoundly religious and subtle thinker, takes no comfort in the misogynist version of the story, which lays full blame on Eve. Instead, he offers us a more nuanced meditation on the nature of sin and temptation.

Just prior to the awful moment of the fall, Adam and Eve were closely entwined, recalling their creation from one flesh. Now in the loss of their innocence, that physical intimacy suggests a sexual embrace colored by sin. The pair is, as yet,

unaware of their new situation, but Michelangelo implicates the viewer, who, living long after the fall, has a nearly unlimited capacity for sinful thoughts, even imagining their prior embrace as fellatio. Turned toward Adam, Eve is one with his flesh; turned away, she separates and begins time's march to death. Her twisted pose and reaching gesture are echoed by the ominously dead branch framed against the sky. In the opposite scene, her youthful bloom and innocent body are transformed into the haggard and thickset frame of a woman who will suffer the pains of childbirth and aging. The terrified and fearful countenances of both Adam and Eve mark the advent of emotions, a vast unknown world that opened with the loss of their innocence.

As is typical of Michelangelo, invention invigorates a traditional Christian subject. But he always observes decorum, and his unorthodoxy is visible mainly to those who seek to better know their faith.

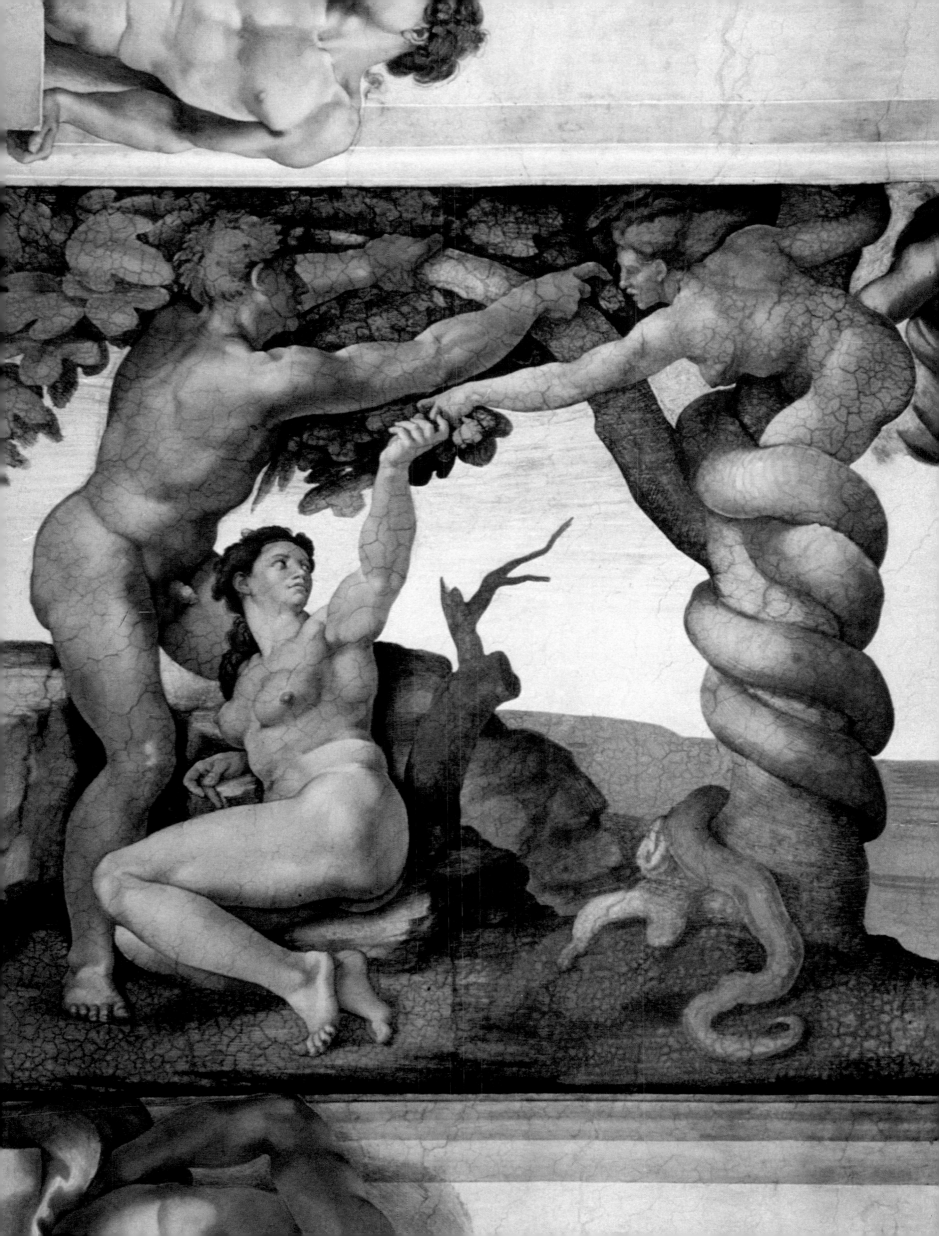

MICHELANGELO
(1475–1564)

Creation of Adam

1508–12

FRESCO
SISTINE CHAPEL, VATICAN CITY, ROME

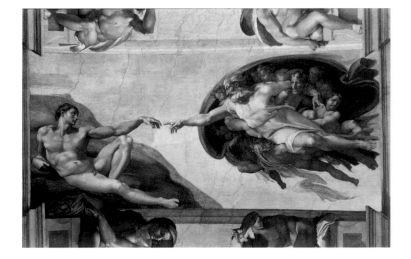

TOWARD the center of the Sistine ceiling is the famous scene of God creating Adam. Ostensibly, a simple composition that magnetically draws and holds our attention, the scene includes many more figures than the *Temptation and Expulsion*. We tend to recall a composition of only two, the first man and his creator, but in fact many others, including perhaps the yet-unborn Eve (or Virgin Mary), Christ child, and a host of angels, are enclosed in the great wavelike surge of God's mantle.

The astonishing energy of the Lord is in striking contrast to an indolent Adam. With inclined head set upon a muscular torso and body, he looks longingly toward his creator, who is about to invest his physically perfect creation with an animating soul. As the Bible explains, God fashioned Adam from a little mud, which is suggested by the dirty color (difficult to achieve in fresco) of the ground on which he reclines. Although landscape is not a principal vehicle of Michelangelo's pictorial vocabulary, he does employ it strategically, if sparingly. In superimposed colored bands, the ground turns from brown to verdant and, finally, a beautiful azure as one rises to heaven and, by suggestion, from the inanimate world to the living realm of air, God, and sky. The wind that blows the Creator's hair, thin drapery, and billowing cloak makes visible the animating spirit *(spiritus)* by which God breathed life into Adam.

As humans, we readily admire and identify with Adam while questioning less the unexpected pose and dress of God. A thin lilac shift barely covers his powerful body, and his pose mirrors that of Adam, who was created "in his own image." God's weight-less flight is assisted by a bevy of wingless and energetic angels, and his powerful arm and pointing finger contrast with the limp yet receptive hand of Adam. In the few centimeters that separate their fingertips is the greatest suspension of time and narrative in the history of art. That gesture is the visual focal point, with a

sparklike intensity, of the ceiling's entire decorative program, and the image is perhaps the most universally recognized and one of the most frequently imitated of all time.

The shape described by God's cloak has been interpreted by one physician as the cross-section of a human brain. Although the suggestion imposes modern science too literally upon artistic imagination, it does remind us that God is *nous*, infinite mind from whom all creation flows. Citing evidence of Michelangelo's early experience with dissection, other scholars have claimed discovery of further anatomical investigations. But it is well to remember what, where, and for whom Michelangelo was painting. This is not an anatomy theater but the pope's holy sanctuary and a powerful visualization of Christian faith.

As God created man, so has Michelangelo boldly invented God from his own imagination. Godlike, the artist forged the image of the deity for all western Christianity. Like Leonardo da Vinci's canonical image of the Last Supper, Michelangelo has given us the most potent and convincing representation of God and his creation.

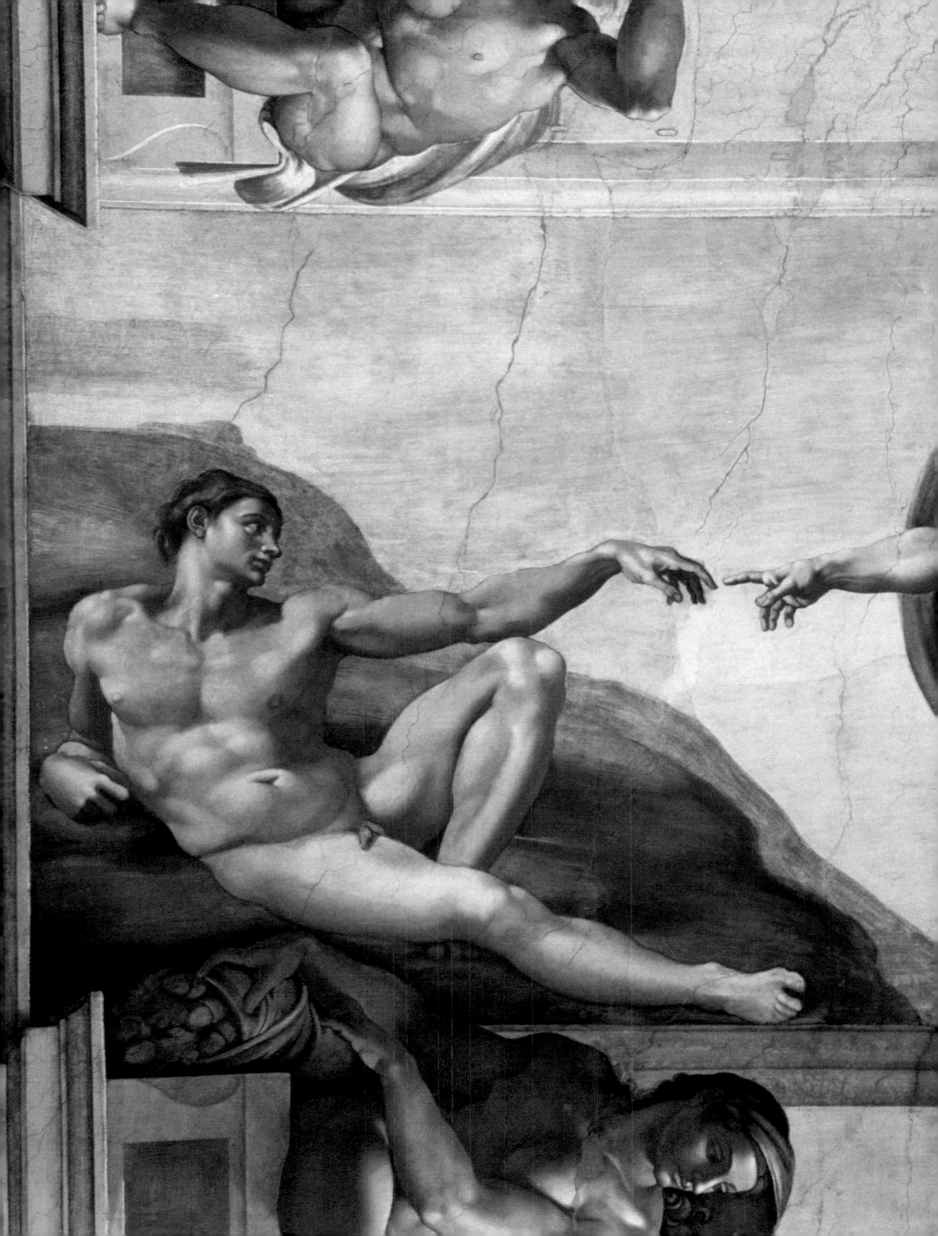

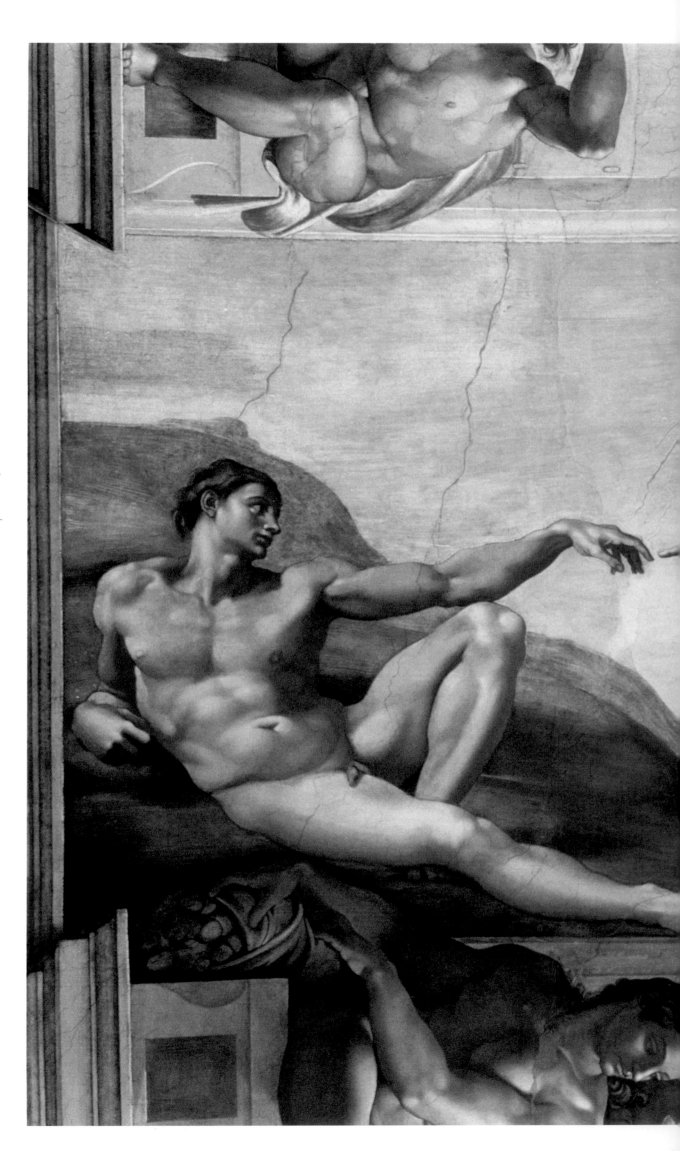

MICHELANGELO
Creation of Adam
1508–12
FRESCO
SISTINE CHAPEL, VATICAN CITY,
ROME

There is no more familiar image in
the world, yet we are still drawn to it,
like moths to a light. As God created
humanity in his own image, so has
Michelangelo—as a godlike creator—
fashioned the images of both man
and God. Never has the second
commandment—not to make any
likeness of God—been so obviously
and successfully contradicted.

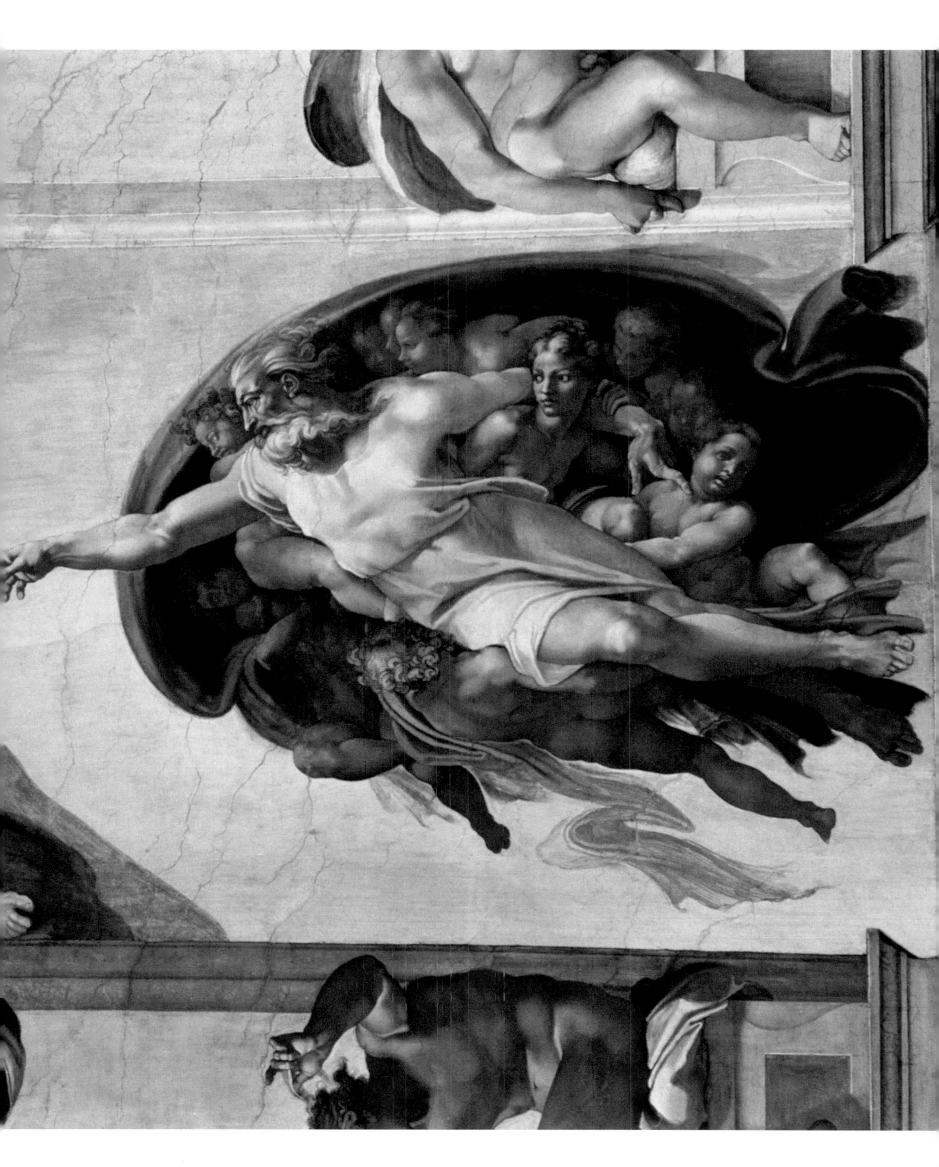

MICHELANGELO

(1475–1564)

Cumaean Sibyl

1508–12

FRESCO
SISTINE CHAPEL, VATICAN CITY, ROME

FLANKING THE Genesis narratives are seven Old Testament prophets and five sibyls, female priestesses and seers from pagan antiquity who were thought to have foretold the coming of a messiah. These large, alternating male and female figures are seated on broad marble thrones, and each is accompanied by two companions, or *genii*, who, like visible thoughts, assist the majestic prophets and sibyls in their scholarly labors of reading, writing, and cogitating. Here, Michelangelo gives full scope to his fecund imagination, inventing a race of beings superhuman in stature and full of prophetic wisdom.

Although less commonly celebrated, Michelangelo's sensitivity to female beauty is fully on view, as attested by the Erythraean and Delphic sibyls as well as some of the comely women (ancestors of Christ) who populate the lunettes. On the other hand, a figure such as the *Cumaean Sibyl* defies simple genders: a masculinized upper body contrasts with her lower half, where toes rest lightly and legs are pressed together in a demure, feminine-like manner that contradicts expectations raised by her massive frame. She is quite possibly the most awesome figure of the entire ceiling.

According to ancient mythology, the Cumaean sibyl was beloved by the god Apollo, who granted the comely maiden whatever she wished. She cunningly asked to live for as many years as the grains of sand in her hand, but failed to also request continuing good health and beauty. Thousands of years later, the sands of time reveal the inexorable effects of passing from youthful bloom to terrifying superannuation.

The giant's open mouth and craggy countenance carry us far beyond the world of polite society and ideal beauty. Her fearsome aspect is underscored by her mountainous shoulders, pendulous breasts, and an astonishingly long and powerful left arm. All contribute to her awful majesty and great antiquity: her age is not measured in years but millennia. As the famous critic John Ruskin wrote, she is "an ugly crone," despite being "the clearest and queenliest in prophecy." The aged priestess holds her heavy tome at arm's length, for she is farsighted, thus emphasizing that her sight is insight, full of spiritual illumination. This great pile of ancient flesh startles us into believing her prophetic utterances.

Cumae was Italy's earliest Greek colony, traditionally said to

have been founded in 750 BCE, on the coast near Naples. The oracular cavern of the sibyl, with its long entrance tunnel carved from natural tufa rock, still exists and continues to exert a strange and otherworldly fascination. One wonders if Michelangelo ever visited the famous site, the only sibylline oracle in Italy. Or was he inspired by the frequent mention of the famous sibyl in ancient literature, such as Virgil's *Aeneid* or *Fourth Eclogue*? Even if the artist never visited Cumae, he has brilliantly imagined a figure of awesome, albeit grotesque, majesty, and we can easily believe her to be the proper denizen of that mysterious place.

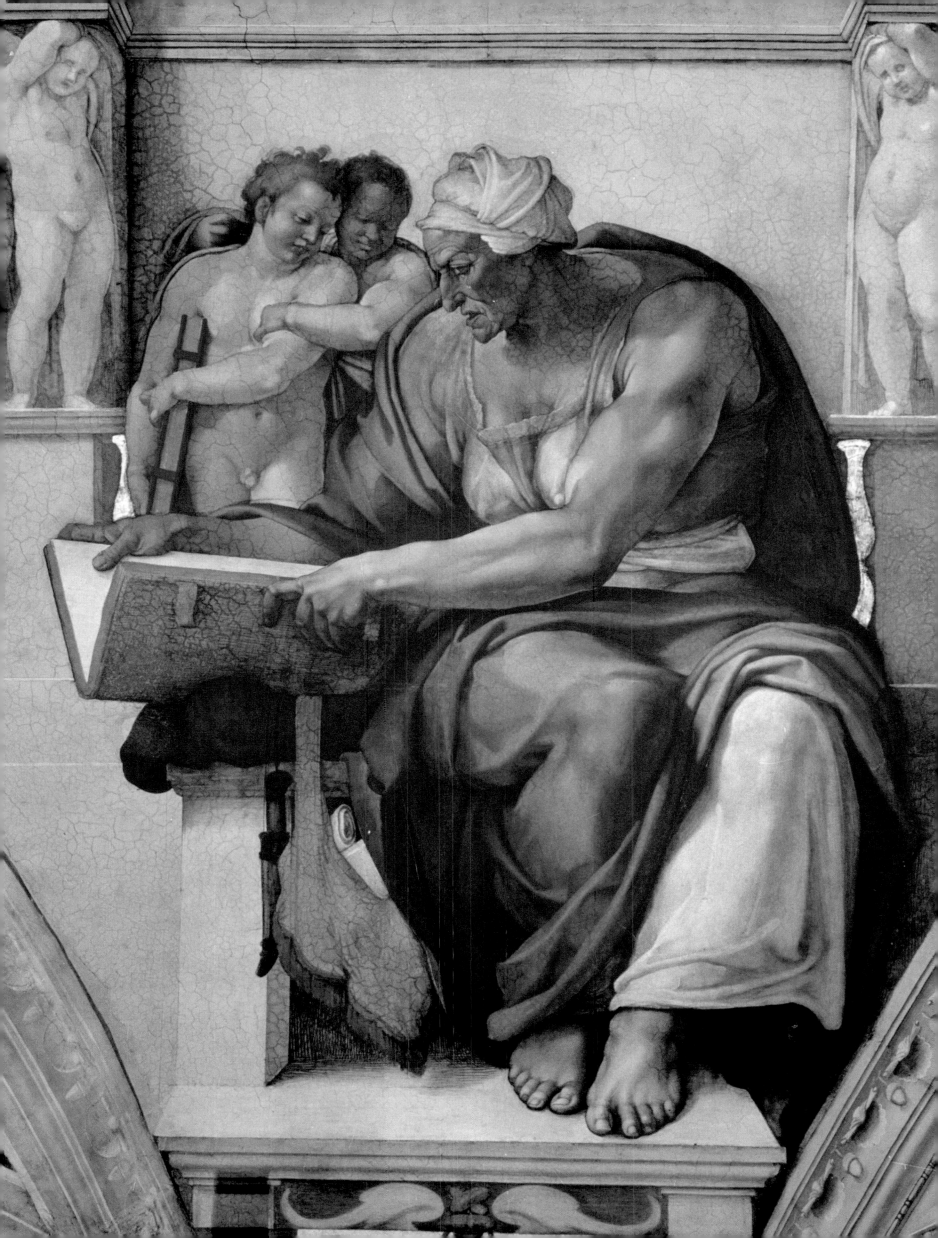

MICHELANGELO

(1475–1564)

Libyan Sibyl

1508–12

FRESCO
SISTINE CHAPEL, VATICAN CITY, ROME

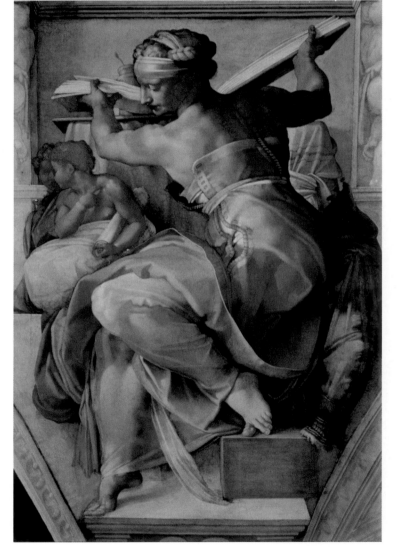

THE *Libyan Sibyl* is one of the largest and most beautiful of the five prophetic female figures. Michelangelo captures her amid an uncomfortable and perhaps impossible torsion as she either picks up or replaces the heavy tome that contains her sibylline prophecies. Giorgio Vasari describes her in the act of setting down and closing her weighty book, but more likely she is holding it up to God. Just above her, the deity has initiated Creation by separating light from dark. This great book receives the first light of God's invention and, by implication, is a direct recipient of divine wisdom and illumination. Thus does Michelangelo knit together pagan belief and Christian knowledge.

Like Moses on Sinai, the sibyl turns away demurely because she is not permitted to gaze upon the Creator, yet she is fully illumined by the divine effulgence. Opposite her, and in shadowed contrast, a brooding Jeremiah laments the destruction of Jerusalem. The figure has frequently been identified as a self-portrait of Michelangelo, and, of course, it inspired Auguste Rodin's *Thinker* centuries later.

On a preparatory drawing in red chalk for the *Libyan Sibyl*, Michelangelo studies the complex pose by drawing a male model whose well-articulated musculature has been transferred to the painted sibyl, a means of emphasizing her grandeur and dignity. The small sheet reveals the artist devoting himself to several problems, such as redrawing the head at the lower left to substitute a gentler, more feminine demeanor for the model's masculine features. He also redraws the left hand, which in the painting more convincingly supports the great weight of the sibyl's book. Even more surprising, he drew the left big toe three times, even though this tiny detail would be viewed from more than sixty feet below. Although it may seem insignificant, that single anatomical element is in fact the fulcrum around which the entire body pivots and is therefore critical to suggesting its imbalance.

All the sibyls and most of the prophets hold, read, write, or meditate upon volumes or scrolls—ancient wisdom preserved in a heavenly library. One of the more interesting and seemingly legible books is consulted by the Erythraean sibyl, who is just about to turn its pages. Her genius companion blows on the flames of a hanging lamp, thereby providing sufficient light for

us to discern a large and easily readable Q atop the left page. We are lured into believing we can discern a text, which in fact is composed of suggestive but illegible squiggles. In any case, we have no business prying into the secret knowledge contained within a sibylline book, for such arcane material requires the interpretative powers of the priestess. We are left with just the capital Q, the first letter of many Latin interrogatives: *quis, qui, quid, quo*. These questions *are* our business, the very queries we are expected to pose to a sibyl: who, what, why, where? The flaming lamp is truth and illumination, the sibyl is utterance and interpretation, we are the humble supplicants asking, "*Qu . . . ?*"

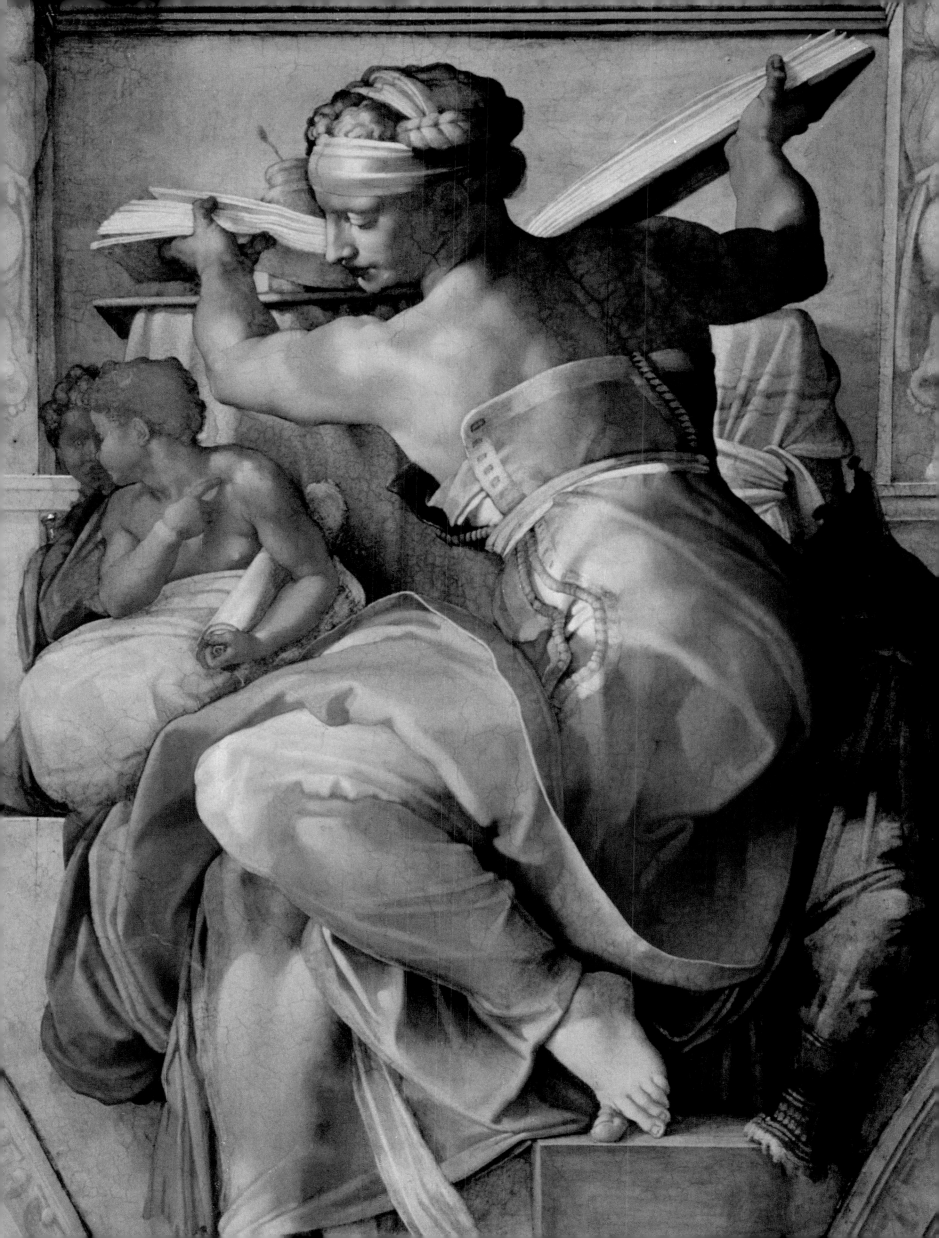

MICHELANGELO

(1475–1564)

Moses

CA. 1513–16

MARBLE
92 ½ IN. (235 CM)
TOMB OF JULIUS II, SAN PIETRO IN VINCOLI, ROME

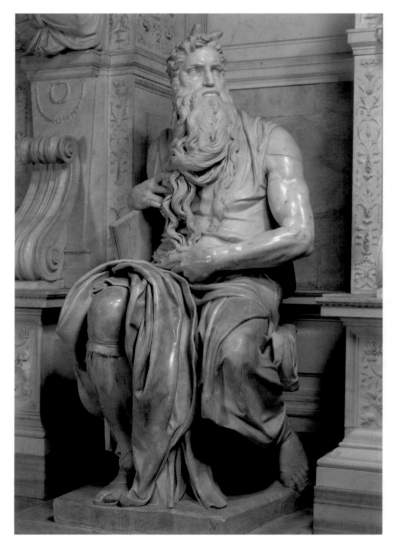

IN A FAMOUS essay on Michelangelo's *Moses*, Sigmund Freud imagined the prophet, angry at the faithless Israelites, restraining himself from rising and hurling the tablets inscribed with the commandments to the ground. Even now the heavy stone slabs seem to be slipping from the prophet's grasp.

Whether we perceive the same implied narrative as Freud, the famous psychoanalyst did attempt to describe what is true of many of Michelangelo's marble sculptures: they have an air of expectancy that endows them with life and movement. Standing before the *Moses*, few observers are concerned that the prophet will leap to his feet; on the other hand, everyone tacitly acknowledges that a palpable vitality and spiritual intensity radiate from this figure. Perhaps the word used by Michelangelo's contemporaries to describe him—*terribilità*, or terribleness—is an apt description of *Moses* as well. The artist has successfully evoked the awesome aspect of the most fearsome prophet in the Old Testament.

Even seated, Moses is taller than a standing person, an immensity that is both real and implied. His powerful gaze is directed slightly upward, as though toward God. Michelangelo has imagined a face that, having beheld divinity, is more than human and thus not for mere mortals to gaze upon. The horns (stand-ins for the beams of light that emanated from Moses as he descended from Mt. Sinai), tempestuous hair, and rippling facial muscles further emphasize the transfiguring force of the prophet's expression. Thick strands of the weighty beard are pulled to one side by the exaggeratedly long fingers of the right hand, an unconscious gesture of peculiar power.

Michelangelo conceived *Moses* as one of four seated prophets intended to adorn the second-story corners of the tomb monument dedicated to Pope Julius II. Taking into account this elevated location, Michelangelo gave Moses an elongated torso whose disproportionate length is evident mainly from the side. Most visitors scarcely note the anatomical distortion, for it is disguised by the enormously powerful arms and extravagant, cascading beard. In the final version of the tomb, Moses was situated prominently at the lower center, the way we see him today. So important is he to the overall effect of the ensemble that many visitors pay little heed to its other interesting elements, among them the reclining effigy of the pope (seen at approximately the height originally intended for Moses), the tapered pistonlike piers, the efflorescence of grotesque decoration, and the curiously anthropomorphic coat of arms.

Vasari tells us that, every Sabbath, the Jews of Rome went to see the *Moses* "like flocks of starlings." As tourists, many of us still flock to San Pietro in Vincoli, surely not to see Pope Julius II but to stand in awe before the Old Testament prophet. Rarely has the countermanding of the second commandment resulted in such a forceful image of faith.

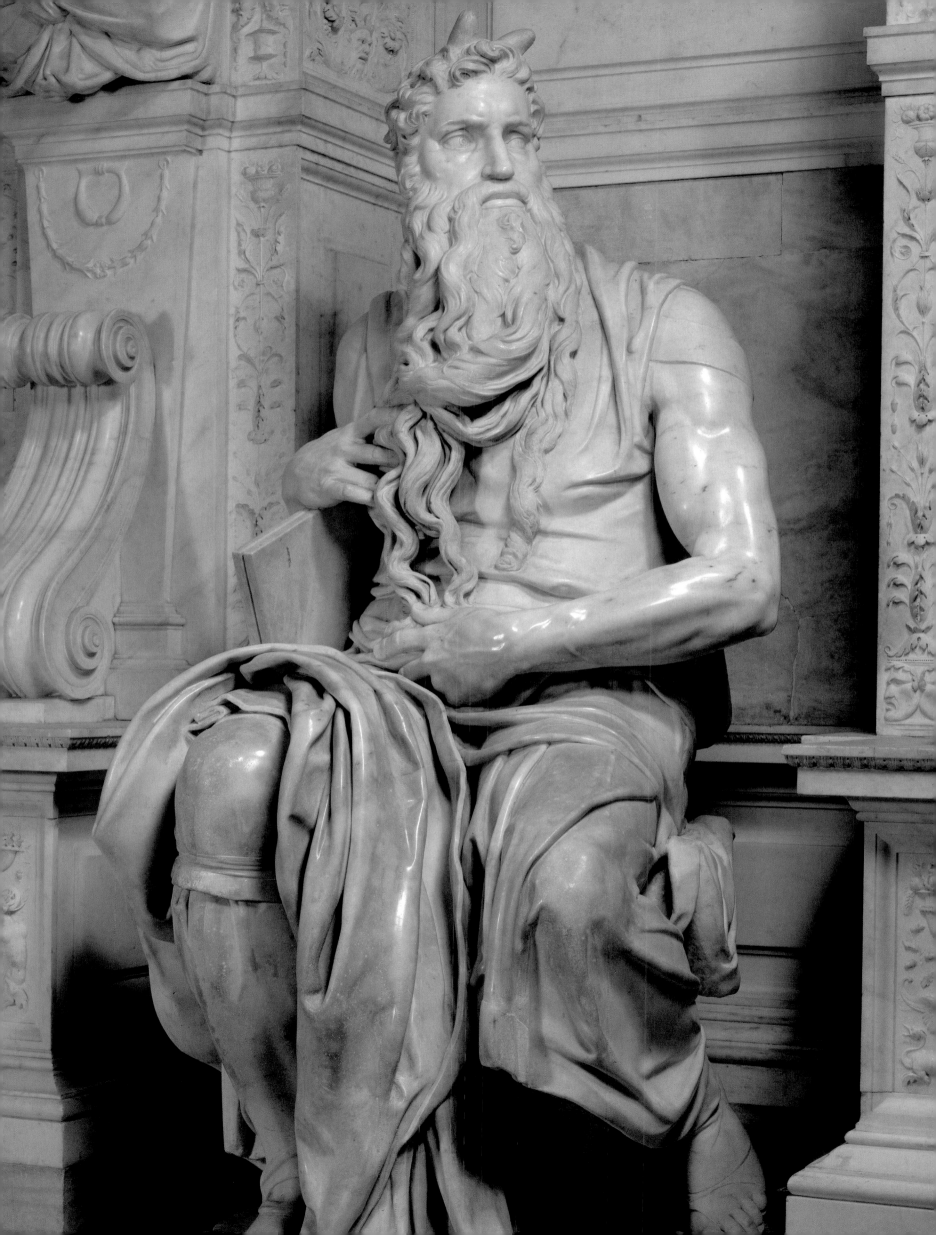

MICHELANGELO
Lower Portion,
Tomb of Julius II
1505–45
MARBLE
SAN PIETRO IN VINCOLI, ROME

It took 40 years for Michelangelo
to complete the pope's tomb. But to
look upon it—one of the largest
and most magnificent tombs of the
Renaissance—as a "tragedy" or
a disappointing compromise is to
overlook its success. Few other
monuments have as many
admiring visitors.

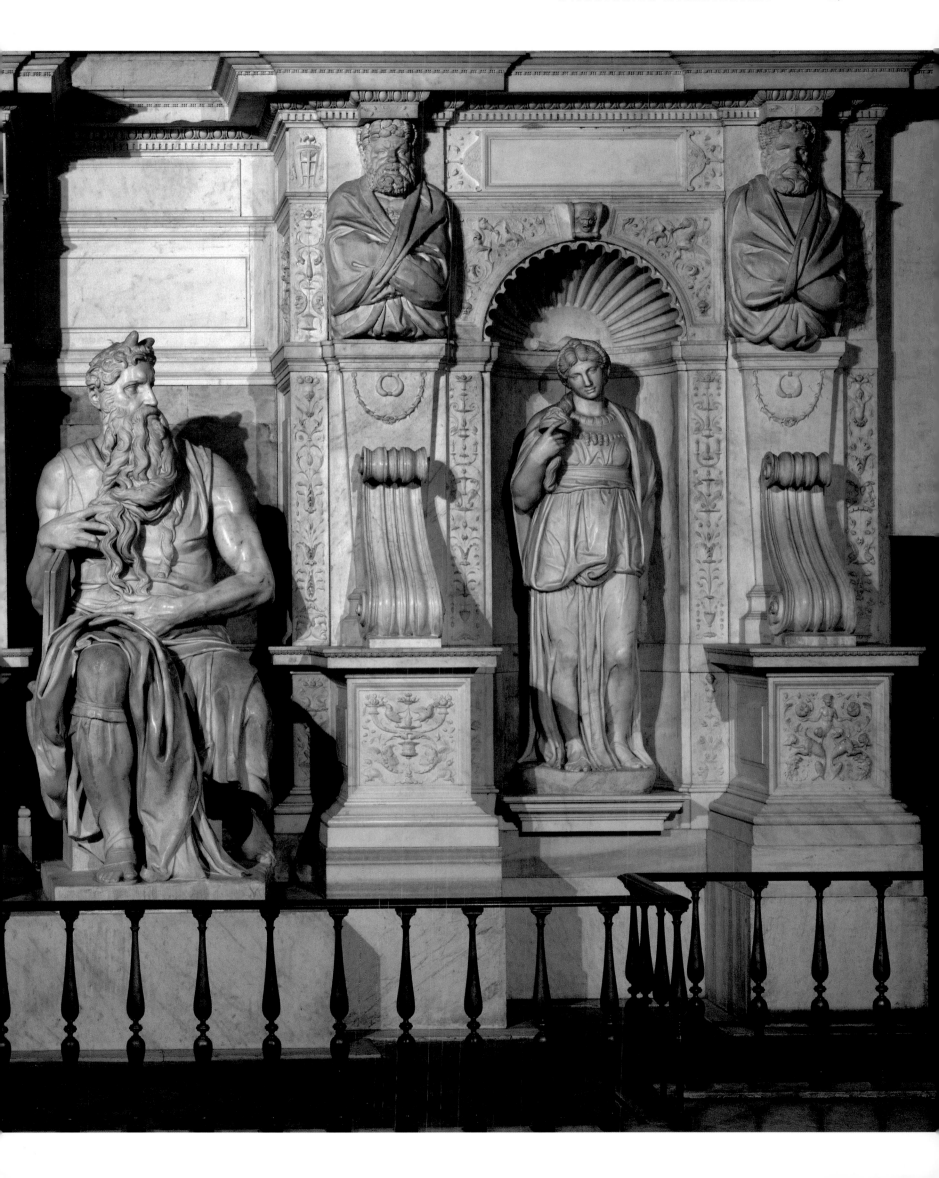

MICHELANGELO

(1475–1564)

Rebellious Slave

CA. 1513–16

MARBLE
HEIGHT: 84 ½ IN. (215 CM)
THE LOUVRE, PARIS

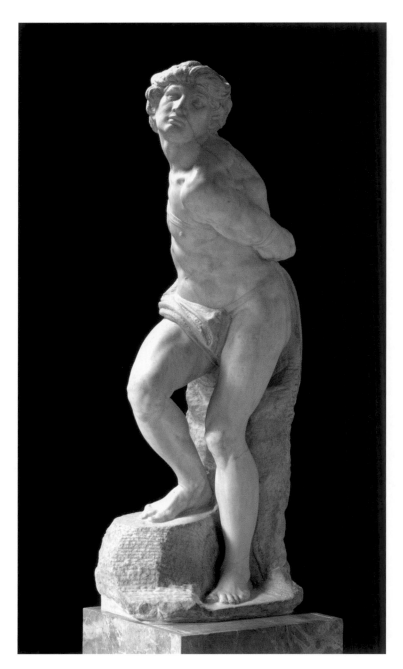

AS PART OF the original conception for the tomb of Pope Julius II, Michelangelo was to carve forty larger-than-life sculptures in marble. It is characteristic of the artist to begin with some of the less important elements, as though he wished to work his way slowly toward the more difficult tasks. It is also typical that he would create masterpieces of these minor figures while never completing the ensemble. No matter how we think about the so-called *Rebellious Slave* and *Dying Slave*, the two figures were intended to be only a small part of a lavish whole.

Michelangelo's intention for including slaves or prisoners (*prigioni*) in the pontiff's tomb is uncertain. Vasari writes that they are "captives meant to represent all the provinces subjugated by the Pope and made obedient to the Apostolic Church." The biographer Ascanio Condivi, with greater subtlety and probably more accuracy, states that they represent the liberal arts, which, like the defunct Julius, were prisoners of death. Although we admire and discuss them independently, the sculptures were likely carved simultaneously. It is possible that Michelangelo imagined them as a contrasting pair, although the lack of context and the modern titles heighten their duality.

The *Rebellious Slave* reveals a similar torsion as the rotating figure of *St. Matthew*, but a more forceful one that turns in the opposite direction. Unlike that earlier statue, whose animated *contrapposto* helps express a state of religious inspiration, here the body is subject to physical restraint. A cloth strap crosses the chest and tightly binds the left arm, causing the muscles to bulge. The implied discomfort is little revealed in the figure's face, which is turned heavenward as if appealing to God. The thick neck and rippling muscles of the torso and shoulders would normally suggest volcanic energy, but the statue embodies little movement. Michelangelo has created a paradoxical state of struggle and stasis.

Running through the sculpture's face, neck, and left shoulder is a disfiguring black vein. Despite his knowledge of stone, Michelangelo could never be certain that a marble was without flaws or impurities. Trying to avoid the defacement, he sculpted the head as if it were tossed back, but the thin block refused to allow him to escape the blemish. Similarly, it seems that he ran out of material when carving the right arm, which explains why that side appears so flat and why most photographs favor views from the opposite angle.

Never having joined the tomb, the *Rebellious Slave* and its companion, the *Dying Slave*, became orphans (they are now in the Louvre). It is testament to the power of Michelangelo's art that such figures, separated from their original purpose and destination, unfinished and lacking easily recognizable subject or iconography, were accepted and admired as independent sculptures. They are simply "works of art" by Michelangelo, a new aesthetic category.

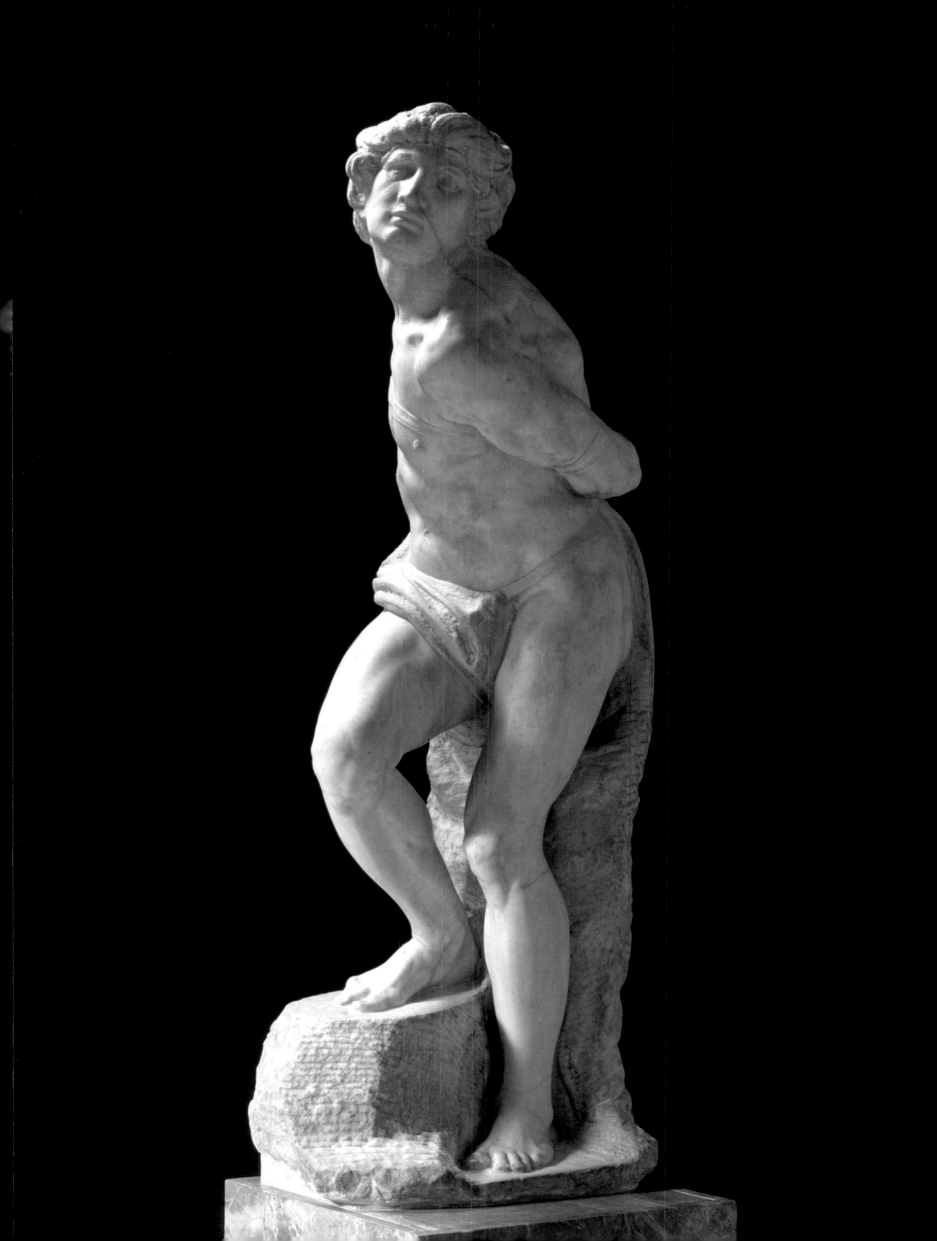

MICHELANGELO
(1475–1564)

Dying Slave
CA. 1513–16

MARBLE
HEIGHT: 90 IN. (229 CM)
THE LOUVRE, PARIS

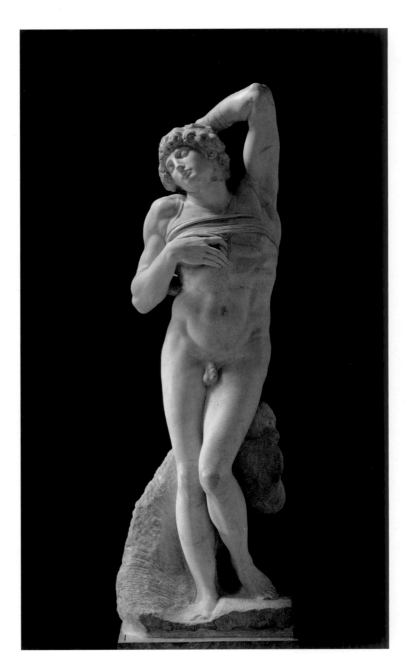

GIVEN ITS languorous and sensuous air, the so-called *Dying Slave* is significantly misnamed. If only dying were such a combination of semi-sleep and relaxed sensuality! The figure rests on its right leg, but without its marble support (a strangely amorphous shape) it surely would not stand: most of the weight is, or appears to be, well to the right of the block's center line. Michelangelo has created the semblance of a reclining body in a vertical position. The sculpture is replete with such paradoxes: the amount of limb movement in contrast to the state of semi-oblivion; the muscular male in a sensual body; and the creation, pygmalion-like, of an erotic fleshy human from hard stone. The indeterminacies extend even to the gender of the figure, which has an almost hermaphroditic quality. The bent left leg demurely crosses but does not cover the genitalia. We are forever noting Michelangelo's masculinization of the female form, but here is an instance of the reverse.

Particularly beautiful is the contrast of raised left and lowered right arms, creating a tilted lozenge shape bisected by the diagonal of the head. The separated index finger of the nearly limp right hand inserts itself gently in a loose fold of the inexplicable cloth band that confuses the state of being nude or naked, bound or unbound. In contrast to earlier figures, the individual curls of hair are not sharply differentiated; rather, the rough mass tends to accentuate the smooth skin and incised facial features. Just behind the thigh is what appears to be a roughly carved head of a monkey: as simians imitate humans, so art apes nature.

As one circles the figure, the spiraling composition rotates in slow motion. As with *David*, *Risen Christ*, or *Moses*, we are made forcefully aware of Michelangelo's remarkable ability to create complicated artistic compositions even from single figures … and how those figures gain life through our movement.

During the pestilent Roman summer of 1544, Michelangelo fell dangerously ill. He was cared for in the palace of the prominent Florentine exile Roberto Strozzi. Shortly after recovering, Michelangelo presented Strozzi with the two unfinished *Slaves*, an astonishing gift, especially since the larger-than-life-size nudes could not be easily moved or displayed. But the marbles, originally destined for the tomb of Pope Julius II, technically belonged to the Della Rovere heirs. Clearly, this unusual and potentially awkward donation was much more than mere thanks for helping the artist during an illness. Michelangelo intended Strozzi to present them to the French king François I, which is how they traveled to France and eventually entered the collection of the Louvre. Two sculptures with a long history: slaves for a tomb become pawns of international diplomacy and ultimately join a list—along with the *Venus de Milo* and the *Mona Lisa*—of must-see tourist icons in the Paris museum.

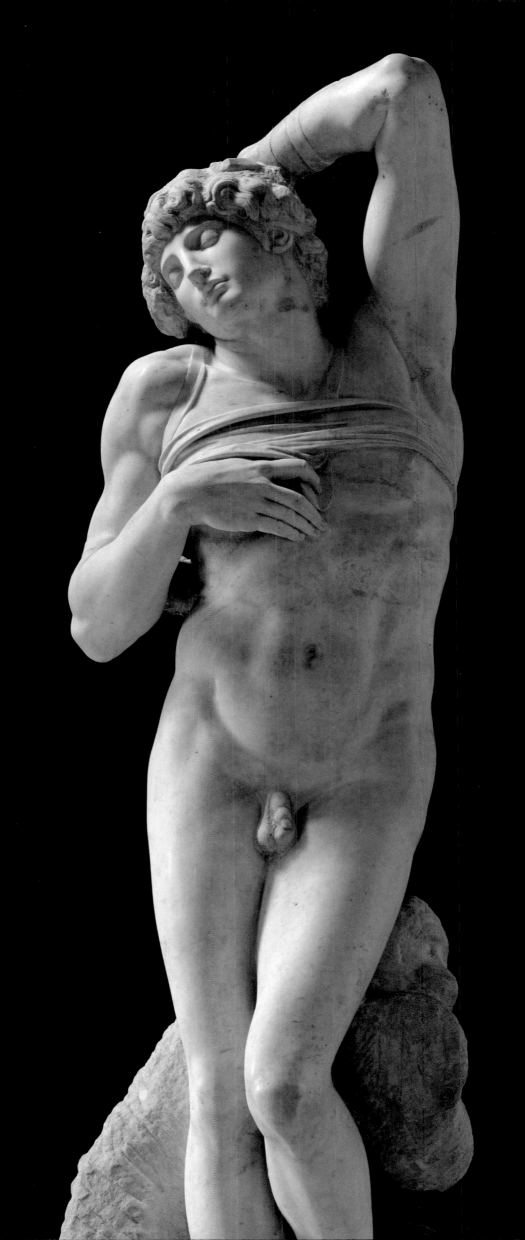

MICHELANGELO

(1475–1564)

"Atlas" or "Blockhead" Slave

CA. 1520–30

MARBLE
HEIGHT 109 IN. (277 CM)
ACCADEMIA GALLERY, FLORENCE

OVER THE YEARS, Michelangelo learned an important lesson. For the earlier *Slaves* (now in the Louvre), he had quarried blocks only as large as the figures. Without extra stone, he sometimes found little or no room to maneuver, especially when he encountered impurities in the marble, as happened with the *Rebellious Slave*. This time, however, he ordered blocks substantially thicker than he needed, virtually guaranteeing enough material should he meet with a flaw. For example, toward the back of the *"Atlas"* or *"Blockhead" Slave*, just where the figure's buttocks would be, is a small triangular excavation, probably an indication of the sculptor cutting out defective or discolored stone.

With excess marble sheathing both statues, we sense the unfinished figures "emerging" from their blocks. For this reason, the four *Slaves* or *Captives* currently in the Accademia Gallery are, for many visitors, their favorite works by Michelangelo. By a sort of poetic extension inspired by the artist's own poetry, we imagine the soul yearning to free itself from its earthly prison. Such descriptions are compelling and infinitely more suggestive than the banal explanation that Michelangelo may simply have abandoned the sculptures upon leaving Florence in 1534.

On the other hand, certain details give us pause and force us to consider whether Michelangelo also responded positively to their unfinished condition. On the right side of the *"Blockhead" Slave*, for example, he left intact a large projecting slab. He has excavated a deep crevice *between* the figure and this remnant from the original quarried block, even adorning the V-like channel with a line of drill holes and neatly parallel chisel marks. Why? If he had intended to carve the figure in the round, it would have been logical and much easier to remove this excess stone. Did the sculptor—like most visitors today—appreciate the contrasting surfaces and the metamorphosis of marble into living flesh that appears to take place before our eyes?

Even the two most "finished" figures, the *"Young" Slave* and *"Bearded" Slave*, are largely *un*finished, at least according to prevailing Renaissance taste. Perhaps Michelangelo was forging a new aesthetic, experimenting with the expressive possibilities of the *non-finito*. He may have discovered that it is sometimes possible to say more with less, through suggestion rather than definition.

When Michelangelo left Florence in 1534, the four *Slaves* were still in his studio. The statues were widely admired and, remarkably, left in their incomplete state; no artist dared to "finish" them. Instead, the Florentine sculptor and architect Bernardo Buontalenti created a suggestive setting for them, an artificial grotto in the Boboli Gardens of the Pitti Palace, where copies of the originals now appear to be emerging from the natural rock. Thus, the four unfinished orphans from the tomb of Julius II became a central feature of a finished work of horticultural art.

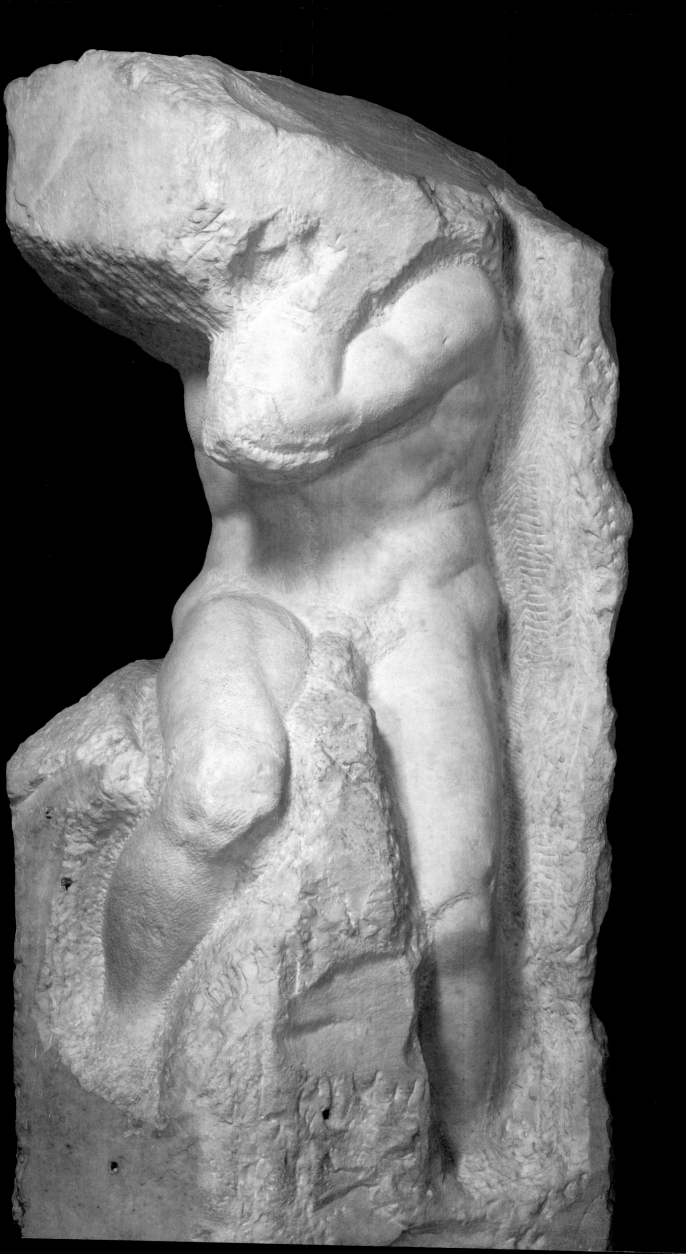

(LEFT)
MICHELANGELO
"Atlas" or "Blockhead" Slave
CA. 1520–30
MARBLE
HEIGHT: 109 IN. (277 CM)
ACCADEMIA GALLERY, FLORENCE

(RIGHT)
MICHELANGELO
"Young" Slave
CA. 1520–30
MARBLE
HEIGHT: 100 ¾ IN. (256 CM)
ACCADEMIA GALLERY, FLORENCE

While visitors pay homage to
David, they often come away from
the Accademia Gallery having
been more interested and moved
by Michelangelo's unfinished
sculptures. With good reason. So
powerful and suggestive are these
figures that no subsequent artist
dared finish, much less touch them.
We see them still "in process":
emerging from their blocks,
struggling to free themselves
from their stone prisons.

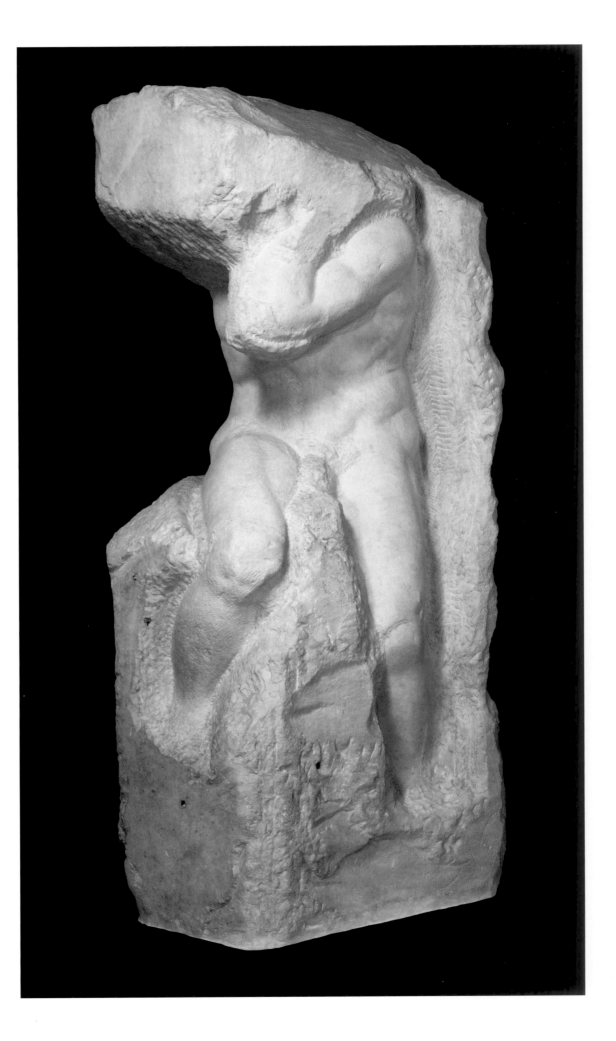

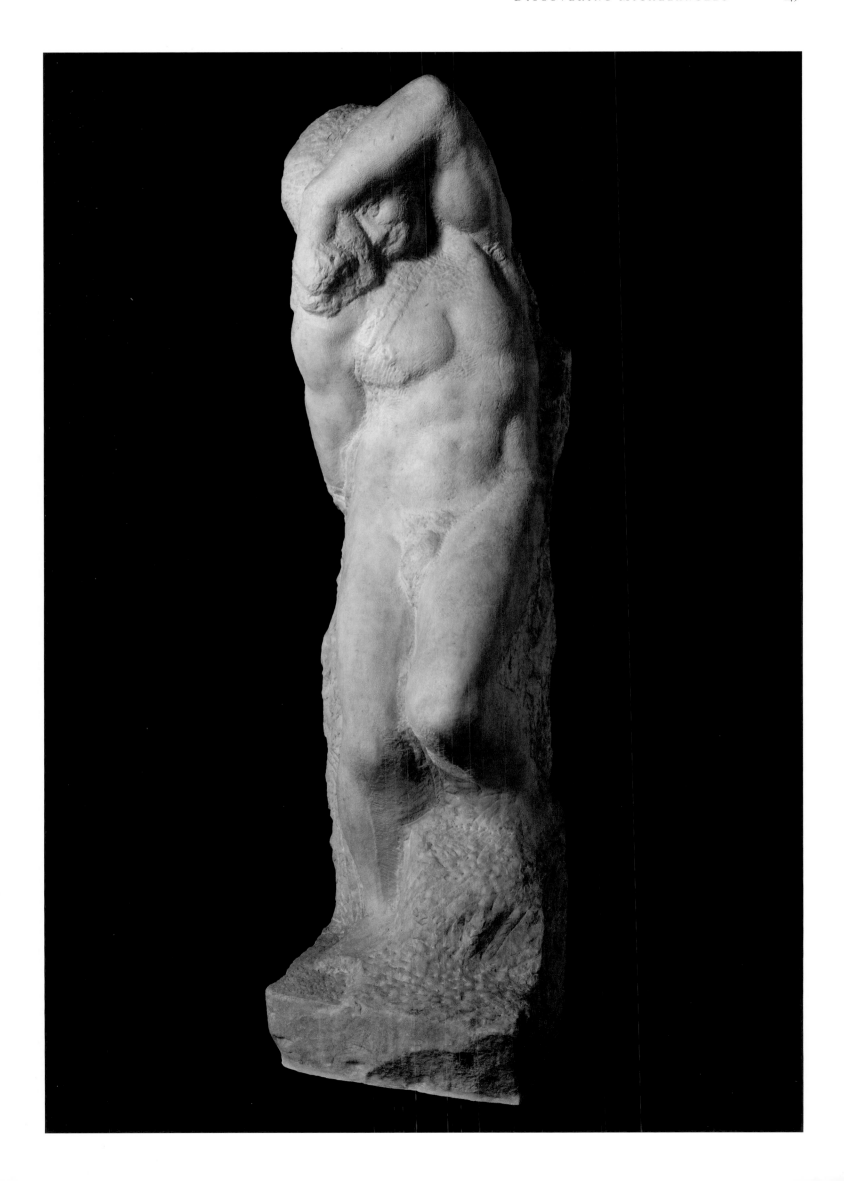

MICHELANGELO

(1475–1564)

Risen Christ

CA. 1519–20

MARBLE
80 ¾ IN. (205 CM)
STA. MARIA SOPRA MINERVA, ROME

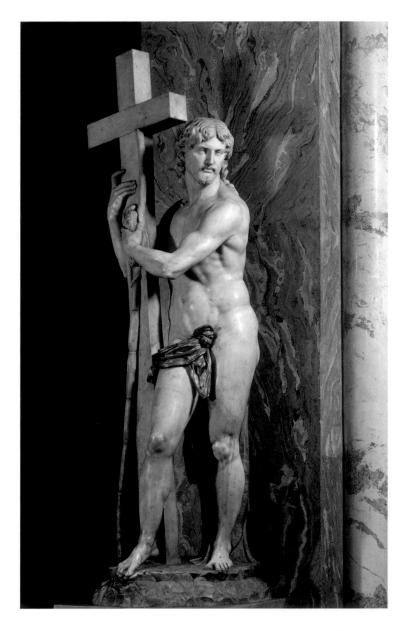

FOR THE church of Santa Maria sopra Minerva in Rome, Michelangelo carved a marble version of the resurrected Christ. The commission, which called for a "life-size nude figure," offered him the opportunity to represent the Christian divinity in the language of classical antiquity. For many viewers, the figure's stark frontal nudity elicits feelings of ambivalence; such audacious nakedness seems more appropriate for a pagan statue than a Christian one. In fact, throughout most of its history, the statue has been covered by a variety of raiments, ranging from a dainty wisp of drapery to a flamboyantly Baroque loincloth.

Many critics of the *Risen Christ* direct attention to its alarming proportions: a weighty torso and excessively broad hips rise above a pair of peculiarly tapered and spindly legs. Particularly displeasing is the side or rear view, which shows the buttocks. To judge Christ by his posterior is a serious infraction of decorum. Not only is the view inappropriate, it was also unavailable to its original audience. In contrast to many of Michelangelo's sculptures, the *Risen Christ* was conceived and carved to be placed in a niche. It seems that the artist, fully aware of the intended setting, sacrificed the back view in order to render convincingly the slender proportions and refined, dancelike pose seen from the front.

It is a self-evident point, but one rarely made, that the appearance of the sculpture subtly but significantly changes, depending on the viewing angle. When seen from the left, Christ no longer appears as an unpleasantly thickset figure with monumental posterior. Rather, his proportions are more slender, and his body merges with the cross in a graceful and harmonious composition.

The turn of the body and averted face are an eloquent and poignant means of rendering Christ inaccessible even as his corporeal reality is made manifest. We are encouraged to regard not the Son of Man's face but the instruments of his Passion. With his powerful but graceful hands, Christ cradles the cross, and the separated index finger directs our attention first to the cross and then heavenward. Behind him, the cloth that wrapped his dead body in the tomb is seen slipping to earth. In this suspended instant just prior to his ascension, Christ is completely and properly nude.

We should imagine how the figure appeared originally: from within a darkened niche, Christ steps forth as though emerging out of a sepulcher and the shadow of death. Foremost are the symbols of the Passion, the relics that he will leave behind upon ascending into heaven. For centuries, the faithful have stroked and kissed the advanced foot of Christ, for, like Mary Magdalene and the Doubting Thomas, they impulsively wish to verify the apparition before it disappears.

To carve a life-size marble statue of a naked Christ was certainly audacious, but it was also iconographically and theologically appropriate. Despite the generally low estimation of the figure by modern audiences, Michelangelo's contemporaries recognized the *Risen Christ* as a moving and profoundly beautiful sculpture that is truthful to sacred history as well as to decorum.

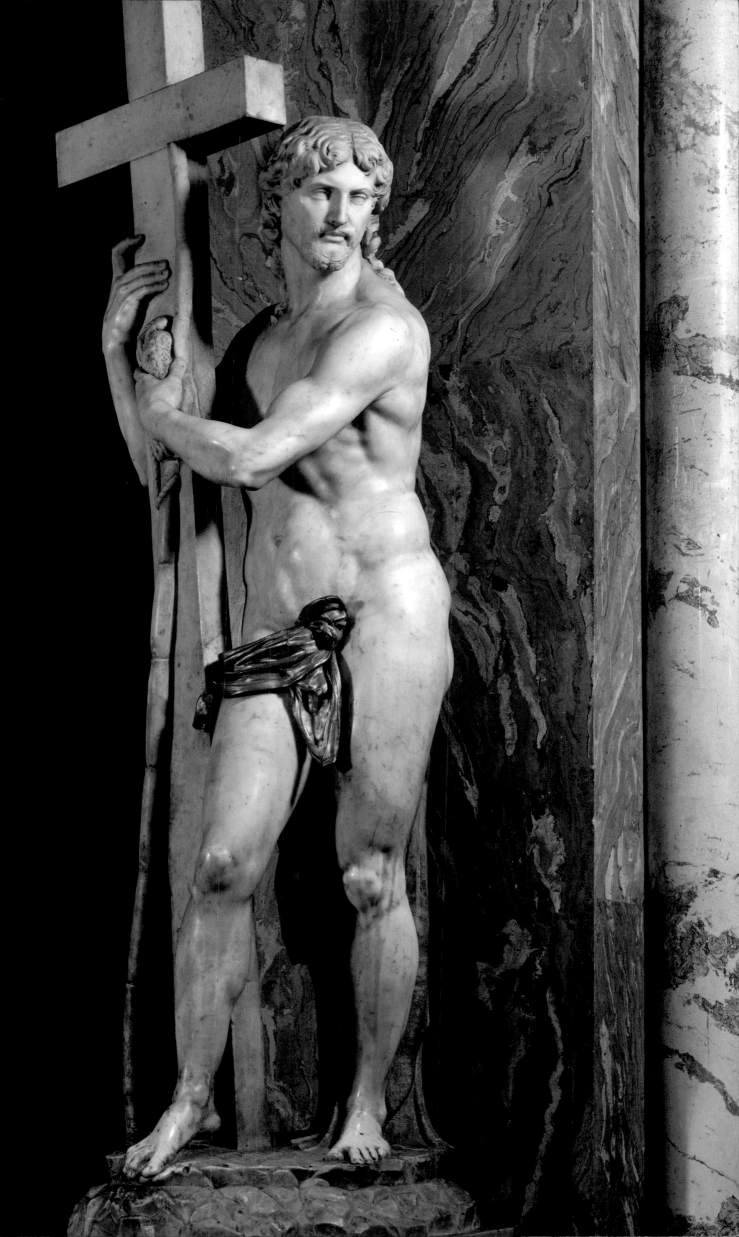

MICHELANGELO
(1475–1564)

Drawing of Quarried Blocks

1517

PEN AND INK ON PAPER
12 ½ X 8 ½ IN. (314 X 218 MM)
CASA BUONARROTI, FLORENCE

I N 1516, at age forty-one, when men of the time usually
contemplated the final phase of their lives, Michelangelo
began a career as an architect, undertaking one of his most
ambitious projects: the construction of an all-marble facade for
the Medici church at San Lorenzo. He imagined the facade as "the
mirror of architecture and sculpture of all Italy," in other words, a
building that would reflect and rival the greatest monuments of
antiquity. A supremely self-confident Michelangelo set out "to
domesticate the mountains" and fashion what he imagined would
be his greatest work of art. His fervid ambition was shared by his
contemporaries, by the patrons willing to underwrite the project's
extravagant cost, and by Florentines who watched with excited
wonder as the first marble blocks arrived from distant quarries.

Quarrying is a conservative, labor-intensive craft that has
changed little in four thousand years, from pharaonic Egypt to
the introduction in the nineteenth century of explosives and the
helicoidal wire saw. Also unchanged are the dangers and expense:
transport fees are approximately ten times the cost of quarrying.
Michelangelo was extremely particular about the quality of his
materials, especially marble. He gained his knowledge from long
experience and many disappointments; he could spot disfiguring
veins, and he could assess the soundness of a block from a few
hammer blows.

Once a block was quarried in Carrara, it had to be brought
down the mountain in a process called *lizzatura*. Blocks were
lashed onto rudimentary wood sledges *(lizza)* equipped with skids
that slid over wood cross-pieces *(parati)* and down precipitous
slopes littered with debris. Square holes were cut into the rock
approximately every thirty feet (ten meters) for the insertion of
hardwood posts *(pirri)*, around which ropes were wound to control
the dangerous descent. Accidents were common, resulting in loss
of life if ropes slipped or tackle broke, as happened several times
to Michelangelo. The nearly hundred-mile (150-kilometer)
journey—from quarry face to valley floor by sledge, to seaside by
oxcart, to Pisa by ship, up the Arno River to Signa by barge, and
to Florence by oxcart—was a complicated logistical operation
bedeviled by a multitude of problems. To obtain a single block
without mishap was expensive and time-consuming; to obtain
marble for an entire facade might well have seemed impossible.

The whole journey, from marble quarry to Florentine
workshop, could take anywhere from two months to a year.
Because it would be many weeks before Michelangelo saw the
marble delivered, he made measured, stereometric drawings
of every quarried block. This sheet comes from a notebook
(quaderno) of fifteen folios containing drawings of seventy
blocks. He accurately drew each one in three dimensions and
noted precise measurements, even recording chipped edges
and irregularities of shape.

Michelangelo was a glutton for marble. Having devoted
enormous energy and nearly three years to quarrying and
transporting the precious material for the facade, he was bitterly
disappointed when Pope Leo X canceled the project in 1520.
The valuable marble, however, did not go to waste: much of it
was subsequently used in the Medici Chapel.

MICHELANGELO
(1475–1564)

Tomb of Giuliano

1519–34

MARBLE
HEIGHT: 20 FT. 7 IN. (6.3 M)
MEDICI CHAPEL, BASILICA OF SAN LORENZO, FLORENCE

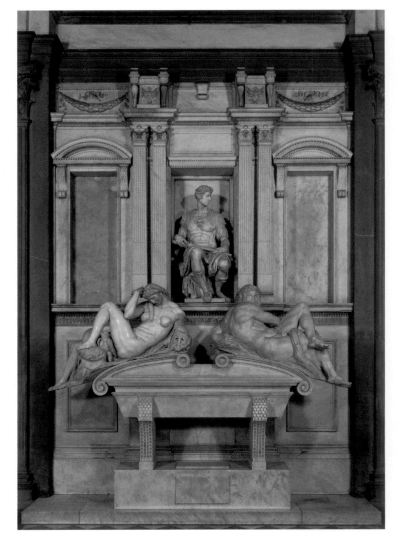

THE MEDICI CHAPEL, or New Sacristy, is the resting place of four members of that illustrious family: Lorenzo the Magnificent and his murdered brother Giuliano, as well as their eponymous descendants, Lorenzo, Duke of Urbino, and Giuliano, Duke of Nemours. The elder "Magnifici" were interred together in the never-completed double tomb; the younger dukes are commemorated by the two tombs that are today the primary decoration in the chapel.

The Medici Chapel was the first realization of Michelangelo's longstanding ambition to combine architecture, painting, and sculpture. Although the painting campaign was aborted and the sculpture is only a fraction of what was initially intended, the satisfying ensemble is still one of the artist's great masterpieces. He fashioned a lavish environment in which marble monuments project from the walls, and the figures adorning them appear to slip from their supports. The two dukes are seated in shallow niches above the sarcophagi that contain their remains. When criticized for not creating more recognizable likenesses, Michelangelo responded that in a thousand years no one would remember their appearance. Just five hundred years later we recall the princes primarily from these invented portraits. It is common to see them not in terms of individual historical personalities but as allegories, a Miltonian pair: "*l'Allegro*" and "*il Penseroso*."

Four nude allegorical figures recline on the curved lids of the sarcophagi. Traditionally, the pairs represent Day and Night and Dawn and Dusk, a sort of figural meditation on time. Rather than relying on attributes (which identify only Night), Michelangelo employed body language and different degrees of finish and polish to suggest their identities.

Day is the most muscular and impossibly contorted of the four. Like the sun rising behind a promontory, his haunting visage looks over his massive right shoulder. The purposefully unfinished head is a means to suggest in stone the indeterminacies of light, the ambiguity of time. A similar use of the unfinished (*non-finito*) is exploited in the head of Dusk, whose rough-cut facial features contrast with the polished surfaces of the body. The smooth limbs of Dawn slide glacierlike down the curved surface of the sarcophagus, while the lifting of her veil suggests inchoate light emerging from under the cloak of darkness. The vacant eyes under arched brows and open but equally vacant mouth leave us suspended between emotions, somewhere between silence and speech, like dawn itself, between dark and light.

As any visitor to the chapel will confirm, the four allegories dominate our attention. It is testimony to the power of Michelangelo's conception that we sense a complete and satisfying work of art even from such fragments of the artist's initial conception. Despite the chapel's unfinished state, Michelangelo created a structure that both honors the dead and speaks eloquently of the political ambitions and dynastic claims of the Medici. His transcendent art ensured their immortality. At the same time, the chapel moves us to more universal reflection on the transience of earthly life and fame.

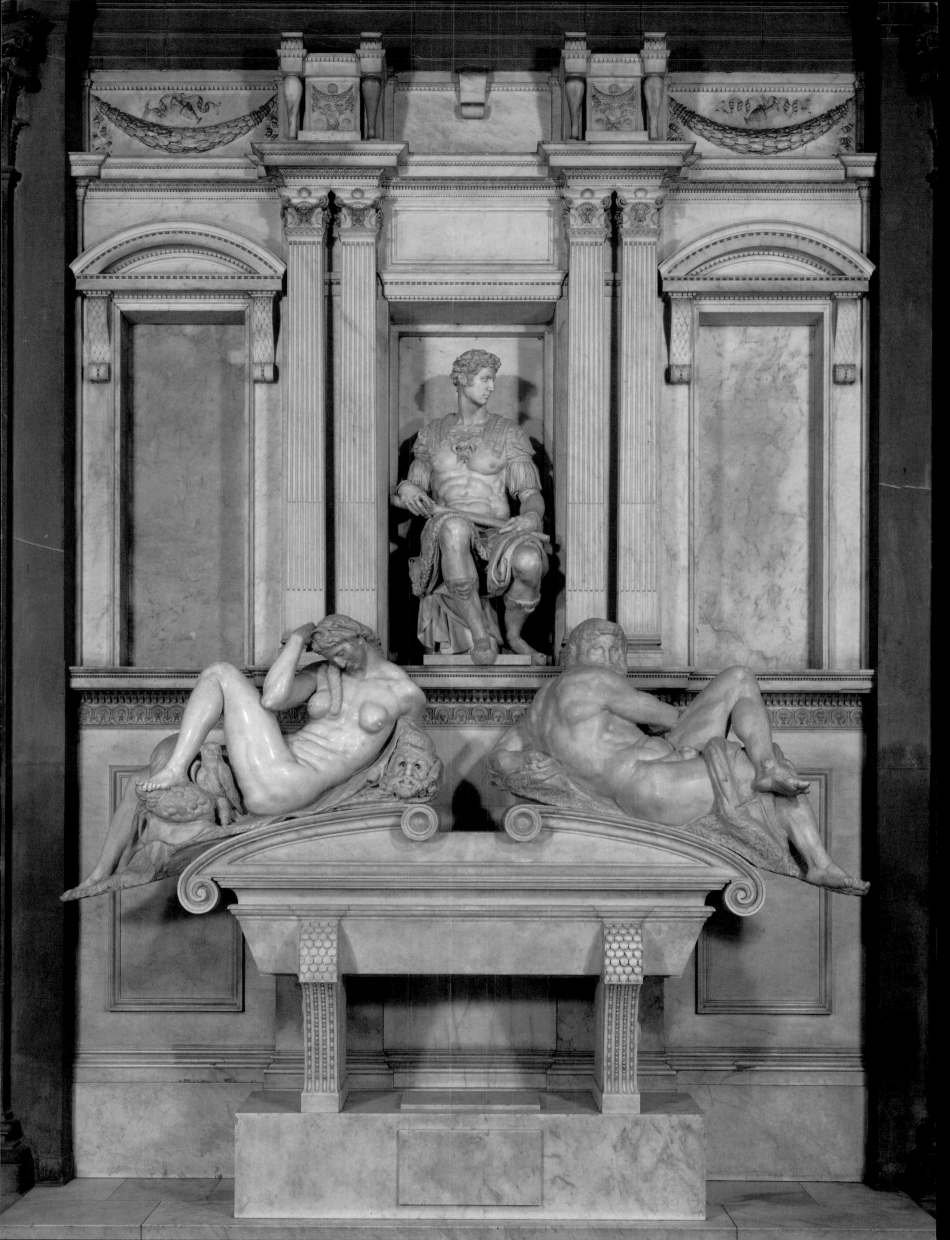

MICHELANGELO
*Interior view of the
Medici Chapel*
CONSTRUCTED 1519–34
BASILICA OF SAN LORENZO,
FLORENCE

So many pieces that Michelangelo
initially imagined are missing from
the Medici Chapel: river gods below
each tomb, painted decorations in the
lunettes, and the most important
element of all, the central tomb of
Lorenzo ("Il Magnifico") and his slain
brother, Giuliano de' Medici. Although
truncated, the chapel is one of the
world's most magnificent and
satisfying architectural and
sculptural ensembles.

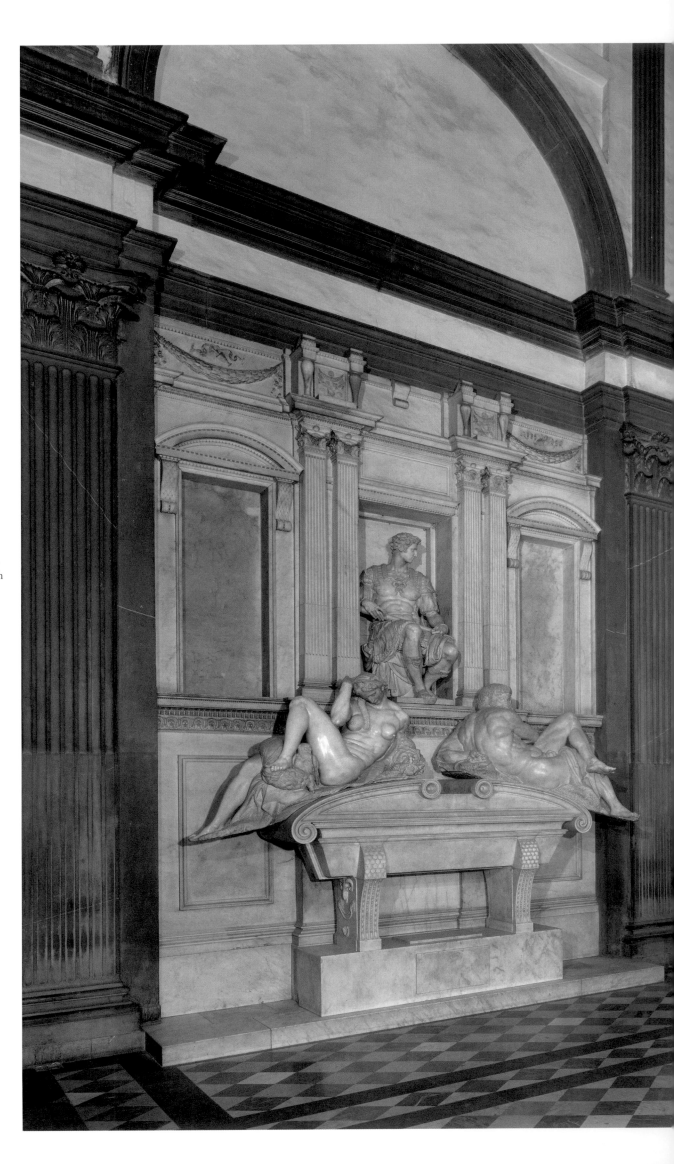

LORENZO IL MAGNIFICO E GIVLIANO DEI MEDICI

MICHELANGELO

(1475–1564)

Night

1519–34

MARBLE
HEIGHT: 76 ½ IN. (194 CM)
MEDICI CHAPEL, BASILICA OF SAN LORENZO, FLORENCE

THE BEAUTIFUL but strangely muscular body of *Night* is bent in impossible contortions yet retains an air of perfect serenity. Poised ambiguously between sleep and wakefulness, she is more flesh than marble, more divine than merely human. Her quality as a living figure was celebrated in a contemporary poem, in which she is described as "sleeping in such a graceful attitude," to which Michelangelo responded with his own verse: "Sleep is dear to me . . . do not wake me—pray, speak softly."

Before carving *Night* and the three other allegories that make up the tomb ensemble within the Medici Chapel, Michelangelo created full-scale models from a mixture of clay with tow, shearings, and string, built around armatures of wood and wire. It was unusual to make full-size models, but the artist had good reasons for doing so. He could not afford a miscalculation of weight and balance when the figures were placed on the curved sarcophagus lids (the clay models were nearly as heavy as their marble counterparts would be), and he needed to judge the aesthetic effect.

To carve the marble figures, he placed the irregularly shaped blocks atop heavy wooden trestles, which gave him access to all sides. First, he used a point (*subbia*) for the rough and rapid working of the raw material. Next, he switched to a flat-headed chisel (*scalpello*, related to the Italian word for stonecarver, *scalpellino* or *scarpellino*) and a multitooth claw chisel (*gradina*) for the majority of figural carving. Polishing was a punishing chore carried out with a series of increasingly fine metal rasps as well as pumice (a light volcanic rock), grit, and lots of elbow grease. We see the miraculous effects in the sheen of the figure's skin, evoking the mysterious radiance of moonlight. She is accompanied by further suggestions of night, sleep, and death— a lunar diadem, a large bunch of poppies, an owl, a mask. Cast in shadow, the face is polished less than the thigh, the hair less than

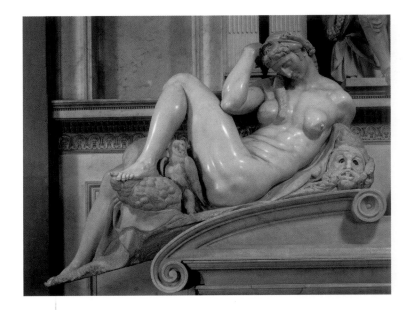

the face, many other surfaces not at all.

Despite his legendary ability to assess a stone's quality, and regardless of the pope's permission to replace pieces deemed inferior, Michelangelo could not abandon every block that proved to contain an unexpected flaw or disfiguring vein. The marble of *Night* has a milky luminescence and is nearly flawless, but the artist did encounter impurities just below the figure's left shoulder. As he removed the flaw, he found himself with too little marble to carve the left hand and forearm. The contortion of the figure and the prominent mask help to disguise the problem.

In the chapel, light falls from high above, leaving the sepulchers in a gloomy realm suggestive of the dead. In the course of the day, sunlight shifts from one part of the chapel to another. The sculptures appear to awaken in turn, then return to stone. For brief moments in this sacred space dedicated to Christ's resurrection, light becomes the revitalizing agent that beckons the dead to rise. As the sun declines toward the end of the day, the chapel returns once again to somber and silent immobility.

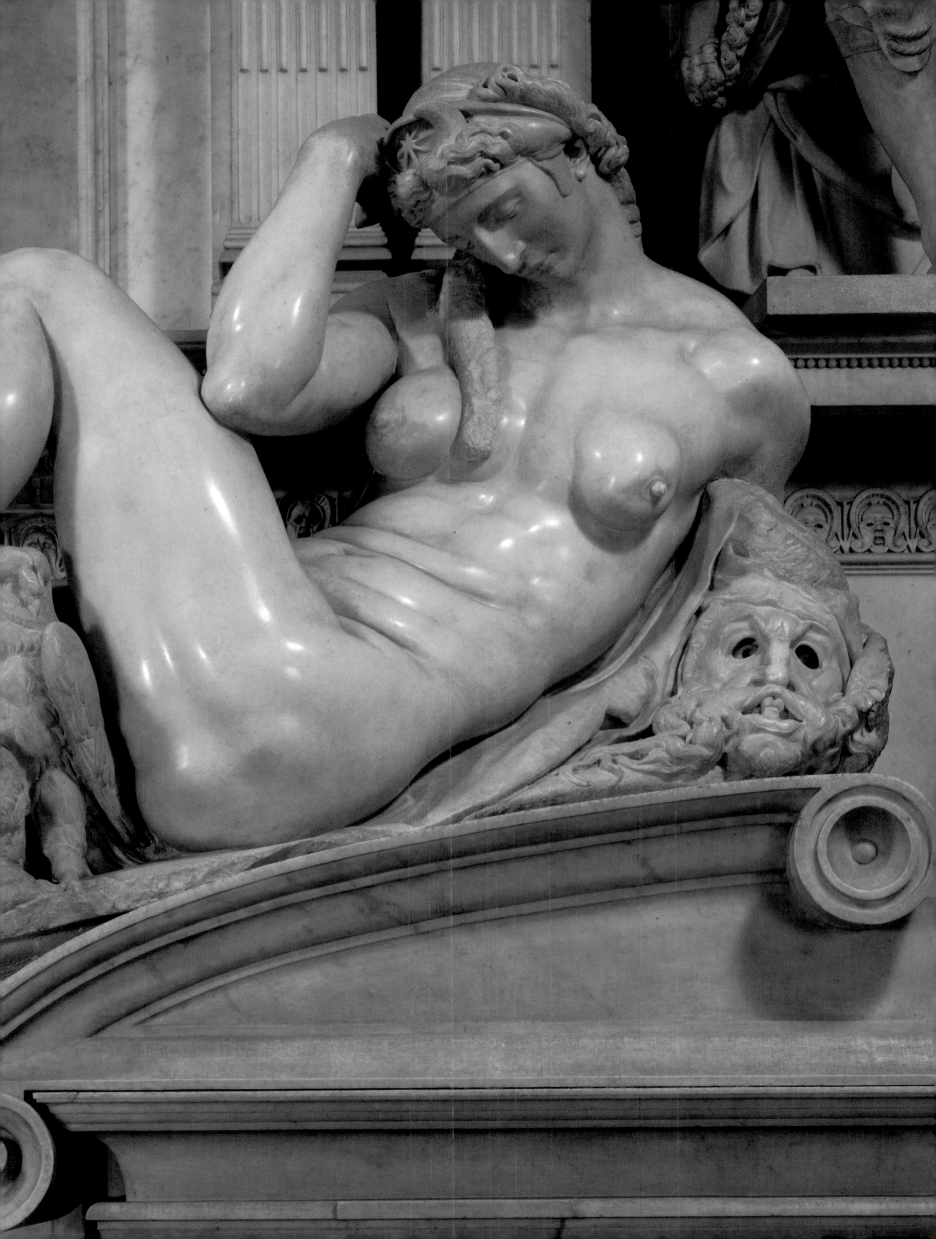

MICHELANGELO

(1475–1564)

Medici Madonna

CA. 1522–34

MARBLE
HEIGHT: 90 IN. (229 CM)
MEDICI CHAPEL, BASILICA OF SAN LORENZO, FLORENCE

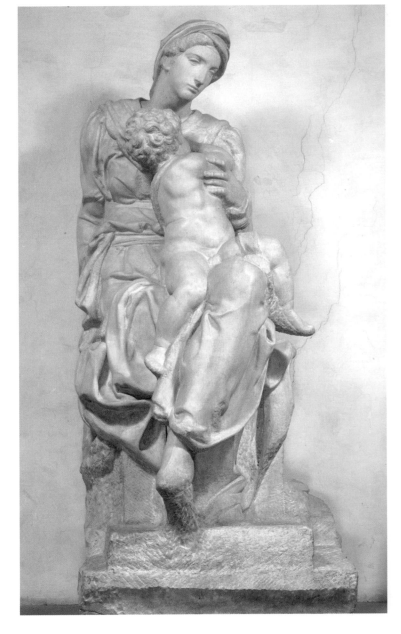

MICHELANGELO left this marble group of a Madonna and her child unfinished in his Florentine studio when he departed for Rome in 1534. Although not installed until years later, the statue was probably intended for the Medici Chapel, as the centerpiece for the never-executed tomb of the family's princes, and that is where we find it today.

The Virgin is seated with her left leg crossed over her right. Straddling the raised limb is the large, muscular child who turns away from us, seeking his mother's breast. Michelangelo has depicted an unusual moment, for the infant is neither suckling nor comfortably situated on his mother's lap; instead, he is shown in midaction, uncomfortable and unfulfilled. The torsion of his body suggests a sort of restless movement that contrasts markedly with his distant, immobile mother.

The two figures engage in a complex gestural counterpoint, each with a hand on the other's shoulder. The counterclockwise turn of the child is matched by a less-violent opposing clockwise motion of the mother. Her left shoulder is forward and hunched down, as if to offer herself to her son; her right arm rests on the rear of her seat, as if to counterbalance his weight.

Similar to the figure of Christ in the early *Madonna of the Stairs* relief, the child here is enfolded in the protective embrace of his mother, yet their contact is more physical than emotional. As if prescient of her son's destiny, the Virgin gazes vacantly into space, classically beautiful but infinitely remote. Her indistinct, slightly out-of-focus mood is accentuated by the web of chisel marks on her unpolished face. Literally and figuratively, we see her through a gauzy veil.

Michelangelo made studies of the central portion of this composition, as seen in a large drawing, or *cartonetto*, housed today in the Casa Buonarroti. We naturally, but not always correctly, assume that a drawing is a preliminary step in the carving of a sculpture. In this case, the drawing may well have been made in the course of carving.

The artist generally worked by excavating the front face of a block. Therefore, the projecting knee of the Madonna, the child's legs, and the muscular right shoulder would have been the first elements to emerge from the raw stone. At this point, Michelangelo was viewing his composition blindly, with the back of the child visible, but the important faces and hands still imprisoned in the unfinished block. It might well be that the Casa Buonarroti cartoon was the artist's attempt to visualize his way into the stone, a drawing providing eyes for his chisel. The sketch represents an early idea for the placement of the arms and hands of both figures. Initially, Michelangelo imagined the Virgin's hand settled on the inside of Christ's thigh, unconsciously drawing attention to his genitalia and, by implication, his humation (God created in the image of man). Upon returning to carving, Michelangelo characteristically made changes, moving Mary's left hand so that it becomes the only support for her precariously perched child.

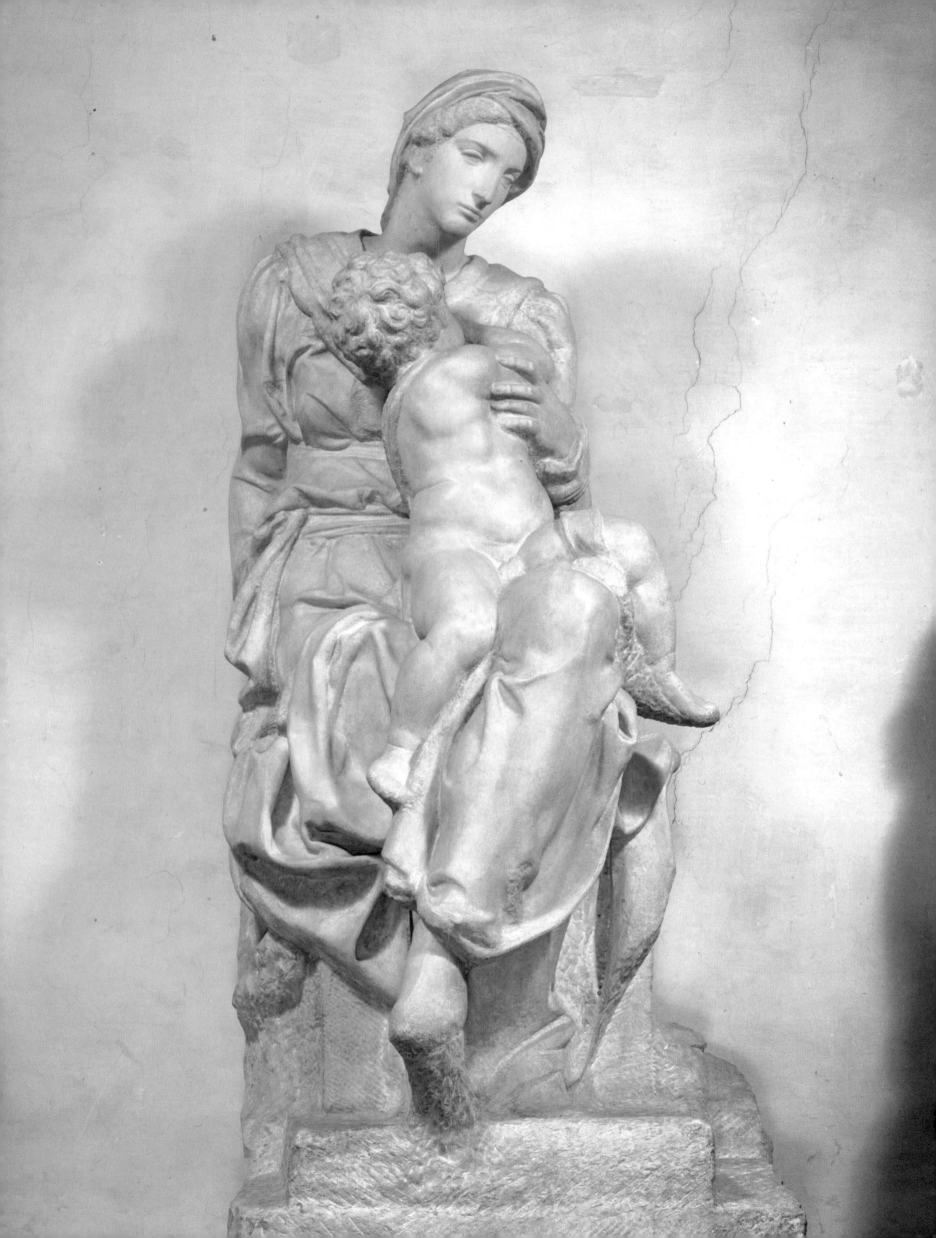

MICHELANGELO
(1475–1564)

Laurentian Library

1523–34

BASILICA OF SAN LORENZO, FLORENCE

FOR SOME sixteen years, from 1516 to 1534, Michelangelo devoted himself to the Medici commissions at San Lorenzo, proving that he was an effective business manager and something of an entrepreneur. Simultaneous with the Medici Chapel he erected the Laurentian Library, the building housing the books donated by the Medici to the church. From a convoluted approach through an unexceptional monastic cloister and up a narrow flight of stairs, the visitor steps into an impressive volume of vertical space. As with the interior of the nearby Medici Chapel, one is greeted by a room full of architectural novelty.

The library vestibule is one of Michelangelo's most famous works of architecture. Rising from the shoulders of giant anthropomorphic consoles are pairs of monolithic column shafts that extend to meet sections of broken entablature. The casual visitor is made to feel small in their stately company. The columns stand firm against a malleable wall that advances and recedes around us, leaving the corner columns squeezed into deep recesses. The unexpectedly organic wall brackets have a vaguely equine appearance, and in the four corners they fuse together as if under terrific geologic pressure.

Filling most of the space is the celebrated staircase, a singular moment in the mostly bleak history of climbing from one level to another. This is an entire room, three stories tall, devoted to the transitional experience of moving from the noisy exterior to the quiet serenity of the reading room. A central flight is articulated by a balustrade barely high enough to be functional; the side flights bleed off into open space. The stairs appear like viscous material or, as Michelangelo described them, as a series of oval boxes set one upon the other. They flow into the space, expand, and threaten to fill it up.

The oft-described sense of enclosure and compression in the vestibule is felt mainly when, like a servant, one stands to the side of the monumental staircase or climbs its wings. To mount the

central flight—"reserved for the prince," wrote Michelangelo—is to feel like a noble or a person of elevated stature. From the middle of the broad stairway, the vestibule is capacious, the prince its center, the columns at attention like so many proud retainers. Beyond is the orderly world of the library proper, where statements of princely patronage are made in the hushed language of reading desks and books.

According to Giorgio Vasari, Michelangelo's Laurentian architecture was a significant departure from classical orthodoxy; it was a display of license that overturned rules and expectations. But history has judged Michelangelo's unorthodoxy as originality, and his Florentine buildings exercised a profound influence on subsequent architects. One might detect distant echoes in the great central staircase of Charles Garnier's Opéra in Paris or even Frank Lloyd Wright's Guggenheim Museum in New York, which is a staircase converted into a continuous spiral. These are examples of how great artists can transform the banal activities of climbing and descending into a life-enhancing experience.

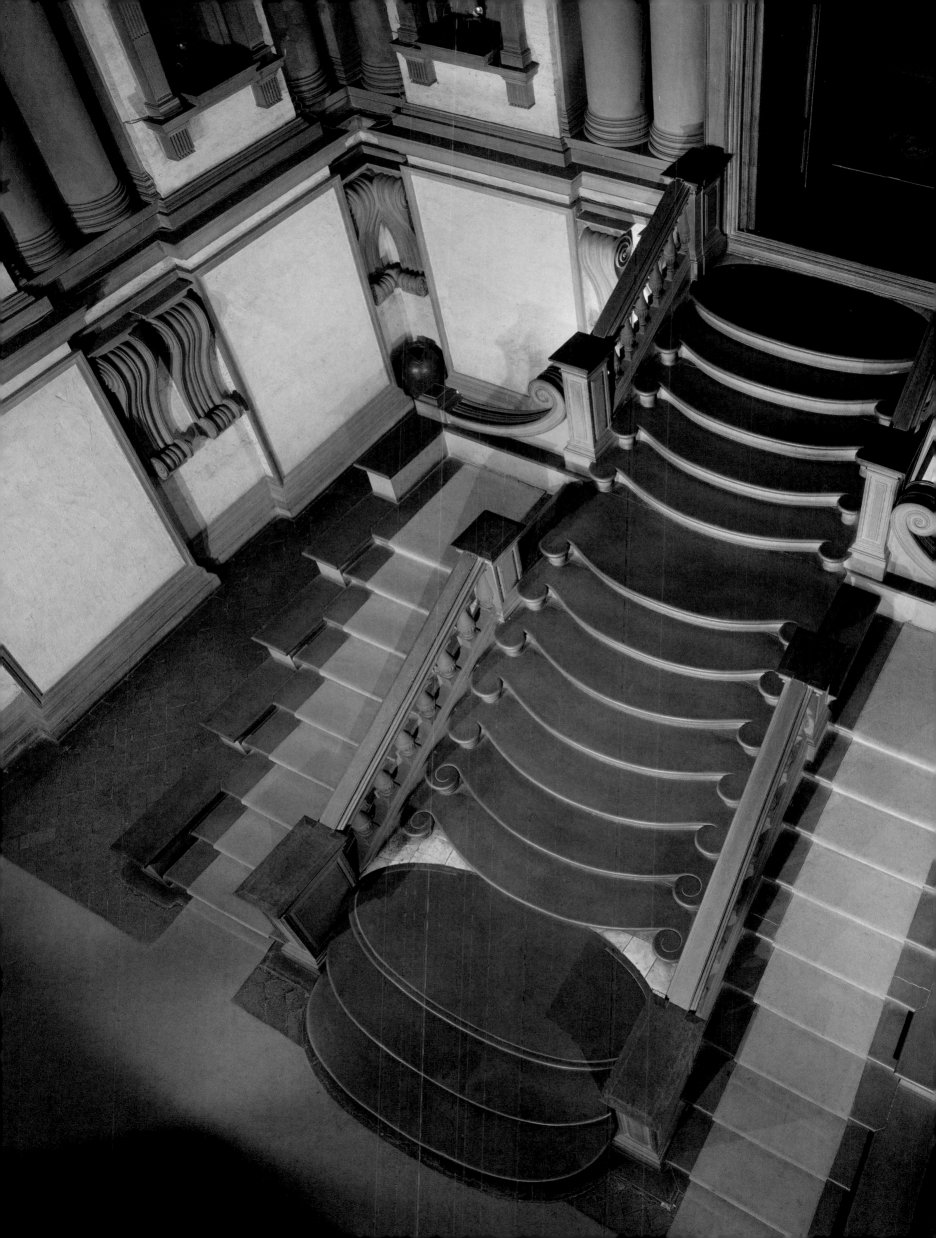

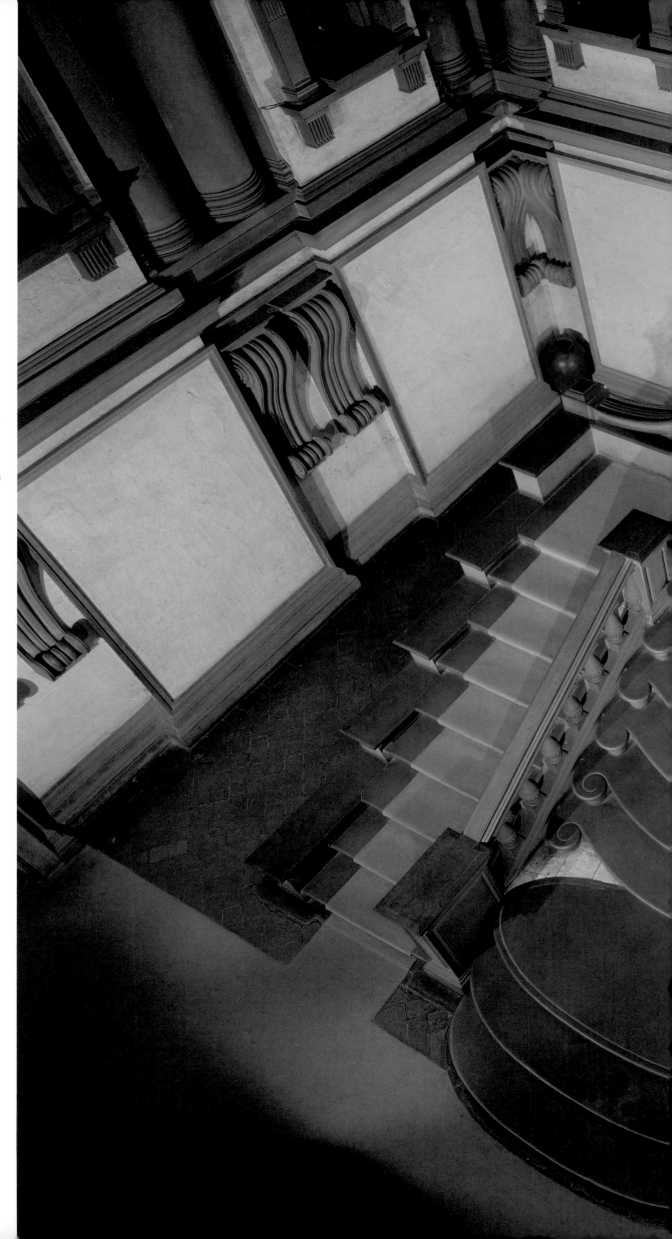

MICHELANGELO
*View of the Laurentian Library
vestibule and steps*
CA. 1523–59
PIETRA SERENA STONE AND PLASTER
BASILICA OF SAN LORENZO,
FLORENCE

One of the most admired staircases
in the world. Michelangelo has
transformed a normally prosaic and
functional architectural element into
a large piece of sculpted furniture,
one that has inspired numerous
subsequent architects.

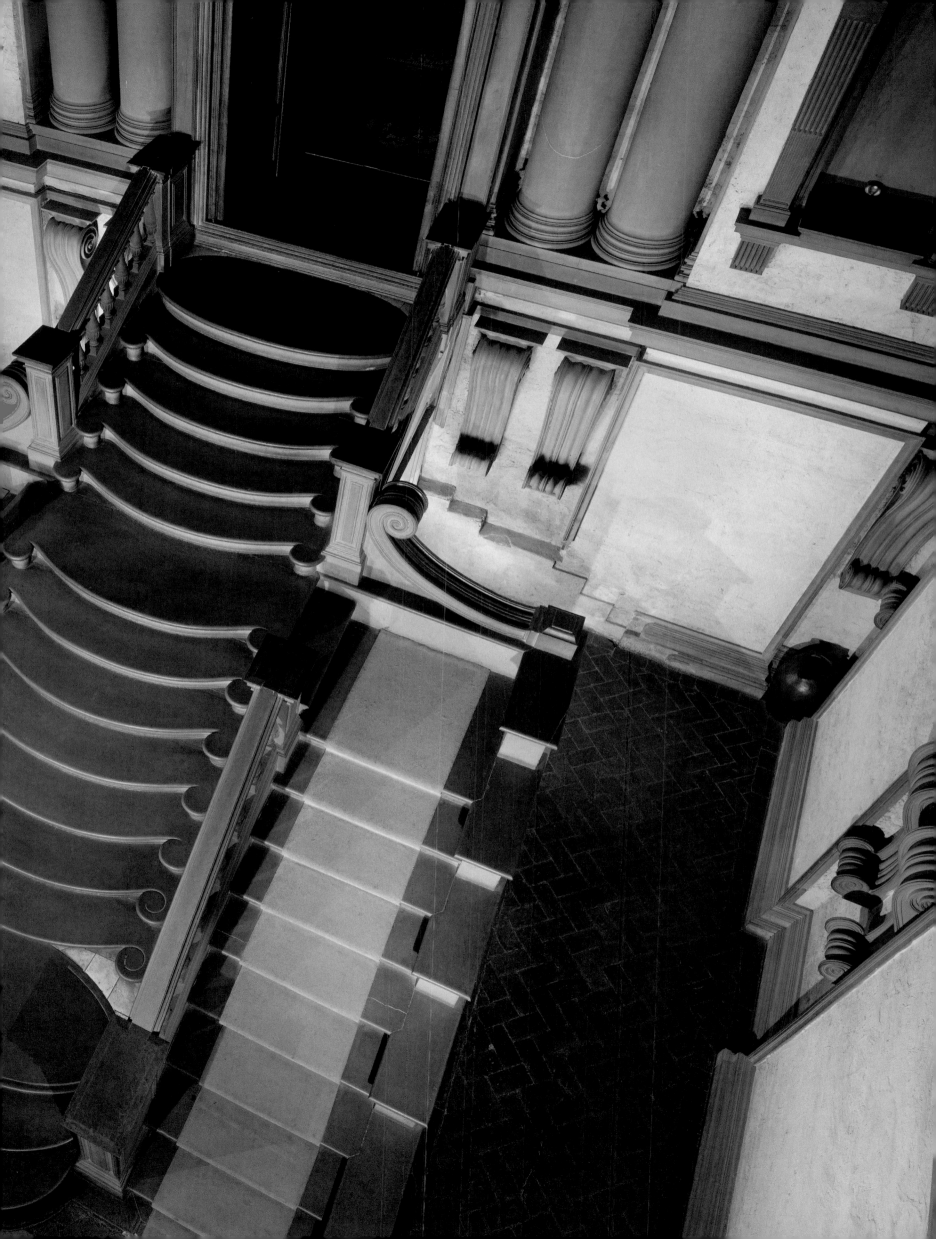

Michelangelo

(1475–1564)

Laurentian Library Reading Room

1523–34

Basilica of San Lorenzo, Florence

The highly cultivated pope Clement VII (reigned 1523–34) was an unfortunate politician but a brilliant patron and a sensitive manger of Michelangelo. The building of the Laurentian Library at San Lorenzo was a project particularly dear to Clement, for it would realize a longstanding desire to provide a proper home for the enormous collection of books donated by the Medici family. The pontiff's enthusiasm for the project is manifest in the flurry of letters he exchanged with Michelangelo, on the order of two and three missives per week. (The mail moved between Rome and Florence more quickly in the sixteenth century than it does today.)

The correspondence is filled with queries regarding the site, cost, and structural problems of the new library, as well as the design of doors, furniture, ceiling decoration, and lighting. In letter after letter, the pope expressed interest in everything from fireproof vaulting to the quality of lime used in making stucco. From where, he asked, would Michelangelo obtain the beams for the library roof? How many desks would be in the reading room? He wanted to know the source, quality, and treatment of the walnut for the desks, and how many books would be placed on each. Insatiable, Clement implored his architect to write more often. The library is the brilliant product of an ideal collaboration between artist and patron.

As Frank Lloyd Wright was to do centuries later, Michelangelo considered a building's furniture integral to its design. The regularly spaced reading desks reiterate the room's simple geometry. Likewise, the wall articulation depends on and is coordinated with the furnishings: the pilasters rise from a stringcourse that runs along at desk level. The furniture is a visual support for, and continuous with, the wall membering. The desks are spaced two to a bay, with light falling over a reader's shoulders from the large, stone-framed windows. The measured rhythm of repeating bays creates a harmonious space conducive to quiet

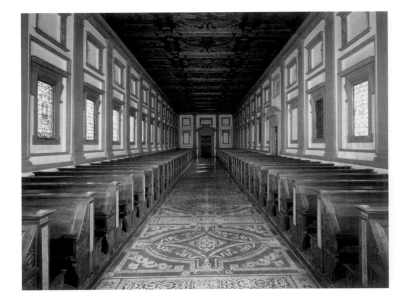

study. In the reading room, building, furniture, and books— that is, architecture, decoration, and function—are seamlessly integrated. To sit at one of the carved walnut desks—at once comfortable seat, reading stand, and storage facility—is to become a part of the building.

The reading room was originally meant to culminate in a triangular rare-book room. As seen from extant drawings for this unusual space, Michelangelo experimented as much in architecture as he did in sculpture and painting. How would such an unusually shaped room feel and function? Had it been completed, movement through the library would have been a sequence of geometries—square, rectangle, triangle—and a metaphor for a life of learning: one mounts to knowledge, but only through ordered and diligent study does one arrive at the greatest wisdom, here contained in a sanctuary-like rare-book room. Unfortunately, this planned space fell victim to the severe disruptions caused by the Sack of Rome, in 1527, and Michelangelo's eventual move to that city in 1534.

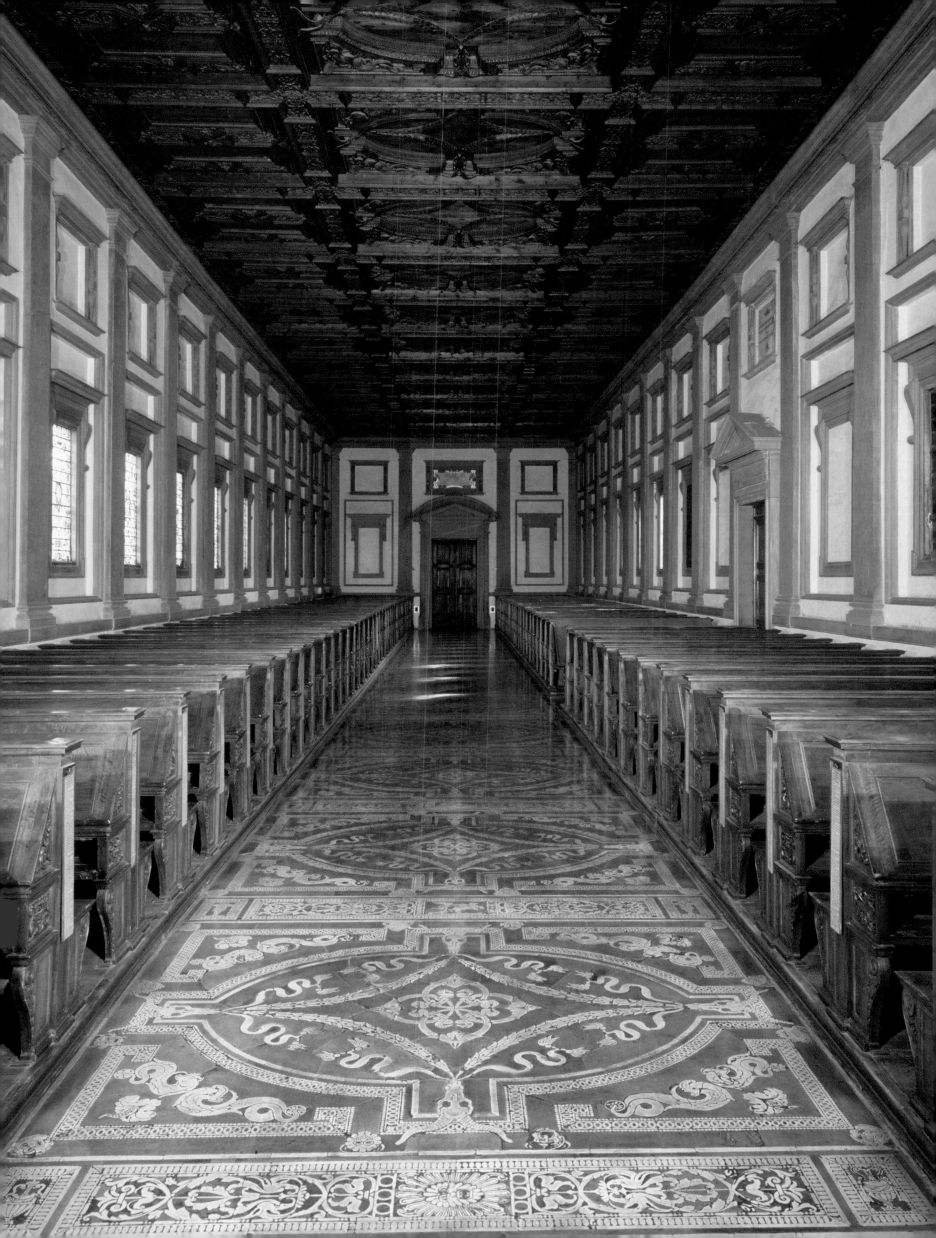

MICHELANGELO

(1475–1564)

Fortification Drawing

CA. 1528

RED CHALK AND PEN ON PAPER
APPROX. 6 X 10 ½ IN. (154 X 271 MM)
CASA BUONARROTI, FLORENCE

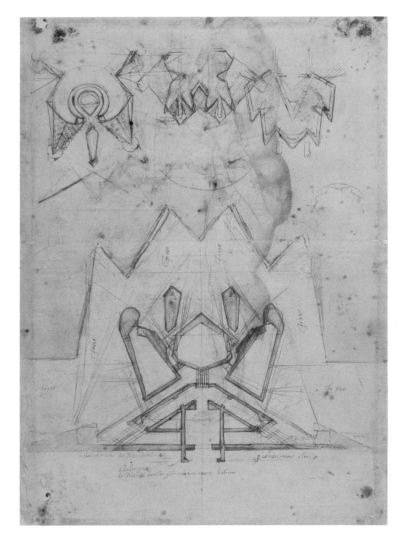

SHORTLY AFTER news of the Sack of Rome reached Florence in 1527, the Medici were expelled from the city and a republican government was reinstated (the so-called Last Republic; 1527–30). Feeling betrayed, Pope Clement VII worked tirelessly for the next three years to reestablish his family's control over Florence. The Treaty of Barcelona, signed by Clement and Holy Roman Emperor Charles V in June 1529, dashed Florentine hopes of maintaining their short-lived independence. The stage was now set for Michelangelo to play a role in world politics. Despite the pope's effort to dissuade him, the artist elected to side with his native city—he was, above all, a Florentine with deeply republican sentiments. The government appointed him Governor General of Fortifications and sent him to inspect the defenses of Florence's subject towns, including Pisa and Livorno. He also visited Ferrara, whose fortifications were considered the most advanced in Italy, and met with Duke Alfonso d'Este, a potential ally with a famous arsenal.

Michelangelo drafted several innovative angled bastions, designed to fortify the high but thin medieval walls of Florence against the destructive power of modern cannon. None of the temporary defensive works he built still exist, but his surviving drawings attest an intense interest in the project. On sketches for star-shaped and angled bastions, he traced firing lines in order to provide maximum protection for the curtain walls and concealed entrances. Although designed primarily to handle the small-arms ordnance that characterized most warfare of the period, such additions were also effective protection against artillery. Through these inventions, Michelangelo initiated a long chapter in military history, which culminated in the elaborate defenses constructed during the American Civil War in the 1860s and along the Maginot Line in the 1930s.

This drawing is one of the earliest of some twenty extant fortification designs by Michelangelo. Thanks to the strength of his draftsmanship, one scarcely notices that he drew directly over earlier figures executed in black chalk. Smaller abstract designs (anticipating the spaceships of *Star Wars* by five hundred years!) precede the larger, more coherent plan for a multibastioned construction that fills the bottom half of the sheet. Although fascinating and potentially functional, the latter is unnecessarily complex and would have been difficult and costly to build. In subsequent drawings, Michelangelo designed simpler bastions that proved effective during the ensuing ten-month siege.

In the Renaissance, military engineering was an important aspect of an artist's profession. Michelangelo once quipped that he knew little of painting and sculpture but considered himself an expert on fortifications. Unlike most other artists and innumerable military theorists, he had the opportunity not only to design but also to build such defenses and thus prove their efficacy in time of war. Michelangelo, not Leonardo da Vinci, is the great Renaissance engineer; the former was a practical builder, the latter a dreaming visionary.

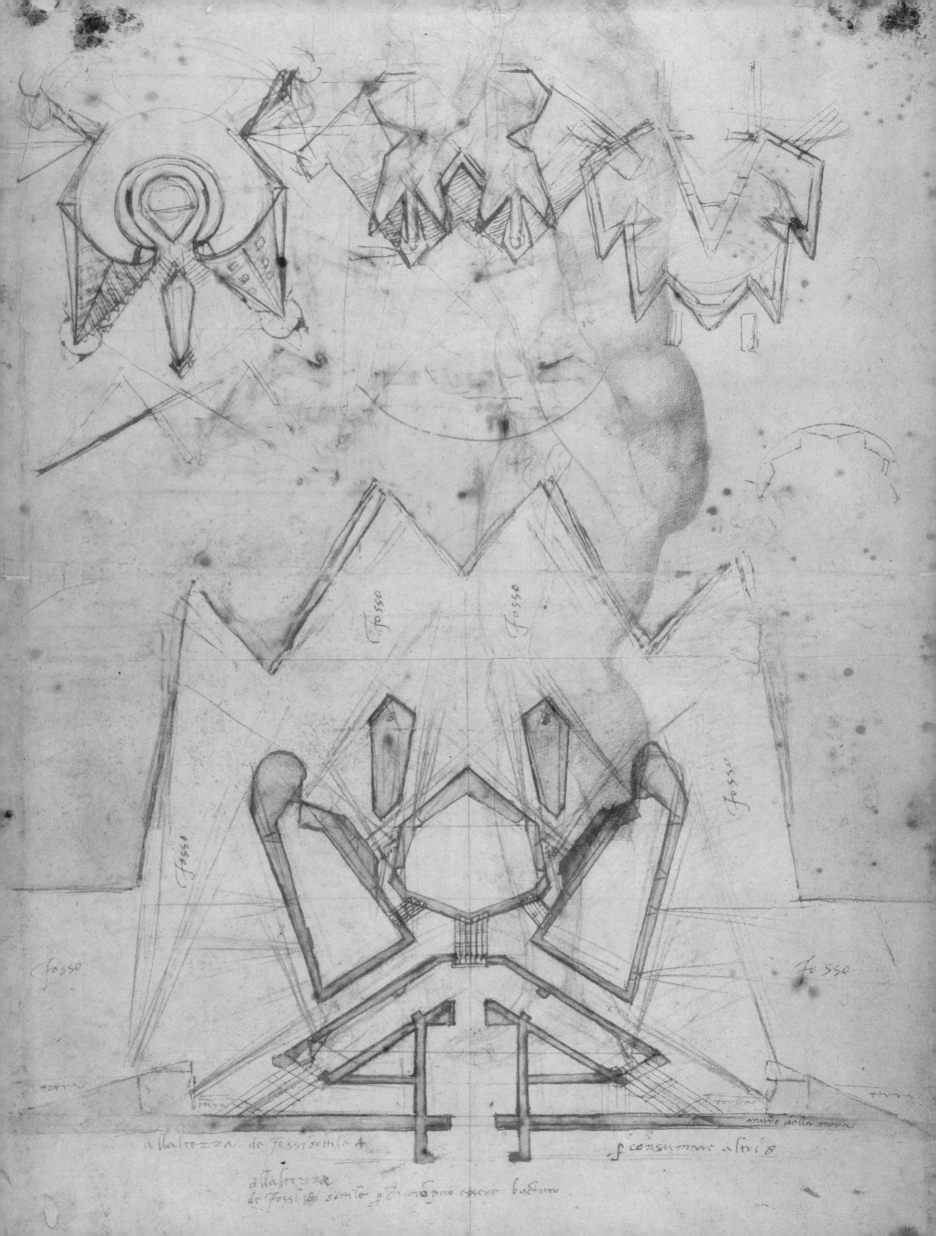

fosso

fosso

fosso

fosso

fosso

fosso

fosso

alla altezza de fossi sette 4

p consumare altri 8

alla altezza
de fossi el sottile p... non puo essere buttato

MICHELANGELO

(1475–1564)

Apollo/David

CA. 1530

MARBLE
HEIGHT: 57 ½ IN. (146 CM)
BARGELLO MUSEUM, FLORENCE

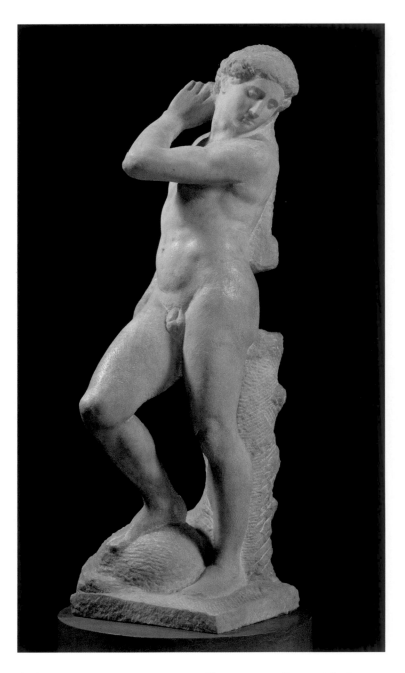

THE SO-CALLED *Apollo/David* may be a less extravagant essay in *contrapposto* than the *Victory*, but in some ways it is no less ambiguous. In both works, one cannot definitively resolve the iconography, although in the former the range of interpretative possibilities is narrower. The subject depends on how one reads the unfinished lumps of stone on the figure's shoulder and under the right foot: a quiver would argue in favor of Apollo; a head underfoot would render it David. That the sculpture can be either a pagan god or a biblical hero, merely by altering an attribute, is testament to Michelangelo's reconciliation, or rather fusion, of classical antiquity and Christianity. The primary element—a standing nude youth— is the same in either case.

Recalling the earlier experiments of the *St. Matthew*, the *Apollo/David* features one leg and one arm raised; the other arm hangs at the right side and appears to grasp something (a stone? an arrow?). The extreme cross-body gesture of the left arm and the turned head recalls the movement of the *Risen Christ*, but without the heroic proportions and smooth finish of that earlier work. Moreover, a gossamer web of chisel marks reminds us of the figure's unfinished status, in the penultimate stage of definition.

Neither of the suggested subjects, David or Apollo, adequately accounts for the reflective quality of the figure's demeanor. The downward tilt of the head, the sinuous movements of the body, and the complete nudity give the sculpture an ambiguous air— modest, serene, and sensual—that contrasts with the potentially violent subject matter. In its highly refined pose, the figure is more a work of art than part of a narrative.

In 1532, Alessandro de' Medici (the bastard son of Lorenzo, who is honored in the Medici Chapel) was proclaimed Duke of Florence, thereby destroying the last vestige of republican government. Florence was now ruled by an irrational and despotic Medici prince who offered little safety and no peace for Michelangelo, and the city was placed under the control of a harsh interim governor, Bartolomeo (Baccio) Valori. A shrewd and calculating individual and a willing servant of power, Valori negotiated the vicious and unforgiving world of rapid political change. He was a man Michelangelo necessarily handled with

diplomatic tact. In a transparent effort to curry favor with the new regime, the artist agreed when Valori asked for a palace design and a sculpture. He began carving the *Apollo/David*, a sculpture whose subject would ultimately be determined according to the whim of the patron.

With the gradual improvement of the political situation in Florence and the appointment of Valori to a diplomatic post in the Romagna region, Michelangelo's attention to both commissions evaporated. The *Apollo/David* was left unfinished and undelivered, yet another sculpture abandoned when the artist moved permanently to Rome in 1534.

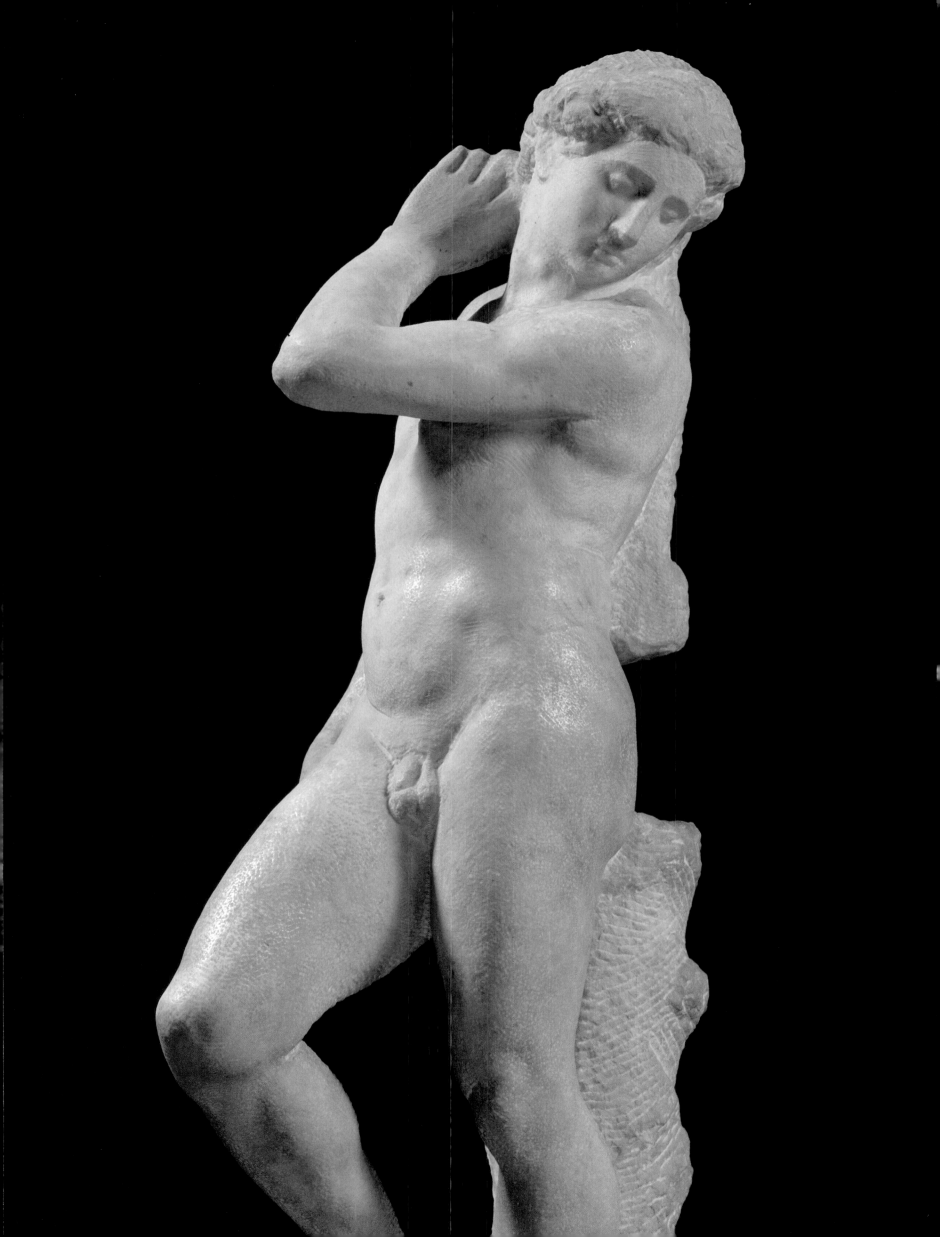

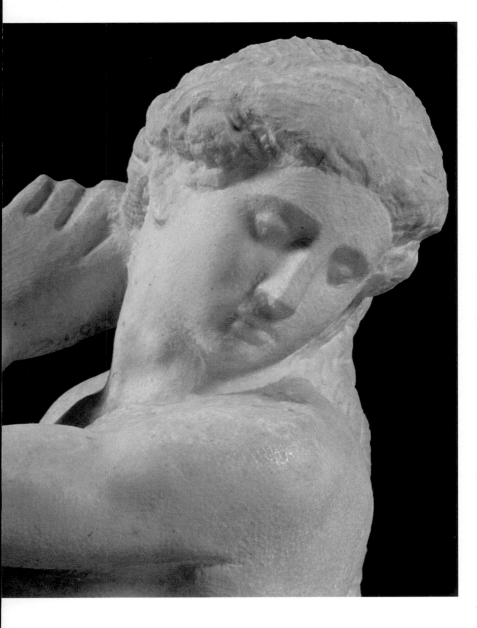

(ABOVE)

MICHELANGELO
Apollo/David (DETAIL)
CA. 1530
MARBLE
HEIGHT: 57 ½ IN. (146 CM)
BARGELLO MUSEUM, FLORENCE

(RIGHT)

ROSSO FIORENTINO
(ATTRIBUTED)
Leda, after Michelangelo's Cartoon
AFTER 1530
OIL ON CANVAS
41 ½ X 55 ½ IN. (105.4 X 141 CM)
NATIONAL GALLERY OF ART, LONDON

During an especially disruptive period in Florence's history, Michelangelo produced several politically motivated works, including *Leda* for Alfonso d'Este—in a failed attempt to enlist his military support for Florence—and the *Apollo/David* for the hateful and imperious military governor Baccio Valori.

MICHELANGELO

(1475–1564)

Victory

CA. 1532–33

MARBLE
HEIGHT: 102 ¾ IN. (261 CM)
PALAZZO DELLA SIGNORIA, FLORENCE

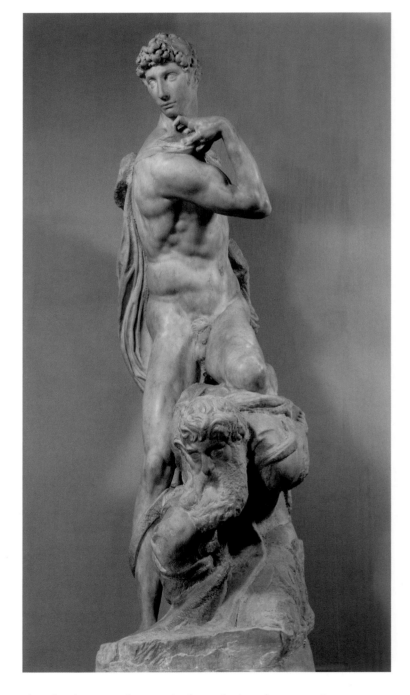

THE *Victory* is a curious work, of uncertain purpose and destination. An immensely tall youth dominates an older man whose bent and folded form is crouched uncomfortably below the youth's left knee. Although only roughly finished, the bearded figure wears the short leather skirt and leggings of a soldier. This specificity contrasts with the idealized, allegorical character of the youth—a modern Nike triumphing over a brutish captive. The extravagant twists of his elongated body are well beyond the realm of the possible. Indeed, no person is capable of imitating the pose of either figure, much less replicating the impossibly mannered composition. The proportions of the victor, especially the small head to the long body, are made even stranger by our *di sotto in su* (from below) view of the sculpture, which is how it is displayed today in the Sala del Cinquecento of Palazzo della Signoria.

As with the Medici Chapel sculptures or the twenty nude youths *(ignudi)* painted on the Sistine ceiling, Michelangelo prompts us to accept as natural an unlikely anatomy and impossible contortions. For example, we see both the front and the back of the victor's torso simultaneously. With an easy grace that belies the extreme twist of the body, he glances over his shoulder and lightly fingers a strap that crosses the shoulder and secures an improbable billow of drapery. Given the multiple satisfying views, it is impossible to determine the sculpture's front side. Like the *Bacchus*, the *David*, or the Louvre *Slaves*, the *Victory* encourages us to move around it. Unlike those earlier sculptures, however, there is no place where this statue "composes" itself, no relaxation to the continuously restless movement.

Most scholars assume that the *Victory* was made for the tomb of Pope Julius II. Yet, like the *Slaves* in the Accademia Gallery, it was treated as an independent work of art and eventually entered the ducal collections. Freed of its original intention and destination, it was widely admired as a unique object and considered a masterpiece of the artist. As he had done all his life, Michelangelo carved a sculpture with few precedents and few concessions to convention. Unfinished and inexplicable, it was at once strange and beautiful, allusive and elusive.

A work such as this again raises the problem of whether or not Michelangelo ever intended to finish it. Did he merely abandon it, or was he genuinely exploring the expressive possibilities of the *non-finito*? Both the Accademia *Slaves* and the *Victory* helped give birth to new aesthetic attitudes: a sculpture that was never delivered to its intended destination could nonetheless have its own raison d'être; despite its unfinished state, it could be viewed as a work of art and inspire admiration and imitation. Michelangelo's twisted *contrapposto* poses and *non-finito* helped shape artistic theory and practice for centuries to come. A revolution in taste was inaugurated.

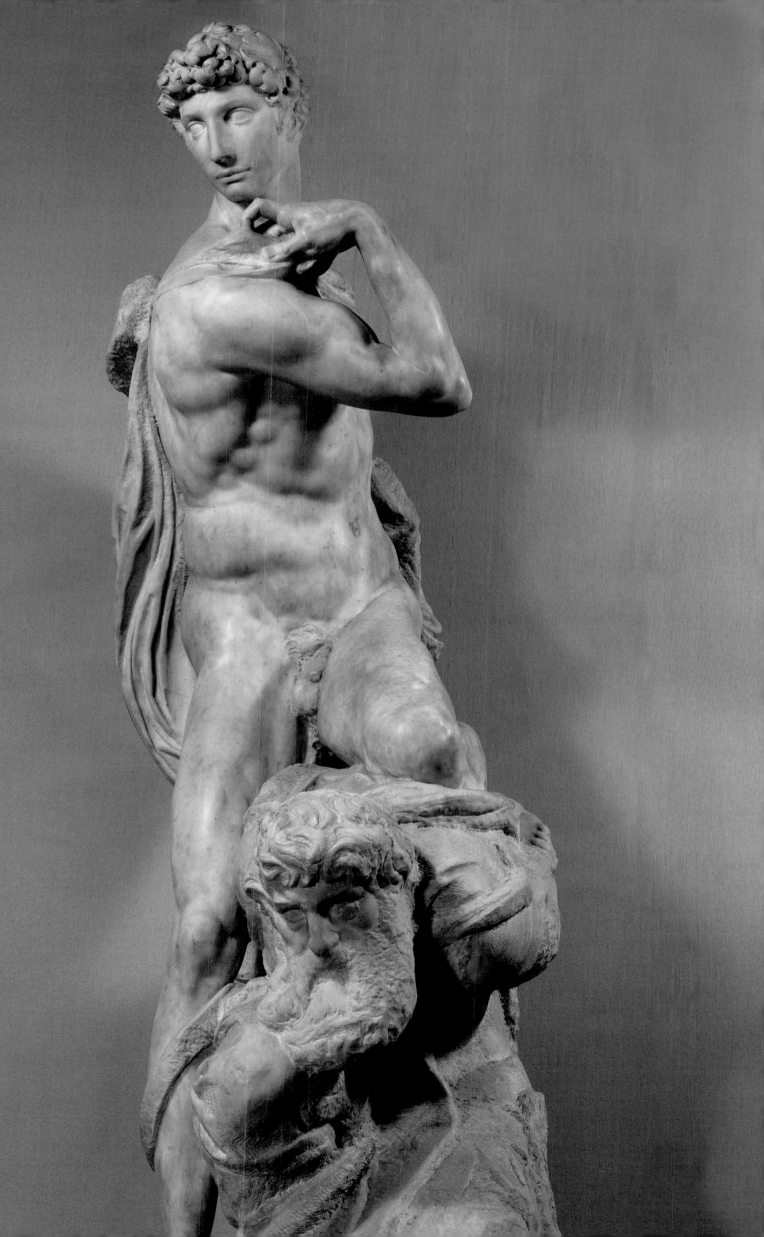

MICHELANGELO

(1475–1564)

Fall of Phaeton

1533

BLACK CHALK ON PAPER
12 ½ X 8 ½ IN. (312 X 215 MM)
BRITISH MUSEUM, LONDON

OR HIS close friends, Michelangelo created some of the most remarkable drawings of all time. These highly wrought images were admired as finished works of art, initiating a new chapter in the history of drawing and collecting. Vittoria Colonna, a renowned poet and close friend of the artist, once thanked Michelangelo for a drawing by praising it as "perfectly painted" and "subtly and marvelously done."

In the rough-and-tumble world of sixteenth-century Rome, one rarely encountered the combination of refinement and physical beauty that Michelangelo appreciated in the young nobleman Tommaso de' Cavalieri. Classic features contributed to the handsomeness of the youth, who was additionally endowed with exquisite manners, physical grace, and a sensitive personality. Cavalieri was probably still in his teens when he first met Michelangelo; during the Renaissance, however, these were the critical years when one passed from adolescence to adulthood. Despite the differences in their age (more than forty years) and social station (Cavalieri was Roman nobility), the two men experienced an instant attraction and enjoyed a friendship that lasted more than thirty years.

In Cavalieri, Michelangelo found a passionate friendship and a vigorous font of poetic and artistic inspiration. The two men met toward the end of 1532, probably through Michelangelo's circle of Roman friends. Their courtship was brief and intense, their friendship long and enduring. It resulted in a large body of poetry and some of Michelangelo's most beautifully crafted drawings. Cavalieri reawakened those highly focused creative energies that Michelangelo commonly experienced at the beginning of projects but that had lain mostly dormant the previous few years.

Early in their blossoming relationship, the two visited the church of Santa Maria in Aracoeli, located on the Capitoline Hill approximately midway between their respective residences. Their reasons for selecting the church were many. Not only was it built over the venerated spot where the Tiburtine sibyl appeared to the Roman emperor Augustus, but it was also home to the Cavalieri family chapel. There was much to see inside the structure, including an ancient Roman sarcophagus (now in the Uffizi)

with a carved marble relief representing the Fall of Phaeton. Inspired by the antique original, Michelangelo created this magnificent drawing to send to his new friend. On this "first draft," he wrote: "Messer Tommaso, if this sketch does not please you, tell [my servant] Urbino since I will have time to make another by tomorrow, as I promised; and if it pleases you and you would like me to finish it, send it back to me." The drawing did indeed please the young man, for Michelangelo drew a finished version that is a miracle of the draftsman's art, a work now in the Royal Collection at Windsor Castle.

The story of the brash young Phaeton (as vividly related in Ovid's *Metamorphoses*) served as a lesson in hubris—overweening pride—and its inevitable punishment. In presenting this exceptional and meaningful gift, Michelangelo was not only demonstrating fine draftsmanship but also admitting the danger of their passionate, newly formed friendship.

MICHELANGELO

(1475–1564)

Crucifixion

CA. 1538/41

BLACK CHALK ON PAPER
14 ½ X 10 ½ IN. (368 X 268 MM)
BRITISH MUSEUM, LONDON

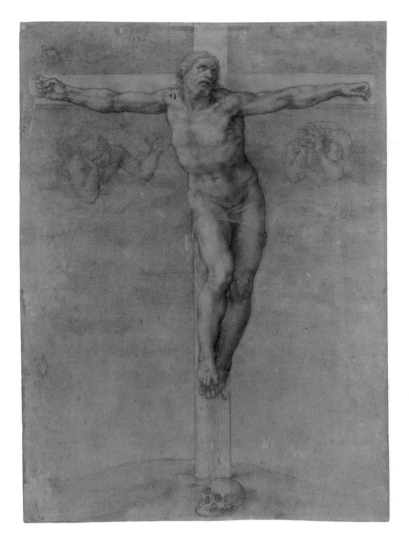

MICHELANGELO found another outlet for his passions in the person of Vittoria Colonna. A member of a distinguished noble family descended from the counts of Tusculum, Colonna was the granddaughter of the great Renaissance humanist prince Federico da Montefeltro, duke of Urbino. Educated and refined, she possessed all the attributes of the ideal female courtier and was an important poetess in her own right. Her arranged marriage to Ferrante Francesco d'Avalos, marchese of Pescara, was happy but brief, ending with his death, in 1525. Until her own death twenty-two years later, Colonna maintained a widow's demeanor, dressing soberly and gradually retreating from worldly society. Nonetheless, she befriended many of the leading literary figures of her day as well as members of the *spirituali*, a group committed to personal salvation and religious reform. In this sympathy, Colonna skirted with heresy, at least in the eyes of the church, whose officials were suspicious of any deviance from orthodoxy. She avoided trouble only because of her status as a pious widow. Profoundly devout, she lived a life of partial seclusion in San Silvestro in Rome and the convent of Santa Caterina in Viterbo.

Michelangelo met Colonna while working on the *Last Judgment*. The two exchanged letters and poems, and the artist made several exquisite drawings as gifts for her, which, like the drawings he made for Tommaso de' Cavalieri, were instantly copied and widely admired. For her, Michelangelo wrote some of his most exalted religious poetry, and he presented her with several choice drawings. Colonna praised the drawings and repeatedly examined them, even using a magnifying glass to appreciate their fine details.

The example from the Isabella Stewart Gardner Museum combines Michelangelo's recurring interest in the theme of the *pietà* and his appreciation for Dante. Inscribed on the cross is a line from canto 29 of *Paradiso*: "No one thinks how much blood it costs." In the drawing of the *Crucifixion* now in the British Museum, the anguished cry of Jesus is merely implied: "My God, my God, why hast thou forsaken me?" In contrast to the emaciated corpus common in Michelangelo's later crucifixion drawings, this Christ, despite his painful writhing, embodies human perfection. Michelangelo not only celebrates the male body, he also suggests the eventual resurrection of the flesh. On receiving the drawing, Colonna wrote to the artist: "One cannot see a better made, more lifelike, and more finished image."

Rarely has the world witnessed such a concentration of artistic excellence and religious fervor. These small and vulnerable objects are precious not for the humble materials of their manufacture, but for their exquisite artistry and the windows they open onto Michelangelo's life, faith, and friendships. The few drawings he made for Vittoria Colonna were among his most celebrated creations. That is why they were so frequently copied and translated into other media, from engravings and bronze plaquettes to paintings and sculptures.

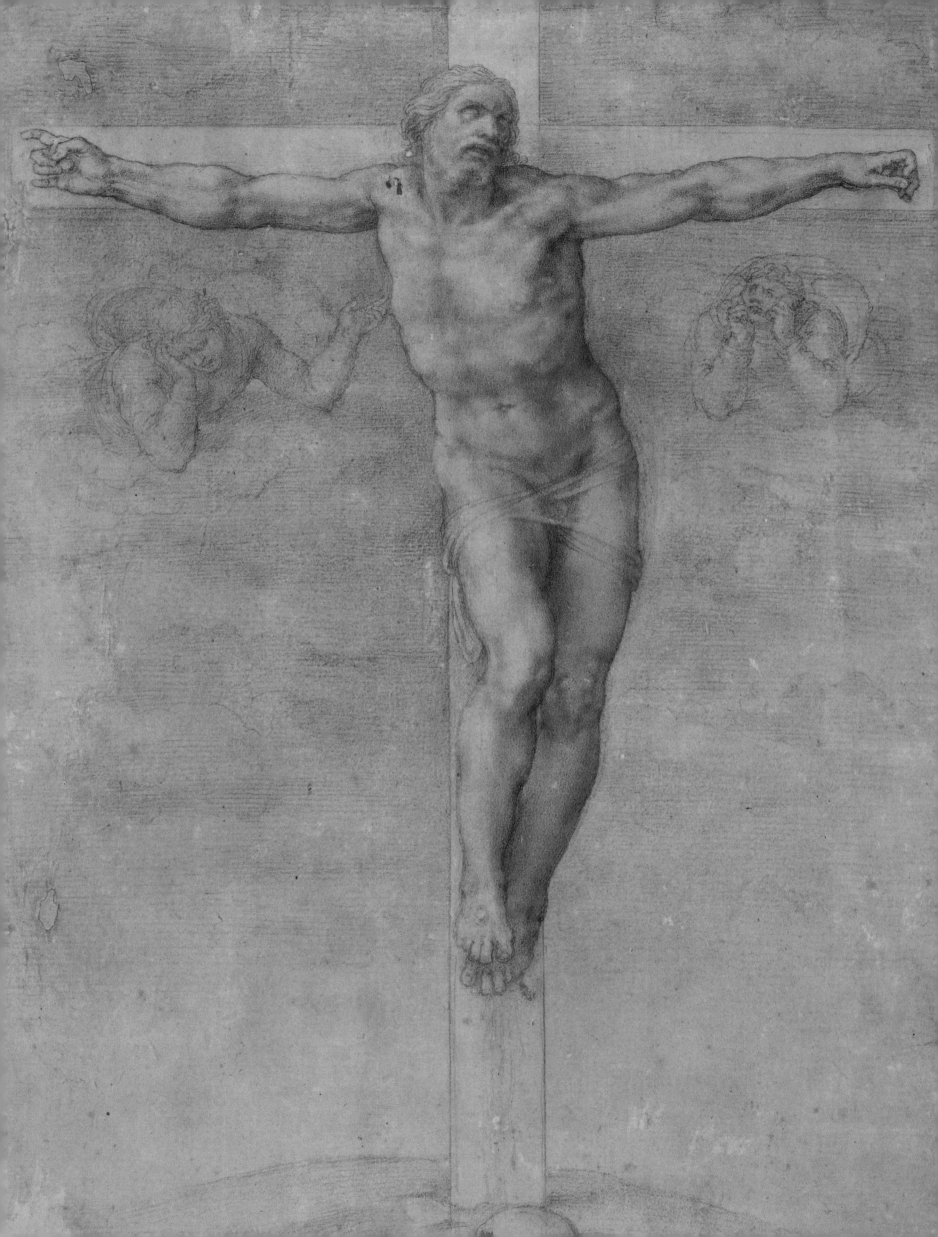

(LEFT)
MICHELANGELO
Crucifixion
CA. 1538/41
BLACK CHALK ON PAPER
14 ½ X 10 ½ IN. (368 X 268 MM)
BRITISH MUSEUM, LONDON

(RIGHT)
MICHELANGELO
Pietà
1540S
BLACK CHALK ON PAPER
11 ¼ X 7 ¼ IN. (289 X 189 MM)
ISABELLA STEWART GARDNER
MUSEUM, BOSTON

With such finished drawings as
these—both made for close friend
and confidant Vittoria Colonna—
Michelangelo helped to invent a new
art form. Traditionally, drawing was
a discardable preparatory medium;
now drawings were collectibles.

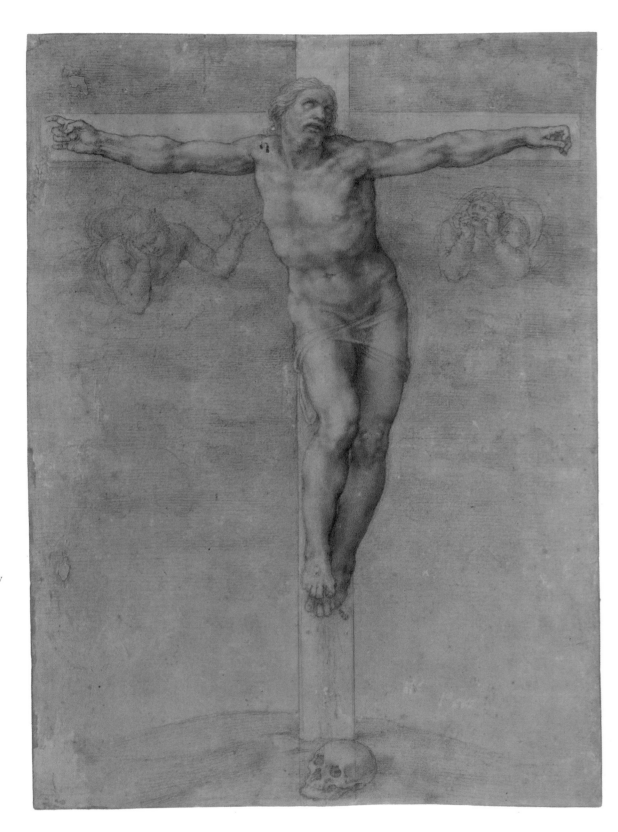

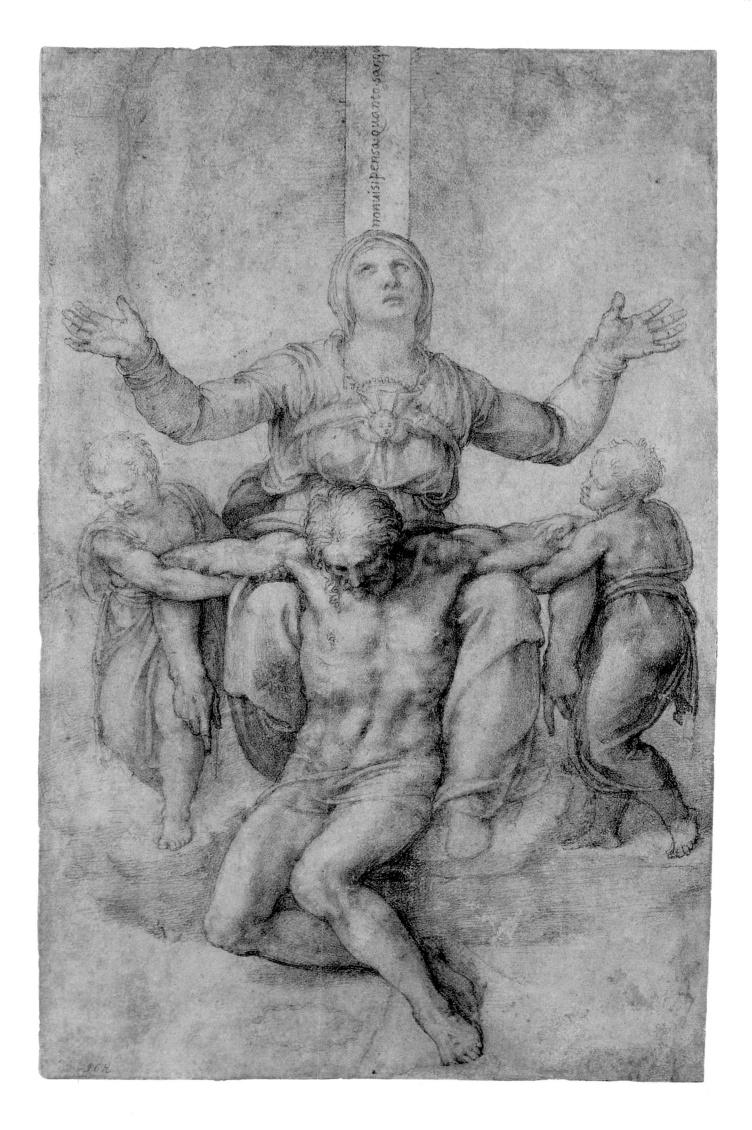

MICHELANGELO

(1475–1564)

Last Judgment

1534–41

FRESCO
APPROX. 52 ½ X 42 ½ FT. (16 X 13 M)
SISTINE CHAPEL, VATICAN CITY, ROME

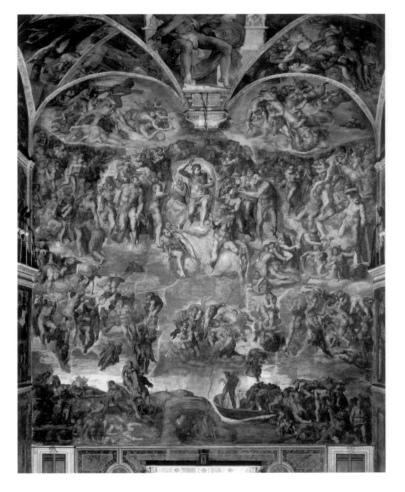

POPE PAUL III (reigned 1534–49) was probably the greatest and most discerning of Michelangelo's many patrons. As profound Christians, the two men shared a trust and mutual respect based in no small measure on their advanced age and commitment to religious reform. Paul lost no time in employing Michelangelo's talents, commissioning him to paint the *Last Judgment* on the altar wall of the Sistine Chapel. What thoughts must have passed through the mind of the artist, painting in the midst of the Catholic Reformation twenty-five years (and four popes) after completing his monumental ceiling?

A sea of humanity rises and falls around the central figure of Christ, whose powerful physique belies the serene visage of the beardless Apollonian Christ. Many viewers, focusing on the raised right arm, see a vengeful Lord. However, the savior looks to the side of the damned, to the souls in need of salvation. He has a gentle countenance, as if he longs to save one more soul before it disappears into hell's maw. The left arm calls attention to the wound in his side—reminding viewers of his sacrifice—and points beyond to the saved. Mary sits within the light of his glowing aureole, ready to intercede on behalf of sinners. Her huddled pose recalls the near fusion of mother and son that Michelangelo would explore in drawings of the Crucifixion and two later sculptures of the *Pietà*.

In the lower left of the vast fresco, the dead are seen issuing forth from graves. In a powerful visualization of the Catholic doctrine describing the resurrection of the body, a skeleton joins its envelope of reawakening flesh. The reborn bodies are assisted in their ascent to heaven by angels (one is hauled to salvation by a rosary), just as, on the opposite side, the damned are thrust violently into hell. Inspired partly by Dante and medieval representations of damnation, Michelangelo is equally imaginative about humanity's fallen state. Wielding his oar is Death's ferryman, Charon, who drives a torrent of doomed souls out of his boat and into the lowest depths of a flaming Hades.

Just below Christ, St. Bartholomew holds the signs of his horrific torture: a knife and his own flayed skin. In a strange form of signature, Michelangelo showed his own distorted features in the limp folds of the saint's epidermis. Perhaps conscious of the hubris of representing eschatological matters, the artist has portrayed himself as a discardable bit of flesh, tenuously hanging over hell … but held in holy hands.

Standing before the *Last Judgment*, the faithful are made painfully aware of their sins but also reminded that salvation and the resurrection of the body are still attainable with the second coming of Christ. Giorgio Vasari declared the fresco "the great exemplar of the grand manner of painting" in which "we are shown the misery of the damned and the joy of the blessed."

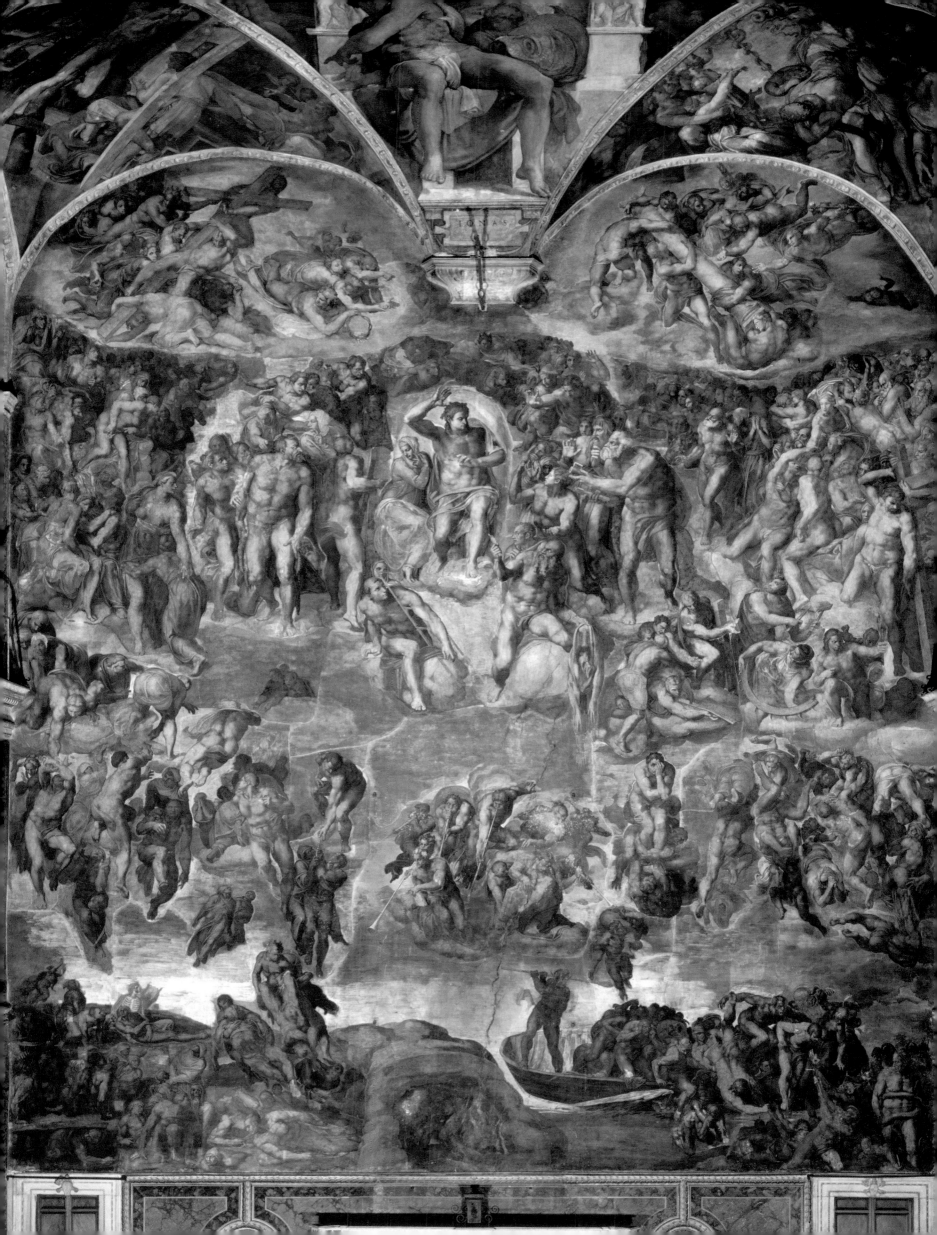

MICHELANGELO
(1475–1564)

Brutus

1540 OR 1548 (?)

MARBLE
HEIGHT: 29 ⅛ IN. (74 CM)
BARGELLO MUSEUM, FLORENCE

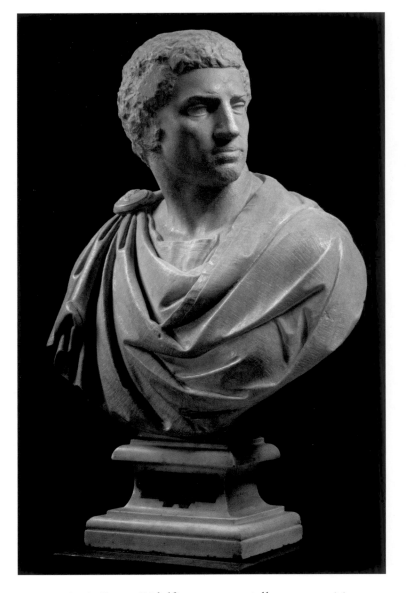

APPROXIMATELY contemporary with his work at the Campidoglio, Michelangelo carved a bust of *Brutus* for his friend Niccolò Ridolfi, a fellow exile from Florence. It is Michelangelo's only true essay in portraiture, an idealized celebration of Marcus Brutus, the murderer of Julius Caesar. The frowning countenance and rough surface suggest the character of the famed man of principle and action, himself fashioned in the roughhewn era of Rome's Republic. Michelangelo has invented his own version of a Republican style, different from the slick finish and soft sensuality of Greek Hellenism or Roman imperialism.

The tyrannicide is dressed in a togalike cloak that is fastened by a large figurated brooch on the right shoulder. The head is turned sharply to the left, revealing the taut muscles of the thick neck. The powerful expression and directed gaze are enhanced by rippling eyebrows, deep-set eyes, and firmly pressed lips. The mat of close-cropped curls contrasts with the smoothness of the face and drapery. Each is textured by the working of the stone to differing degrees, from the lumpy rawness of the hair to the exquisite net of parallel chisel marks that describe the woven cloth. There is nothing unfinished about these passages: the stone is carved to illusionistic ends while the material is never denied.

Clearly Michelangelo has used the unfinished, or rough finish, toward representational ends. The immediacy and forceful presence of the commanding figure, somewhere between life-size and colossal, is enhanced by the roughened surfaces. Curiously, the bust was inspired by an imperial portrait of the emperor Caracalla, making this work yet another example of how Michelangelo fashioned an original creation from the inherited past, brilliantly transforming the image of a despised emperor into a republican hero. As was true throughout the artist's life, antiquity was a catalyst, an articulate language that he forged into his own original manner. *Brutus* may have been inspired by an ancient prototype, but it would never be mistaken as a work from antiquity. Like the *Bacchus*, it is more classical than much ancient art.

Michelangelo's biographers listed Cardinal Ridolfi among the artist's close friends. As the de facto leader of the Florentine exile community in Rome, Ridolfi was a potentially compromising figure. When pressed, Michelangelo protested, "I talk to no one, least of all to Florentines." But these claims of being "always alone" and "talking to no one" are exaggerations that reflect his habitual caution, especially toward political entanglements. Michelangelo's family commonly advised one another to "attend to your own affairs and speak to no one," a sentiment so widespread that it was expressed proverbially: *bocca chiusa, occhio aperto* (mouth shut, eye open). The *Brutus* is most certainly a politically charged sculpture and the best evidence of Michelangelo's lifelong devotion to the ideal of Florentine liberty, willingly purchased even at the price of tyrannicide.

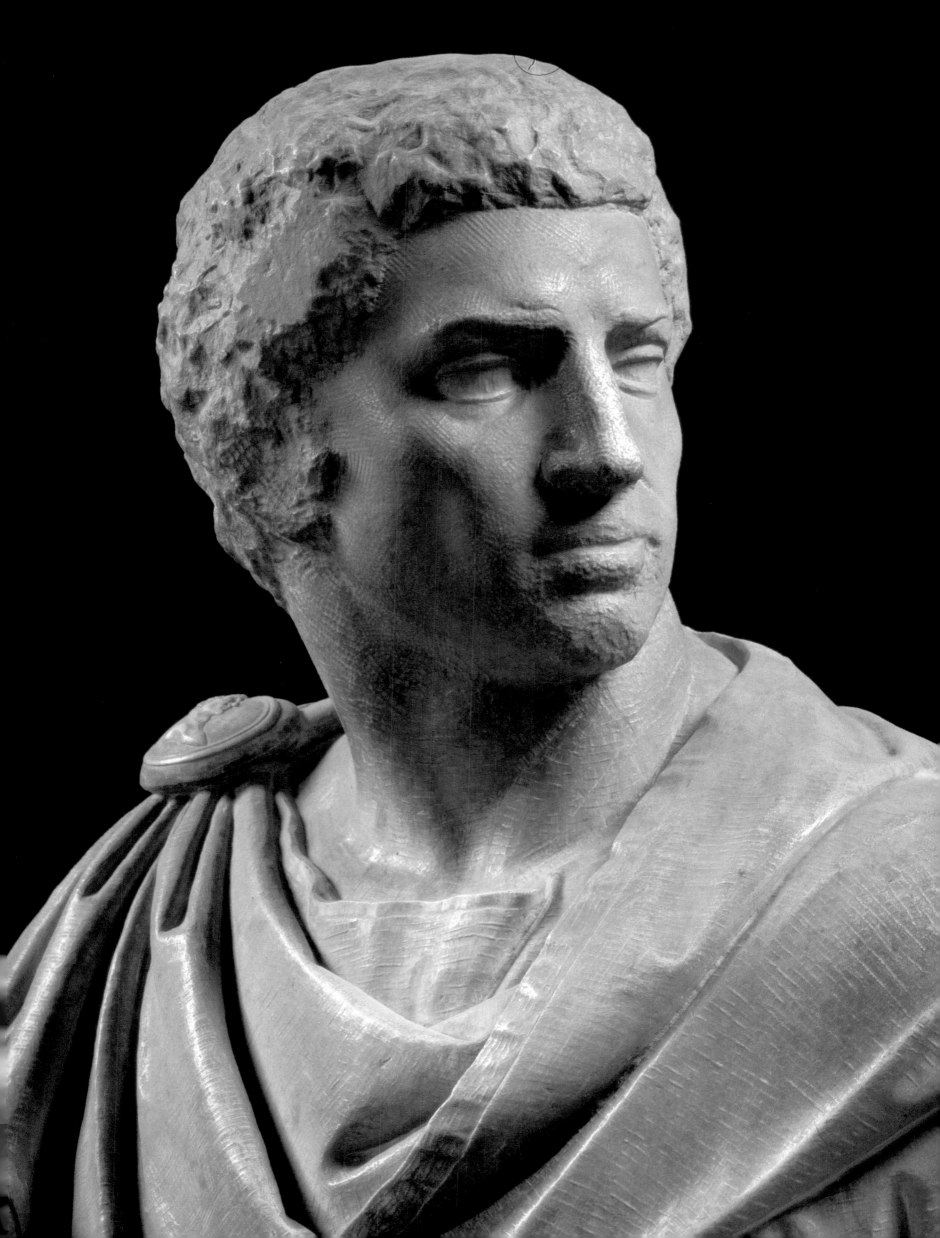

MICHELANGELO
(1475–1564)

The Capitoline Hill

BEGUN CA. 1538

ROME

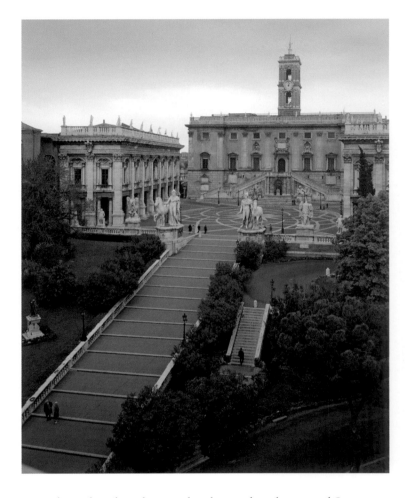

THE CAPITOLINE HILL, or *Campidoglio* in Italian, was the geographical and ceremonial center of ancient Rome. The Temple of Jupiter Optimus Maximus crowned the hill, and from there departed roads linking the far reaches of the empire. By the sixteenth century, the former ceremonial center was little more than an untidy conglomeration of dilapidated buildings and served as the site of criminal executions. It was Pope Paul III who entrusted Michelangelo with the task of refurbishing the ancient capitol.

He began in brilliant fashion by relocating the equestrian statue of the emperor Marcus Aurelius to the center of the site. This ancient bronze had survived the anti-pagan despoliations of the Middle Ages under the mistaken guise of Constantine, the first Christian emperor. By the Renaissance, its correct identity was well established, although the statue continued to be revered as a symbol of ancient authority. Moreover, Marcus Aurelius's great work of stoic philosophy, the *Meditations*, had since earned him respect as a proto-Christian thinker. Michelangelo thus reinvested the site with a venerated symbol of ancient and Christian Rome, fused in one important monument. Around the sculpture, he designed an architectural ensemble at once sober (appropriate to its civic functions) and magnificent (recalling its original function of more than a millennium earlier).

In architecture as in sculpture, Michelangelo looked to the center to find a solution for the disorder that had overtaken the site. He began by defining the torso; the rest was appendage. The equestrian statue provided a focus, and the buildings, like the bones of a body, delineate the torso. In architecture, the torso is space, and it is space that is the impressive achievement of the Capitoline complex. It is a giant outdoor room, a plaza enclosed and protected but open to the sky, made accessible through five symmetrical openings.

A long, tapering ramp *(cordonata)* rises to the broad piazza. The central oval is slightly domed, suggesting the umbilicus of the world: Rome *Caput Mundi*. Articulating the edges of the trapezoidal shape are the Palace of the Conservators (Palazzo dei Conservatori) and a new wing (Braccio Nuovo), set at an irregular, splayed angle to each other and to the central Senate building (Palazzo del Senatore). Michelangelo created a new facade for the dilapidated Conservatori, and he designed the Braccio Nuovo to serve as a mirror complement, providing balance and coherence to the ragged ensemble. The facades are a perfect balance of contending forces: the powerful verticals of the "giant order" pilasters (extending over more than one story) are counteracted by thick horizontal entablatures and the solid square bays of the lower-story arcade. Surfaces are densely layered, appearing simple and strong from a distance, dynamic and densely ornamented up close.

As with many of Michelangelo's architectural projects, most of the Capitoline was realized posthumously, in part, with the helpful oversight of Tommaso de' Cavalieri. The strength and clarity of Michelangelo's design ensured that the result largely reflects his intentions, and the complex is rightly considered among his masterpieces.

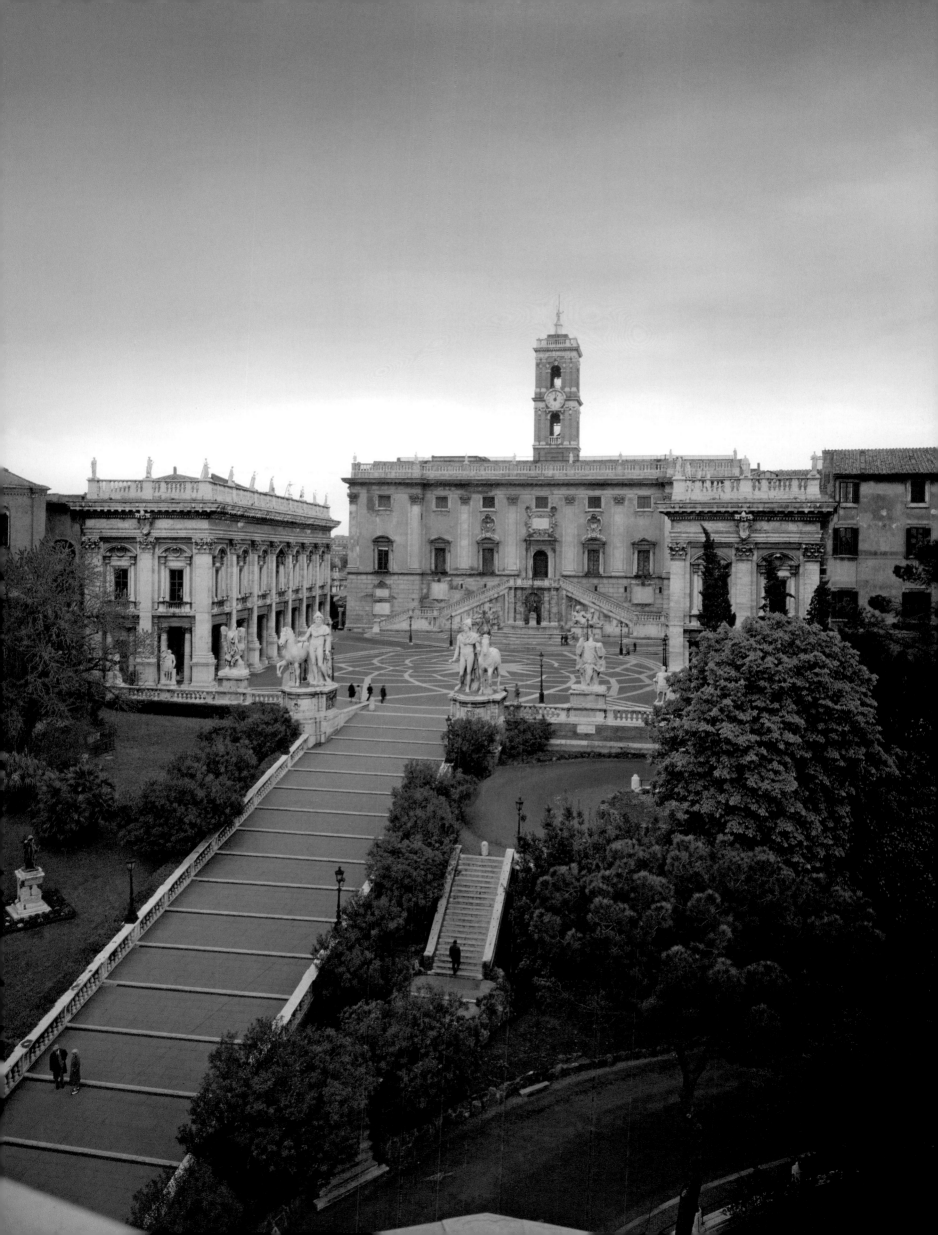

(ABOVE)

MICHELANGELO
Capitoline Hill
BEGUN CA. 1538
ROME, ITALY

(RIGHT)

STEFANO DUPÉRAC
*View of Piazza del
Campidoglio*
1569
ENGRAVING
19 ¾ X 25 ½ IN. (501 X 647 MM)

At a single stroke, Michelangelo
revived the glory and importance
of the ancient Roman capital
while simultaneously creating a
thoroughly modern and impressive
center for city governance. It is one
of the world's most perfectly
designed and satisfying
urban spaces.

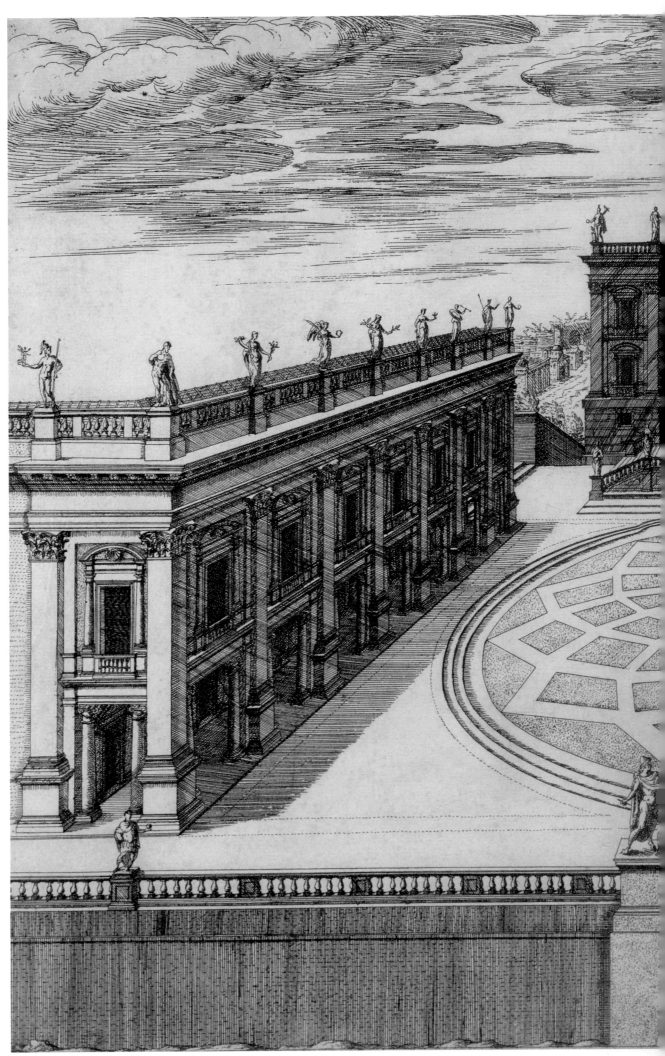

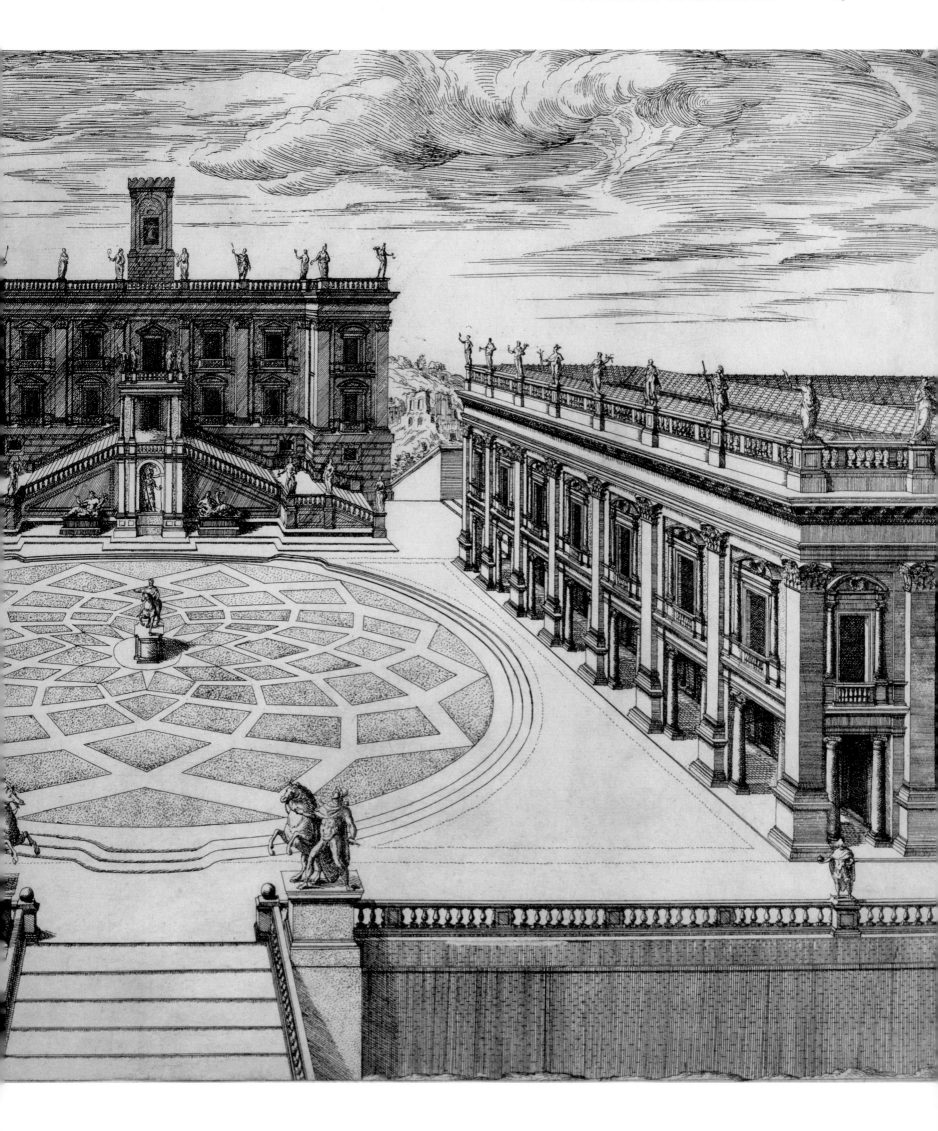

MICHELANGELO

(1475–1564)

Rachel and *Leah*

1505–45

MARBLE
TOMB OF JULIUS II, SAN PIETRO IN VINCOLI, ROME

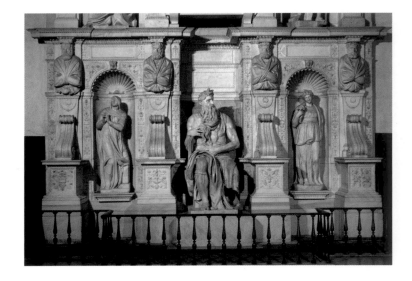

THE COMMISSION for the tomb of Julius II began auspiciously in 1505, when the pope promised to pay Michelangelo the astronomical sum of 10,000 ducats (enough to build a small church) to create a colossal monument decorated with some forty marble statues. Forty years later, the tomb, much reduced but still grand, was finally installed, not in its intended location of St. Peter's but in San Pietro in Vincoli, the titular church of Julius. During this drawn-out history, Michelangelo drafted at least six different designs, signed no fewer than four contracts, and changed his mind several more times. He also carved many sculptures destined for the project, although only three figures by the artist—representing Moses, Rachel, and Leah—adorn the tomb today.

Rachel and *Leah* are allegorical figures carved for the final structure (contract of 1542). Because modern sensibilities are drawn to the expressive power of Michelangelo's sculptures, they have often been perceived as weak or banal. Indeed, it is difficult to fully appreciate their quiet dignity, set in stark contrast to the sublime *Moses* and amid the dense ornament of the tomb's lower story. Michelangelo created purposefully demure, even diminutive, female figures that represent Faith and Good Works, or, as they were commonly allegorized, the contemplative and the active life. In substituting these subjects for the earlier slaves (especially those in the Accademia), Michelangelo turned from a language of exaggerated physicality to one of spiritual yearning, from pagan to Christian allegory expressed in the comely forms of appropriately clothed femininity. The modesty of their size and expression, well confined by the niches that enclose them, is remarkable, given our tendency to think of Michelangelo's titanic forms as bursting the bonds and boundaries of their blocks.

According to the Bible, Leah was not as comely as her sister, but she was favored by God. A knot of drapery draws attention to her womb, evoking her fertility and the six sons she bore Jacob. As though to express the beauty of her inner spirit, Michelangelo has created one of the most majestic and supremely lovely creatures of his entire oeuvre.

In relating the long, tortuous history of the tomb of Pope Julius II, Ascanio Condivi resorted to calling it a "tragedy." Surely he was reflecting Michelangelo's frustrations and lamenting, as many have since, that the tomb, much reduced from its original conception, was great in ambition but disappointing in reality. Still, to imagine what the tomb might have been is to remain blind to what Michelangelo did accomplish. He devoted enormous energy to creating one of the grandest and most noble funerary ensembles of the Renaissance. In Condivi's final judgment, "the tomb is yet the most impressive to be found in Rome and perhaps anywhere else." The number of daily visitors to San Pietro in Vincoli attests to the truth of this statement.

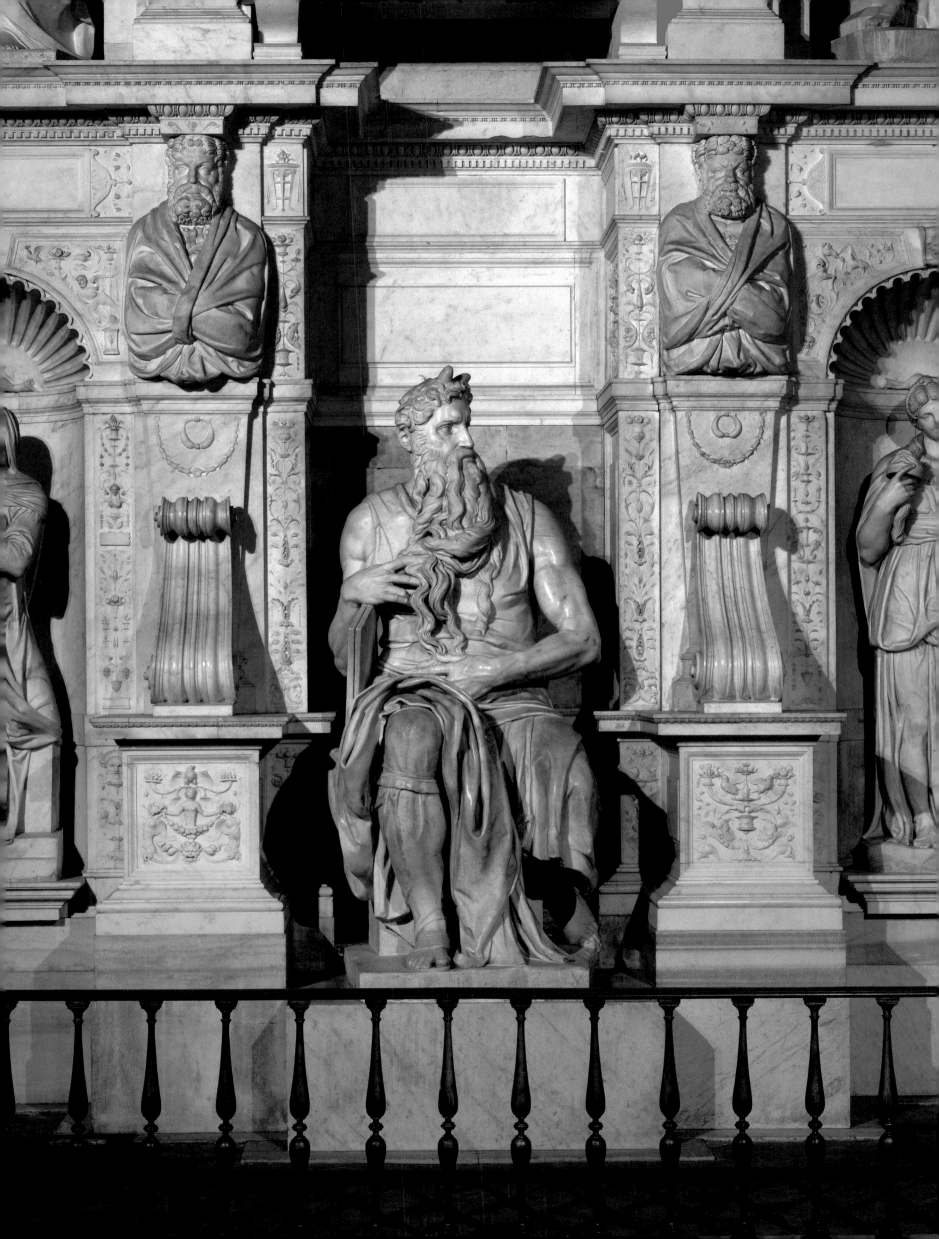

MICHELANGELO
(1475–1564)

Conversion of Saul

COMPLETED 1549

FRESCO
20 FT. 5 IN. X 21 FT. 7 IN (6.2 X 6.6 M)
PAULINE CHAPEL, VATICAN CITY, ROME

WITHIN THE Vatican complex, sandwiched between St. Peter's and the papal apartments, is a chapel containing Michelangelo's last and least-known paintings. The Pauline Chapel, so named for Pope Paul III (reigned 1534–49), who built and dedicated it, served a dual function as Chapel of the Sacrament and Chapel of the Conclave. Here the popes were elected and began their mission as Peter's successor. Where once the College of Cardinals deliberated, the current pope quietly prays; it is one of the innermost sanctuaries of the Christian religion. Pope Paul viewed Michelangelo's paintings shortly before he died in November 1549. After eight years of intermittent work, Michelangelo that same year finished painting the *Crucifixion of Peter*, with the death of his patron fresh in his mind.

Despite the importance of the chapel and its patron, the Pauline frescos are often considered among Michelangelo's least successful works, the products of declining abilities in his old age. The paintings disobey conventional rules of composition, ground planes appear oddly tilted, the scale shifts unexpectedly, and figures are cut off abruptly or exhibit peculiar proportions. In contrast to the well-known Sistine Chapel, this nearby chapel is relatively inaccessible, better known through photographs than first-hand experience. But Michelangelo's frescos are ill served by reproduction. They are best experienced in situ, as decorations flanking the long, narrow space. The oft-remarked oddities of scale and composition are greatly exaggerated when the frescos are seen from the "ideal" frontal view shown in most photographs. In fact, Michelangelo adjusted the arrangement and proportions so that the figures would appear correct, as successive parts in an unfolding narrative, from several, mostly oblique viewpoints. In addition, he was extremely sensitive to the conditions of natural light within the space, locating the subject of crucifixion on a darkened wall while the conversion scene is flooded by direct sunlight.

Upon entering the chapel, our attention is drawn first to the dramatic and well-lit *Conversion of Saul*, on the left wall.

Descending as a bolt of lightning from heaven, a deus-ex-machina Christ causes Saul, oppressor of the Jews, to fall from his horse, which now leaps in terror into the background. Although Saul shields his eyes from the glaring light and is blinded temporarily, this is the moment he first "sees" and converts to Christianity. As Paul, he will begin his mission in the city of Damascus, indicated by Christ's finger pointing to the background.

In innovative, almost cinematic, fashion, Michelangelo created compositions that unfold like continuous narratives as the viewer walks the length of the chapel. We become more than mere spectators of the events of Christian history; we are made responsible participants. Rather than revealing evidence of declining abilities, the Pauline frescos evince Michelangelo's prodigious inventiveness and sensitivity as a narrative painter. These were his last paintings, and very nearly the last works of art he ever completed.

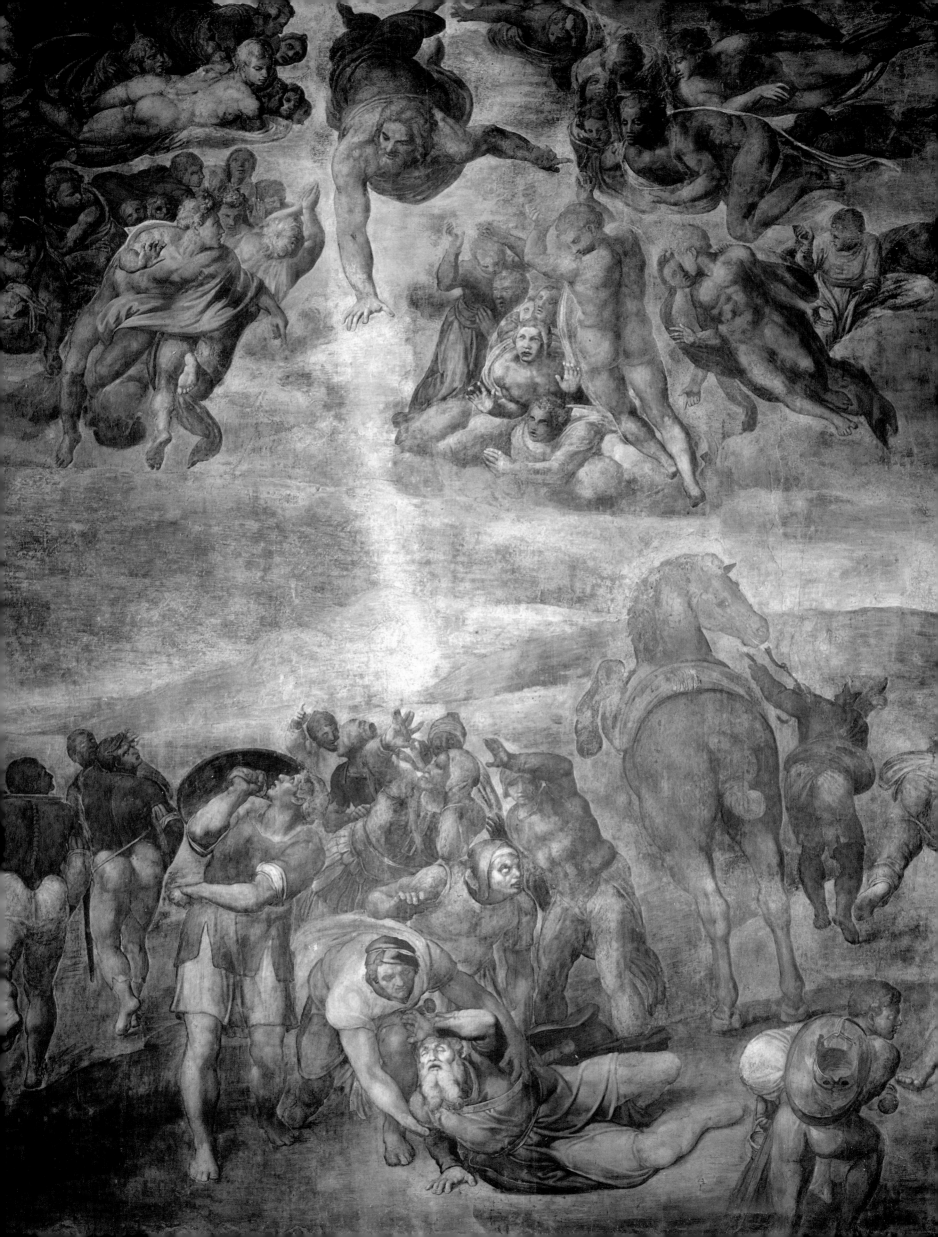

MICHELANGELO
(1475–1564)

Crucifixion of Peter

COMPLETED 1549

FRESCO
20 FT. 5 IN. X 21 FT. 7 IN (6.2 X 6.6 M)
PAULINE CHAPEL, VATICAN CITY, ROME

ON THE WALL opposite the *Conversion of Saul* is the much darker *Crucifixion of Peter*. Just as the former is enhanced by the fall of natural light, so, too, the drama of the latter is intensified by its absence. An atmosphere of foreboding and tragedy, heightened by the semidarkness, enshrouds the slow-moving and ponderous figures. The crucifixion scene is a disturbing subject that, without the aid of artificial lighting, is difficult to see and nearly impossible to grasp in its entirety. Our inclination is to penetrate the gloom by moving closer to the wall, where we discover, disconcertingly, a group of huddled women mourners, two of whom stare back at us unremittingly. In the words of Kenneth Clark: "They are like a Greek chorus, intermediaries between us and the tragedy."

A giant figure, sometimes identified as a self-portrait of Michelangelo, looms above and appears to stride into our space. Its unusual proportions have been frequently remarked upon, but its size is dependent on our proximity to the scene and the angle from which it is viewed. Toward the left side of the composition, we join the cortege of soldiers that climbs the hill to the site of Peter's torment. The mounting figures on the left and their descending counterparts on the right describe a slow circular motion, which is echoed in the raising of the cross and further suggests the circular *tempietto* that was built over this sacred site.

The *Conversion of Saul* unfolds dramatically before the spectator as a rapid series of vignettes; the *Crucifixion of Peter* occurs with greater solemnity. The magnitude of Peter's act is comprehended as slowly as it takes to view it. In both cases, but in significantly different ways, Michelangelo has convincingly and forcefully included us in the drama, guiding our perception as well as our understanding of the events.

The narratives that unfold to the left and right culminate at the altar, the view of the pope. The multifigure compositions and separate narrative vignettes are distilled to their essential elements. From the former confusion, we distinguish Saul and the crucified

Peter, whose piercing gaze makes a powerful and lasting impression. For the pope and cardinals who gathered in the chapel, Peter serves as admonition and dispensation, bestowing a burden and a blessing. He reminds us that sacrifice is the duty of all Christians, and it is through devotion to Christ that the faithful will gain eternal life. The pope at the altar is encouraged to reflect on his predecessors and his mission as Christ's vicar. The Christian pilgrims are made privileged witnesses to Saul's dramatic conversion and Peter's heroic martyrdom.

On the death of a pope, the College of Cardinals meets in a secret conclave to elect a new pontiff. Until the required majority vote of two-thirds plus one is reached, the cardinals remain confined to the Vatican Palace, sometimes for several weeks. Originally, the cardinals met in the Pauline Chapel; elections are now held in the nearby and larger Sistine Chapel.

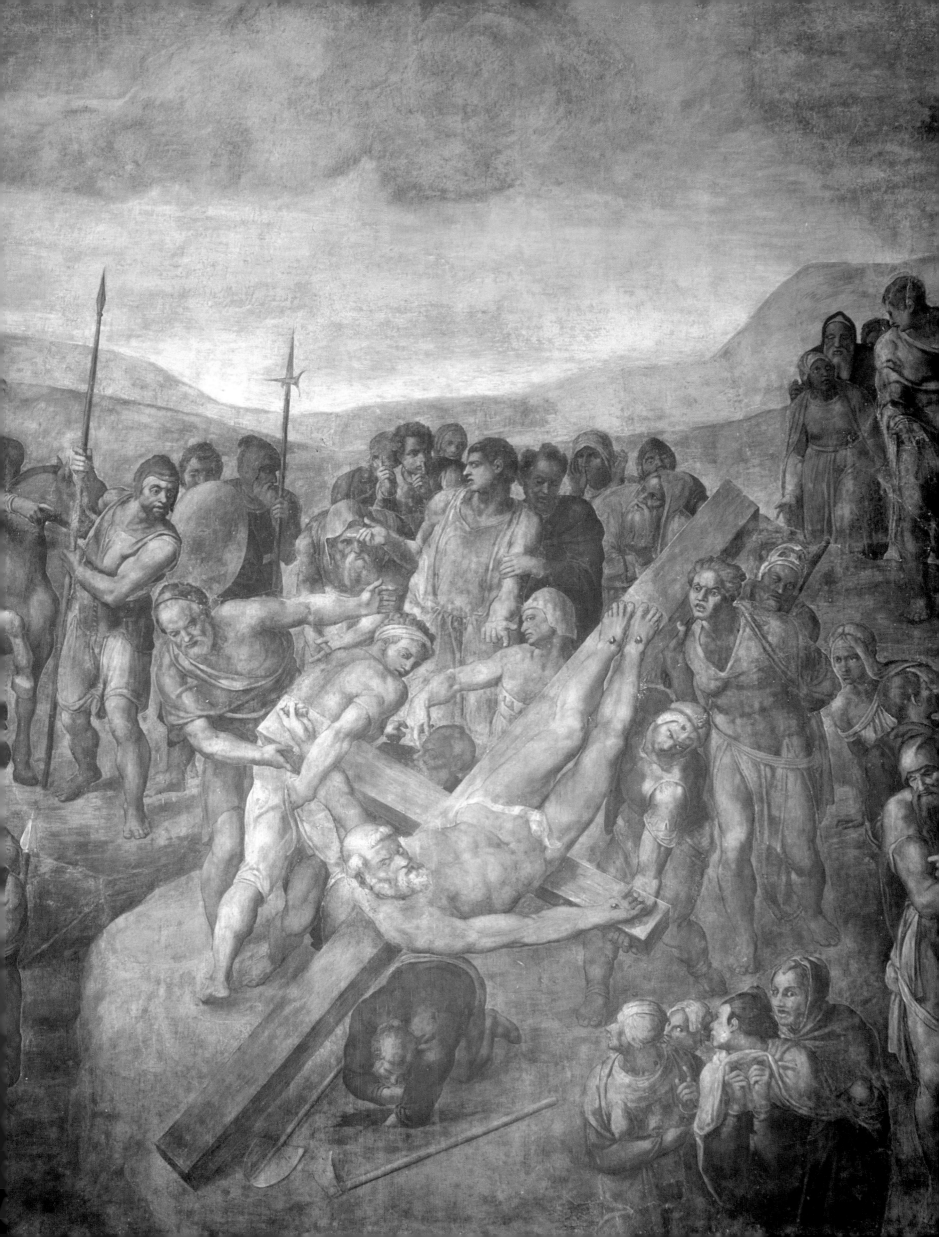

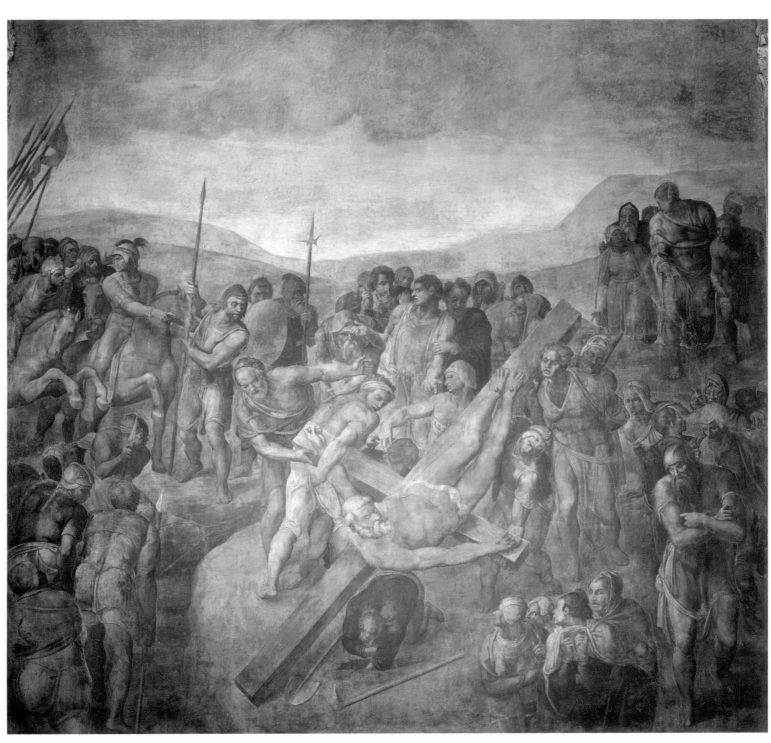

(ABOVE)

MICHELANGELO
Crucifixion of Peter
COMPLETED 1549
FRESCO
20 FT. 5 IN. X 21 FT. 7 IN (6.2 X 6.6 M)
PAULINE CHAPEL, VATICAN CITY,
ROME

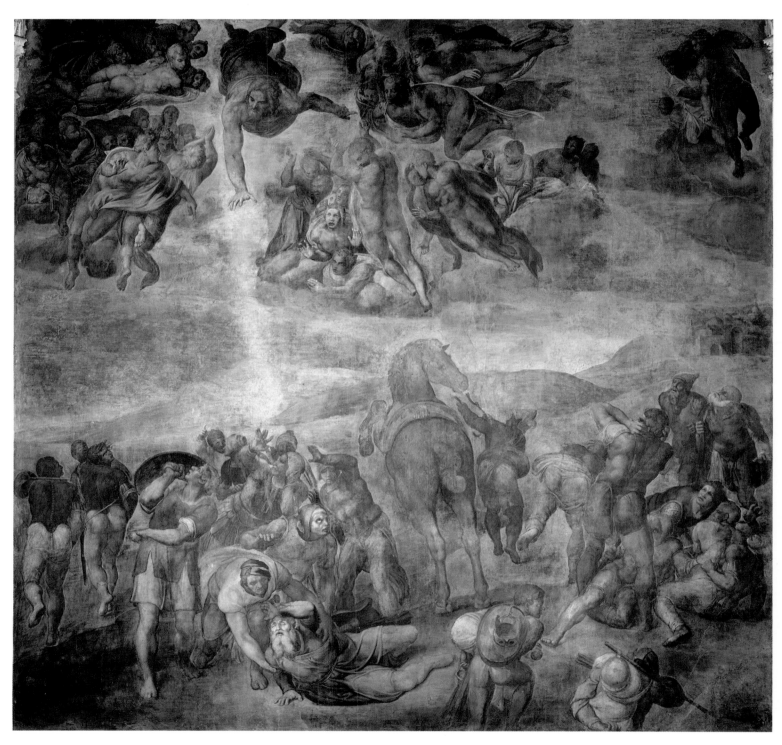

(ABOVE)

MICHELANGELO
Conversion of Saul
COMPLETED 1549
FRESCO
20 FT. 5 IN. X 21 FT. 7 IN (6.2 X 6.6 M)
PAULINE CHAPEL, VATICAN CITY,
ROME

Although less accessible and less well known than the nearby Sistine Chapel, these frescoes are Michelangelo's last painted works and his greatest achievement in narrative painting. Situated at the heart of the Vatican and created at a time of religious turmoil, the pair of early Christian subjects affirms Catholic belief in saints and relics, conversion and personal sacrifice.

MICHELANGELO

(1475–1564)

New St. Peter's

1546–64

VATICAN CITY, ROME

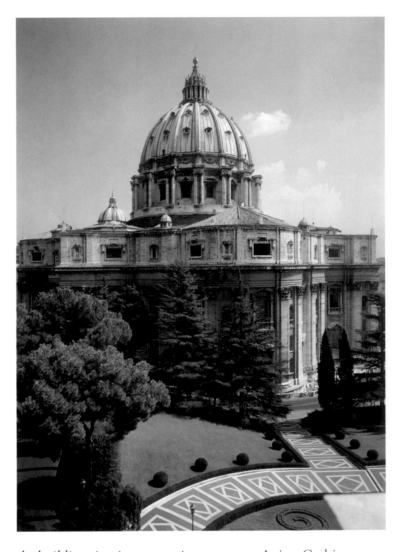

ON JANUARY 1, 1547, Pope Paul III appointed Michelangelo supreme architect of St. Peter's, "to his intense dismay and completely against his will." It was a dubious honor. He inherited a recalcitrant workforce and a bevy of thick-headed, obstructionist overseers as passionately loyal to the former architect, Antonio da Sangallo, as they were skeptical of the new one. Michelangelo was seventy-one years old at the time, and he would devote the remaining seventeen years of his life to the project.

Alterations to Old St. Peter's began in the mid-fifteenth century, but it was Donato Bramante who undertook the real business of building a new basilica during the reign of Pope Julius II (1503–13). As Michelangelo labored on the pope's tomb and painted the Sistine Chapel ceiling, he bore witness to the insensitive destruction of Emperor Constantine's venerable basilica and the sometimes incompetent, mostly inarticulate efforts to replace it with a new church.

Despite Michelangelo's propensity to grandiosity, his greatest contributions to the new church include reviving Bramante's initial conception and correcting its engineering deficiencies. In removing much intervening construction, Michelangelo reversed nearly forty years of building history, a feat that must have demanded enormous faith, courage, and vision on the part of both artist and patron. The resulting concentration reinvested the church with exterior and interior clarity. From the outside, the structure is a compact sculptural mass; inside it is an expansive, luminous, and uplifting spatial experience.

The outer skin of St. Peter's is a sort of architectural geology: like giant tectonic plates, great slabs of stone rise, sink, slide, and buckle. Wall surfaces are layered, overlap, and ripple with movement. The densely packed pilasters and rhythm created by blind and open niches obliterate simple surfaces. Michelangelo invented a "giant order" of monumental proportions. Each travertine pilaster stretches to vast vertical dimensions, extending past two oversize windows in one bay and three in the next. The vertical thrust is so great that only the weight of the attic and cornice is enough to counteract the upward surge. The dome both continues and concentrates these vertical forces. From ground to lantern,

the building rises in one continuous sweep. As in a Gothic cathedral, the solid mass and complex surface of the exterior contrast with the spacious, luminous interior. At the center of the immense building is the grave of St. Peter; over this venerated spot soars the majestic, light-filled dome.

Michelangelo remained devoted to the project despite setbacks and the determined efforts by Duke Cosimo de' Medici to lure him back to Florence. He worked on the building for less than twenty years, but in that time he corrected what had gone before and largely shaped what was to follow. From this point onward, St. Peter's remained Michelangelo's foremost concern and his best hope for remission from his sins. Despite changes inflicted on St. Peter's during its approximately 150-year construction history, we rightly think of it as Michelangelo's masterpiece. It was the largest church in Christendom, a prominent symbol of papal authority, and a crowning achievement of Michelangelo's art.

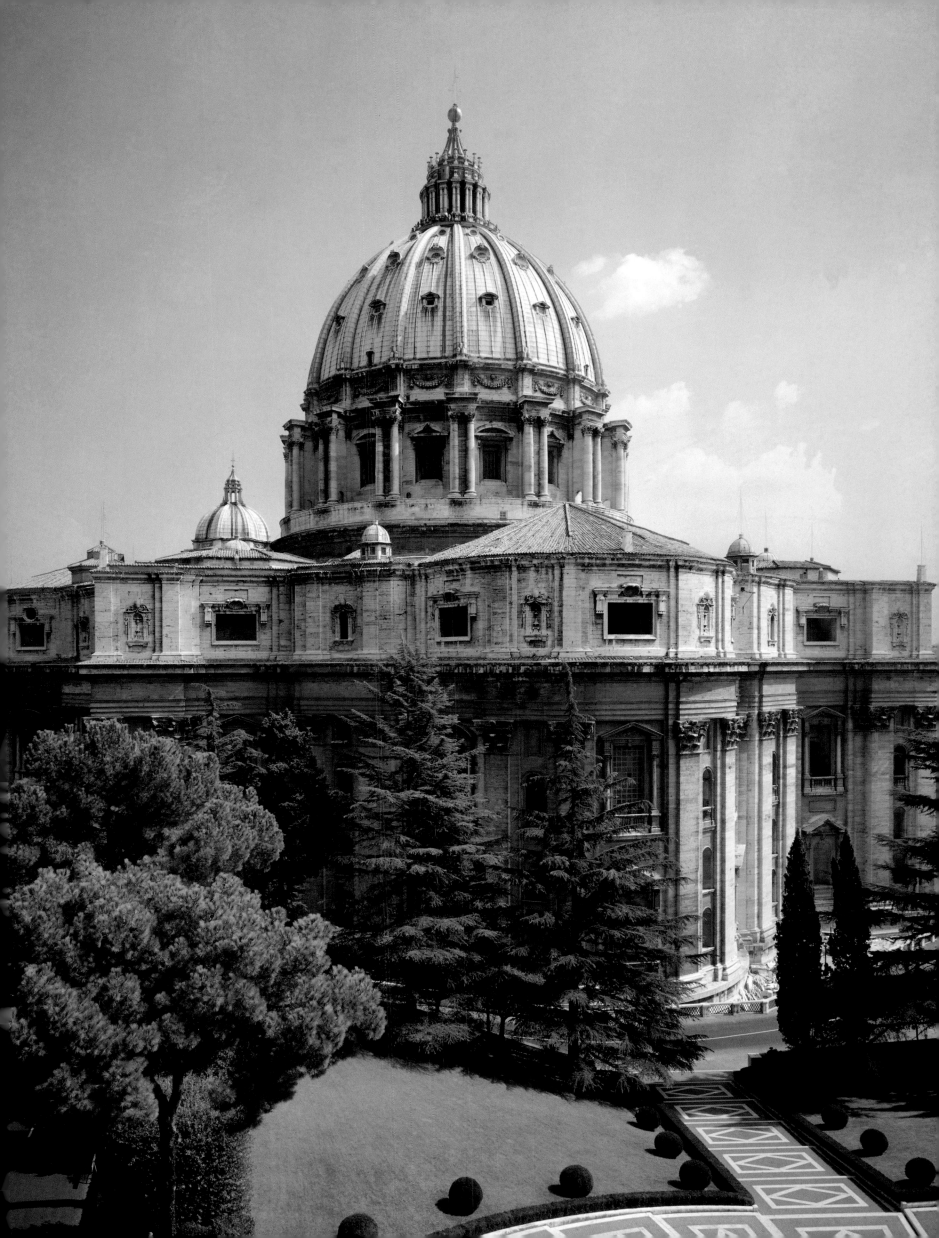

MICHELANGELO

(1475–1564)

Pietà

CA. 1547–55

MARBLE
HEIGHT: 89 IN. (226 CM)
MUSEO DEL OPERA DEL DUOMO, FLORENCE

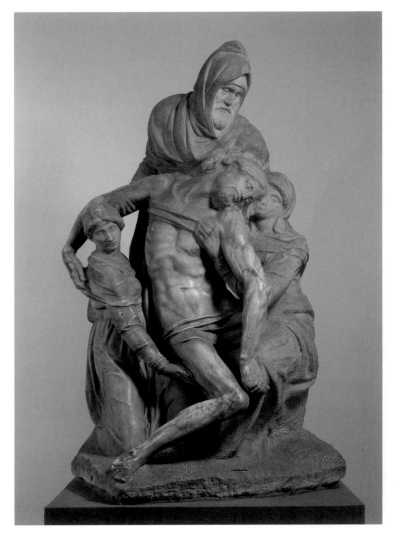

THE SO-CALLED Florentine *Pietà* is, after the *David*, the largest and most ambitious sculpture ever carved by Michelangelo. He was returning to one of his earliest subjects as well as to an early challenge posed by the most famous ancient sculpture: the *Laocoön*. From the time of its discovery in 1506, Michelangelo was aware that the three-figure statue had not been carved from a single block, as the Roman author Pliny had maintained. This knowledge merely intensified the challenge: could a modern artist succeed where antiquity had failed? Michelangelo attempted not only to rival the classical past but also to surpass it by carving four figures from one piece of marble.

The problems inherent in carving a three-figure group are enormous; those attendant to carving four figures from a single block are exponentially more complex. It was a feat rarely attempted even by Gian Lorenzo Bernini or the great marble technicians of the seventeenth and eighteenth centuries. Giorgio Vasari implicitly recognized the exceptional undertaking when he saw the sculpture in progress and anticipated that "it will surpass every other work of his." But the *Pietà* was never finished.

Michelangelo tended to change his mind while working. He had learned to quarry extra-large blocks to allow sufficient material to alter the form and disposition of figures as he carved. But a multifigure composition leaves little excess stone. The Virgin is already too small compared to the bodies of Christ and the standing Nicodemus. In fact, there is not enough marble to complete her face without compromising the more realized head of her dead son. Similarly, Michelangelo left insufficient material to finish carving Mary's left hand, which rests on Christ's chest. And then the artist encountered an even more intractable problem when forming Jesus's left leg. Whether the marble broke or was purposefully removed is uncertain, but the limb has been trimmed to receive an attachment. Such expediency was contrary to Michelangelo's notion that true sculpture is created from a single block of stone. These are the sorts of problems whose cumulative effects may have resulted in his abandoning the sculpture. Perhaps we are reluctant to imagine the mature master meeting irreconcilable difficulties, but it seems we are witness to

a combination of personal and technical impediments that plagued this project.

The *Pietà* includes a self-portrait of the artist in the guise of Nicodemus, who was himself a sculptor and a secret follower of Christ. Like Nicodemus, Michelangelo was devoted to his savior, a "pilgrim soul," a seeker of salvation. The sculpture is an eloquent expression of the artist's faith, and it was intended to mark his grave. But there lay a dilemma. To finish the sculpture was to bring the marble to life, but also to resign oneself to death. For any number of technical and psychological reasons, it was destined to remain incomplete. Yet despite damage and its troubled history, the Florentine *Pietà* remains a moving and satisfying work of art.

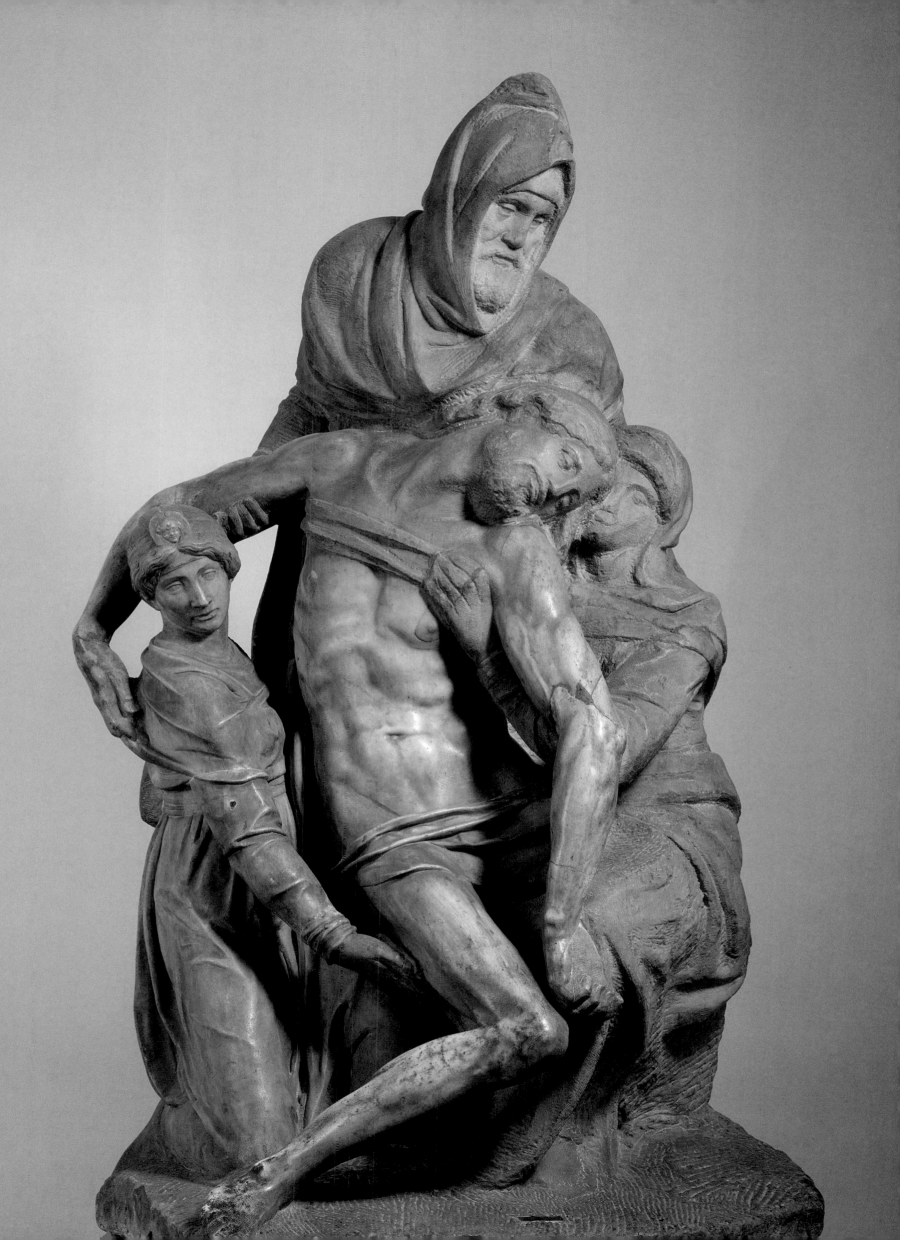

MICHELANGELO

(1475–1564)

Porta Pia

CA. 1561

ROME

FROM THE TIME of Pope Paul's pontificate (1534–49), Michelangelo devoted much of his attention to architecture, thus helping to transform Rome from a dilapidated ancient metropolis into a modern Christian capital. His contribution to the city's future lay in the scale and audacity of the vast number of projects he undertook: the Campidoglio, the Farnese Palace, San Giovanni dei Fiorentini, Santa Maria degli Angeli, the Porta Pia, and St. Peter's.

The Porta Pia and Santa Maria degli Angeli were part of Pope Pius IV's (reigned 1559–65) campaign of urban renewal and development in the outlying districts of Rome. A long, straight street, aptly named the Via Pia (today the Via XX Settembre), was extended from Monte Cavallo to the distant city wall. Densely populated in ancient times, the area was sparsely inhabited throughout the Renaissance. On large tracts of open land, the local elite built luxury villas and cultivated gardens and vineyards. Everywhere was evidence of the city's former grandeur: in the ruined hulks of buildings, fragments of ancient walls, and stretches of mostly nonfunctioning aqueducts. The new Via Pia passed through a fortified gate near the ancient camp of the Praetorian Guard (*Castra Praetoria*) and continued northeast, toward the town of Mentana and the Sabine Hills. The gate was not heavily trafficked. Then, as now, it was viewed mainly from *within* the walls, and it was this curious orientation that Michelangelo emphasized: a gate that faces inward, toward the city.

Michelangelo worked through his ideas for the Porta Pia in dense, layered drawings that anticipate the three-dimensional surfaces of his architecture. In the remarkable example preserved in the Casa Buonarroti, we can trace the gate's rapid evolution from conservative to extravagant design, from an architecture that obeys rules and employs a classical language to a new and highly original conception. The work reveals the artist's characteristically intense concentration on a problem, his manner of combining alternative solutions, and his tendency to enlarge a design while in the act of drawing. The constant revision finds a counterpart in Michelangelo's contemporaneous figural drawings, especially his late religious works, in which the artist's hand appears reluctant to abandon the sheet. Seldom before or since has the three-dimensionality of architecture been so powerfully evoked in the two-dimensional medium of drawing.

The gate as it was constructed retains many of the qualities anticipated in the preliminary designs and reveals several novel features: multilayered pilasters with earlike appendages, pediment fragments that suggest giant springs under tension, extravagant blind windows floating in broad expanses of brick, and carnival-like crenellations capped by travertine balls. The Porta Pia metamorphoses the genre of fortified city gate. Rather than asserting military might, it is a porous diaphragm that signals the edge of "civilization," between city and country, urbanity and rusticity. The traditional purposes of protecting the town and marking its boundaries remain but are subverted, through both whimsy (*fantasia*) and the grotesque.

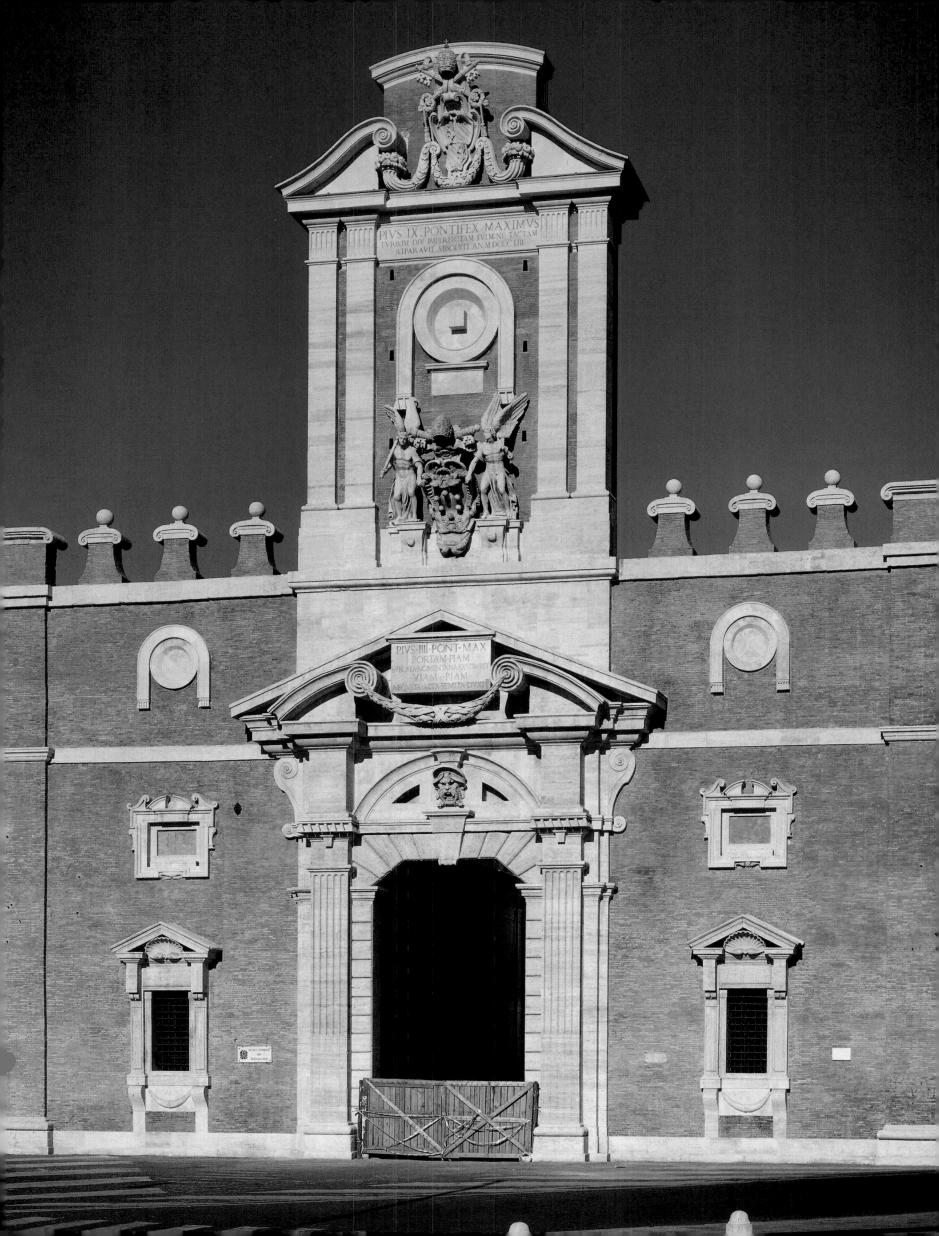

(LEFT)

MICHELANGELO
Porta Pia
CA. 1561
ROME

(RIGHT)

MICHELANGELO
Drawn Design for Porta Pia
CA. 1561
BLACK CHALK, PEN, AND BROWN
INK WASH WITH HIGHLIGHTS ON
PAPER
17 ⅜ X 11 ⅛ IN. (441 X 282 MM)
CASA BUONARROTI, FLORENCE

Both the drawing and the gate built
from it are strange architectural
fantasies, but ones that inspired
many subsequent architects to take
greater license with the rigid rules
of classical architecture. There is
nothing "by the book" in what
Michelangelo invents.

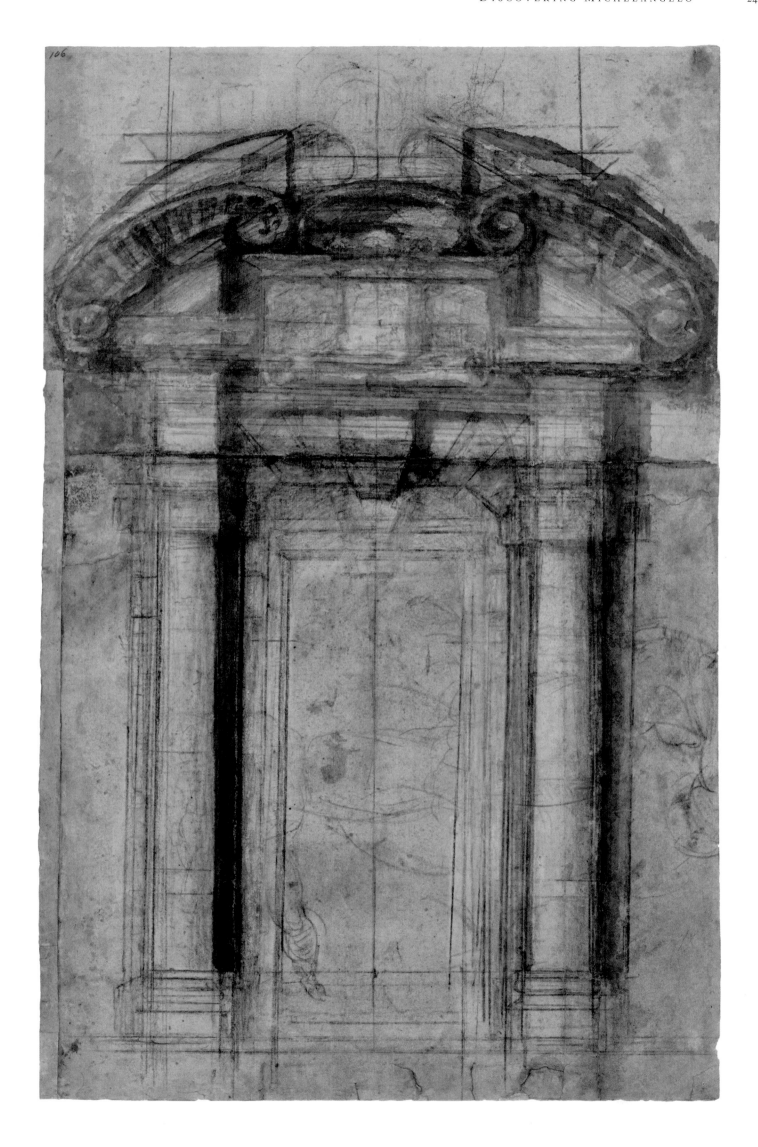

Michelangelo
(1475–1564)

Plan of San Giovanni dei Fiorentini

1559–60

Pen with brown ink and wash on paper
Approx. 16 ½ x 14 ¾ in. (417 x 376 mm)
Casa Buonarroti, Florence

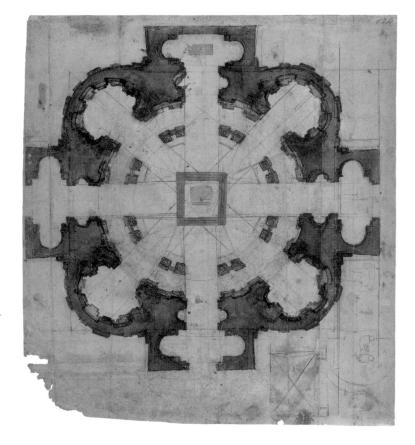

Construction of a new church in Rome for the Florentine nation, aptly named San Giovanni dei Fiorentini, after their patron saint, had been decided upon as early as 1518, during the pontificate of Pope Leo X. Virtually every Florentine architect (and some foreign ones) showed interest in the project, with the predictable result that nothing much was accomplished. Antonio da Sangallo (1484–1546) was the most prolific in providing plans for a new church. Upon Sangallo's death, the church became yet another task eventually inherited by Michelangelo.

In mid-1559, Michelangelo was approached by members of the Florentine community to propose a design for the church. Using his work on St. Peter's as an excuse, the artist had repeatedly refused Cosimo de' Medici and was unwilling to consider the proposal unless the duke approved. This prompted a gracious letter from the latter requesting that Michelangelo furnish a design for the national church. Thus, while Cosimo awaited Michelangelo's return to Florence, he employed the artist on a "Florentine" commission in Rome.

By this time in his career, Michelangelo was working closely with the artist Tiberio Calcagni, who provided on-site supervision for many architectural projects. Calcagni proved an especially valuable aid during the design phase of San Giovanni dei Fiorentini. As Michelangelo had admitted to the duke, his advanced age greatly inhibited his ability to draw neatly (he was well into his eighties at the time); therefore, he relied on Calcagni to make finished drawings from his designs. Michelangelo further entrusted his assistant with traveling to Florence, in March 1560, to present the project to the duke, who was much taken with Calcagni's gracious manners and the "most beautiful design" submitted by Michelangelo.

Several of Michelangelo's drawings amply attest his imaginative approach to architecture as dynamic space rather than enclosing box. The designs reveal his process of condensation and consolidation, similar to the one in evidence at St. Peter's. He was thinking from the inside out—from the spatial core of a building to its external skin.

The plan for San Giovanni dei Fiorentini, now in the collection of Casa Buonarroti, is one of the most dynamic and impressive architectural drawings of the Renaissance. For all its familiarity through frequent reproduction, the large sheet is visually stunning and still a surprise when seen "in the flesh." Pairs of swiftly ruled parallel lines articulate broad corridors radiating from a central dome. The building appears to have been sculpted from a solid block, with its perfectly symmetrical and dynamic interior neatly contained by the building's robust epidermis. Entrusted with this design, Calcagni supervised construction of a wood model, whose appearance is recorded in an engraving. Delays, funding problems, and Michelangelo's death just four years later resulted in his design never being realized. In contrast to this powerfully articulated, centralized plan, the church that stands today on the Tiber embankment appears as little more than a banal pile, the architectural inventiveness of its architect, Giacomo della Porta, paling in comparison to the masterful vision of Michelangelo.

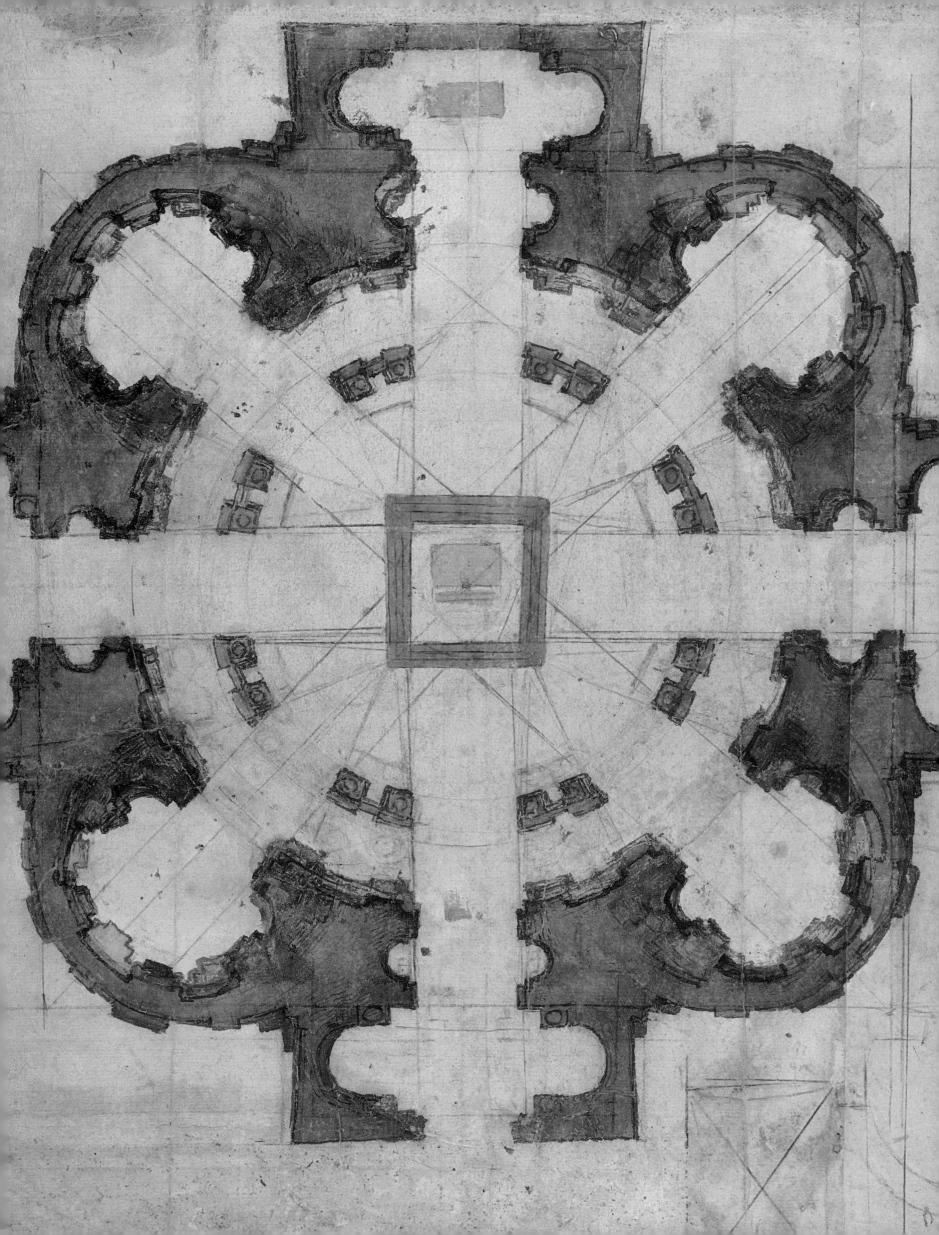

MICHELANGELO
(1475–1564)

Cartonetto of the Annunciation

CA. 1547

BLACK CHALK ON PAPER
15 ⅛ X 11 ¹¹⁄₁₆ IN. (383 X 297 MM)
THE MORGAN LIBRARY & MUSEUM, NEW YORK

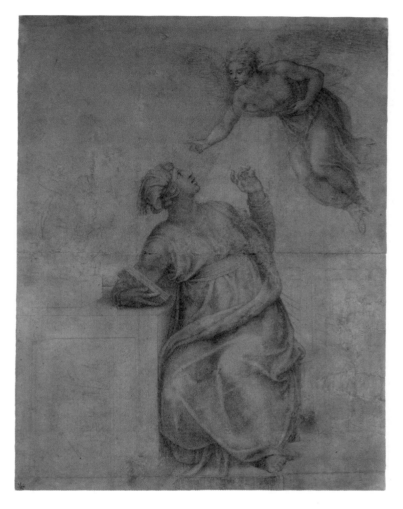

AN ESSENTIAL aspect of Michelangelo's later career was the steady increase of demands made upon him. As he grew older, it seemed that everyone wanted something from his hand, "*di sua mano*." With the great architectural projects of St. Peter's, the Capitoline Hill, and the Porta Pia, Michelangelo had less time—and perhaps less inclination—to paint and carve the sort of unique, single-author works that had characterized his early career and helped establish his reputation. Only occasionally did he fulfill requests for work, and he increasingly satisfied demands by furnishing drawings to other artists. Primary among these is an artist who today receives too little regard: Marcello Venusti.

Venusti (ca. 1512–1579) first came to Michelangelo's attention after painting a large-scale copy of the latter's *Last Judgment* on commission for Cardinal Alessandro Farnese. Michelangelo was drawn to Venusti's highly polished, enamel-like manner, a style much in demand in the sixteenth century but little regarded today. In the 1540s he elected to collaborate with the younger artist, and the two men became friends. (Michelangelo even acted as godfather to Venusti's first child, who was named after the master.) So began a long and fruitful collaboration: Michelangelo drew designs that Venusti then translated into paint. Because Renaissance connoisseurs credited the author of a design rather than its painter or craftsman, such pictures were attributed to Michelangelo. These collaborative works were wildly popular and often copied, which has left the false impression that Venusti was little more than a copyist.

From designs furnished by Michelangelo, Venusti painted two large altarpieces for the Roman churches of Santa Maria della Pace and San Giovanni in Laterano. In addition, he executed smaller pictures from several of Michelangelo's drawings, including versions of this Annunciation and the *Crucifixion*, *Pietà*, and *Christ and the Woman of Samaria* presented to Vittoria Colonna. The sheer number of replicas attests the fame of Michelangelo's conceptions, the widespread desire for examples of his art, and the central importance of Venusti in satisfying a rapidly growing demand. Yet, far more than a tool to increase

artistic production, Venusti was a talented associate who also helped spark the master's creativity.

This highly finished black chalk drawing of the Annunciation was long attributed to Venusti largely because scholars preferred Michelangelo's rapidly drawn sketches to such highly refined and carefully crafted, jewel-like designs. As the influential critic Bernard Berenson wrote: "The highly elaborated, smoothly finished design is likely to be either a failure or an absurdity." Berenson was adamant that drawings such this could not possibly have been created by the master. Now the pendulum has swung in the opposite direction. Not only do we accept and admire such drawings, but some scholars suppose that the exquisite paintings Venusti made from them were painted by Michelangelo himself. Poor Marcello! We have a harder time recognizing the qualities of this fine artist than did Michelangelo, who chose to collaborate with Venusti and genuinely admired his unique style.

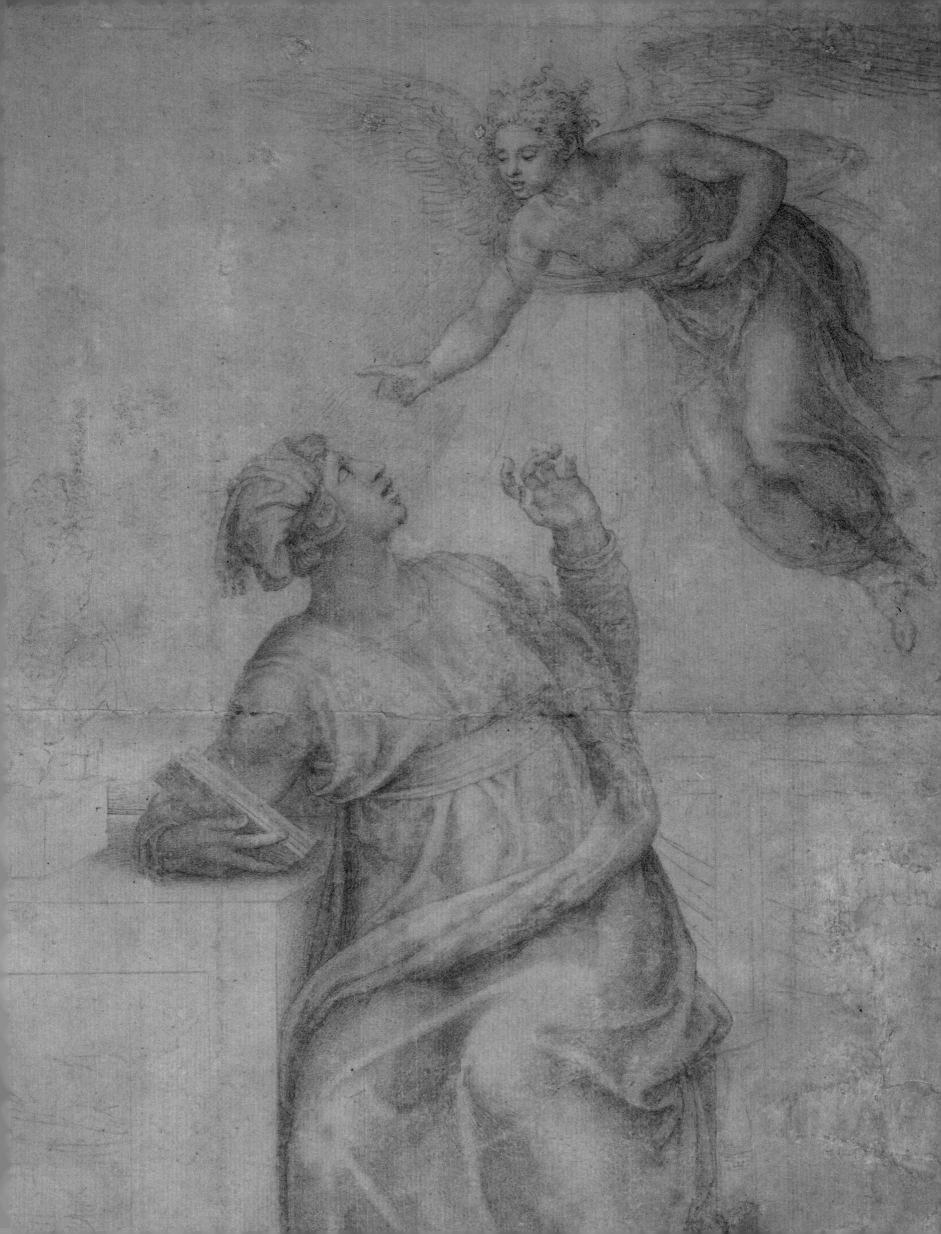

MICHELANGELO

(1475–1564)

Crucifixion

1550–60

BLACK CHALK ON PAPER
16 ⅛ X 11 IN. (410 X 278 MM)
BRITISH MUSEUM, LONDON

As MICHELANGELO grew older, drawing and poetry became his most important vehicles of creative expression. In a series of moving and intensely personal drawings of the crucifixion, he distilled matters of his faith. He repeatedly drew the same subject, as though, through the caressing marks of chalk on paper, he could approach even closer to Christ. These haunting images are the visual equivalent of the artist's deeply felt religious poetry.

In the example shown here, Mary and John huddle close to the cross, as though seeking the last bit of warmth in the dying flesh of their son and savior. In another, Christ hangs limply on a Y-shaped cross, his face obscured by the shadow of death. His drooping head and straggling matted hair suggest his expiration, yet in his last living moment he commends his mother to John's care. The figures are ghostlike, hunched by the weight of their grief. A heavily cloaked Mary extends her right arm in a gesture that both presents her son and expresses her anguish. Her arms are folded across her chest, a private clutching at sorrow. In the double set of limbs, as in the repeated shivering contours of the figures, we see not anatomical freaks but figures in motion, successive moments in a tragic drama.

Drawings such as this allowed Michelangelo to come into physical contact with Christ. In the repeated contours, we bear witness to the artist's hand attempting to reach out to his Lord. In a perfect fusion of art and life, Christian viewers may be moved to prayer and to poetry, thus lending voice to their mute pain. In imagining Christ's death, Michelangelo became supremely aware of his own mortality. In his later years, the inexorable creep of age was his constant companion, as is evident when he wrote, "No thought is born which does not have death within it."

Along with most other commentators, I assume that some of Michelangelo's late religious poetry complements, if not accompanies, these drawings. In a literary equivalent to such haunting imagery, the artist sounds his appeal: "O Lord, in my last hours, stretch toward me your merciful arms, take me from myself and make me one who'll please you." In yet another poem he wrote:

Let your blood alone wash and glaze
and touch my faults. Let full pardon enfold
me, abounding all the more, the more I grow old.

At times, Michelangelo must certainly have created poetry and drawing together. One imagines him hearing verses as he sketched, picturing these tremulous images while putting words to paper. In similar fashion, he moved easily between poetry and sculpture. Each is simply a different form of shaping—the fashioning of raw materials to create art, whether from words or from stone. Poet and artist were one, divine. Because, like the God in which he so strongly believed, Michelangelo used inert materials to create art and life.

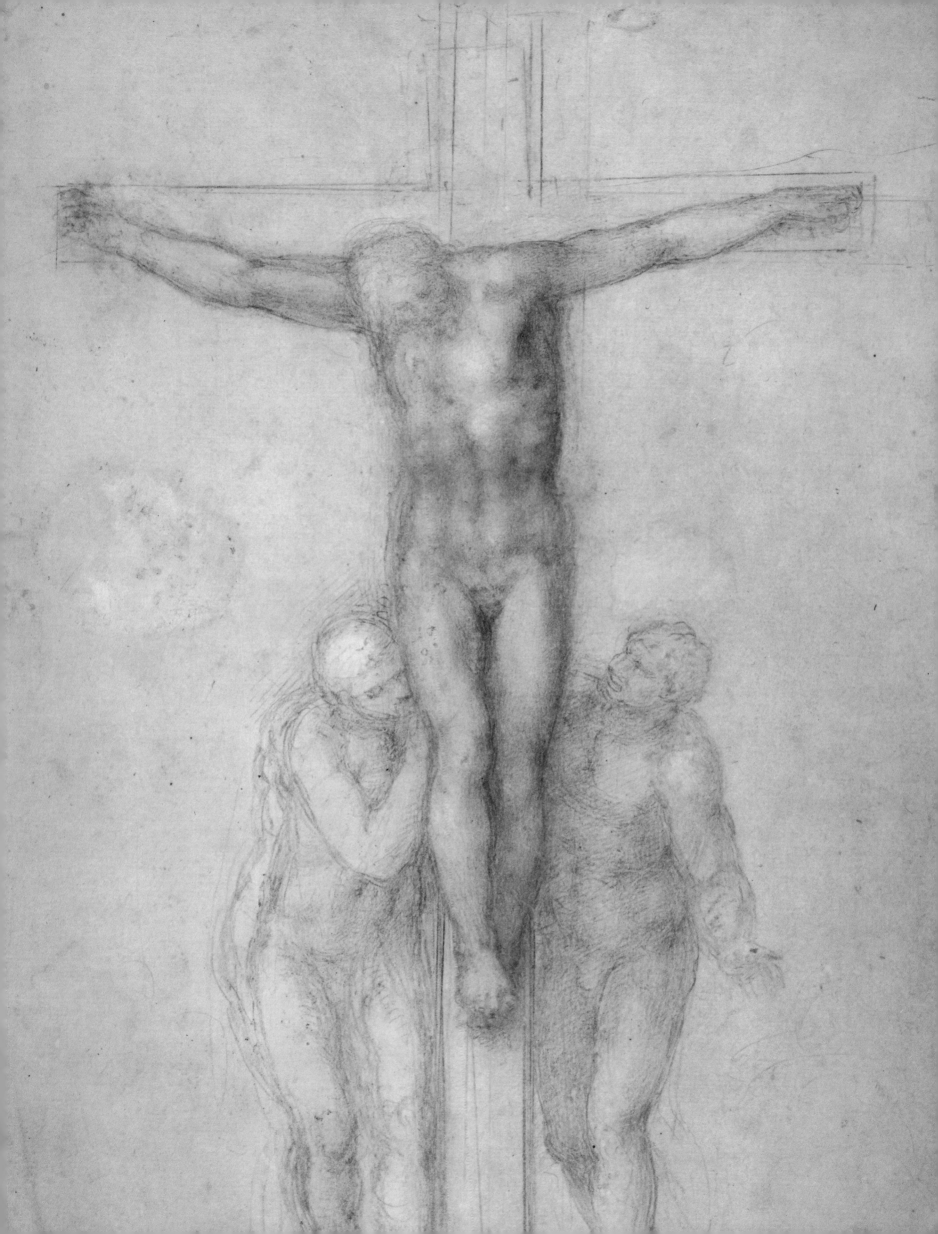

(LEFT)

MICHELANGELO
Crucifixion
1550–60
BLACK CHALK ON PAPER
16 ⅛ X 11 IN. (410 X 278 MM)
BRITISH MUSEUM, LONDON

(RIGHT)

MICHELANGELO
The Three Crosses
CA. 1520
RED CHALK ON PAPER
15 ½ X 11 IN. (394 X 281 MM)
BRITISH MUSEUM, LONDON

Among the most moving and haunting images ever created. These drawings are like prayers, private meditations upon Christ's sacrifice and Christians' faith. How easy to discard or destroy such unresolved images; it is testament to their intrinsic power and Michelangelo's fame that these fragile sheets were preserved.

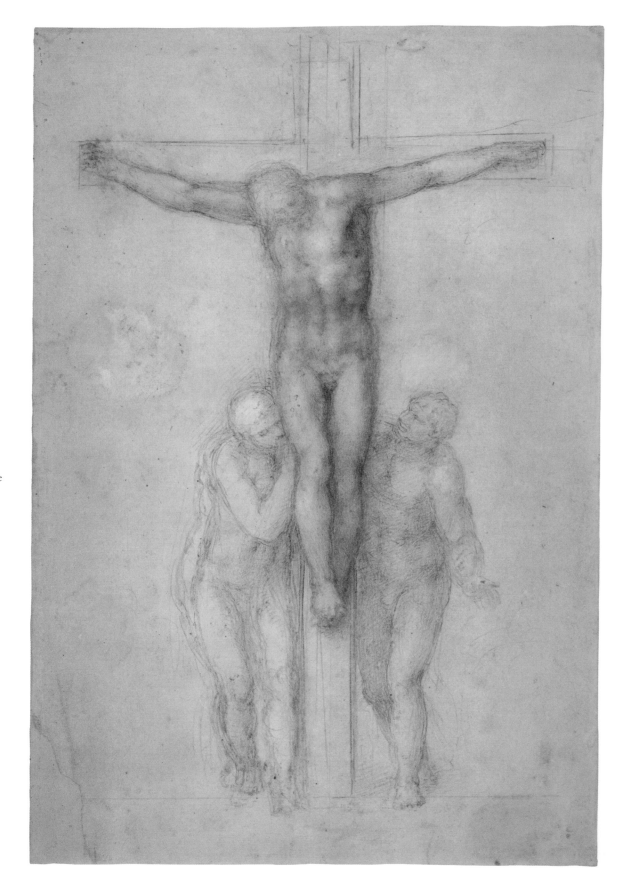

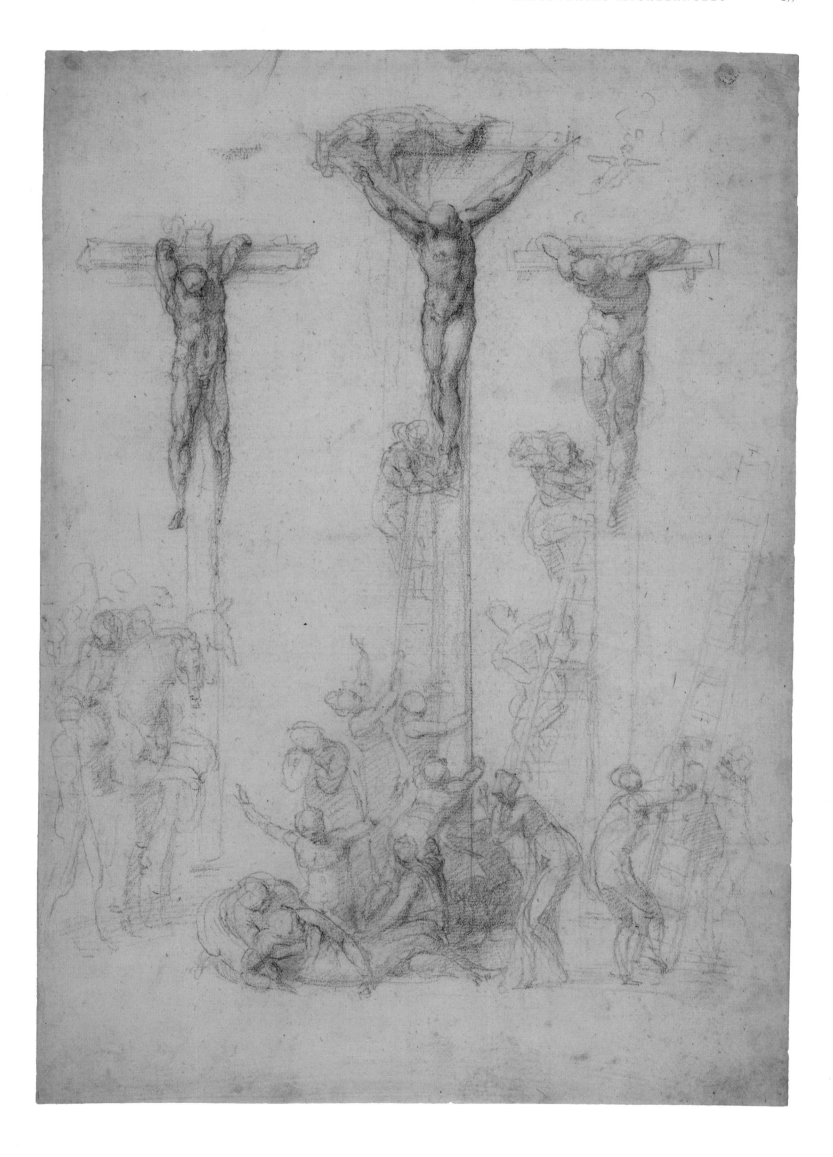

MICHELANGELO

(1475–1564)

Rondanini Pietà

1555–64

MARBLE
HEIGHT: 76 ¾ IN. (195 CM)
CASTELLO SFORZESCO, MILAN

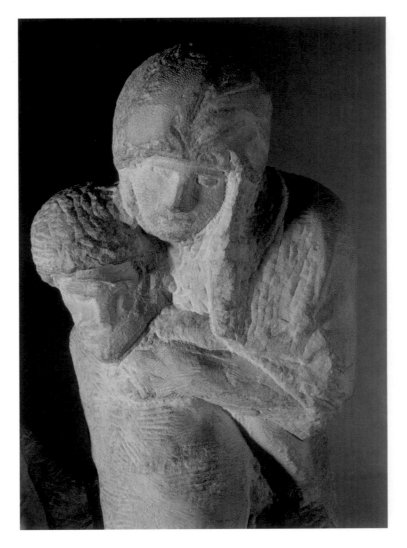

UNTIL JUST a few days before his death, Michelangelo was working on the so-called *Rondanini Pietà*, named for the palace of the Roman family in which it long stood. There is no indication that the sculpture was intended for anyone but the artist himself. It is a counterpart to his late religious poetry, most of which he wrote as a form of private devotion and personal consolation. So, too, it seems that carving was a form of prayer, a way of bringing him closer to God: salvation through creation.

The subject of the sculpture is difficult to describe. We call it a *pietà*, but it is radically different from Michelangelo's other two versions of the subject and unlike anything else he ever made. Mary stands on a rock and embraces, but scarcely supports, the weight of her dead child. Defying both logic and gravity, the figures are suspended in a timeless moment. The semi-standing pose and unfinished character of Christ lend him greater animation than might be expected from a slumping, lifeless body. His head turns, and at least one eye appears to gaze toward his mother's hand, which rests on his shoulder. The forms fuse. Mary and Christ, once of one flesh, have become so again.

Looking at the sculpture less poetically and less forgivingly, one sees that the artist had too little stone remaining to fully define each figure. Michelangelo carved and recarved, removing one idea after another as he cut deeply into the tall, thin block. Evidence of multiple iterations is most obvious in the detached stalk of Christ's right arm. A remnant of an earlier composition, this haunting fragment attests to a larger and more muscular body. Without this ghostly truncation—a moving testimony of the artist's relentless assault on the block—the viewer might never imagine that Michelangelo had made so many radical changes. He kept carving but never finished, confronted by the unavoidable paradox of representing spiritual matters in material form.

A side view of the sculpture reveals the extent of Michelangelo's excavation of the stone. The abstracted forms suggest a sculpture by Constantin Brancusi or a curling tongue of fire (a rising flamelike form that metaphorically offers the slimmest hope of resurrection). We are attuned and appreciative of such radical abstraction, but the artist surely saw the Son of Man, imagined his love for his Lord, and the loss to Mary.

Every blow of the hammer was a further laceration of Christ's flesh. In anguish, Michelangelo lamented "my wicked ways" and admitted a profound sense of futility: "No one has full mastery before reaching the end of his art and his life." His poetry is often as fragmentary as his sculpture. In the last fifteen years of his life, Michelangelo carved just two sculptures, both *pietàs*. They were his tomb, testament and epitaph, his means of dying well. Death was central to his thoughts, his waning life, and his meditative poetry: "What more can or should I feel at your wish, O Love, before I die?"

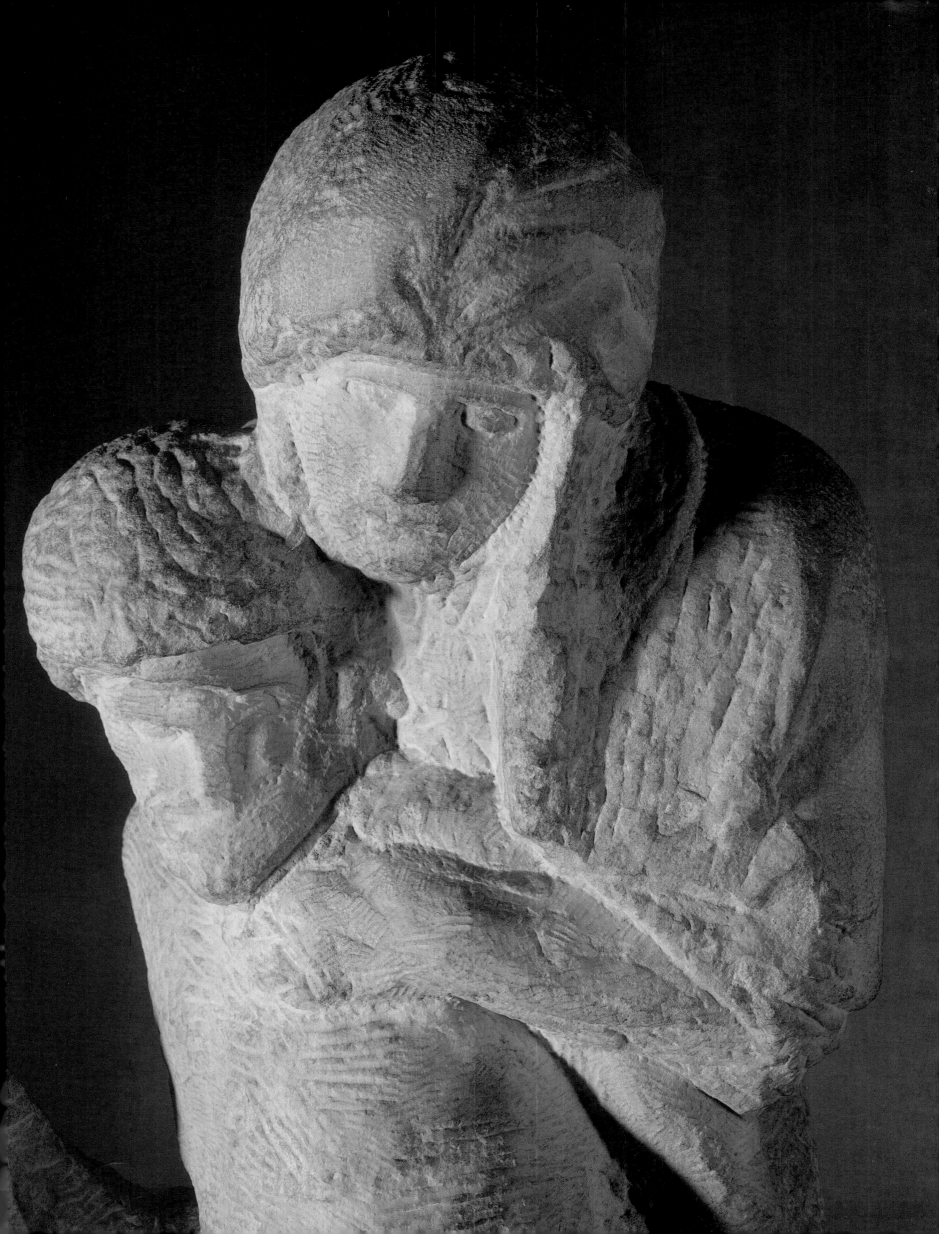

INDEX

Agony and the Ecstasy, The (Stone), 9
Alberti, Leon Battisti, 12
Aldovrandi, Giovanni Francesco, 13, 40
Angelico, Fra, 74
Apollo Belvedere, 46
Apollo/David (Michelangelo), 18, 19, 180–183
Arca, Niccolò dell', 40
Aretino, Pietro, 24
Ascension of St. John (Giotto), 26
"Atlas" or "Blockhead" Slave (Michelangelo), 138–141

Bacchus (Michelangelo), 14, 23, 46–49, 60, 186
Battle of Anghiari (Leonardo da Vinci), 68
Battle of Cascina, The (Michelangelo), 15, 36–39, 68–71, 74
Battle of the Centaurs (Michelangelo), 12, 13
Berenson, Bernard, 246
Bernini, Gian Lorenzo, 46, 232
Botticelli, Sandro, 74
Bramante, Donato, 16, 228
Brancusi, Constantin, 256
Bregno, Andrea, 14, 54
Bruges Madonna (Michelangelo), 15, 78, 88–91
Brunelleschi, Filipo, 12
Brutus (Michelangelo), 21, 204–207
Bugiardini, Giuliano, 96
Buonarroti, Ludovico, 11, 12
Buontalenti, Bernardo, 138

Calcagni, Tiberio, 242
Capitoline Hill, Rome (Michelangelo), 20, 21, 208–211, 246
Caravaggio (Michelangelo Merisi), 9
Cartonetto of the Annunciation (Michelangelo), 246–249
Cavalieri, Tommaso de', 19, 20, 21, 22, 190, 194, 208
Cellini, Benvenuto, 68
Clark, Kenneth, 222
Clement VII, Pope (Giulio de' Medici), 13, 18, 19, 172, 176
Colonna, Vittoria, 20–21, 190, 194, 246
Condivi, Ascanio, 11, 12, 15, 16, 23, 36, 96, 130, 214
Conversion of Saul (Michelangelo), 20, 218–221
Creation of Adam (Michelangelo), 110–113
Crucifixion, Ca. 1538/41 (Michelangelo), 194–197
Crucifixion, Ca. 1550–60 (Michelangelo), 250–253
Crucifixion of Peter (Michelangelo), 20, 218, 222–225
Cumaean Sibyl (Michelangelo), 116–119

David (Michelangelo), 8, 9, 10, 15, 23, 54, 60–63, 74, 134, 186, 232
Dawn (Michelangelo), 18, 152
Day (Michelangelo), 9, 18, 152
Del Riccio, Luigi, 20
Donatello, 12, 13, 32, 37, 60, 78
Doni, Agnolo, 8, 15, 82
Doni Tondo; see *Holy Family with the Infant and St. John the Baptist*
Drawing of Quarried Blocks (Michelangelo), 148–152
Duccio, Agostino di, 15
Dusk (Michelangelo), 18, 152
Dying Slave (Michelangelo), 130, 134–137, 186

Fall of Phaeton (Michelangelo), 190–193
Ficino, Marsilio, 13
Flood (Michelangelo), 102–105
Florentine Pietà (Michelangelo), 21, 22, 232–235
Fortification Drawing (Michelangelo), 176–179

Galli, Jacopo, 14
Garnier, Charles, 166
Ghiberti, Lorenzo, 96
Ghirlandaio, Domenico, 12, 26, 96
Giotto di Bondone:
 Ascension of St. John, 26
Goethe, Johann, 17
Granacci, Francesco, 96
Group of Two Figures, after Giotto (Michelangelo), 26–29

Hercules (Michelangelo), 13
Holy Family with the Infant and St. John the Baptist (Doni Tondo) (Michelangelo), 8, 12, 82–85

Julius II, Pope (Giuliano della Rovere), 15, 16, 17, 20, 96, 124, 214, 228

Landino, Cristoforo, 13
Laocoön, 232
Last Judgment (Michelangelo), 10, 19, 20, 23, 96, 194, 200–203, 246

Laurentian Library (Michelangelo), 18, 166–169, 172–175
Leah from the Tomb of Julius II (Michelangelo), 9, 21, 214–217
Leo X, Pope (Giovanni de' Medici), 13, 17, 18, 148, 242
Leonardo da Vinci, 9, 15–16, 54, 74, 176
 Battle of Anghiari, 68
 Last Supper, 96, 110
Libyan Sibyl (Michelangelo), 120–123
Lippi, Fra Filippo, 74

Madonna and Child (Michelangelo), 15, 88–91
Madonna and Child and the Child St. John (Pitti Tondo) (Michelangelo), 78–81
Madonna of the Stairs (Michelangelo), 13, 32–35, 162
Masaccio, 26
Medici Chapel, San Lorenzo, Florence, 18, 148, 152, 158, 162, 166, 186
Medici family, 13, 14, 18, 19, 20, 152, 172, 180, 242
Medici Madonna (Michelangelo), 18, 161–165
Michelangelo
 Apollo/David, 18, 19, 180–183
 "Atlas" or "Blockhead" Slave, 138–141
 Battle of the Centaurs, 12, 13
 The Battle of Cascina, 15, 36–39, 68–71, 74
 Bruges Madonna, 15, 78, 88–91
 Brutus, 21, 204–207
 Capitoline Hill, Rome, 20, 21, 208–211, 246
 Cartonetto of the Annunciation, 246–249
 Conversion of Saul, 20, 218–221
 Creation of Adam, 110–113
 Crucifixion, Ca. 1538/41, 194–197
 Crucifixion, Ca. 1550–60, 250–253
 Crucifixion of Peter, 20, 218, 222–225
 Cumaean Sibyl, 116–119
 David, 8, 9, 10, 15, 23, 54, 60–63, 74, 134, 186, 232
 Dawn, 18, 152
 Day, 9, 18, 152
 Doni Tondo; see *Holy Family with the Infant and St. John the Baptist*
 Drawing of Quarried Blocks, 148–152
 Dusk, 18, 152
 Dying Slave, 130, 134–137, 186
 Fall of Phaeton, 190–193
 Flood, 102–105
 Florentine Pietà, 21, 22, 232–235
 Fortification Drawing, 176–179
 Group of Two Figures, after Giotto, 26–29
 Hercules, 13
 Holy Family with the Infant and St. John the Baptist (Doni Tondo), 8, 12, 82–85
 Last Judgment, 10, 19, 20, 23, 96, 194, 200–203, 246
 Laurentian Library, 18, 166–169, 172–175
 Leah from the Tomb of Julius II, 9, 21, 214–217
 Libyan Sibyl, 120–123
 Madonna and Child (1503-5), 15, 88–91
 Madonna and Child and the Child St. John (Pitti Tondo), 78–81
 Madonna of the Stairs, 13, 32–35, 162
 Medici Madonna, 18, 161–165
 Moses, 10, 17, 54, 124–127, 134, 214
 New St. Peter's, Rome, 20, 21, 23, 228–231, 246
 Night, 18, 152, 158–161
 Pietà, 10, 14, 15, 23, 50–53, 60, 64, 78, 88
 Pitti Tondo; see *Madonna and Child and the Child St. John*
 Plan of San Giovanni dei Fiorentini, 242–245
 Porta Pia, Rome, 236–239, 246
 Preparatory Drawing for Sistine Chapel Ceiling, 92–95
 Rachel from the Tomb of Julius II, 21, 214–217
 Rebellious Slave, 130–133, 134, 138, 186
 Risen Christ, 18, 134, 144–147, 180
 Rondanini Pietà, 21, 22, 23, 256–259
 St. John the Baptist, 14
 St. Matthew, 15, 64–67, 130, 180
 St. Paul and St. Peter, 54–57
 St. Petronius, 13, 40–43
 St. Proculus, 13, 40
 Sistine Chapel ceiling, 9, 10, 12, 16, 17, 23, 64, 96–99, 102–105, 106–109, 110–113, 116–119, 120, 186, 228
 Sleeping Cupid, 14
 Taddei Tondo; see *The Virgin and Child with the Infant St. John*
 Temptation and Expulsion, 106–109
 Tomb of Giuliano, 18, 152–155
 Tomb of Pope Julius II, San Pietro in Vincoli, Rome, 16, 17, 20, 21, 23, 92, 124, 130, 134, 138, 186, 214
 Victory, 9, 18, 19, 64, 180, 186–189

The Virgin and Child with the Infant St. John (Taddei Tondo), 74–77, 78
Moses (Michelangelo), 10, 17, 54, 124–127, 134, 214
New St. Peter's, Rome (Michelangelo), 20, 21, 23, 228–231, 246
Night (Michelangelo), 18, 152, 158–161

Old St. Peter's, Rome, 228

Paul III, Pope (Alessandro Farnese), 19–20, 200, 208, 218, 228, 246
Pauline Chapel, The Vatican, Rome, 218, 222
Piccolomini, Cardinal Francesco, 14, 54
Pico della Mirandola, Giovanni, 13
Pietà (Michelangelo), 10, 14, 15, 23, 50–53, 60, 64, 78, 88
Pisano, Giovanni, 36
Pisano, Nicola, 36, 40, 60
Pitti Tondo; see *Madonna and Child and the Child St. John*
Pius III, Pope (Francesco Piccolomini), 14
Pius IV, Pope (Giovanni Angelo Medici), 21, 236
Plan of San Giovanni dei Fiorentini (Michelangelo), 242–245
Pliny, 232
Poliziano, Angelo, 13
Porta, Giacomo della, 242
Porta Pia, Rome (Michelangelo), 236–239, 246

Quercia, Jacopo della, 40, 60, 96

Rachel from the Tomb of Julius II (Michelangelo), 21, 214–217
Raphael, 16, 74
 St. Catherine, 64
Rebellious Slave (Michelangelo), 130–133, 134, 138, 186
Rembrandt van Rijn, 9
Riario, Cardinal Raffaele, 14, 46
Ridolfi, Niccolò, 204
Risen Christ (Michelangelo), 18, 134, 144–147, 180
Rodin, Auguste:
 Thinker, 110
Rondanini Pietà (Michelangelo), 21, 22, 23, 256–259
Ruskin, John, 116

St. John the Baptist (Michelangelo), 14
St. Matthew (Michelangelo), 15, 64–67, 130, 180
St. Paul and St. Peter (Michelangelo), 54–57
St. Petronius (Michelangelo), 13, 40–43
St. Proculus (Michelangelo), 13, 40
Sangallo, Bastiano ("Aristotile") da, 68, 96, 228, 242
Sangallo, Giuliano da, 16
Sansovino, Jacopo, 64
Savonarola, Girolamo, 14
Schongauer, Martin:
 The Temptation of St. Anthony, 26
Sistine Chapel ceiling (Michelangelo), 9, 10, 12, 16, 17, 23, 64, 96–101, 102–105, 106–109, 110–113, 116–119, 120, 186, 228
 preparatory drawing for, 92–95
Sleeping Cupid (Michelangelo), 14
Soderini, Piero, 8, 15
Stone, Irving, 9
Strozzi, Roberto, 134
Strozzi family, 13

Taddei, Taddeo, 74
Taddei Tondo; see *The Virgin and Child with the Infant St. John*
Temptation and Expulsion (Michelangelo), 106–109
Temptation of St. Anthony, The (Schongauer), 26
Thinker (Rodin), 110
Tomb of Giuliano (Michelangelo), 18, 152–155
Tomb of Pope Julius II, San Pietro in Vincoli, Rome (Michelangelo), 16, 17, 20, 21, 23, 92, 124, 130, 134, 138, 186, 214

Uccello, Paolo, 96

Valori, Bartolomeo (Baccio), 180
Varchi, Benedetto, 78
Vasari, Giorgio, 8, 11, 22, 60, 120, 124, 130, 166, 200, 232
Venusti, Marcello, 246
Victory (Michelangelo), 9, 18, 19, 64, 180, 186–189
Virgin and Child with the Infant St. John, The (Taddei Tondo) (Michelangelo), 74–77, 78
Volterra, Daniele da, 22

Wright, Frank Lloyd, 166, 172